MAGNETIC

Humanity and the Asian Elephant

LARRY LAVERTY

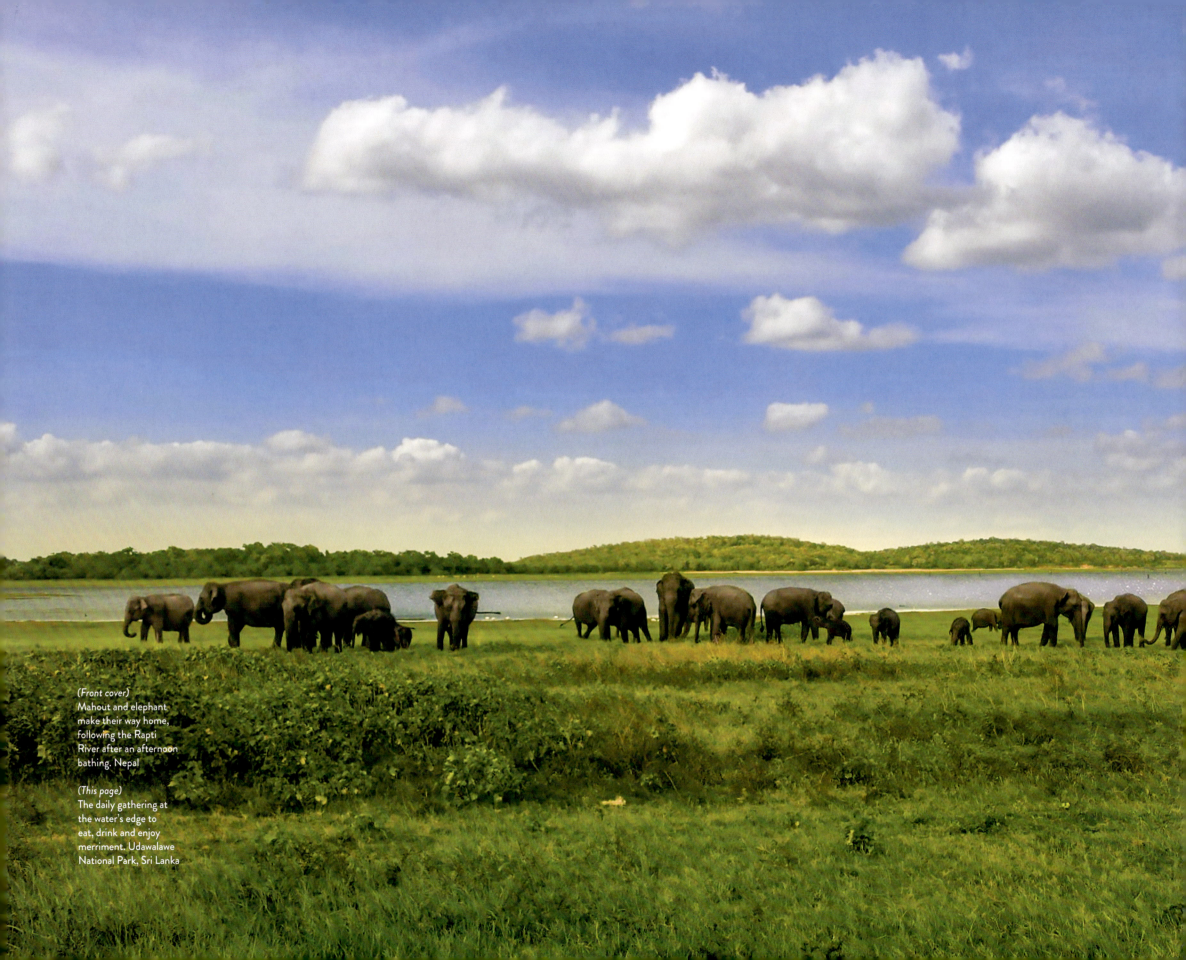

(Front cover)
Mahout and elephant make their way home, following the Rapti River after an afternoon bathing. Nepal

(This page)
The daily gathering at the water's edge to eat, drink and enjoy merriment. Udawalawe National Park, Sri Lanka

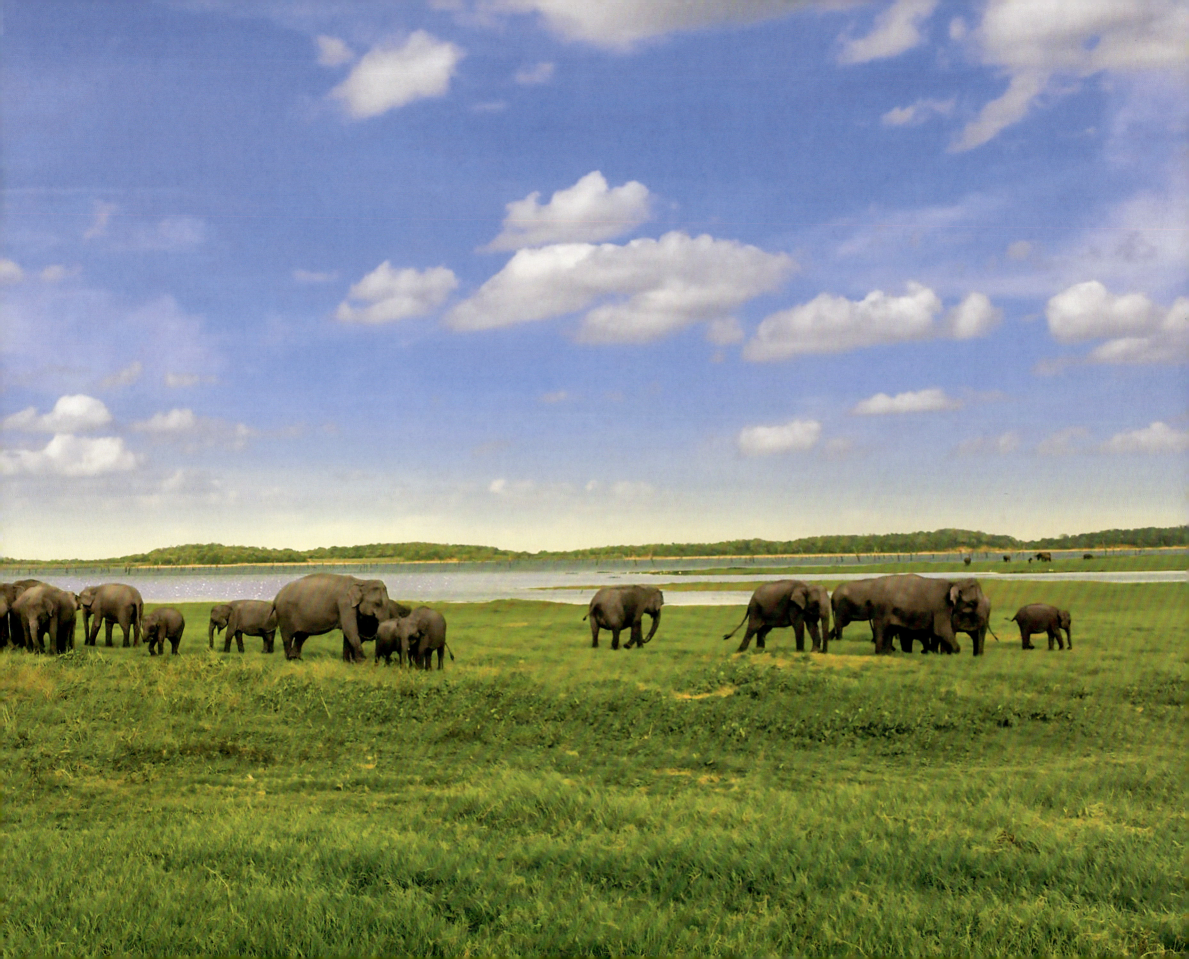

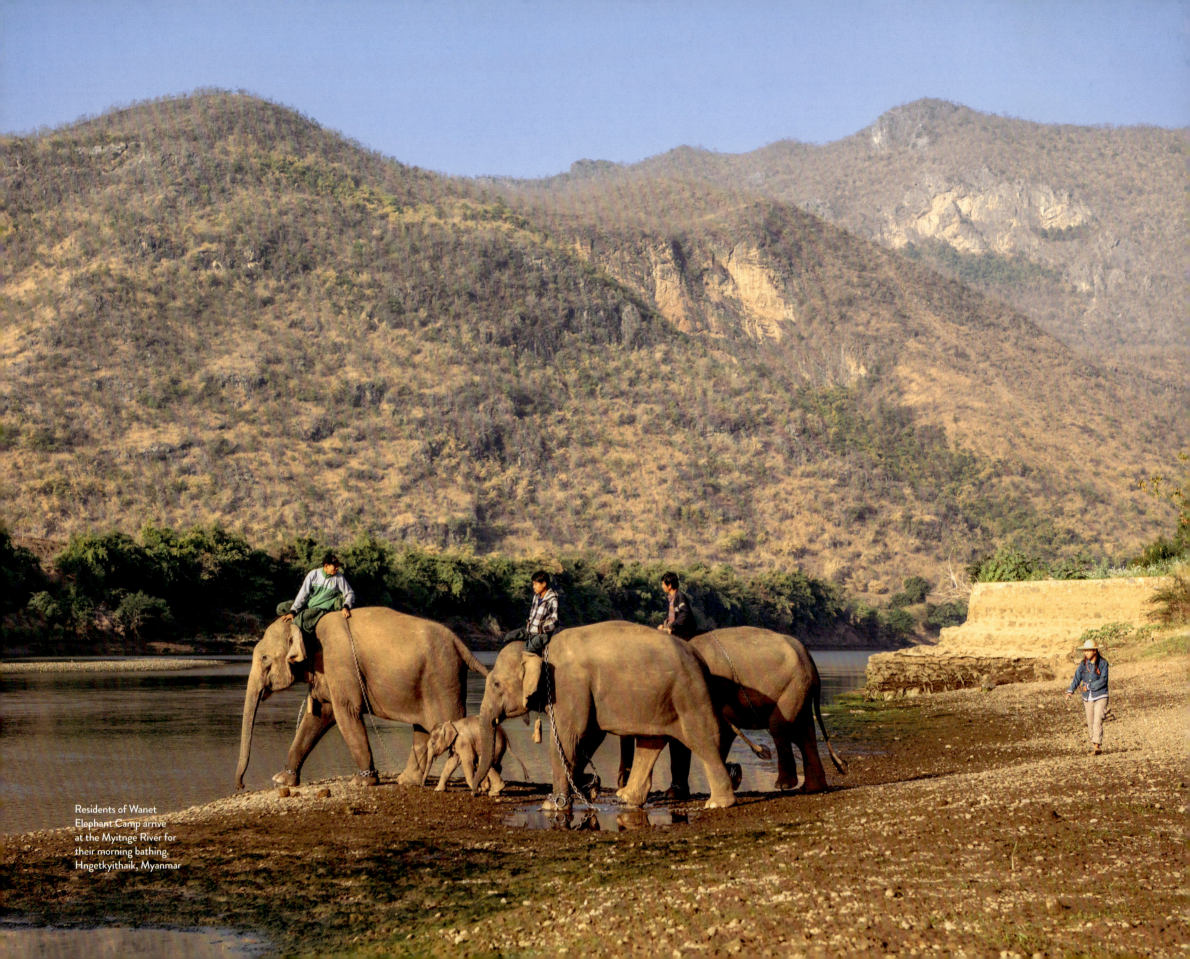

Residents of Wanet Elephant Camp arrive at the Myitnge River for their morning bathing. Hngetkyithaik, Myanmar

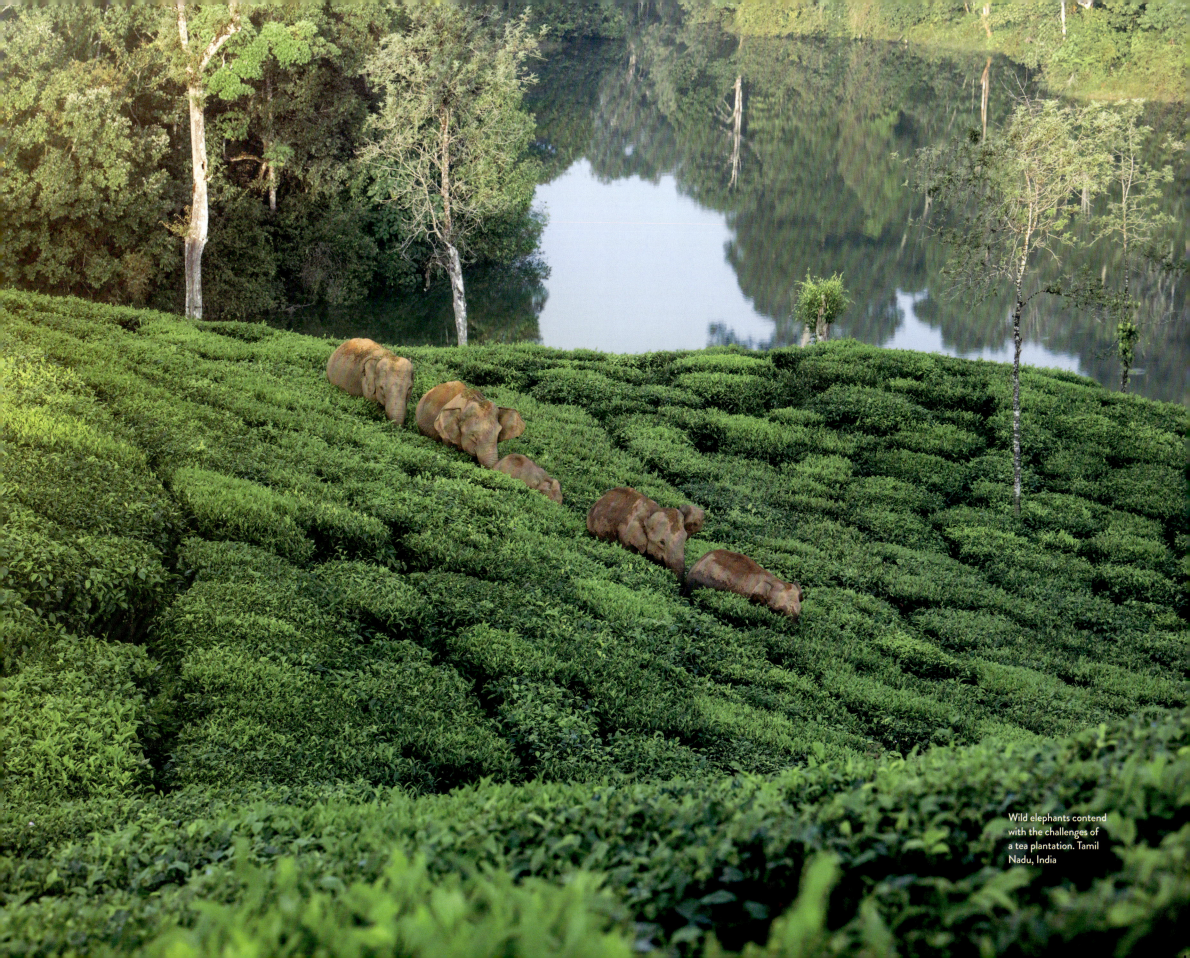

Wild elephants contend with the challenges of a tea plantation. Tamil Nadu, India

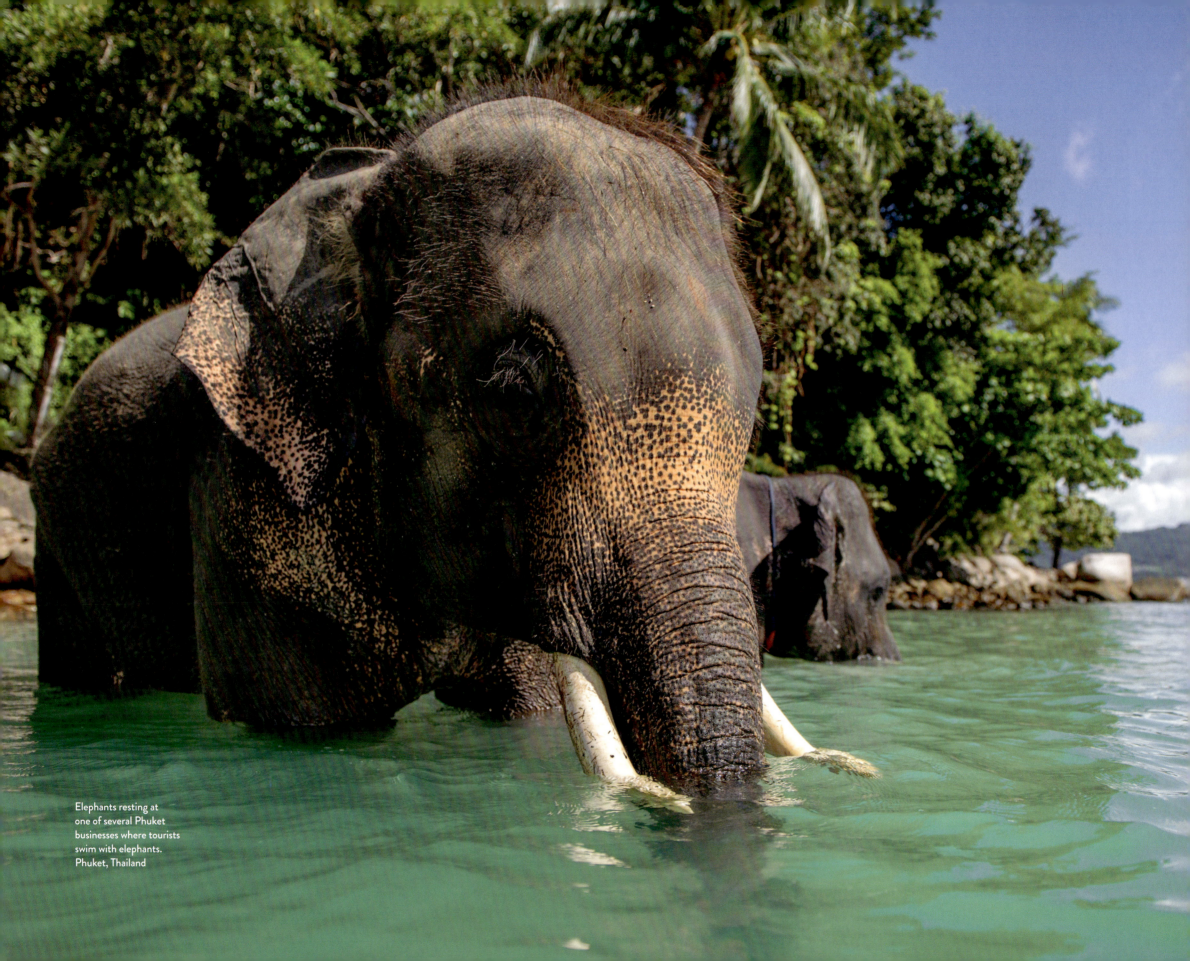

Elephants resting at one of several Phuket businesses where tourists swim with elephants. Phuket, Thailand

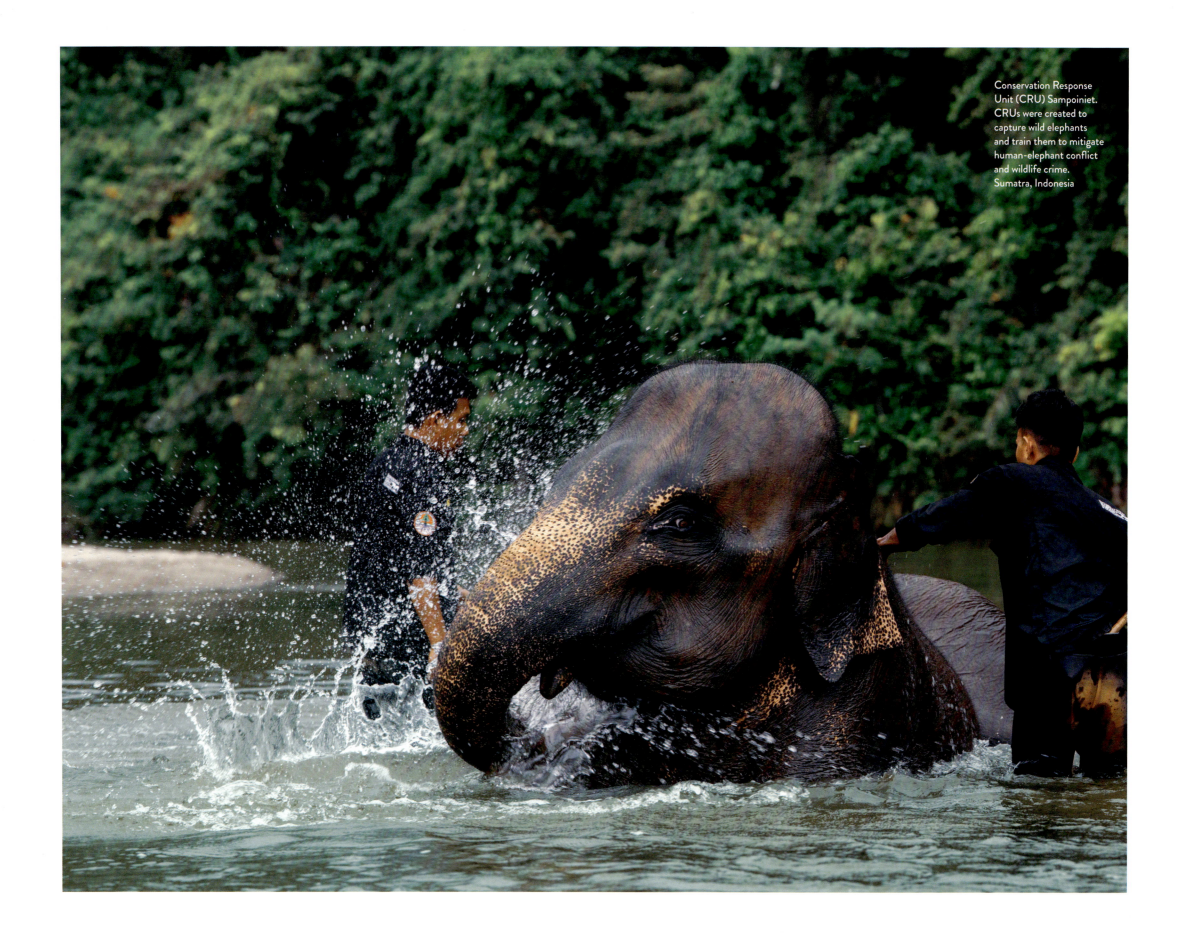

Conservation Response Unit (CRU) Sampoiniet. CRUs were created to capture wild elephants and train them to mitigate human-elephant conflict and wildlife crime. Sumatra, Indonesia

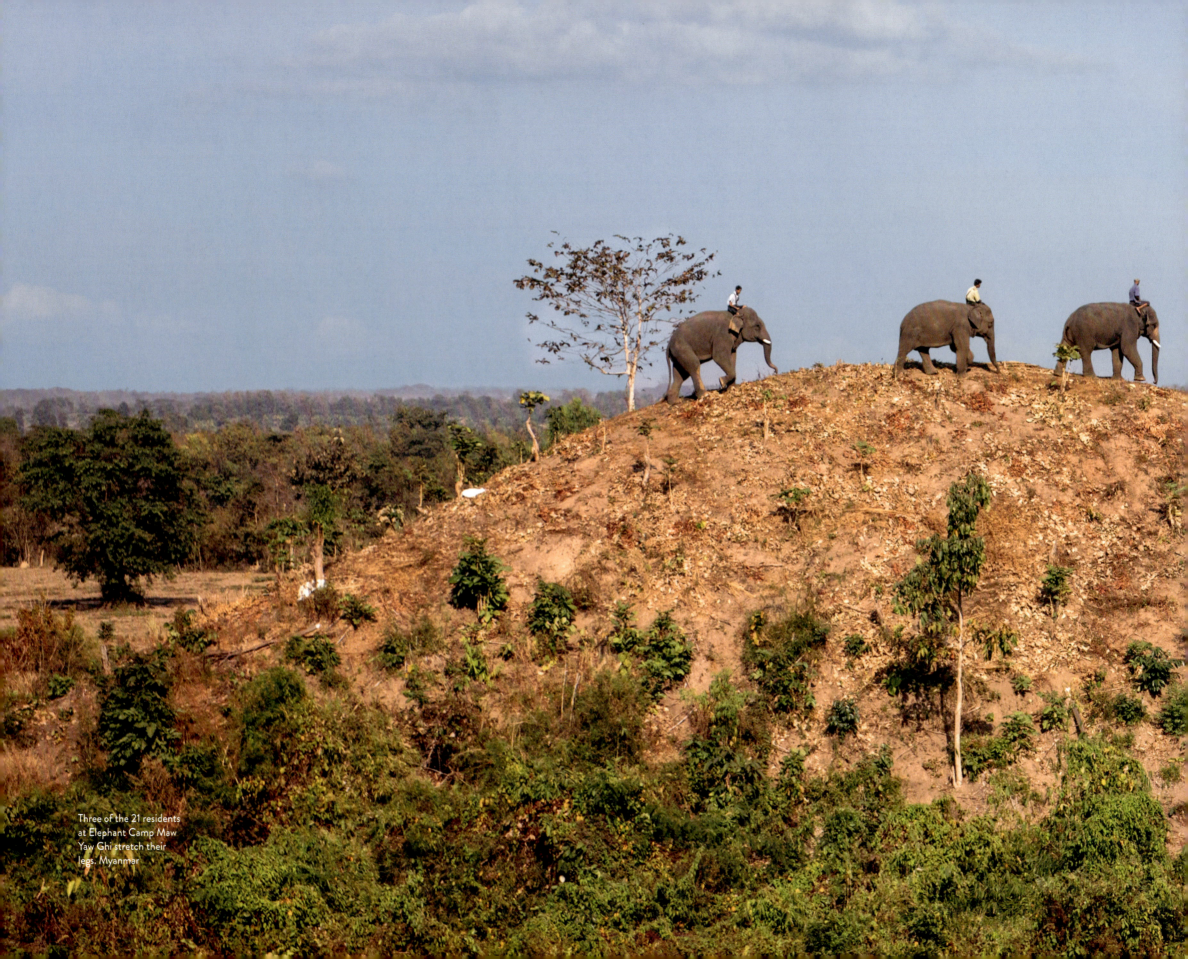

Three of the 21 residents at Elephant Camp Maw Yaw Ghi stretch their legs. Myanmar

One of the numerous elephants hired to take part in festivities at Thrissur Pooram Hindu festival awaits permission for delivery. Kerala, India

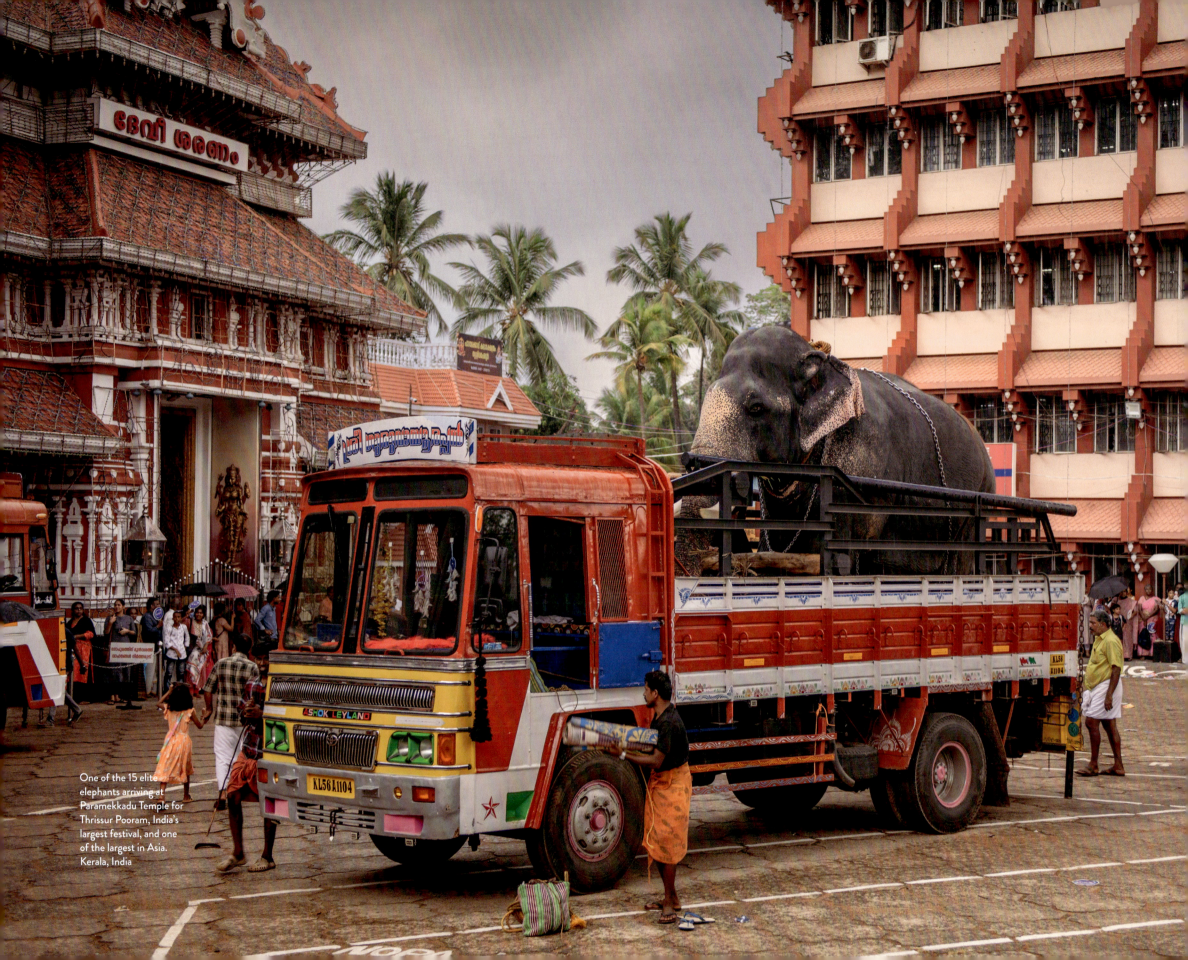

One of the 15 elite elephants arriving at Paramekkadu Temple for Thrissur Pooram, India's largest festival, and one of the largest in Asia. Kerala, India

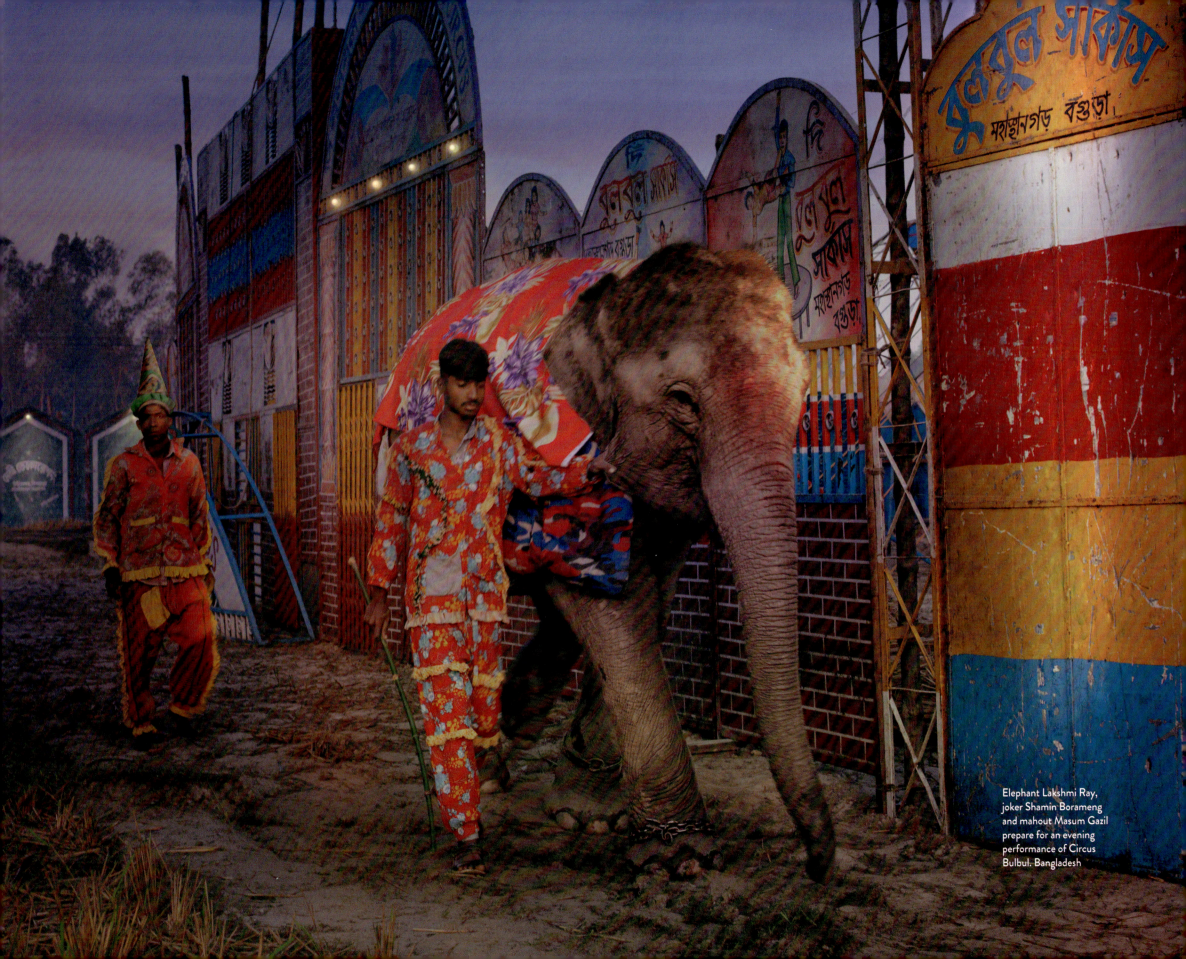

Elephant Lakshmi Ray, joker Shamin Borameng and mahout Masum Gazil prepare for an evening performance of Circus Bulbul, Bangladesh

Published by
LID Publishing
An imprint of LID Business Media Ltd.
LABS House, 15–19 Bloomsbury Way,
London, WC1A 2TH, UK

info@lidpublishing.com
www.lidpublishing.com

A member of:

businesspublishersroundtable.com

All rights reserved. Without limiting the rights under copyright reserved, no part of this publication may be reproduced, stored or introduced into a retrieval system, or transmitted, in any form or by any means (electronic, mechanical, photocopying, recording or otherwise) without the prior written permission of both the copyright owners and the publisher of this book.

© Larry Laverty, 2025
© LID Business Media Limited, 2025

Printed in China
ISBN: 978-1-915951-55-7
ISBN: 978-1-915951-56-4 (ebook)

Cover and page design: Caroline Li

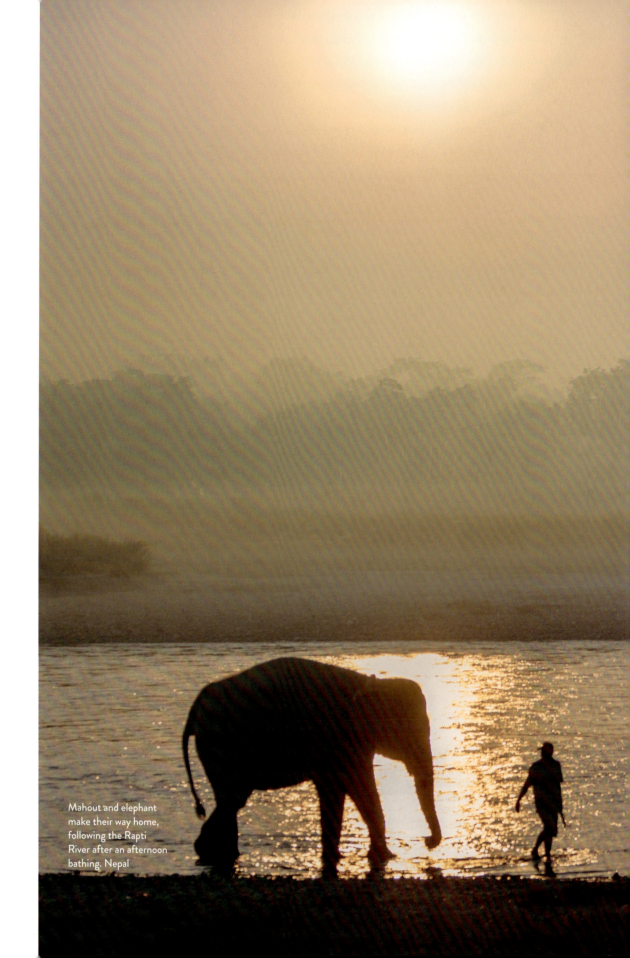

Mahout and elephant make their way home, following the Rapti River after an afternoon bathing. Nepal

MAGNETIC
Humanity and the Asian Elephant

Larry Laverty

MADRID | MEXICO CITY | LONDON
BUENOS AIRES | BOGOTA | SHANGHAI

CONTENTS

5 DEDICATION

7 CONDITIONS

15 INTRODUCTION

26 HISTORY

34 WAR ELEPHANT

42 TRIBUTE ELEPHANT

50 TIMBER ELEPHANT

60 BANDOOLA
TIMBER ELEPHANT

70 MAHOO NEE AND THE GUIDE MAN
TIMBER ELEPHANTS

85 TEMPLE ELEPHANT

96 MALIGAWA RAJA
TEMPLE ELEPHANT

112 ENTER THE VICIOUS

120 VANISHING POINT VIETNAM

126 LAKSHMI THE FUGITIVE
BEGGING ELEPHANT, ELEPHANT FOR HIRE

146 UNCLE BOO LOY
ELEPHANT SANCTUARY WORKER

157 AFTERWORD

161 YOU CAN HELP

167 ACKNOWLEDGEMENTS

175 BIBLIOGRAPHY

179 IN DREAMS

181 ABOUT THE AUTHOR AND PHOTOGRAPHER

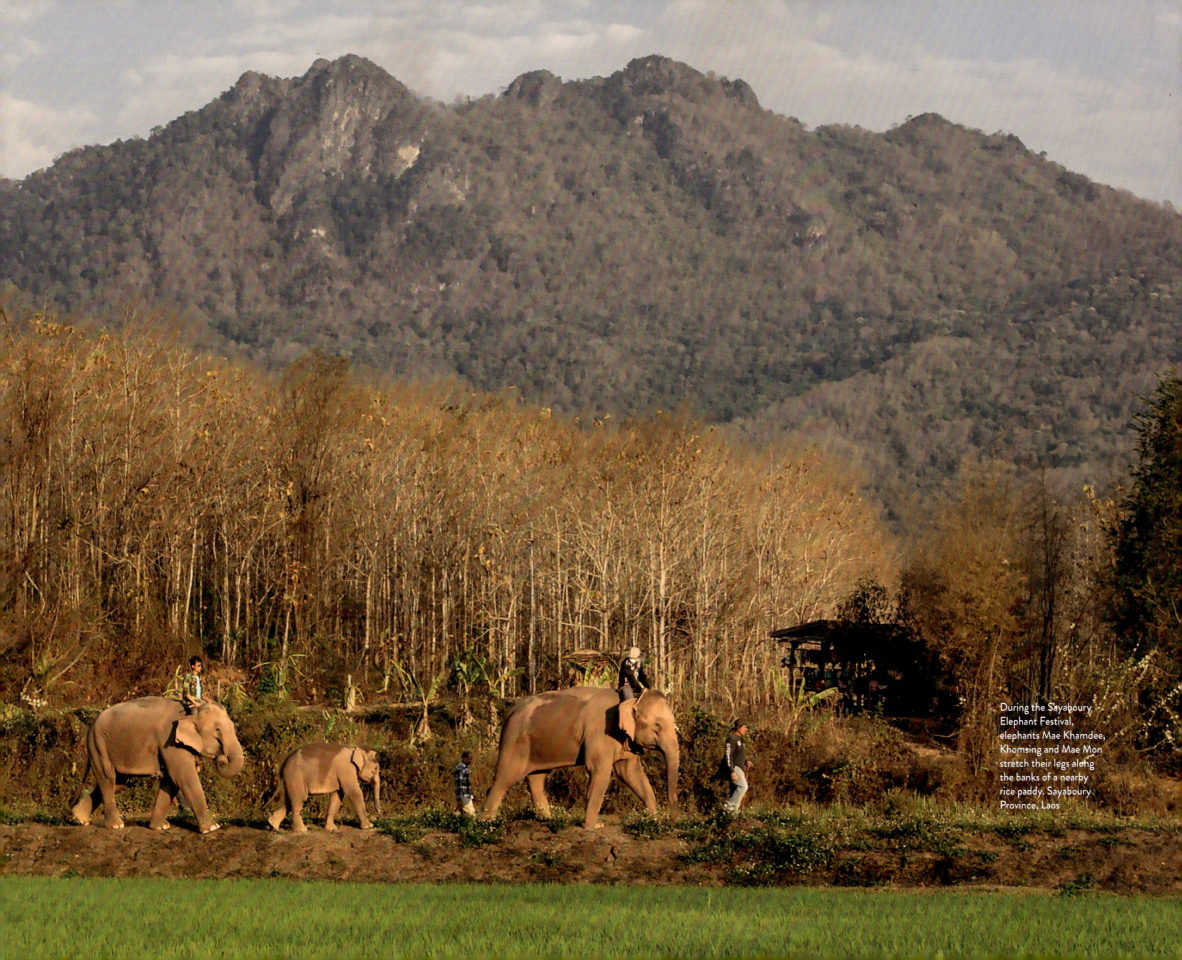

During the Sayaboury Elephant Festival, elephants Mae Khamdee, Khomsing and Mae Mon stretch their legs along the banks of a nearby rice paddy. Sayaboury Province, Laos

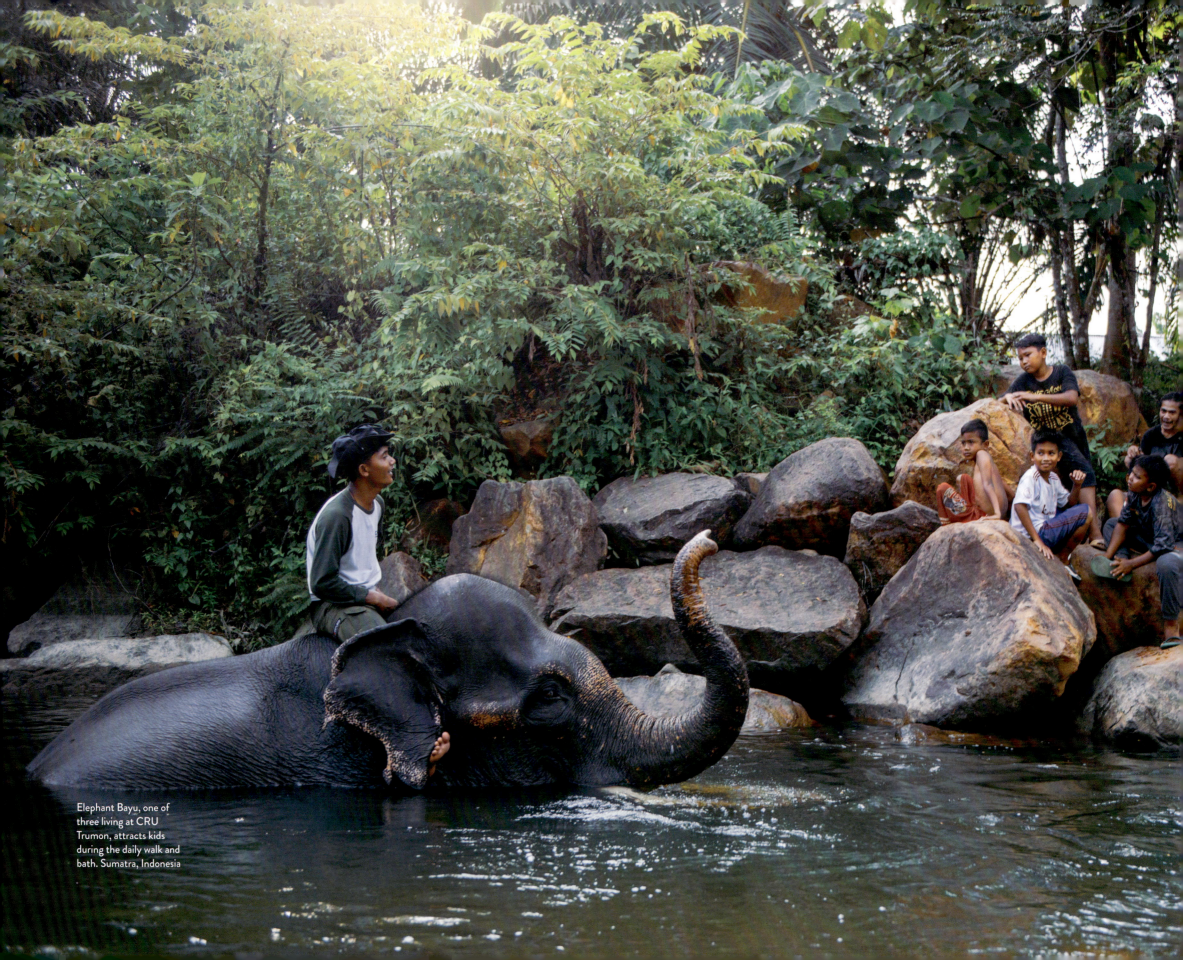
Elephant Bayu, one of three living at CRU Trumon, attracts kids during the daily walk and bath. Sumatra, Indonesia

DEDICATION

This record of the elephant in Asia was created to raise global awareness of their plight. It is inspired by the lives of all elephants, living and passed, who have suffered at the hands of humanity. In the same breath, it is inspired by every human being who cherishes elephants and has gone out of their way to help them. The thorough nature of this account was made possible by the cooperation of countless mahouts and elephant owners who graciously opened their world to me. I share that this book would not have been possible without the strength and insight given to me by my parents, Gordon and Marjorie Laverty, and my uncle, Bruce R. Laverty. And finally, I dedicate this book to the life and spirit of blind elephant Ploy Thong, who was lost to flood waters of the Mae Taeng River in Thailand, October 3, 2024. May this book preserve her memory and that of each elephant recorded here, in image or in word, as their lives are every bit as significant as any human life on this earth.

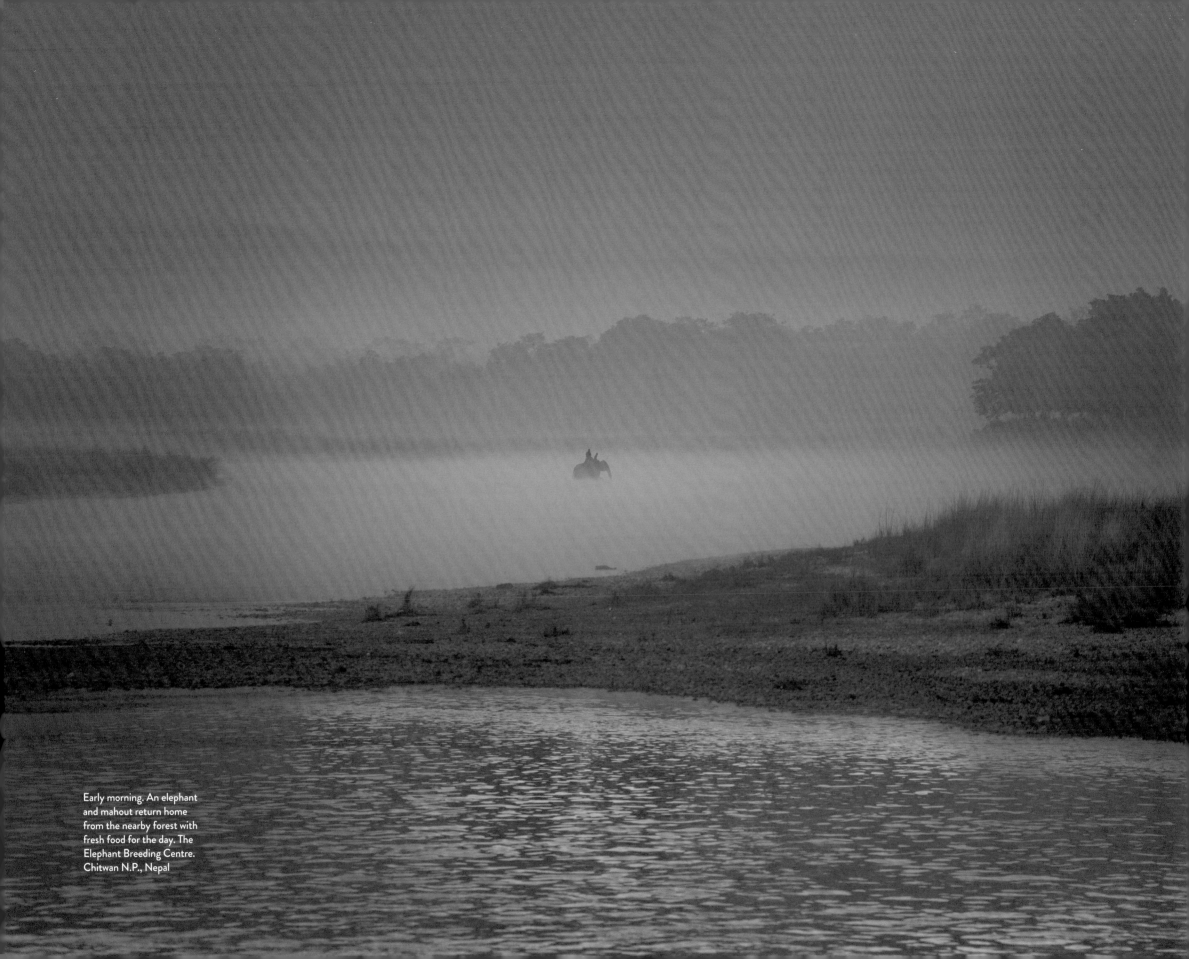

Early morning. An elephant and mahout return home from the nearby forest with fresh food for the day. The Elephant Breeding Centre. Chitwan N.P., Nepal

CONDITIONS

The elephants of Asia, on a day-to-day basis, are simply trying to survive. This is true for both those living in captivity and those living in the wild. With each new sunrise, most of them don't know what to expect next from humanity. And much of the time, the interactions aren't very pleasant.

As you take in this book, you might be expecting an experience like you've had with feel-good travel magazines or TV shows. This record, however, will show you how things really are, not how we wish they might be.

For many, certain images in this record will be difficult to take in. The human race today and throughout history has failed mightily to give elephants the respect they deserve – ironic, given the elevated place these beings hold in both culture and religion.

As I recorded each image you're about to see, I stood before them, I witnessed, I felt. In many instances, the events that took place broke my heart. At times I fought back tears, at other times I was raised to anger. I have now been to hell on earth. I have repeatedly seen the devil at work. And in almost all instances, I longed for the ability to bring justice, to make the world right for elephants. On this matter, you should know that at times I failed to contain myself. At times, I shouted profanities at the top of my lungs at heartless human beings. But at the same time, I knew that my incarceration or expulsion from a country would gain nothing, and the lives of the elephants documented would continue unknown.

In many instances, I was granted unusual access to elephants, access in many cases that no human being from the Western world had ever been given before, especially a photographer. To each human being who trusted me to be civil, to be respectful, I owe a debt of gratitude. Their faith in me, which in several cases grew to that accorded their closest family and friends, won my heart, even when their treatment of elephants could have been much better.

Some readers here may long for more images of elephants living free in the wild, the kind of images recorded of elephants in Africa. I actually set out with great intent to record the lives of free-roaming elephants throughout Asia. But the continent of Asia is a far different place than the continent of Africa. In many countries, wild elephants have retreated so deeply into remaining forests that locating one can take several days. And then there's the fact that nearly one in every three elephants alive today in Asia lives in captivity anyway. So, as I learned, any discussion of elephants in Asia, going back over several thousand years, cannot be had without recognizing the long-standing entanglements introduced by humans.

Regarding the text included among the following pages, a word on terminology. In the world of captive elephants, it's important to note that these elephants live under one of several arrangements with humans. Many have both an owner and a handler in their lives. Others have just an owner and he does all the handling. Under still other arrangements, the handler, whether he is owner or not, will have an additional person or two assisting him in various duties like gathering food or cleaning. So to avoid confusion, I'll generally limit my referencing of humans in discussions of captive elephants to the handlers and will refer to them as 'mahouts,' an approximation of the Indian word 'mahawat' used most commonly throughout Asia.

Finally, over ten years now into my relationship with elephants, people continue to ask, "Why? Why elephants?" Why do I find elephants so magnetic? Realizing that my crusade is usually beyond comprehension, I simply respond by paraphrasing a thought shared years ago by a legendary friend of elephants, the late Dame Daphne Sheldrick of Kenya: they're like us, only better.

Larry Laverty
November 2024

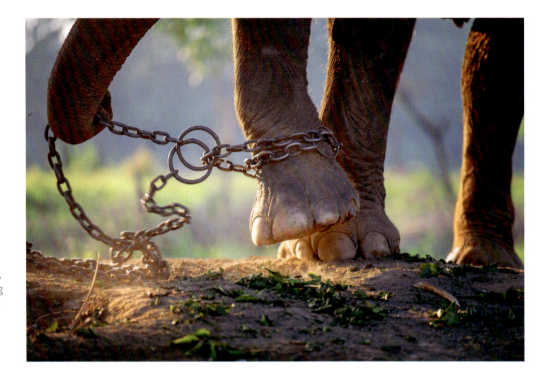

Though granted time off-chain twice each day, elephants at the breeding and conservation centre, Bardia Hattisar, are well aware that freedom is just an agonizing dream. Bardia N.P., Nepal

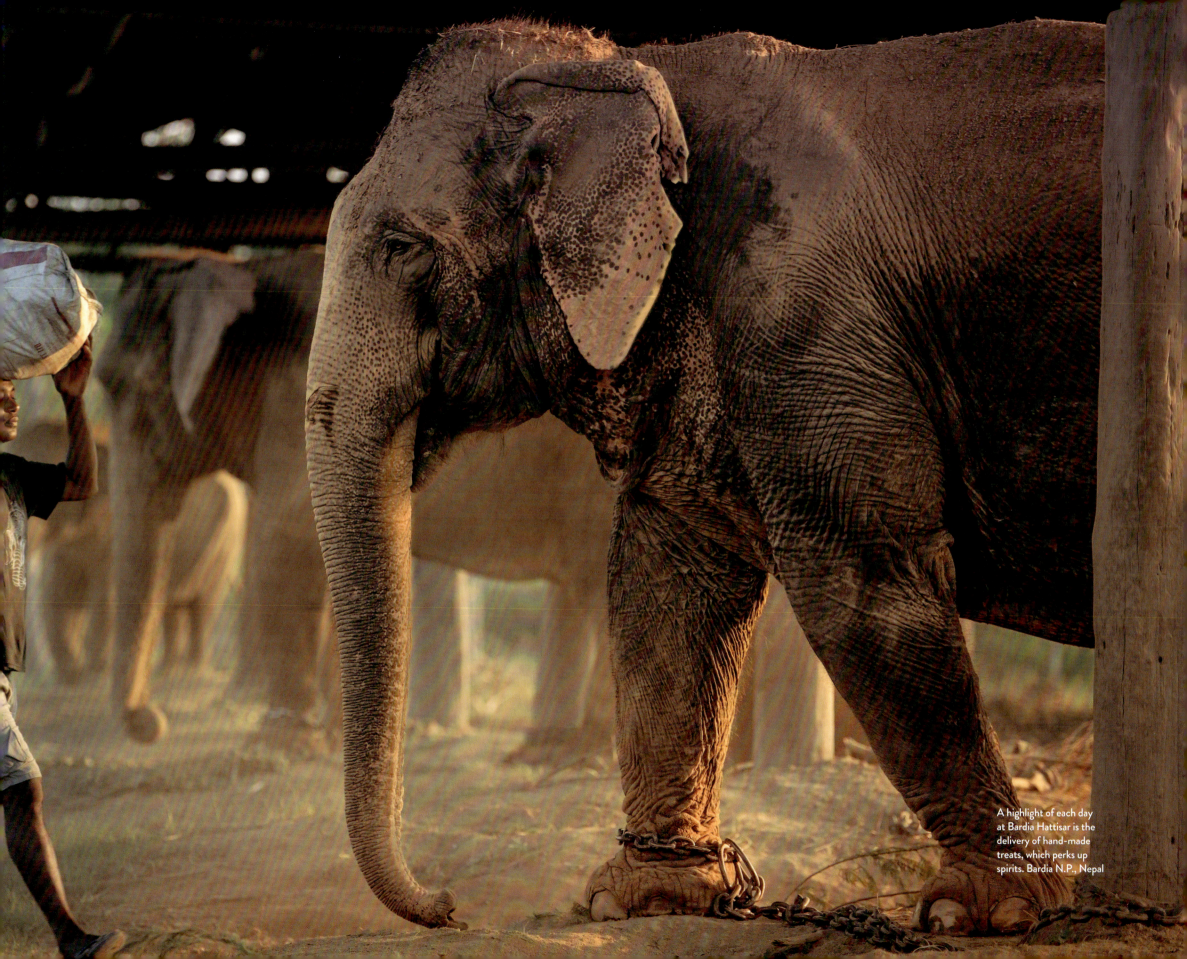

A highlight of each day at Bardia Hattisar is the delivery of hand-made treats, which perks up spirits. Bardia N.P., Nepal

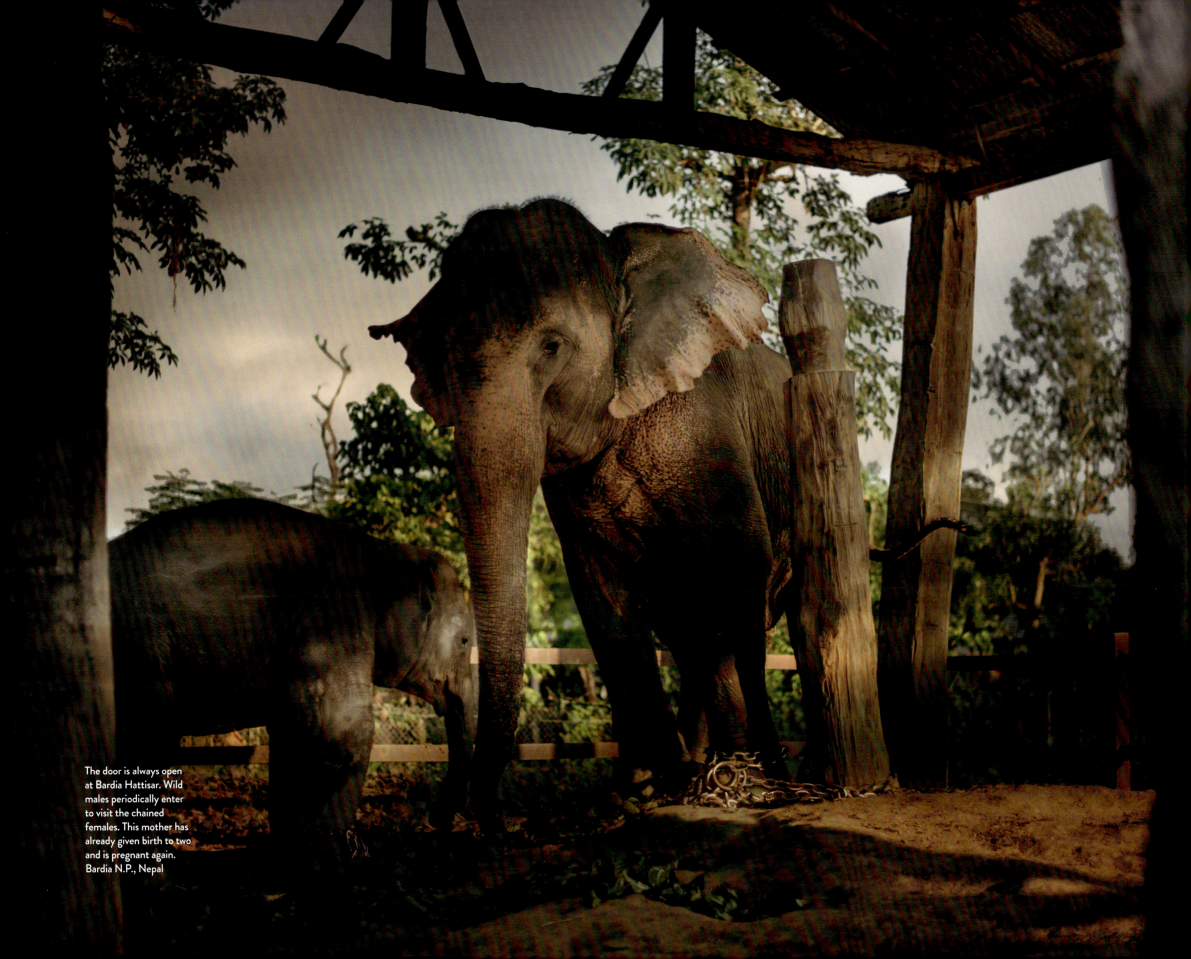

The door is always open at Bardia Hattisar. Wild males periodically enter to visit the chained females. This mother has already given birth to two and is pregnant again.
Bardia N.P., Nepal

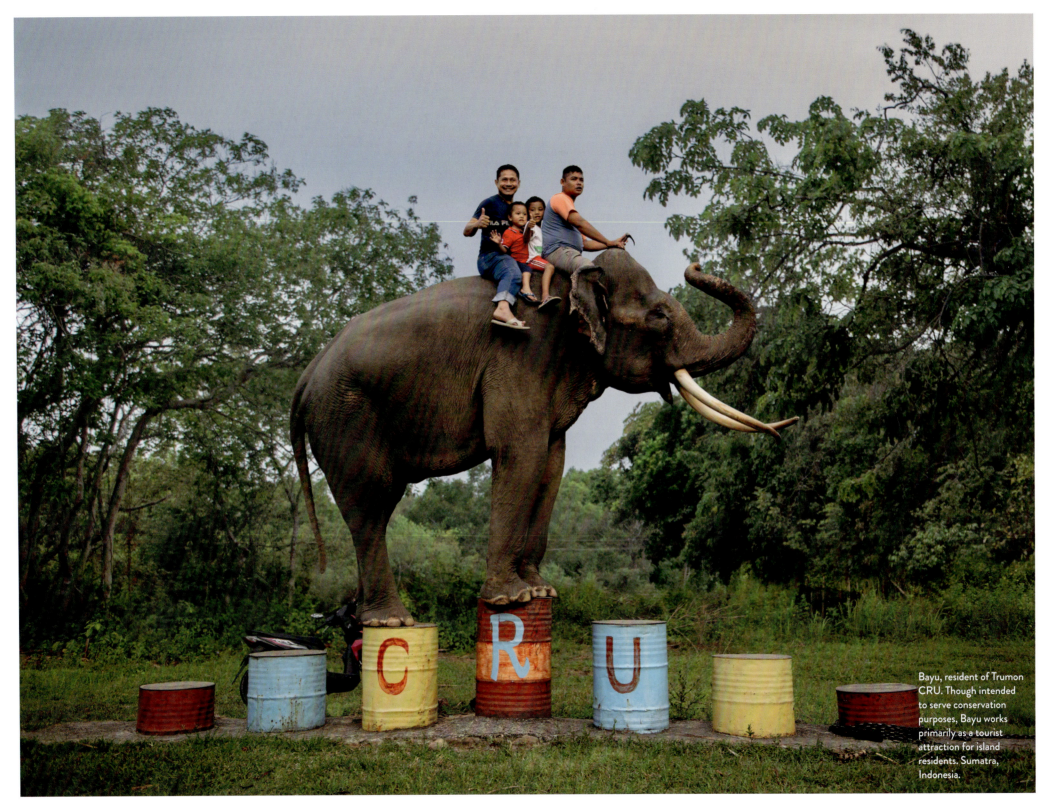

Bayu, resident of Trumon CRU. Though intended to serve conservation purposes, Bayu works primarily as a tourist attraction for island residents. Sumatra, Indonesia.

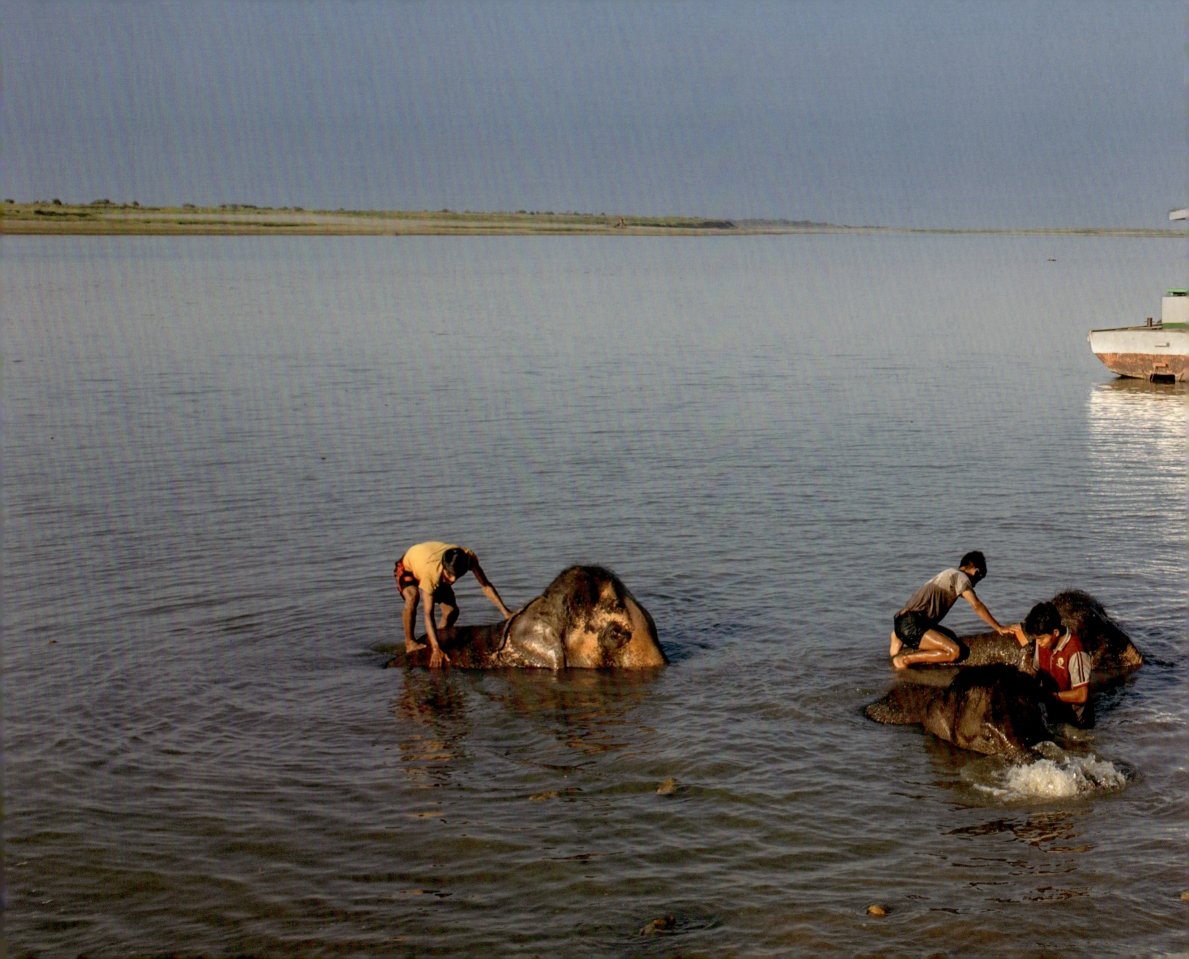

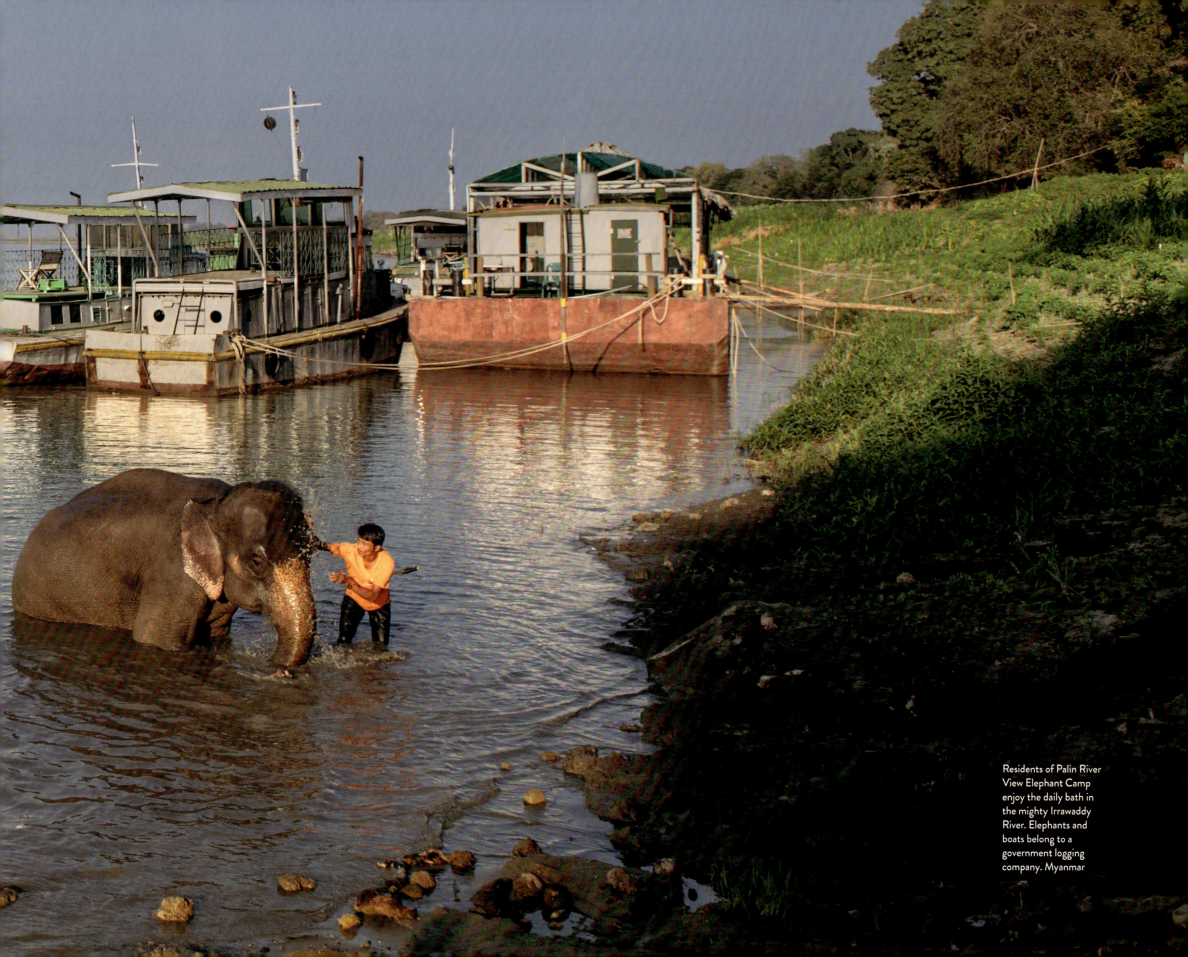

Residents of Palin River View Elephant Camp enjoy the daily bath in the mighty Irrawaddy River. Elephants and boats belong to a government logging company. Myanmar

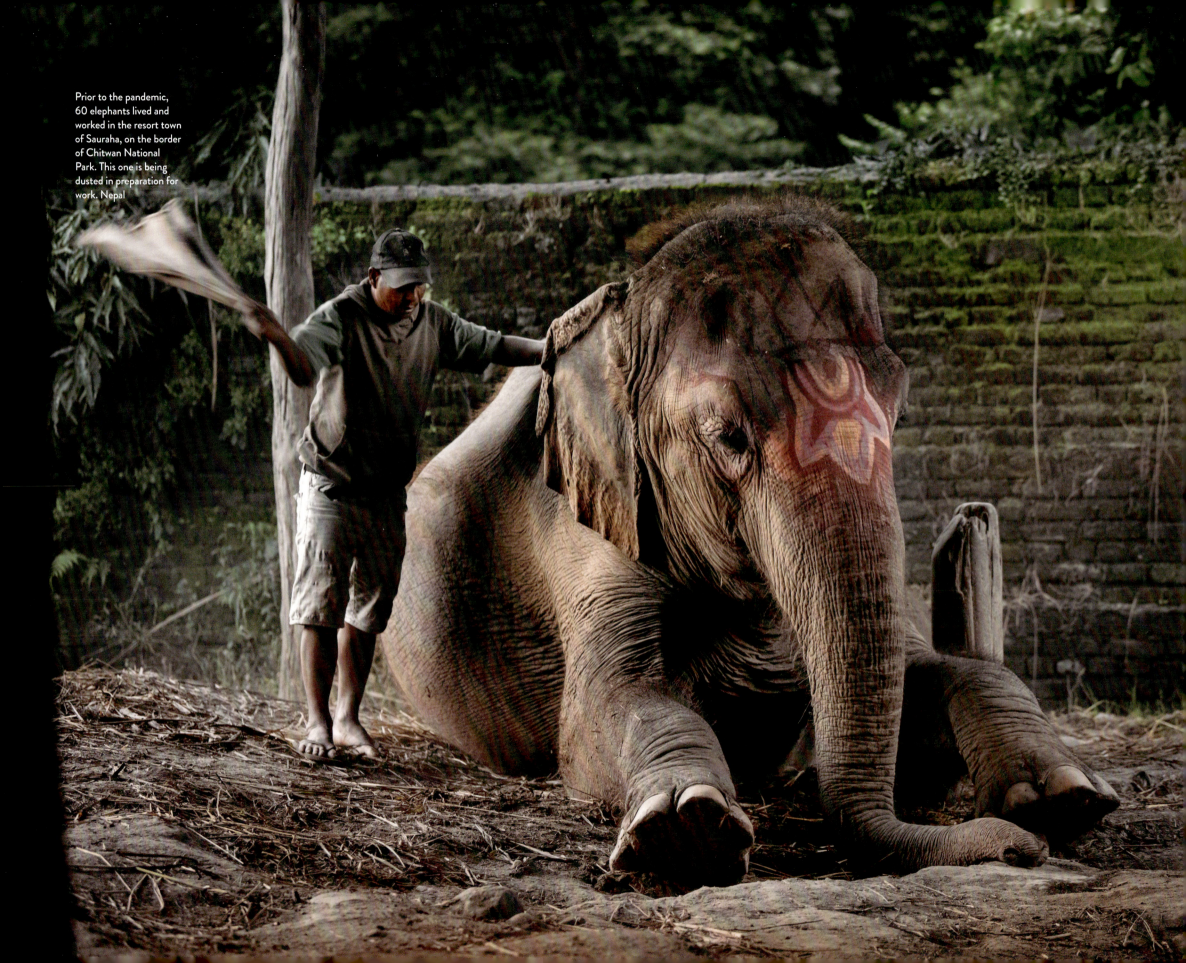

Prior to the pandemic, 60 elephants lived and worked in the resort town of Sauraha, on the border of Chitwan National Park. This one is being dusted in preparation for work. Nepal

INTRODUCTION

To this day, I can still recall the rough texture of the skin, the short little hairs that covered it. I can recall how big for a baby it seemed, and how it barely moved.

As the first born of three children, I was privileged at a young age to accompany my father out into the world on all sorts of field trips. We often visited the hardware store, the grocery store, his place of work, but then there were the occasional trips that struck me as daring and adventurous. We attended a Vietnam War protest in nearby Berkeley, California, standing next to lawmen in riot gear, ears pierced by the shouts of young men in long hair. We parked at the end of the runway at nearby Naval Air Station Alameda to watch fighter jets destined for Vietnam passing just feet overhead. There were trips to the rail yard to watch trains being put together. And on one occasion, we arrived at the entrance to a travelling carnival in Oakland to find a baby elephant tethered to a fence.

That evening, as we walked from the car, I took in the silhouettes of other people walking in, the motion of the rides and the many-coloured lights. At the booth where my dad paid our entry, I found myself standing next to the legs of a large animal. As I sized it up, I heard my dad's voice say, "That's a baby elephant!" And as I continued to explore this most unusual sight, I was struck by how roly-poly it was, and how it was just standing there in the dim light like a statue. I remember touching it, recording the texture of its leathery skin, with some hairs, but most of all I remember how out of place it seemed to be.

Many chapters of life rolled over me following that night at the carnival, most of them taking me to live in other regions of the country. Then, as if from a dream,

I found myself in a faraway land touching an elephant again. This time, it was during the explorations of Africa for my first book on elephants. With the assistance of Big Life Foundation, I had tracked down the iconic elephant named Tim, but something wasn't right.

Tim was clinging oddly to the company of two other big males, in the shade of a smallish acacia tree. It became clear that Tim and his friend Craig were in fact guarding the third elephant, Ulysses, who was unable to move. We then discovered that Ulysses was suffering terribly from a festering spear wound on one of his legs. We immediately notified Kenya Wildlife Service and within an hour, an aircraft carrying their mobile veterinary team landed nearby. With my camera in hand, I documented the entire medical procedure.

While Ulysses was on the ground, unconscious, I walked all around the big boy, savouring the opportunity to be so close to a live, wild African elephant. I looked at every inch of him, I listened to his breathing, I smelled his trunk, and I touched him, his head, his tusks, one of his feet.

Following this event, years of my life once again passed and a new chapter with elephants was underway – this one, preparing for this book. Along the way, I touched countless elephants, all of them living lives in captivity. They were employed in circuses, the logging of forests, religious ceremonies, begging on the street and participating in cultural festivals. I've touched blind ones, crippled ones, young ones, old ones, happy ones, sad ones. But the touch nowadays has always been motivated not by curiosity, but by compassion, and has included a request for forgiveness.

I had committed to this project on the Asian elephant almost immediately after the book on Africa's elephants was off to the printer. I knew that I'd explore at least ten Asian countries, just as I'd done for the African project. What I couldn't foresee without spending a significant amount of time in Asia was the dominant role that captive elephants would end up playing. I should have known, though, given that roughly one third of all elephants living in Asia are held in captivity.

Over the course of five years, I divided the survey into a series of explorations.

For each exploration, I began at home with research, scouring the internet, books and the minds of experts. I prepared an itinerary and secured the help of local guides. Once in the field, though, I rarely kept to the plans I'd made, as fresh

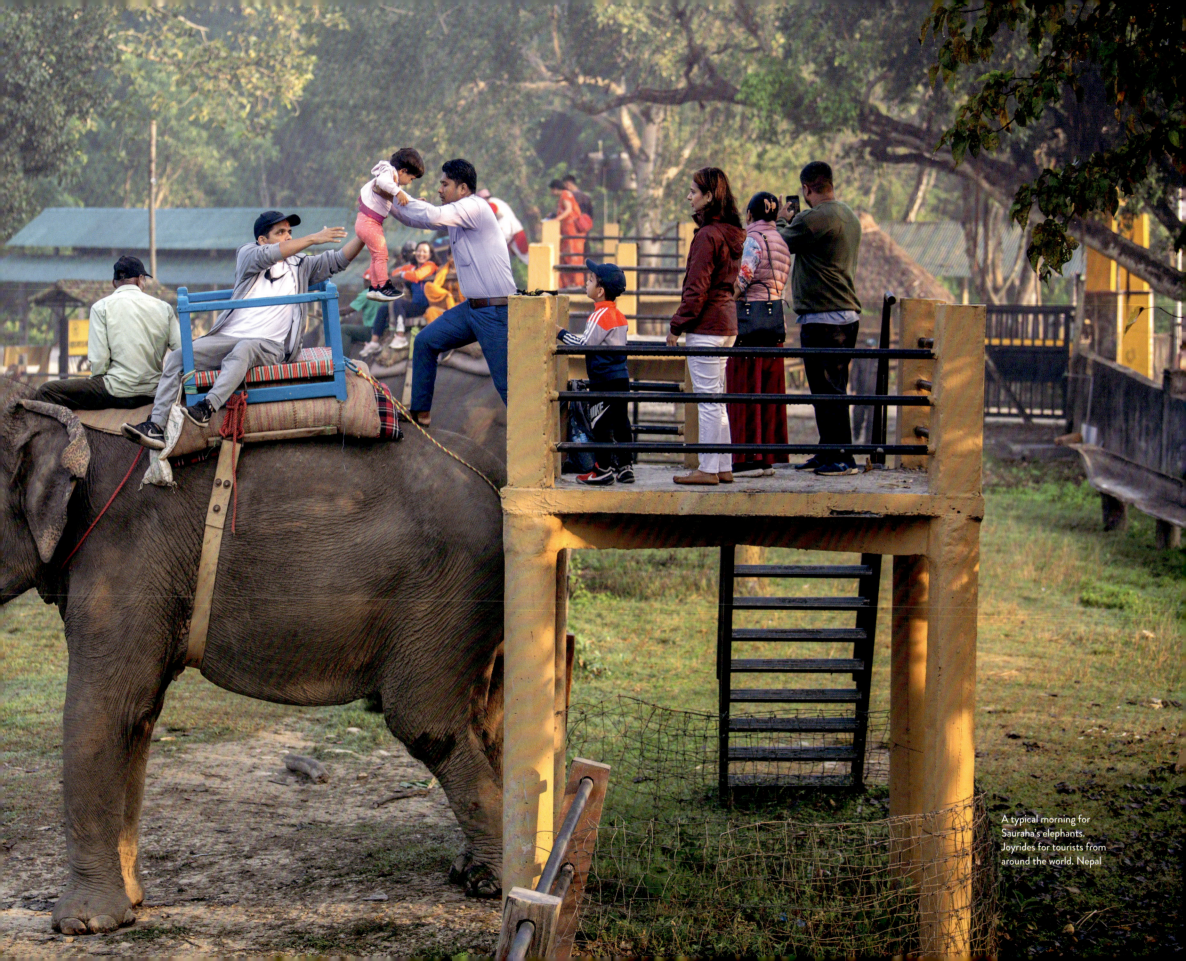

A typical morning for Sauraha's elephants. Joyrides for tourists from around the world. Nepal

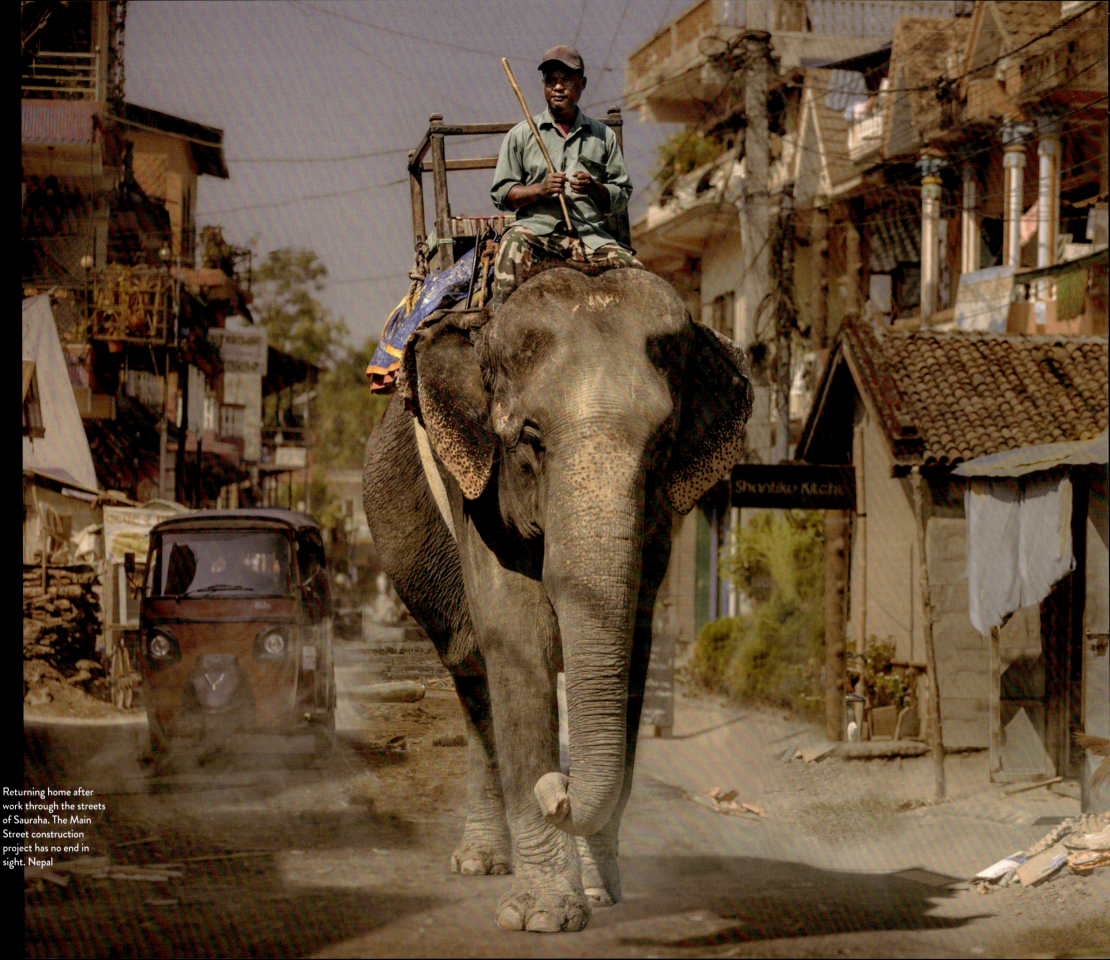
Returning home after work through the streets of Sauraha. The Main Street construction project has no end in sight. Nepal

> *"Life is as dear to a mute creature as it is to a man. Just as one wants happiness and fears pain, just as one wants to live and not die, so do other creatures."*
>
> – **DALAI LAMA XIV**, Spiritual leader, head of Tibetan Buddhism

information appeared almost daily. The guides for the most part opened whole new worlds to me, as they introduced me to friends of theirs, and friends of friends, bravely reaching out to strangers on my behalf.

In the end, many of the most memorable encounters with elephants came simply from asking passers-by, like local hunters, fishermen, farmers and cowboys. Translated by my guides, conversations with these local people led to the discovery of captive elephants hidden away in remote villages. And they led to finding elusive wild elephants by following elephant trails, broken branches, dung and the sound of snapping branches in the forest. I have to say that the search for wild elephants made for the most awesome treasure hunt of a lifetime.

In looking back, the survey brought a grand adventure, even more so than the months spent in Africa. My overnight accommodations ran the spectrum, from well-appointed bungalows on tea plantations to empty rooms with no mattress, no running water. To get around, including out to remote destinations, I rode motorcycles, tuk-tuks, carts, rickshaws, bicycles, motorboats and dugout canoes – and of course I hoofed it for countless miles, over hill and dale, across rivers and streams, always guarding the camera like a tigress guards her cubs. And then there were the ever-present leeches, mosquitoes, ticks and fleas.

Wild elephants in Asia today live on less than ten percent of the land they once did. Their portion continues to shrink with every passing day, replaced by more people, more farming and more livestock. Captive elephants endure their own challenges, of exploitation, abuse, confinement, boredom and isolation. Despite the pervasive disrespect, there's a place in the heart of most people who interact with elephants that can only be described as 'magnetic.' The mere sight of an elephant on display at a religious temple or munching on vegetation at the edge of a village is paralysing to local people. All human distraction comes to a halt as the giant beings are taken in, their every move. And so it should be, this captivation, just as it was for me that evening as a young child outside a travelling carnival in Oakland, California, and every single time since.

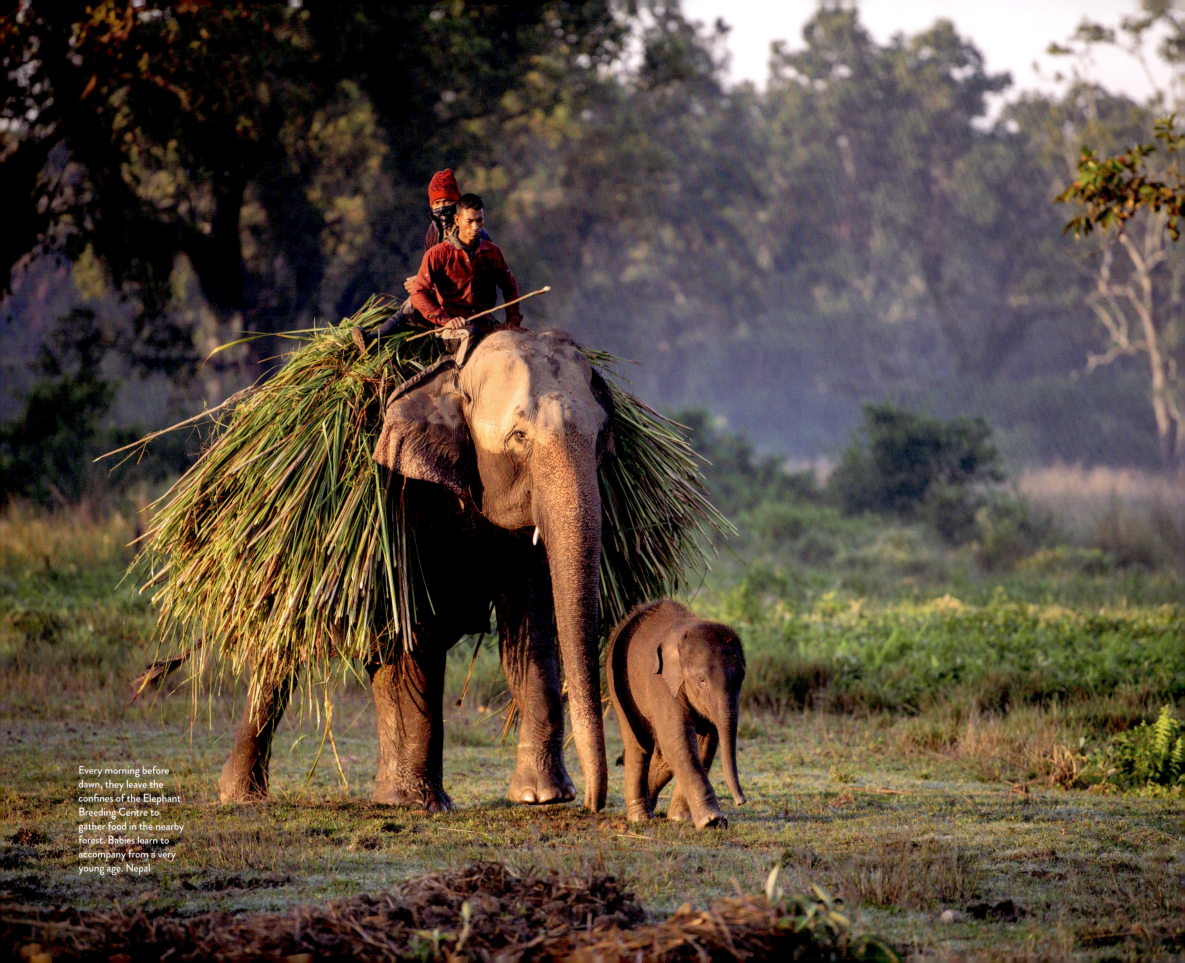

Every morning before dawn, they leave the confines of the Elephant Breeding Centre to gather food in the nearby forest. Babies learn to accompany from a very young age. Nepal

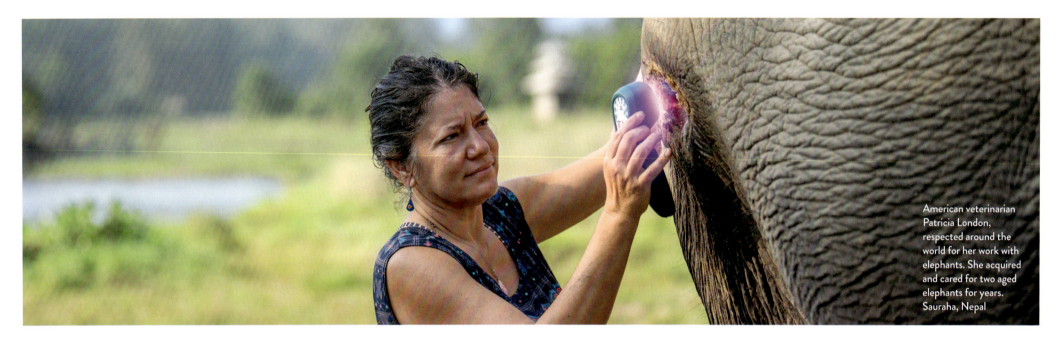

American veterinarian Patricia London, respected around the world for her work with elephants. She acquired and cared for two aged elephants for years. Sauraha, Nepal

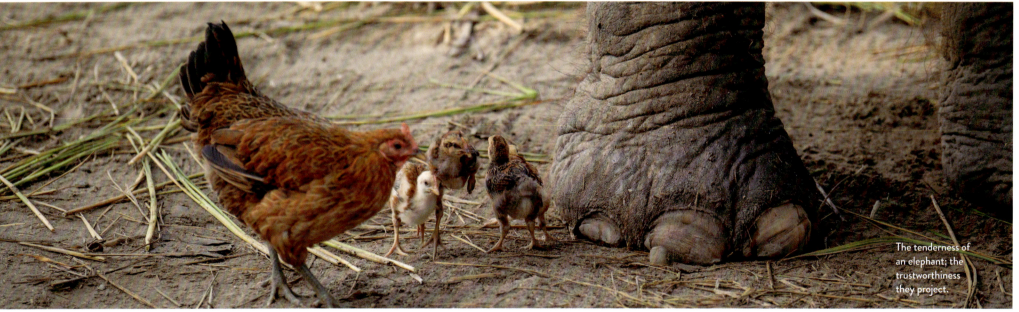

The tenderness of an elephant; the trustworthiness they project.

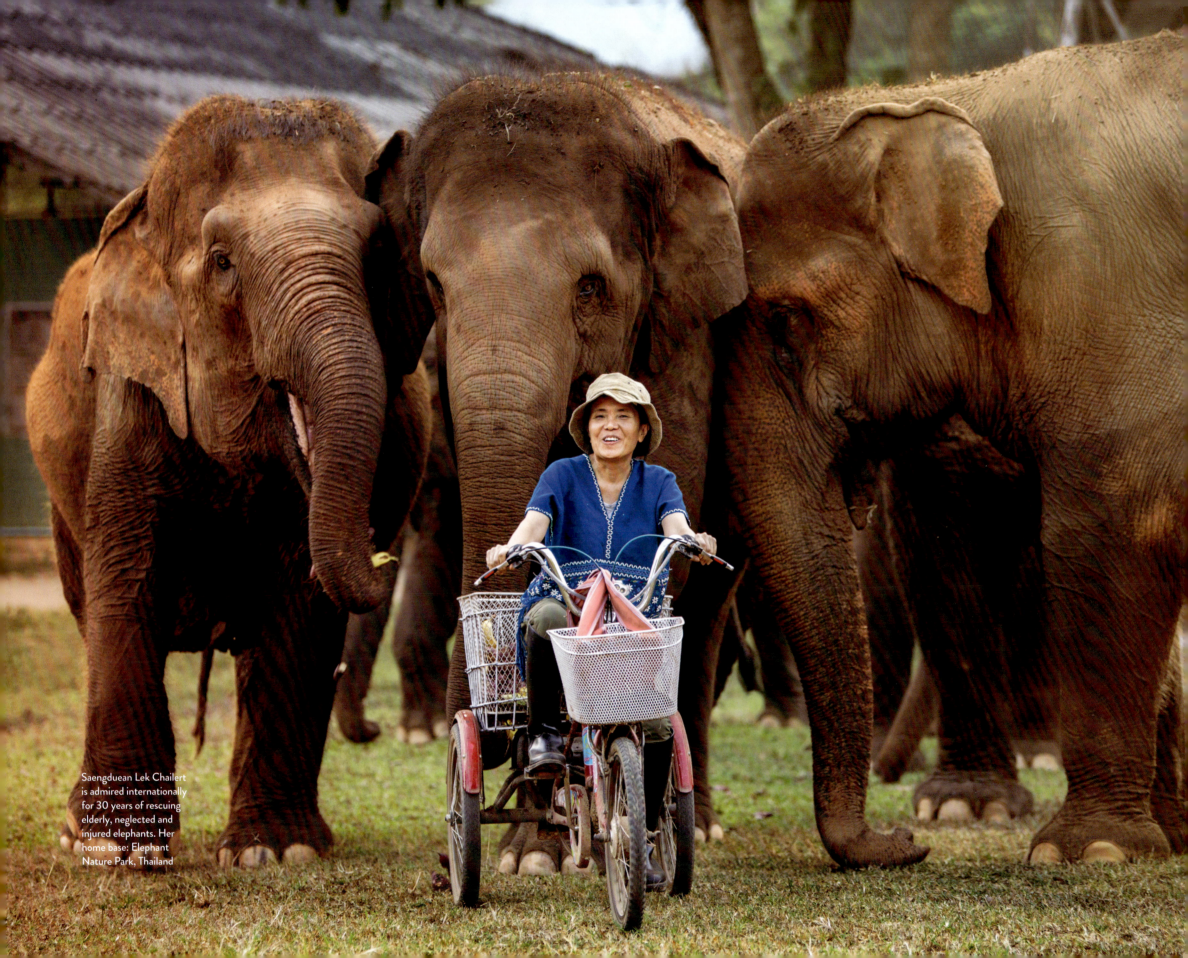

Saengduean Lek Chailert is admired internationally for 30 years of rescuing elderly, neglected and injured elephants. Her home base: Elephant Nature Park, Thailand

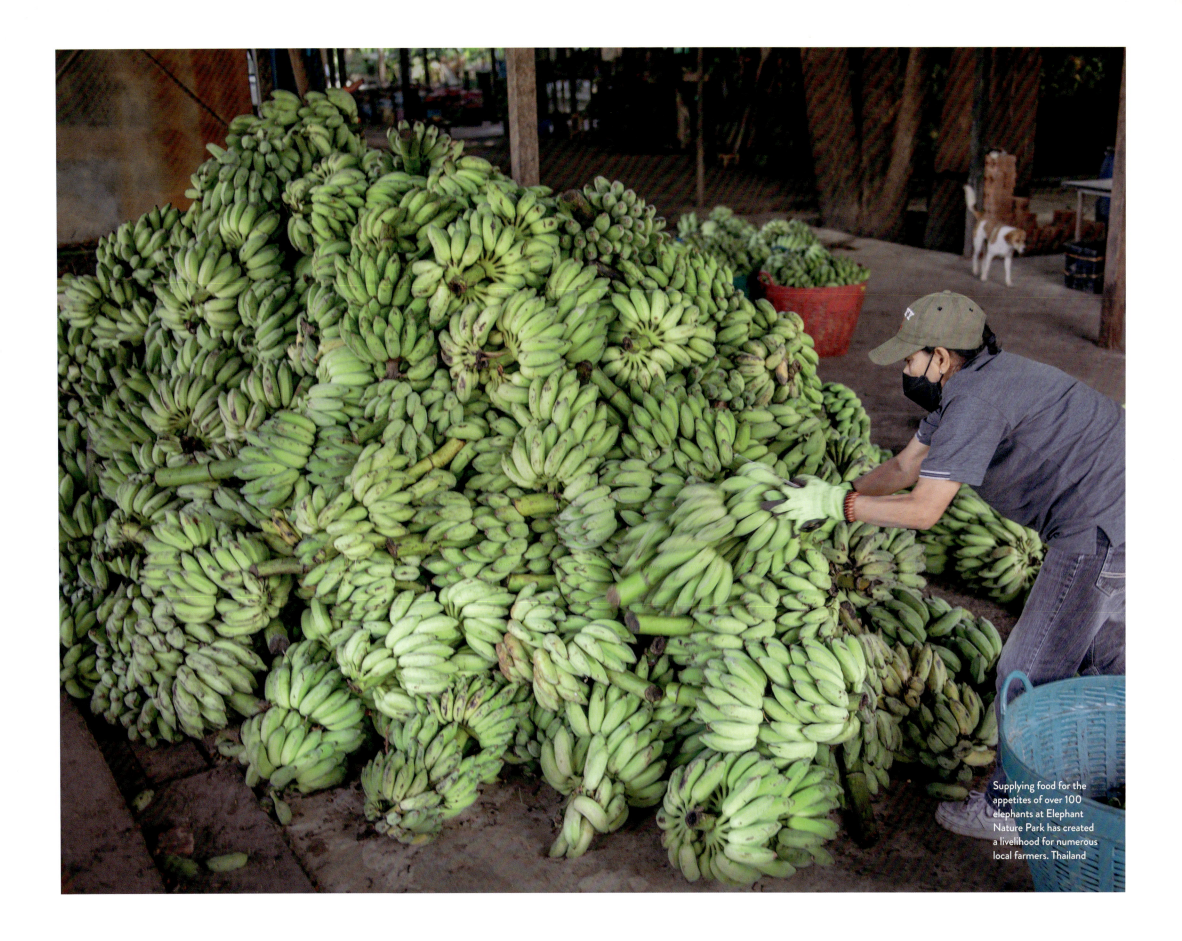

Supplying food for the appetites of over 100 elephants at Elephant Nature Park has created a livelihood for numerous local farmers. Thailand

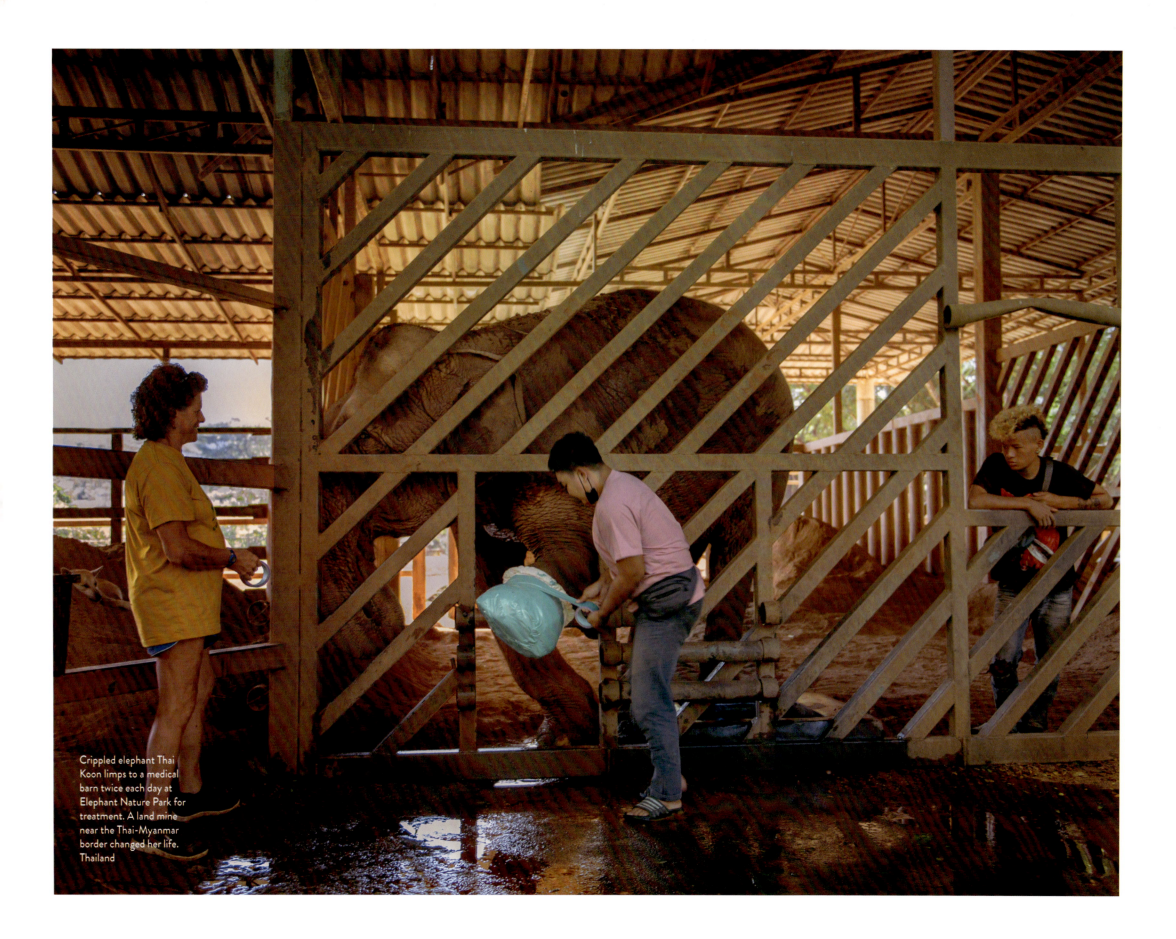

Crippled elephant Thai Koon limps to a medical barn twice each day at Elephant Nature Park for treatment. A land mine near the Thai-Myanmar border changed her life. Thailand

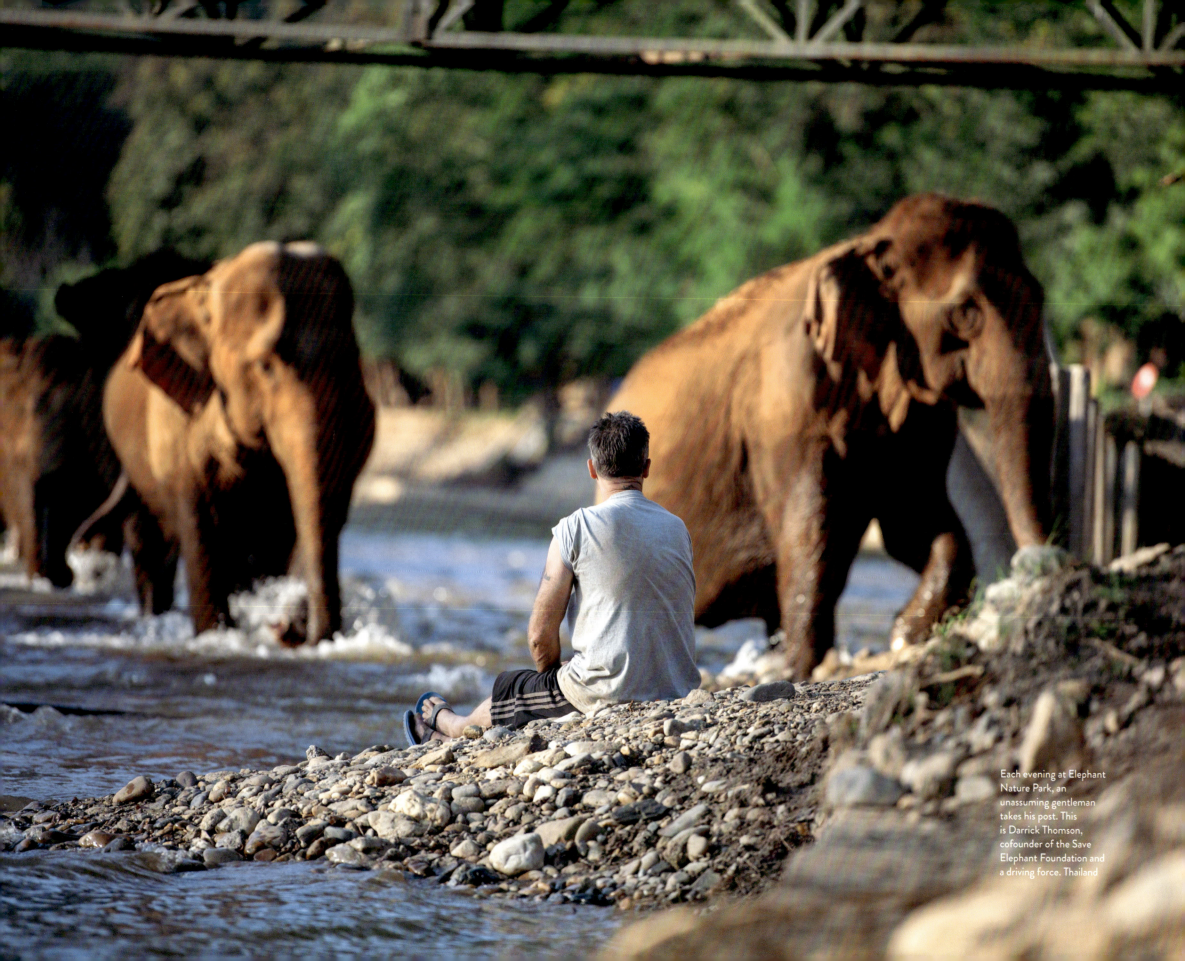

Each evening at Elephant Nature Park, an unassuming gentleman takes his post. This is Darrick Thomson, cofounder of the Save Elephant Foundation and a driving force. Thailand

HISTORY

In a cloud of dust with a touch of gas, our earth began its life four and a half billion years ago. There were no elephants, no human beings, no living things at all. A whopping four billion years then followed, a period of all sorts of actions and reactions, before the first plants and animals appeared. Through all that time, even throughout the age of the dinosaurs, still there were no elephants and no human beings.

Finally, by about five million years ago, there were living things roaming the earth with trunks, and others strutting about on two legs. The apparent location for these origins: Africa. But these beings weren't the ones we know today. These were early versions, destined to go through a long process of fine-tuning. Then, after another two or three million years passed, more advanced versions of the first elephants and the first humans looked around Africa and decided to go on a trip, to explore the rest of the planet.

Once out of Africa, both groups eventually drifted eastward, making their way into what is now China. This is how a group of elephants known as *Stegodon* originated there and went on to inhabit a good portion of Asia well before the arrival of the Asian elephant. For a long time, both *Stegodon* and Asian elephants were alive on the continent together, each keeping to their respective territories.

Though certainty is hard to come by, it is believed that the Asian elephant first appeared in or near today's India about 250,000 years ago. Having evolved from migratory ancestors who made their way out of Africa, they continued to move, and spread far and wide to inhabit the 13 Asian countries they do today in addition to inhabiting the modern nations of Syria, Iran, Iraq, Turkey, Afghanistan and Pakistan.

As time passed, the Asian elephant came to share the landscape with an incredible list of species, including the Bengal tiger, the Asiatic lion, the Asiatic cheetah, the leopard, the Indian and Javan rhinoceros, the Asiatic hippopotamus, the Indian bison and possibly even the long extinct Asiatic giraffe. While all these beings generally lived in harmony, there came one more species that chose not to. And from the outset, this one carried with it the potential to turn nature's balance upside down.

The early humans had been making tools for half a million years. They could hunt, and they could butcher meat. They also had discovered how to capture fire and use it for cooking. Wave after wave of them migrated out of Africa and into Asia, each wave lasting for a while then

eventually dying out. Centuries passed like seconds on a ticking time bomb. Then there appeared *Homo sapiens*, us, and despite the eventual failures of early migrations, one wave finally found a way to endure, 65,000 years ago.

It was members of this migration wave that settled in the Indus River Valley of today's western India and eastern Pakistan. Along with later migrants from other regions of Eurasia, they went on to embrace the creation of agriculture, including, by 9,000 years ago, the domestication of animals. By 4,500 years ago, they were capturing and taming elephants, the first humans known to do so.

But who in their right mind would consider the hare-brained idea to capture a wild elephant, a ten-foot-tall, ten-thousand-pound being, stronger than dozens of men put together? And why? The explanation is a simple one and has occurred over and over throughout human history. We humans carry with us an inherent urge to dominate every aspect of the world around us.

The ability to capture an elephant, though, was an accomplishment long in coming. First, humans had to learn how to communicate with each other. With this skill, those early hunters could coordinate their efforts at animal capture. They had learned how to make rope, critical in the acts of capturing and then managing. And they had gained confidence from domesticating other animals, like the dog, cattle and, just a thousand years before, the horse.

Once that first Asian elephant was subdued and trained, it must have been obvious that the giant beings would do almost anything asked of them. So as civilization developed, the uses for elephants grew and grew. Near the top of a very long list, they have been used for transportation, hauling freight, ploughing fields, building roads, harvesting timber, fighting wars, entertainment and religious ceremony.

All along, there has existed a specialized group of men: the elephant men. These were the human beings who risked their lives to capture, tame and train wild elephants. Many of these men went on to spend the rest of their lives living with their elephants, working alongside them. And as the popularity of the captive elephant spread throughout Asia, the ranks of the elephant men swelled.

In regions where wild elephants were especially numerous, communities of elephant men emerged. Together, they'd refine the art of capturing, taming and training. They constructed an extensive language understood by elephants that permitted the two species to perform increasingly complicated tasks together. As time passed, traditions developed, and working with captive elephants became a way of life. At the heart of this life, this community, was the father and son. Young men would accompany their fathers in every step of the process, each of the stages, listening to oral instructions and learning by doing. Apprenticeship. And so, the skills were passed from generation to generation.

For centuries, the relationship – the culture – persisted. But over the past 40 years, the dynamic between the two beings has taken a turn, a tenuous turn. Wild elephant populations across most of Asia, brought to their knees by hunting, capture and habitat loss, began disappearing. Captive populations, with decreasing demand for their services, began fading away. And in the ebb and flow of history, the communities of the elephant men have all but disappeared, many of their settlements turned into ghost towns.

The preceding summary accounts for 5,000 years of history shared by elephants and humans. With nothing to boast about, it's safe to say that by our staggering numbers and by our comfortable lifestyles, humanity has come out on top. The elephant, meanwhile, as a pawn in the deranged human scheme of things, is fighting for its very survival.

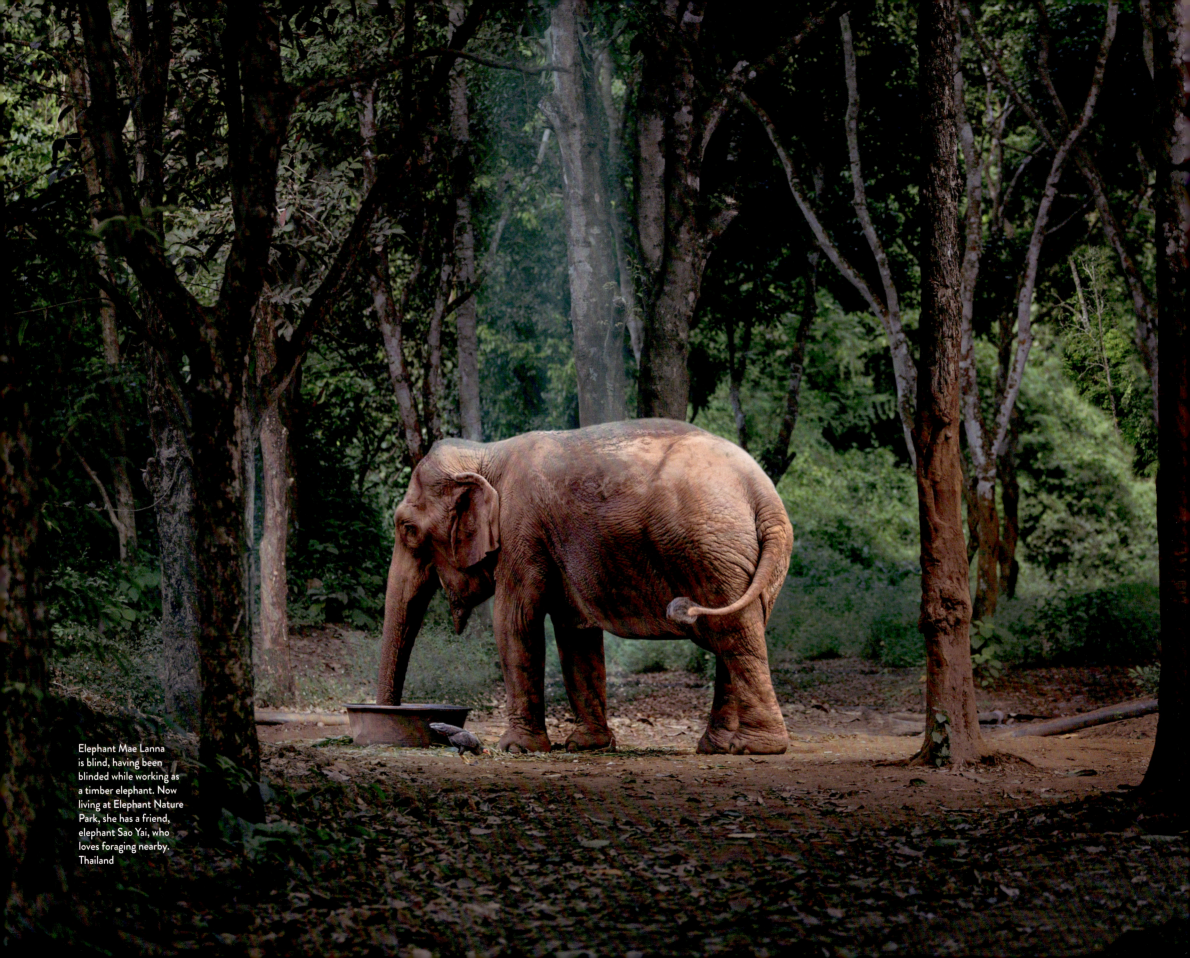

Elephant Mae Lanna is blind, having been blinded while working as a timber elephant. Now living at Elephant Nature Park, she has a friend, elephant Sao Yai, who loves foraging nearby. Thailand

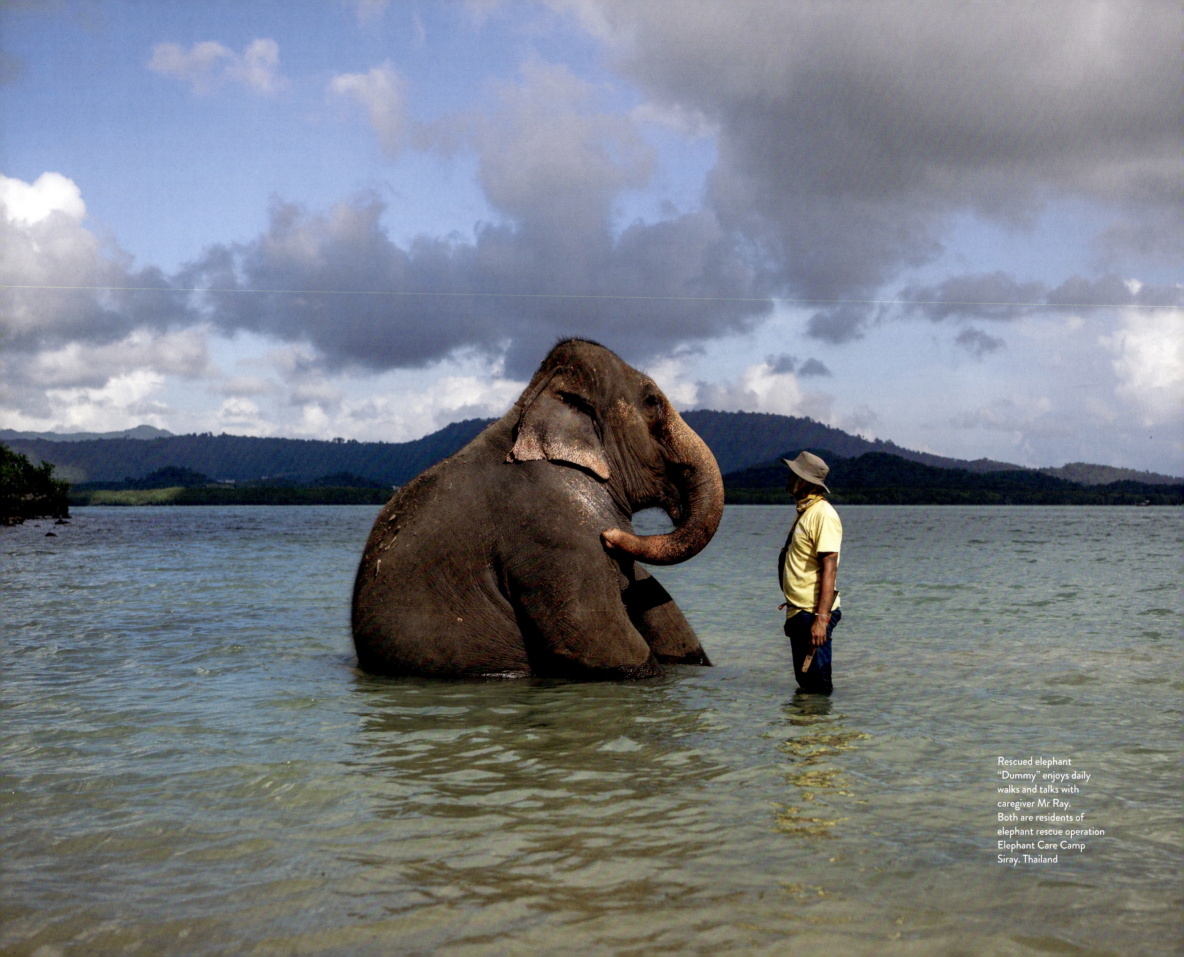

Rescued elephant "Dummy" enjoys daily walks and talks with caregiver Mr Ray. Both are residents of elephant rescue operation Elephant Care Camp Siray. Thailand

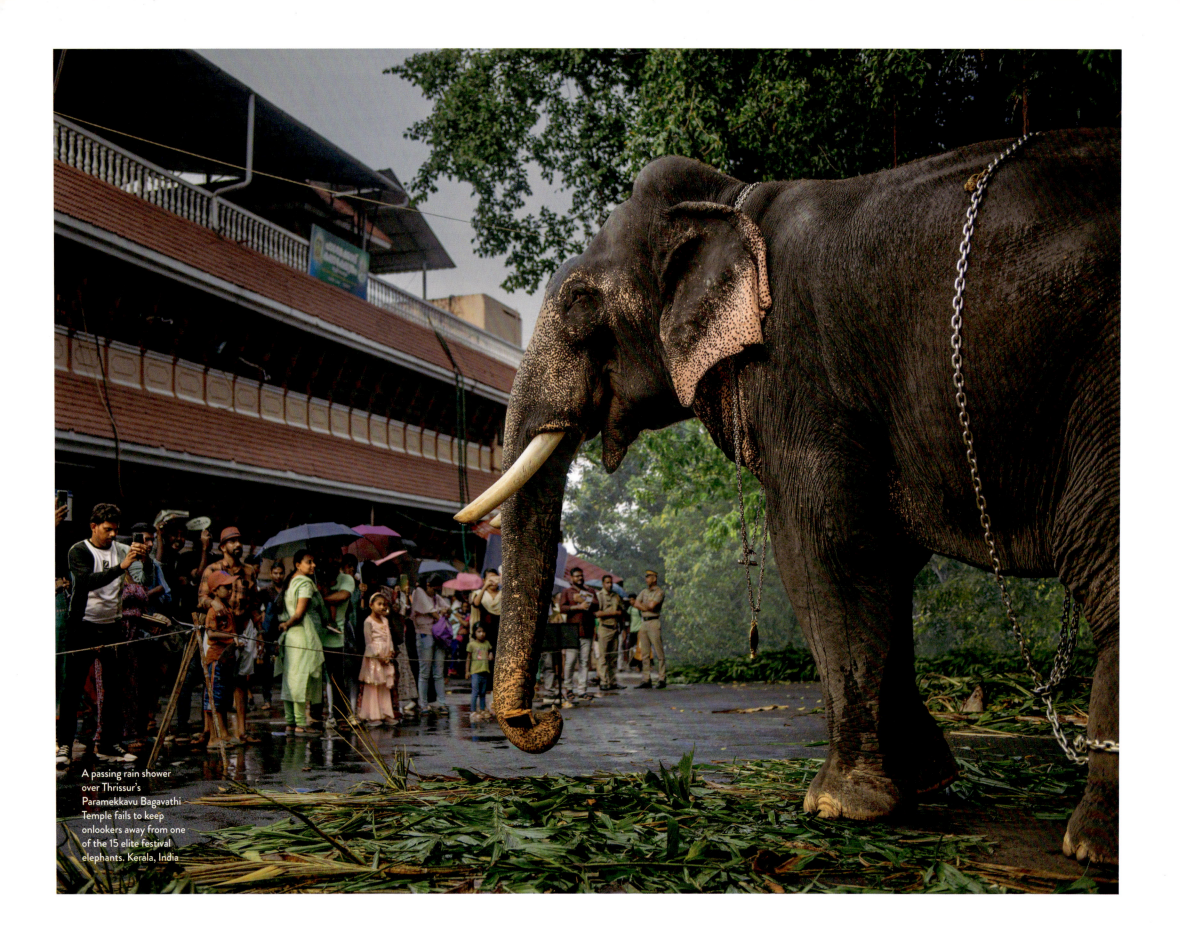

A passing rain shower over Thrissur's Paramekkavu Bagavathi Temple fails to keep onlookers away from one of the 15 elite festival elephants. Kerala, India

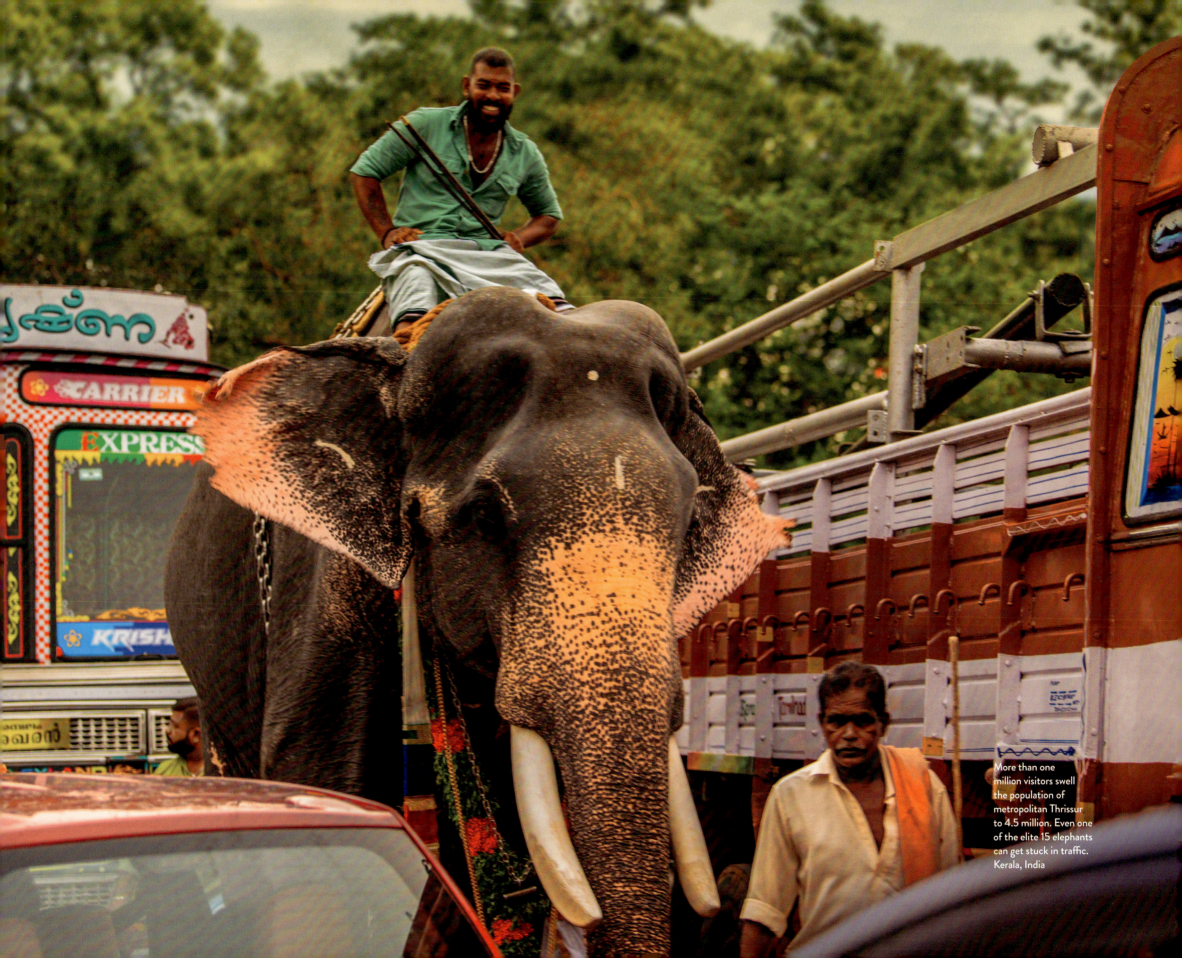

More than one million visitors swell the population of metropolitan Thrissur to 4.5 million. Even one of the elite 15 elephants can get stuck in traffic. Kerala, India

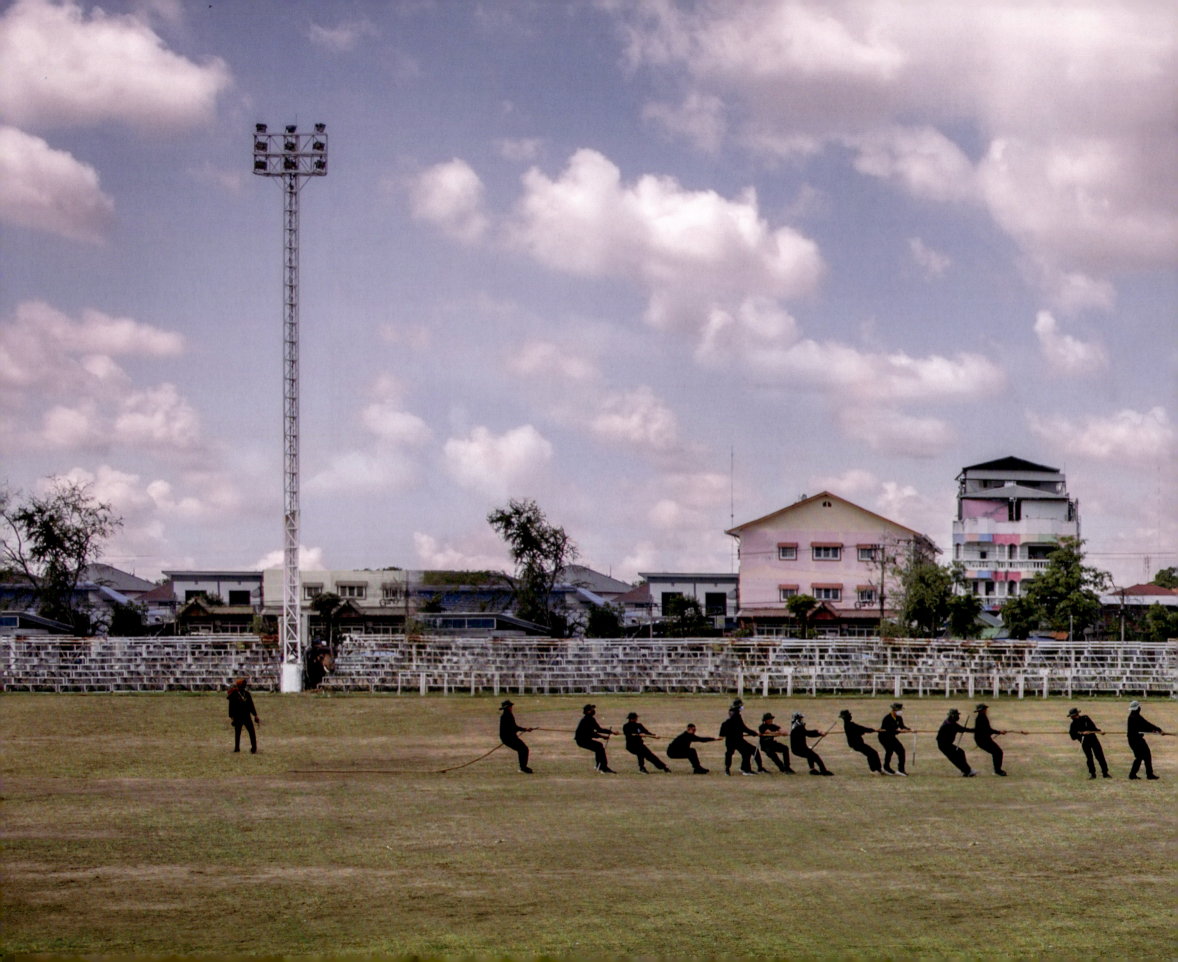

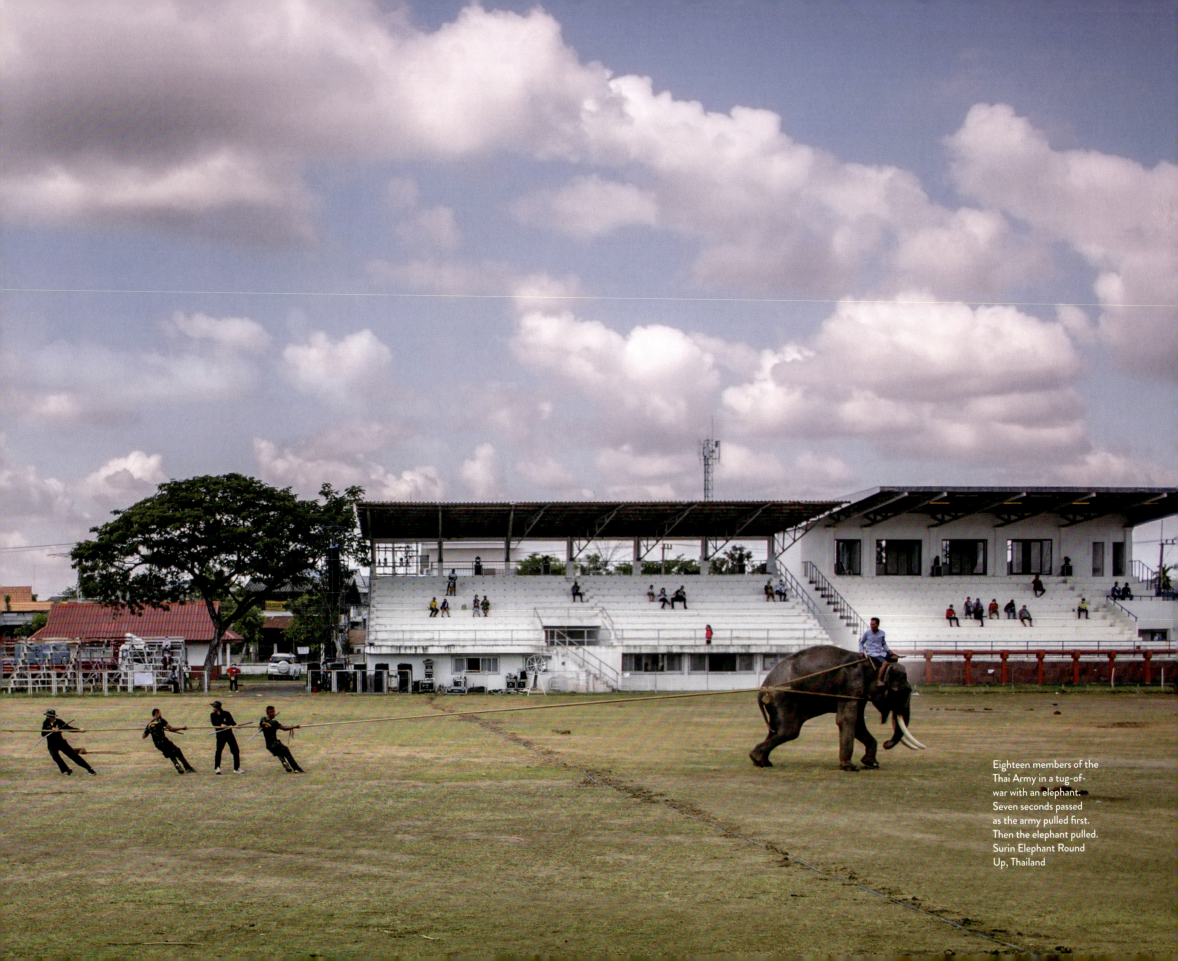

Eighteen members of the Thai Army in a tug-of-war with an elephant. Seven seconds passed as the army pulled first. Then the elephant pulled. Surin Elephant Round Up, Thailand

WAR ELEPHANT

This narrative was constructed by sourcing information from various historians including Kenneth C. Wylie whose writings are included in the collective work *Elephants, Majestic Creatures of the Wild*, edited by Dr. Jeheskel Shoshani, and the comprehensive book on the subject by John M. Kistler, *War Elephants*.

Human beings do exceptionally well at one thing. That thing got its start in the African nation of Sudan 13,000 years ago. By 9,000 BC, organized violence between groups of humans was commonplace. With the creation of the world's first kingdoms by 3,000 BC, rulers began invading and conquering neighbouring settlements and cities to expand their wealth and influence. Once humans acquired the skills of capturing, taming and training elephants soon after, elephants not only hauled supplies for men at war but joined soldiers on the field of battle.

Adaptable and obedient, elephants were trained to charge the enemy, fight off charges brought by the enemy, act as platforms for the deployment of all sorts of weapons, and to act as battering rams in the siege of forts. At times, their tusks and trunks were outfitted with swords and countless other deadly objects, their bodies covered in armour. And most fundamentally, they were a psychological weapon, who by their size and training always possessed the ability to trample enemy soldiers to death. As time passed, it became common for the larger, more powerful kingdoms and empires to maintain corps of combat elephants numbering in the thousands.

An early example of elephants in war comes from the history of Cyrus the Great, one of the first kings of Persia, modern-day Iran. By 530 BC, his kingdom controlled the largest confederation of states the world had seen, encompassing both western and central Asia. According to a Greek historian writing in the autumn of that year, Cyrus and his army were having their way with a rival power in battle. At a crucial point in the fighting, the enemy's commander deployed a hidden squad of specially trained elephants. Surprising all, Cyrus' cavalry turned and ran in a panic. In the ensuing chaos, Cyrus fell from his horse, was speared by an enemy javelin and later died.

Another example comes from Alexander the Great, the famous king of the ancient Greek kingdom of Macedon. By 326 BC, he too had built one of the largest empires in world history. Intent on marching east across Asia and to the end of the earth, Alexander at one point had to contend with King Porus of India. In a battle along the Jhelum River in today's Pakistan, Porus deployed trained elephants along the eastern shore to deter Alexander's crossing. But under cover of darkness, Alexander moved upstream and made the crossing anyway. Discovering the move, Porus took his army and most of his 200 trained elephants to meet

> *"People speak sometimes about the bestial cruelty of man, but that is terribly unjust and offensive to beasts. No animal could ever be so cruel as a man, so artfully, so artistically cruel."*
>
> **– FYODOR DOSTOYEVSKY**, Russian novelist, regarded as one of the greatest literary minds in human history

Alexander. Alexander attacked, pushing the forces of Porus back toward their elephants for protection. In the fog of battle, the elephants failed to distinguish which forces were on their side and trampled all who came near. Meanwhile, Alexander's archers targeted Porus' elephant drivers while his infantry, armed with spears and swords, blinded the poor elephants, hacked away at their trunks and stabbed them. Porus' surviving men were surrounded. Elephants who were able to ran for their lives. In the end, Alexander found Porus on the field of battle, severely wounded, hunkered down with his elephant. For his bravery, Alexander permitted Porus to continue his rule.

For hundreds of years before the fall of Cyrus the Great, chiefdoms and republics in Asia were capturing and maintaining small elephant armies. In time, these states supplied the more accomplished rulers across Asia as did numerous small villages with elephant-catching traditions. Accomplished rulers also maintained their elephant ranks through the capture of elephants held by defeated enemies and by arranged tributes from lesser states. From the time of Alexander the Great onward, the use of war elephants was commonplace. Across North Africa and all the way to Carthage in the western Mediterranean, Asian elephants were put into combat. One of Alexander's former generals along with others even managed to capture and train a number of African elephants for war.

Over time, military leaders found ways to deal with elephants in battle. One of the earliest and most effective counter-measures came during Hannibal's invasion of Italy in 218 BC as charging infantry simply went around and through the lines of elephants in their way. With the 9th century invention of gunpowder and the 13th century invention of the cannon and gun, the use of elephants on the field of battle diminished significantly but not all together. In India, the Mughals continued to field elephants into the 18th century. And the Afghans continued to field elephants until the Afghan War of 1878-1880 between Afghanistan and the British.

Though the use of elephants in combat did eventually come to an end, their use in war did not. Throughout the First and Second World Wars, and lasting until the end of the Vietnam War, elephants were enlisted by the hundreds for heavy labour, constructing roads and railroads, and carrying military supplies across landscapes where motorized vehicles held little purchase.

War elephants, both those who fought in battle and those who risked their lives to carry the heavy loads of supply, deserve recognition. They were deprived of normal lives as wild elephants, let alone lives as common captive elephants. Thousands died or were maimed in battle. In many cases, their actions on the field of battle changed the course of human history. For their station in life, for their demeanor and for their actions, many were given names. Out of respect, the following elephants are recognized as representative of the thousands who fought with abandon on behalf of humanity.

Gajmukta of the Mughal Empire, Ram Prasad of the Kingdom of Mewar, Hawa'i of the Mughal Empire, Surus of Carthage, Kandula of the Anuradhapura Kingdom, Maha Pambata of the Anuradhapura Kingdom, Ajax of India, Nicon of Epirus, and Jangia of Akbar's Mughal Empire.

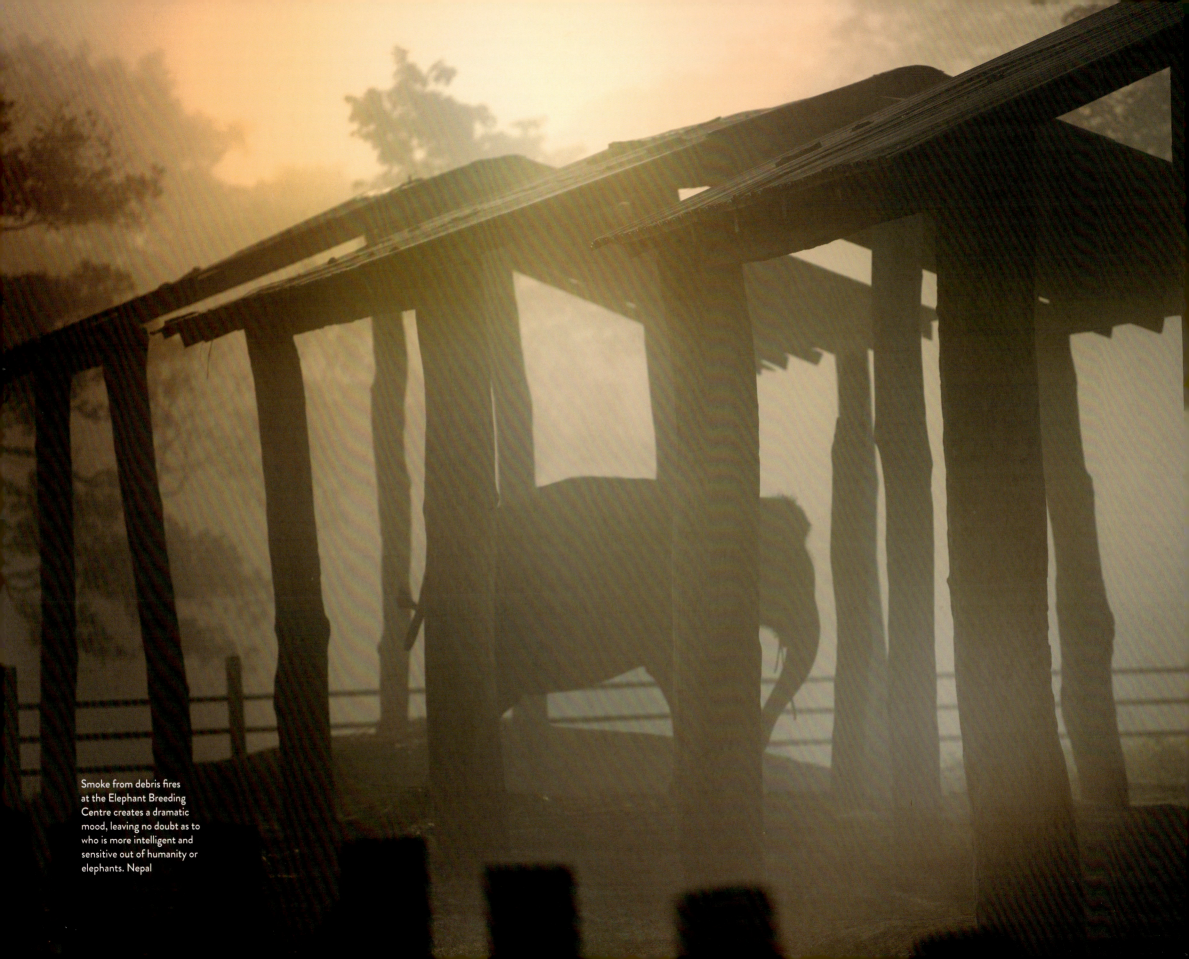

Smoke from debris fires at the Elephant Breeding Centre creates a dramatic mood, leaving no doubt as to who is more intelligent and sensitive out of humanity or elephants. Nepal

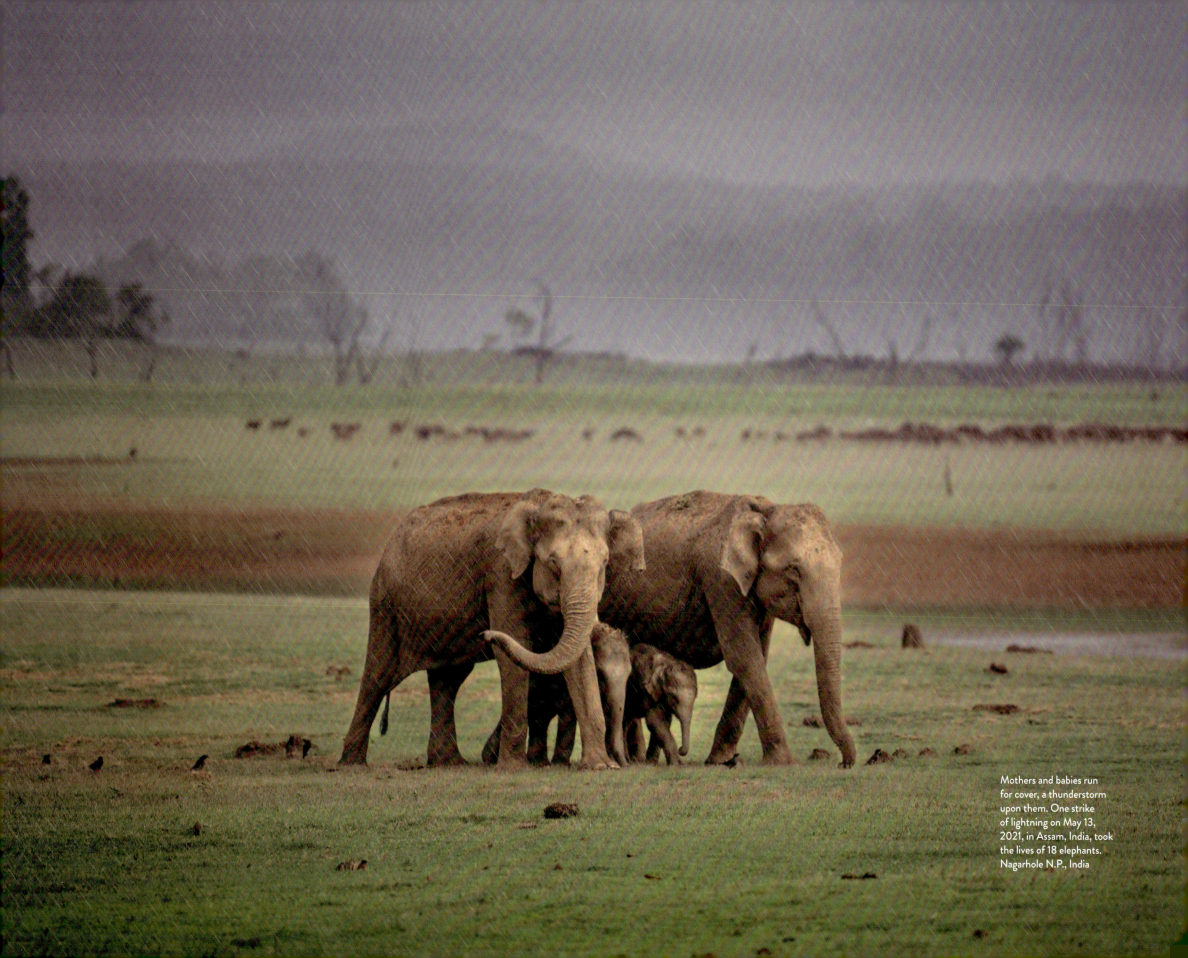

Mothers and babies run for cover, a thunderstorm upon them. One strike of lightning on May 13, 2021, in Assam, India, took the lives of 18 elephants. Nagarhole N.P., India

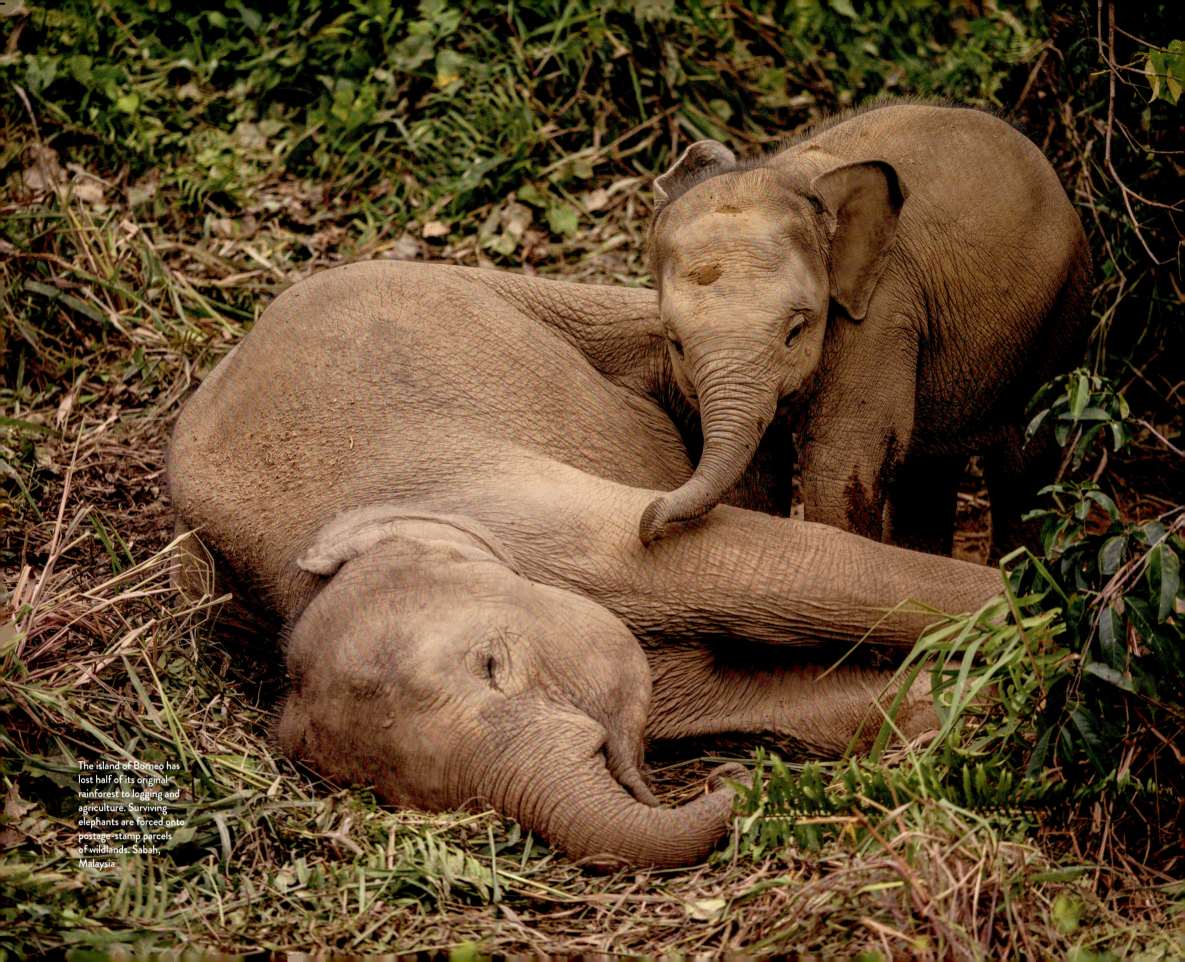

The island of Borneo has lost half of its original rainforest to logging and agriculture. Surviving elephants are forced onto postage-stamp parcels of wildlands. Sabah, Malaysia

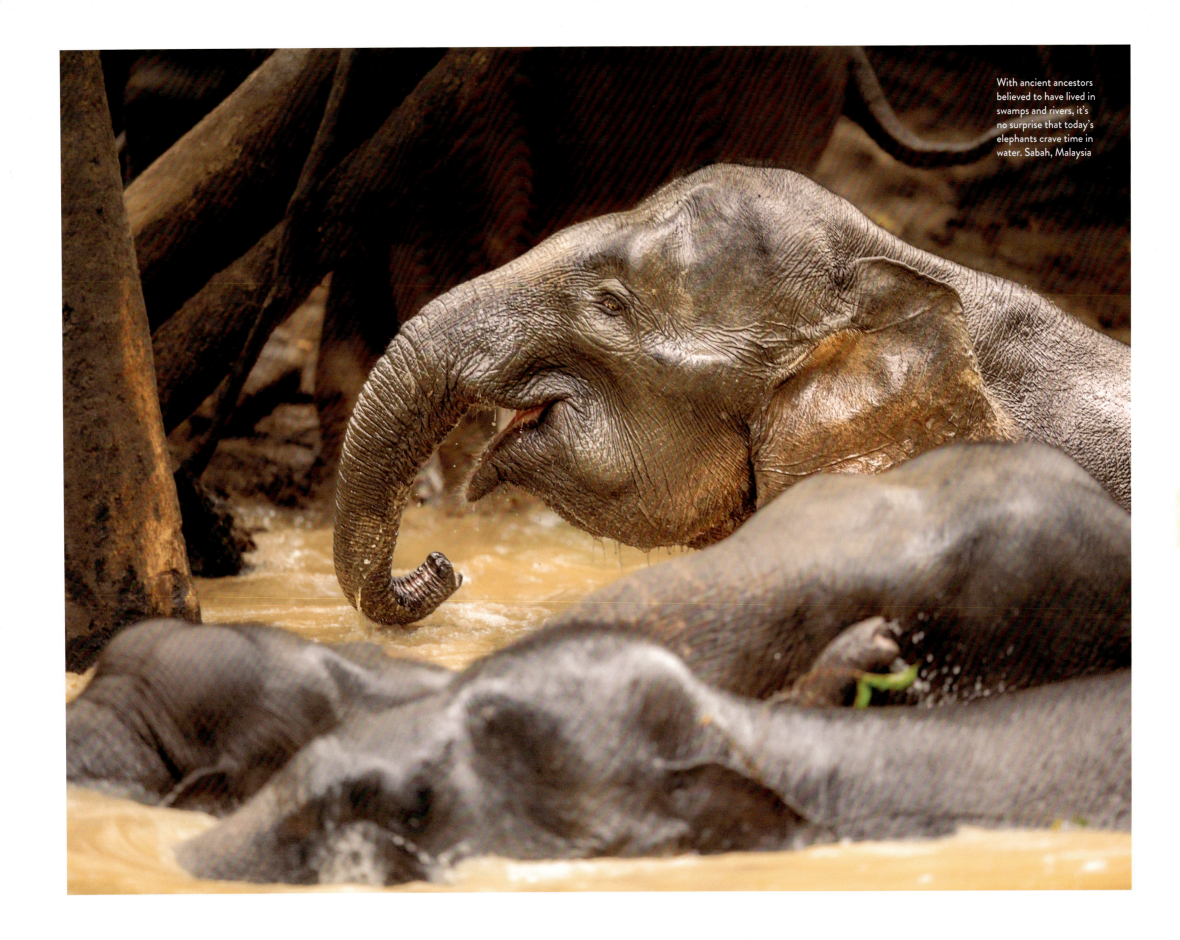

With ancient ancestors believed to have lived in swamps and rivers, it's no surprise that today's elephants crave time in water. Sabah, Malaysia

Formerly a place used for farming, today's reservoir and surrounding grassland are among the few human creations that benefit elephants. Udawalawe N.P., Sri Lanka

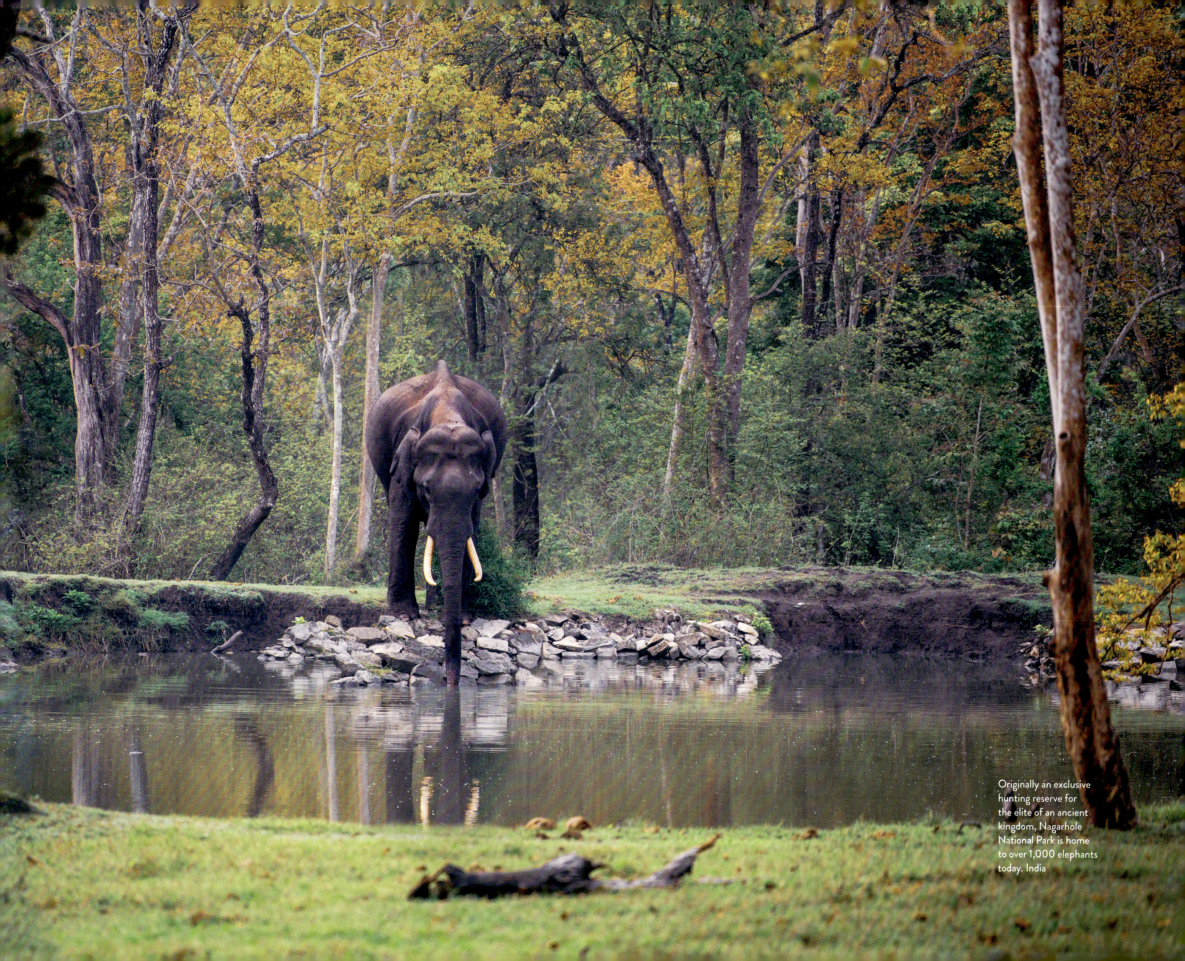

Originally an exclusive hunting reserve for the elite of an ancient kingdom, Nagarhole National Park is home to over 1,000 elephants today. India

TRIBUTE ELEPHANT

In the ancient world, when one powerful state conquered another state's lands, the victorious ruler would often require the defeated ruler to hand over items of value as signs of submission. A similar arrangement would often be reached between a powerful state and one of its allies as a sign of the less powerful state's allegiance. These items of value eventually became known as 'tributes' and were commonly required to be surrendered on a regular basis, often once each year. Among the items presented in tribute were gold, jewels and valuable animals, most notably elephants.

For an elephant singled out for tribute, the familiar life they'd known, good or bad, was taken away. Never again would they see the places, the people, the other elephants they'd come to know. Away they'd be taken, marched off, in a journey that usually lasted days, sometimes weeks. Marched off into the unknown, for better or for worse.

Some of the earliest known examples of tribute elephants were recorded during the Assyrian Empire which lasted from the 14th century BC to the 7th century BC. During the 10th century BC to the 7th century BC, the one-time city-state assembled the greatest army known to that date and employed it to create the largest empire of its day. For their many valuable qualities, elephants were gathered in as tributes from the various population centres that dotted the empire. As a result of the various pressures brought by the empire on the area's wild elephants, they went extinct by the early 8th century BC.

Later, the long and complex history of India included countless examples of elephants taken in tribute. From the 4th century BC to the 2nd century BC, the Maurya Empire was the first state to rule from one side of India to the other. Its rulers were quick to require elephants in tribute from the lands they conquered, especially those of the forest tribes. Then, from the 10th century until the 19th century, Muslim invaders ruled over India, owing a great deal of their power to the war elephants they gathered from both capture and tribute. It was during this period, between the years 1556 and 1605, that one of the greatest elephant stables in history was assembled by Emperor Akbar, boasting a collection of 5,000 individuals.

Although the first known European, a Greek citizen, explored Asia in 515 B.C., it was the aggressive Portuguese more than one thousand years later who were the first to arrive by sea,

The preceding narrative was created by tapping several sources, including an article in *Smithsonian Magazine* published October 21, 2015 by Danny Lewis entitled "There's an Elephant Buried Underneath the Vatican," and the invaluable book *The Story of Asia's Elephants* by Dr. Raman Sukumar.

> *"That is how we refer to the magnificent animals of our jungles and to the beautiful birds that brighten our lives. I wonder sometimes what these animals and birds think of man and how they would describe him if they had the capacity to do so. I rather doubt if their description would be very complimentary to man. In spite of our culture and civilization, in many ways, man continues to be not only wild but more dangerous than any of the so-called wild animals."*
>
> – **JAWAHARLAL NEHRU**, Author and the first Prime Minister of India

and the first to arrive with imperial designs. The year was 1498 and their initial motivation was control of the spice trade but their appetite was for much more. King Manuel I of Portugal, in addition to collecting live elephants in Asia, demanded a tribute each year of ten elephants from the Asian states he came to control.

As leader of a Catholic nation, Manuel wanted the brand-new Pope, Leo X, on his side as his nation ventured deeper into Asia. In order to demonstrate the power of his kingdom and the significant conquests already made, Manuel sent a special caravan of exotic gifts in tribute to Leo X, including gold, jewels and rare animals, one being a four-year-old Asian elephant named Hanno.

Leo X became deeply attached to Hanno. A personal letter of gratitude was sent to Manuel. A fountain made of marble featuring Hanno's head, his trunk serving as the water spout, was commissioned at a hillside villa outside of Rome. But sadly, little Hanno became ill and died just two years later. Leo X, heartbroken, wrote a lengthy epitaph and had it carved in marble. He then put the artist Raphael to work on a memorial fresco of the little elephant at the entrance of St. Peter's. To this day, Hanno's remains lie where he was first buried, 500 years ago, under Belvedere Courtyard in the Vatican.

With the presentation of Hanno from Manuel to Leo X, the line between tribute and gift grew increasingly fuzzy. At the root of elephant diplomacy is the preservation of peace and the cultivation of goodwill. At some point, the event of state visits by one leader to another came to frequently involve the gifting of an elephant. Thailand has gifted an elephant to Sri Lanka. Sri Lanka has gifted an elephant to the Philippines. India has gifted an elephant to Iran. Myanmar has gifted an elephant to Sri Lanka. On and on it goes. The most recent gifting came in April, 2024, when Nepal pledged to gift two young elephants to Qatar's Emir Sheikh Tamin bin Hamad Al Thani during a two-day state visit.

But what happens to these elephants gifted from one head of state to another in the modern age? Most often, they end up handed over to zoos, as was the case for one-year-old elephant Kaavan following his gifting from the government of Sri Lanka to the government of Pakistan.

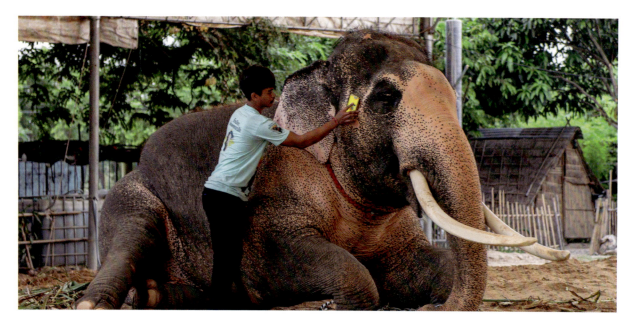

(Top)
The cell phone of a Buddhist devotee is placed to the head of white elephant Plai Ekachai to gather good luck. Saraburi Province, Thailand

(Bottom)
Celebrities Raghu and former mahout Bomman brave daily crowds of adoring fans. Their fame: 2023 Academy Award-winning film *The Elephant Whisperers*. India

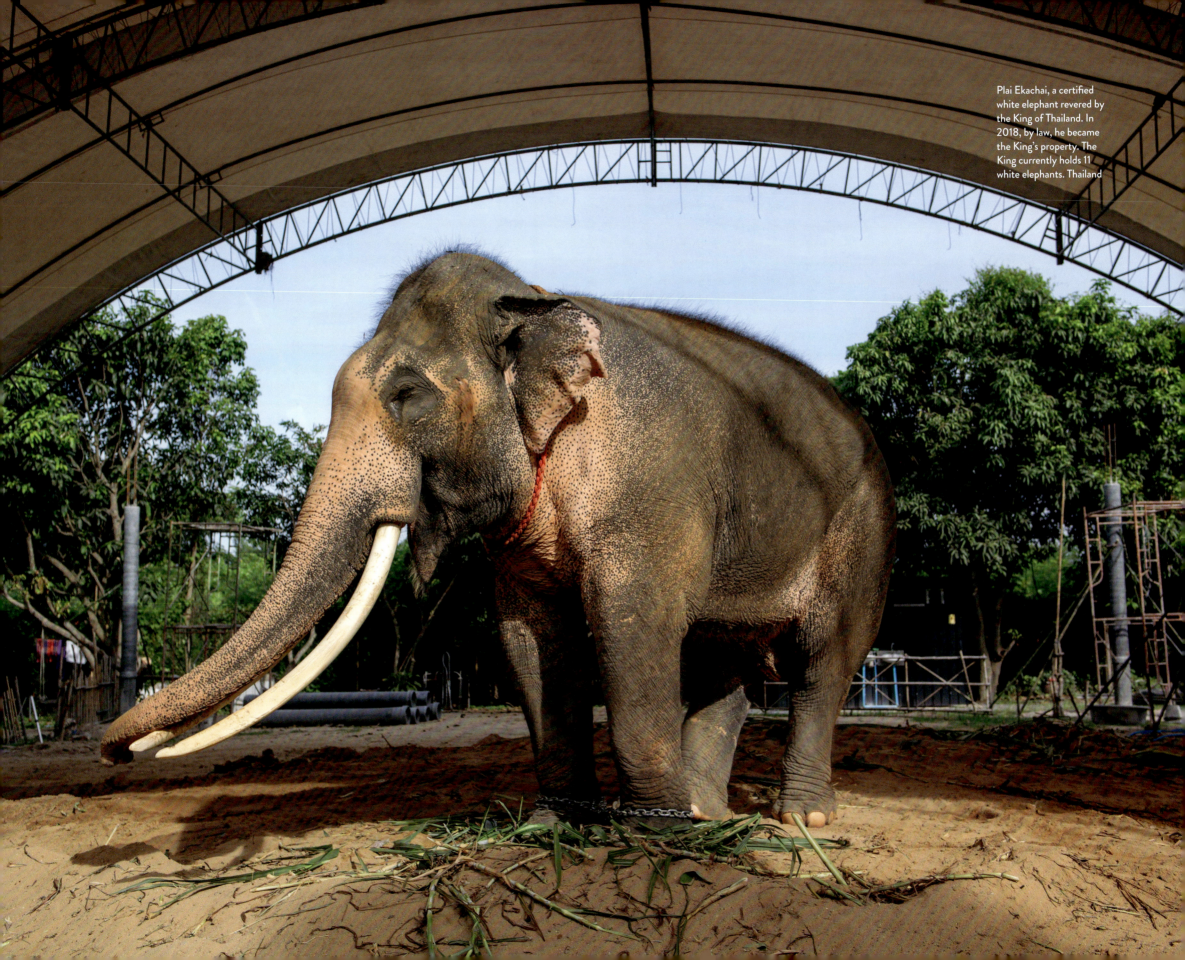

Plai Ekachai, a certified white elephant revered by the King of Thailand. In 2018, by law, he became the King's property. The King currently holds 11 white elephants. Thailand

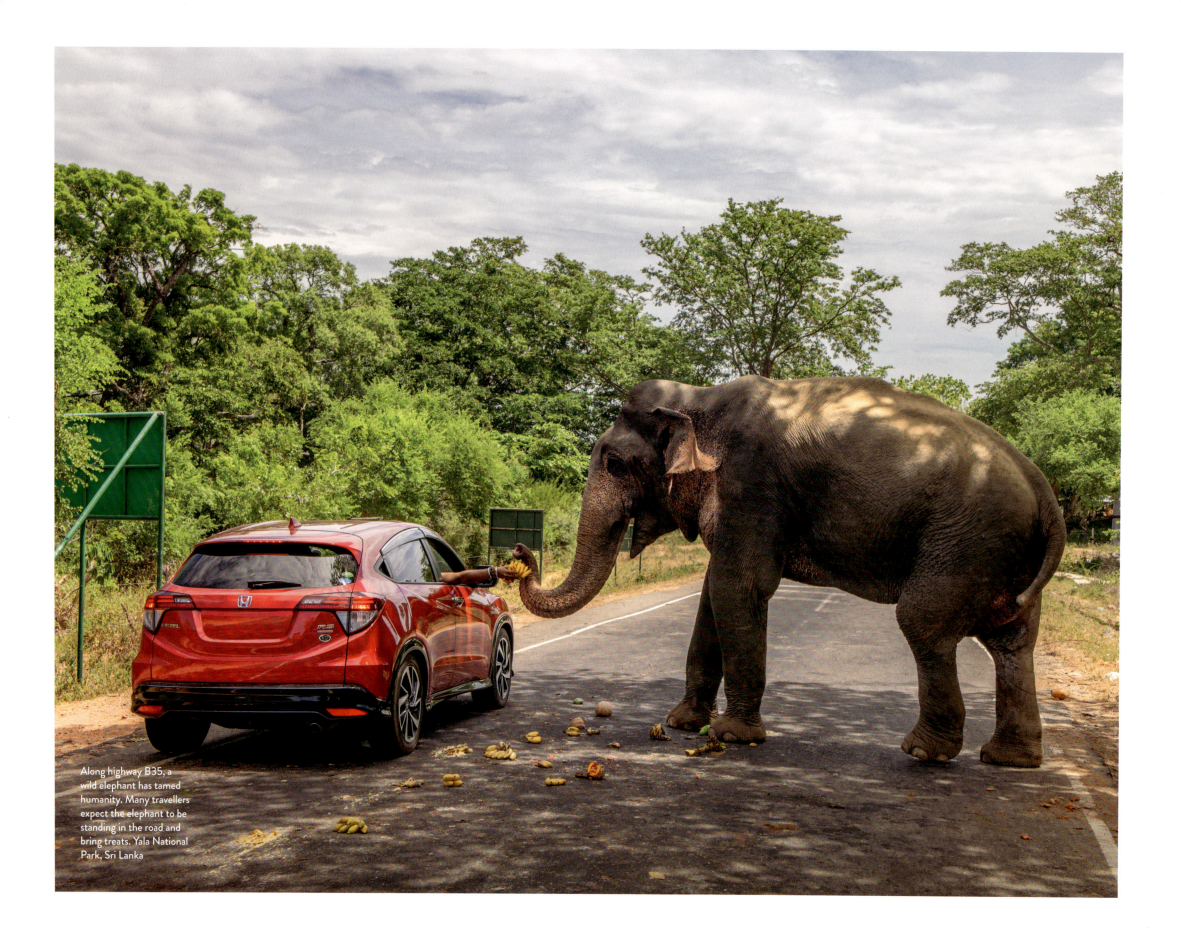

Along highway B35, a wild elephant has tamed humanity. Many travellers expect the elephant to be standing in the road and bring treats. Yala National Park, Sri Lanka

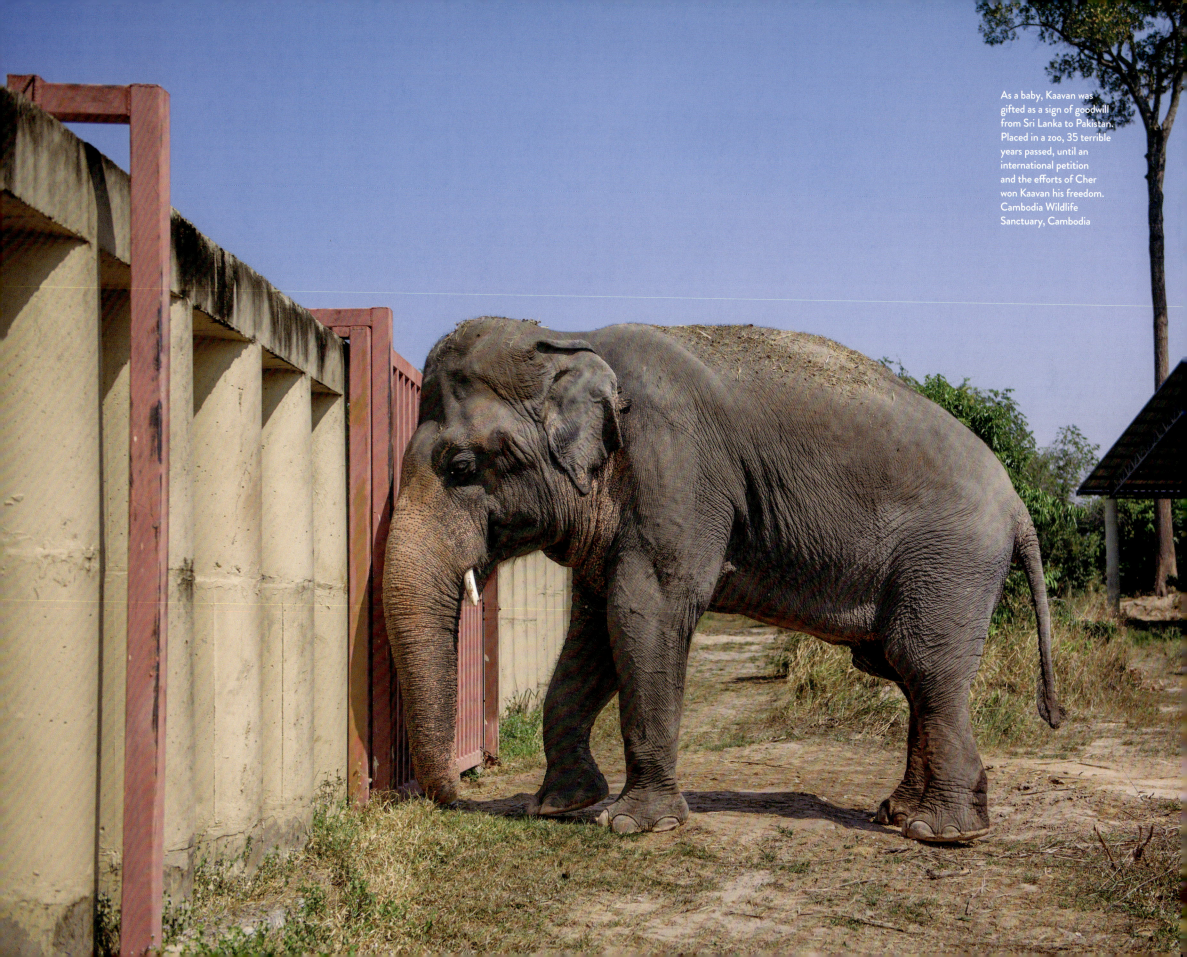

As a baby, Kaavan was gifted as a sign of goodwill from Sri Lanka to Pakistan. Placed in a zoo, 35 terrible years passed, until an international petition and the efforts of Cher won Kaavan his freedom. Cambodia Wildlife Sanctuary, Cambodia

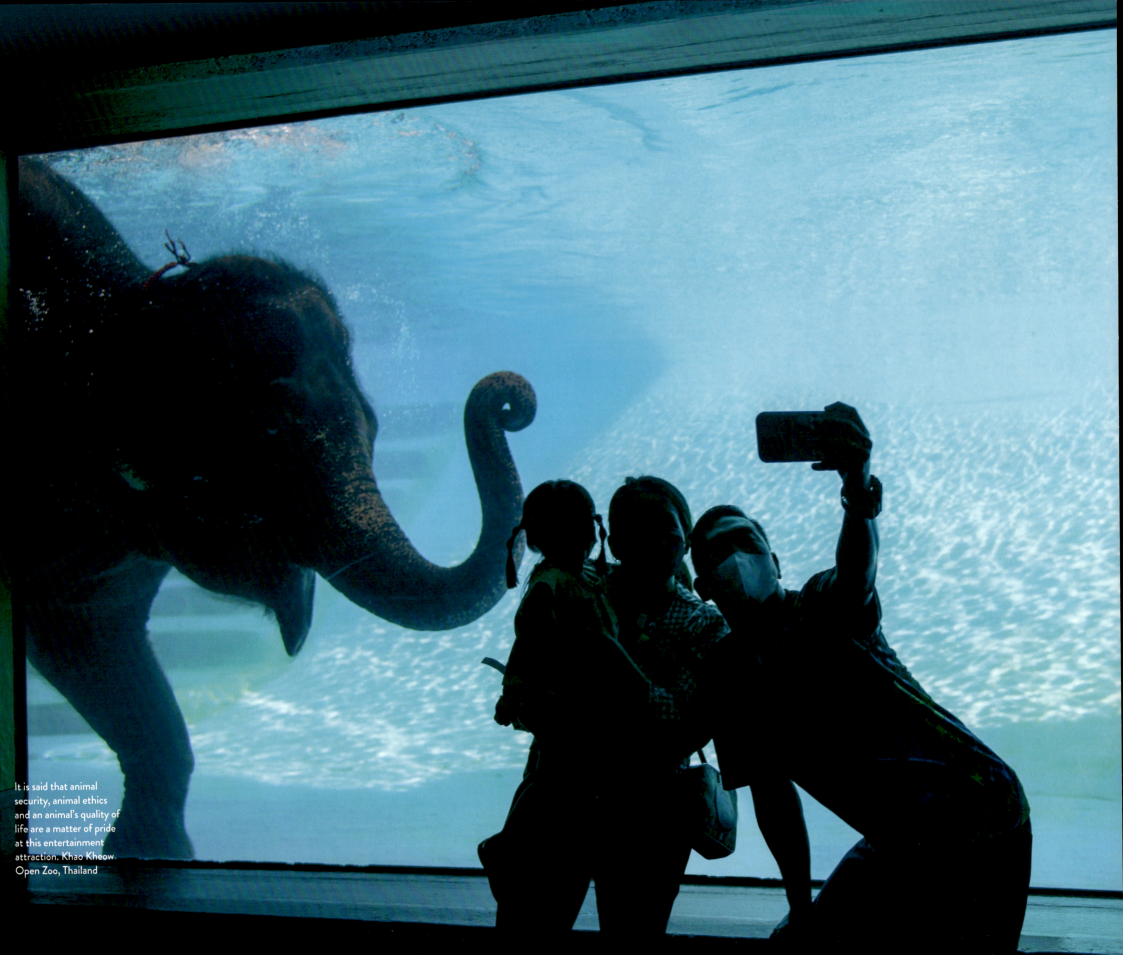

It is said that animal security, animal ethics and an animal's quality of life are a matter of pride at this entertainment attraction. Khao Kheow Open Zoo, Thailand

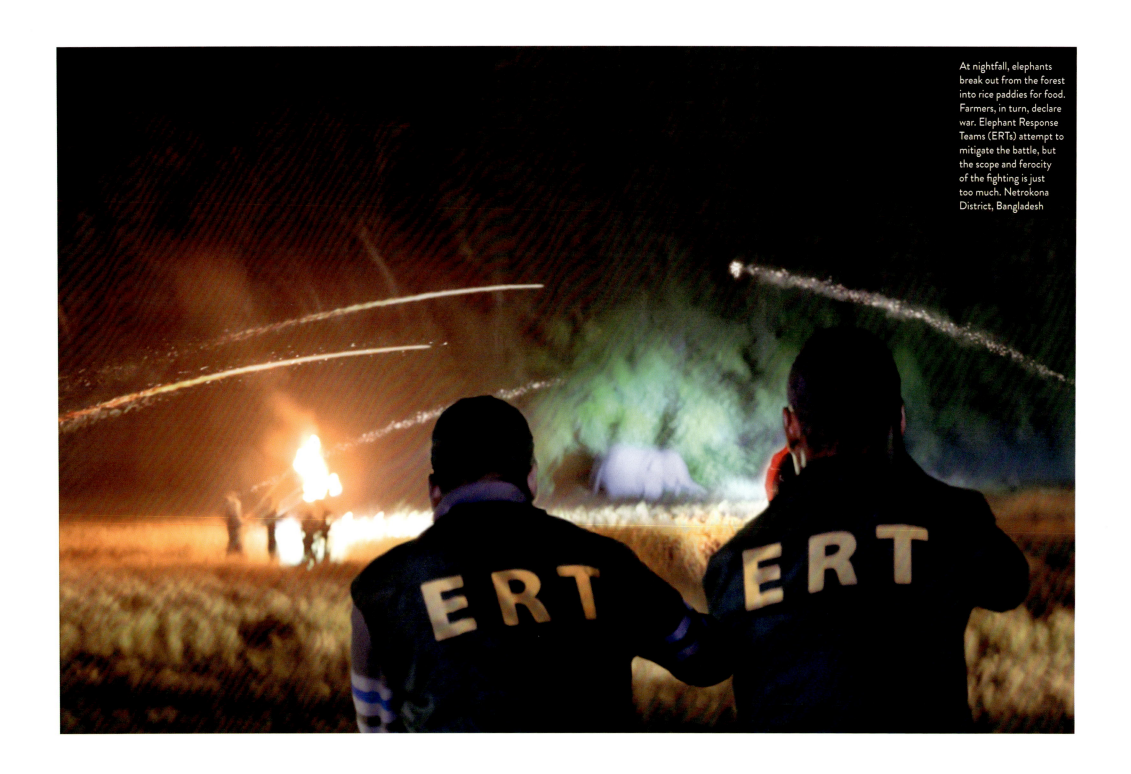

At nightfall, elephants break out from the forest into rice paddies for food. Farmers, in turn, declare war. Elephant Response Teams (ERTs) attempt to mitigate the battle, but the scope and ferocity of the fighting is just too much. Netrokona District, Bangladesh

TIMBER ELEPHANT

Deforestation has followed human beings wherever we've gone throughout history. Our appetite for things made of wood has always been insatiable, as has our preference for converting forest lands to other uses. Southeast Asia has suffered the most of any place on earth, with loggers in Indonesia, Malaysia and Myanmar leading the global harvest.

Elephants have been used as beasts of burden for centuries. Their work in the forests of Asia has facilitated thousands of years of logging. It is no coincidence that while the forests of Asia have been disappearing, so too have the elephants. Even more diabolically, elephants have been forced to take part in this great deforestation, this great dismantling of the forest home that they have depended on for countless millennia. And in Burma, today's Myanmar, the destruction has been especially criminal.

Burmese elephants had long been used for getting timber out of the forests, the logs then hauled to construction sites of religious temples and royal palaces. For centuries, the country's royals had controlled these projects and the deployment of elephants. But following their arrival in 1824, the imperial British – and their Forestry Department – soon dominated every aspect of the forests and logging. Tropical woods, especially teak, were critical to the British for the maintenance and construction of their ocean-going fleet, upon which everything depended. As they refined their methods of harvest, demand and production grew exponentially. An international market for hardwoods opened up, and the available timber facilitated the construction of a vast railroad network.

British timber-harvesting in Burma peaked just prior to the Second World War. Following the country's independence from Britain, government bureaucrats took over the industry. Greed overwhelmed the bountiful forest. Between the late 1960s and the early 1990s, over 53,000 square miles of forest were wiped out. In the mid-1990s, the government finally put some control on the trade, under pressure from international trade partners. The temporary reduction in logging rippled throughout most of Southeast Asia, bringing unemployment to many elephants and their mahouts.

With their survival in jeopardy, these elephants and mahouts were forced to make their way to the streets of major cities and towns, hoping for the best. Instead of relief, most found starvation and horrible living conditions.

This narrative was constructed from various sources including the article "Myanmar's Tainted Timber and the Military Coup," by Faith Doherty and Alec Dawson of the Environmental Investigation Agency, and the article "Blood Teak for the Super Rich Props Up A Cruel Regime," by Serdar Vardar, Pelin Ünker, Scilla Alecci, Jelena Cosic, and Giulio Rubino for *Deutsche Welle*.

*"I will remember what I was. I am sick of rope and chain.
I will remember my old strength and all my forest affairs.
I will not sell my back to man for a bundle of sugarcane.
I will go out to my own kind, and the wood-folk in their lairs.*

*I will go out until the day, until the morning break,
Out to the winds untainted kiss, the water's clean caress.
I will forget my ankle ring and snap my picket stake.
I will revisit my lost loves, and playmates masterless!"*

— **RUDYARD KIPLING**, British Poet and Novelist, from *The Jungle Book*

With no alternative, they begged for food and drank the foul water of drainage ditches and polluted rivers. In time, a cross-border trade developed with Thailand, a nation that had embraced the notion of putting the elephant to work in the tourist trade. Many of the elephants seen giving rides to tourists today are survivors of a former life, the life of a timber elephant in the forests of Burma.

Burma had won independence from Britain in 1948, but a prolonged internal struggle for power followed. Ethnic conflict dominated the land as it does today. With no peace in sight, the Burmese military has controlled the country since 1958, save for a failed ten-year attempt at democracy. In 1989, believing a change of name might smooth everything out, the military officially replaced the country's name of Burma with the name Myanmar. Nothing changed except the name. Even under democratic rule, illegal logging persisted, with the government seizing almost 10,000 tons in 2020 alone, only to sell it off on the international market. Since the most recent installation of military government in 2021, logging of the forest is as widespread and greed-oriented as ever, with forest dwellers, soldiers and resistance fighters all taking advantage of the lawlessness.

Demand for the illegal wood is coming from China and India. Once again, deforestation threatens the forest across the country. Even the glorious national parks have been plundered and are no longer safe for man or beast. Where discretionary cutting had been practised, clear-cutting has laid waste to vast tracts of land. Soldiers have set up checkpoints where they profit from charging smugglers to look the other way. And, deep in the forest, far from the eyes of the outside world, elephants continue to toil away, pushing and dragging logs to market, as they have done for centuries.

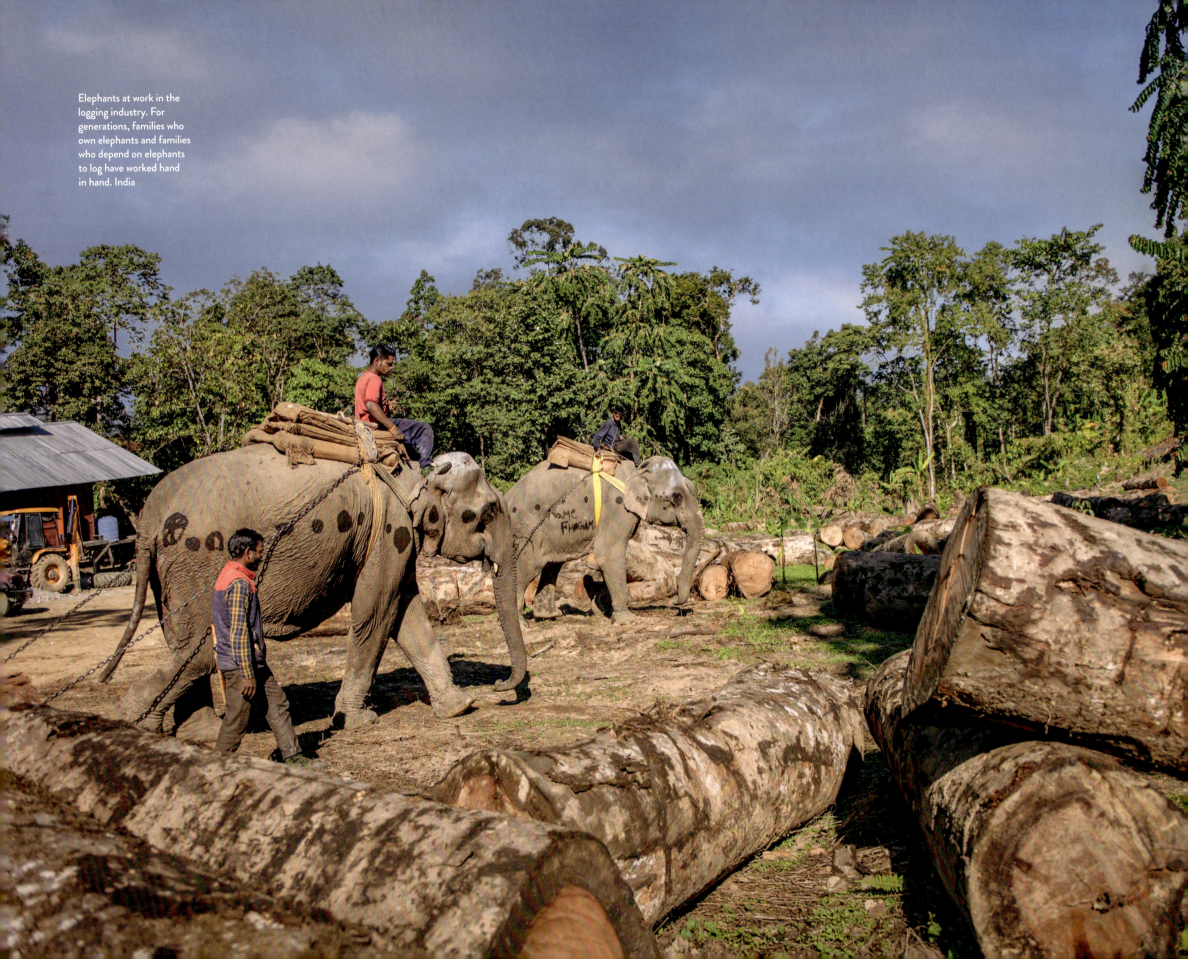

Elephants at work in the logging industry. For generations, families who own elephants and families who depend on elephants to log have worked hand in hand. India

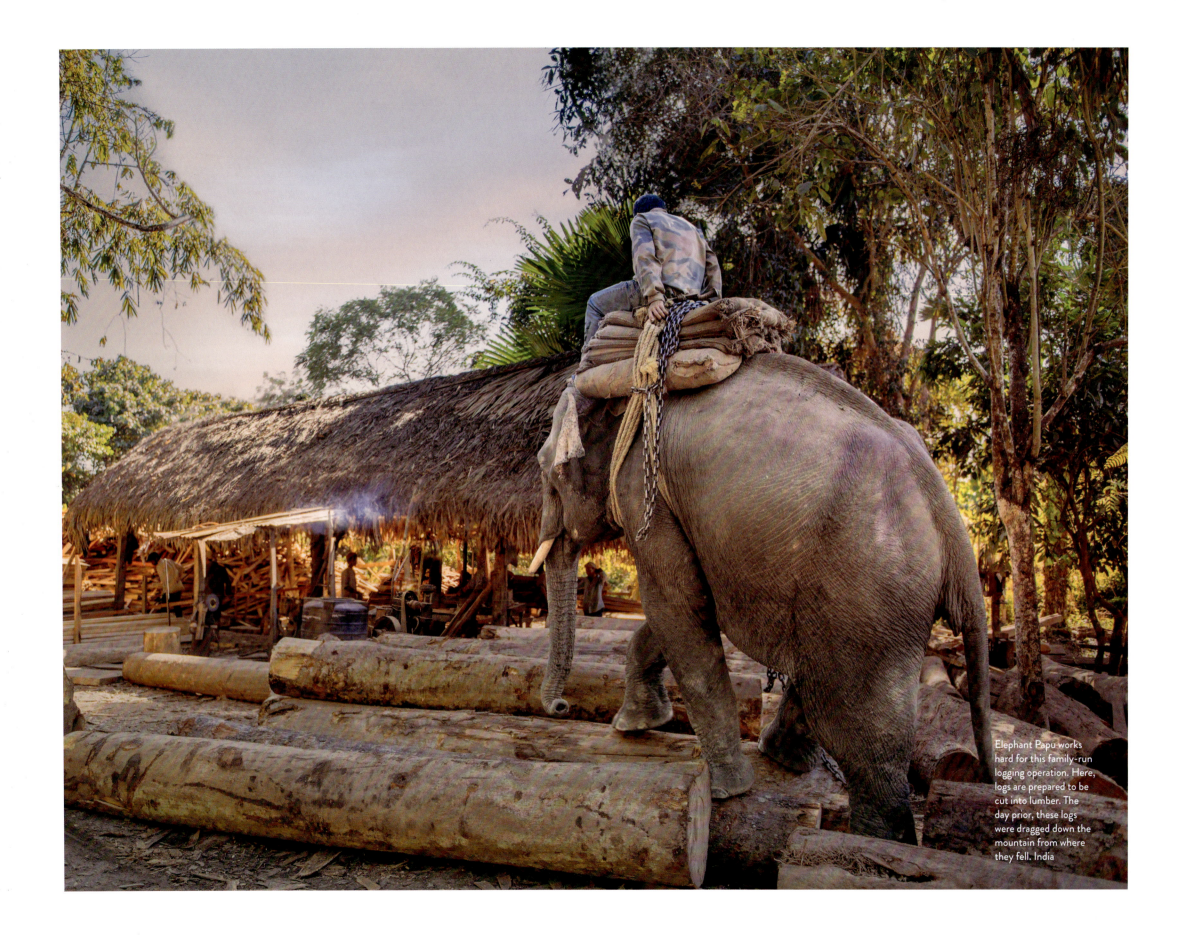

Elephant Papu works hard for this family-run logging operation. Here, logs are prepared to be cut into lumber. The day prior, these logs were dragged down the mountain from where they fell. India

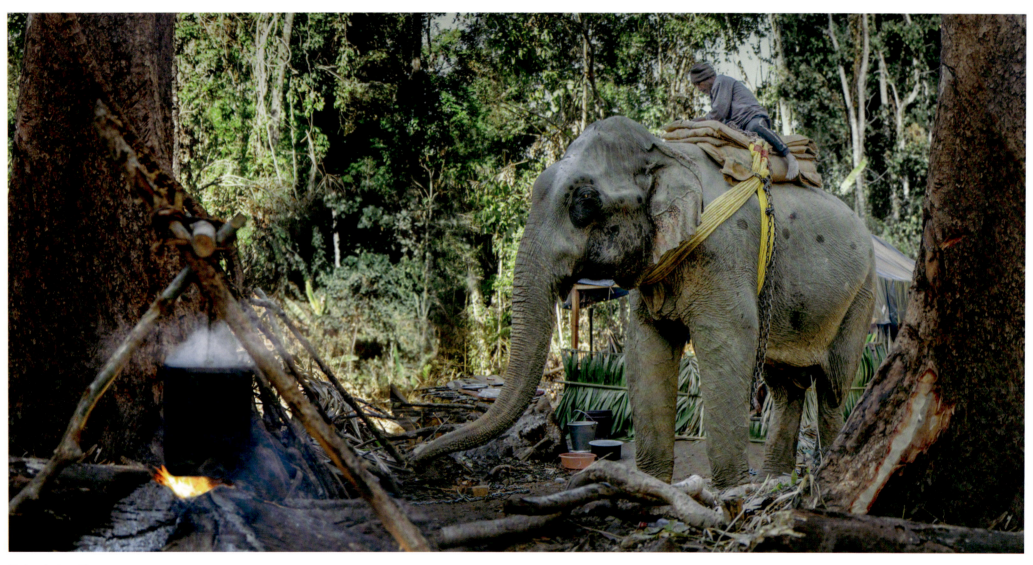

Timber elephant Fhagam, having put in a day of work, returns to camp and will have the afternoon off. India

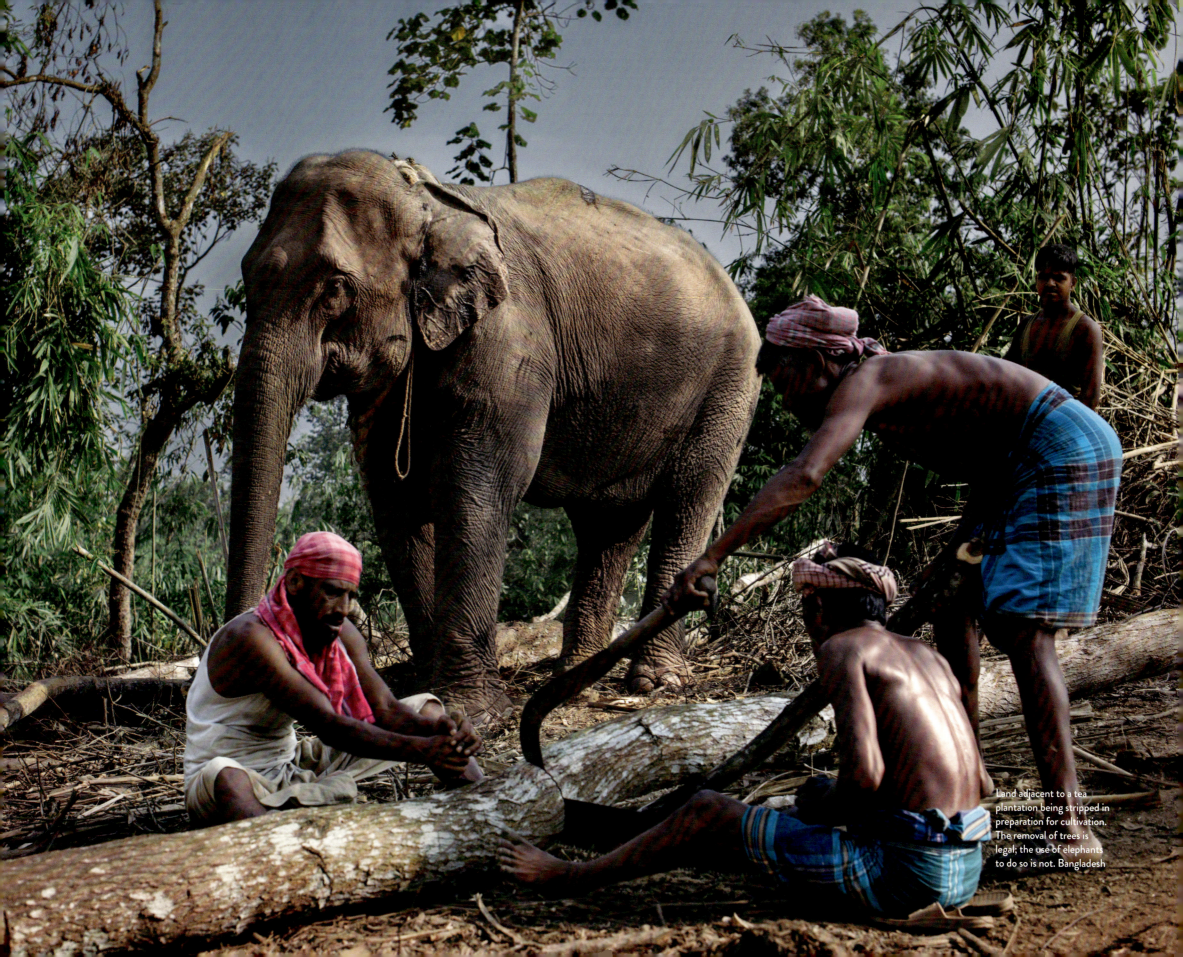

Land adjacent to a tea plantation being stripped in preparation for cultivation. The removal of trees is legal; the use of elephants to do so is not. Bangladesh

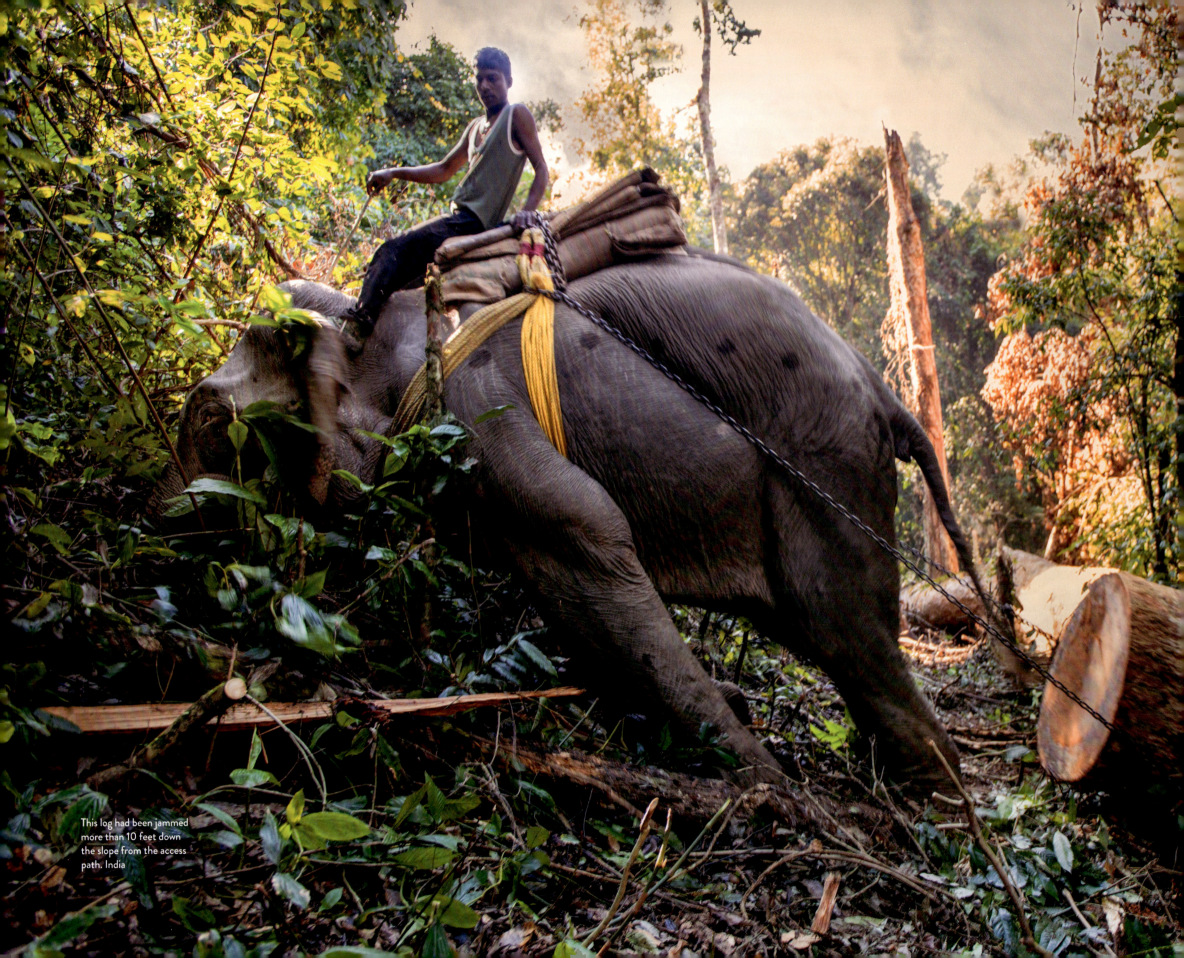

This log had been jammed more than 10 feet down the slope from the access path. India

Asia has the highest rate of deforestation in the world. It's sadly ironic that elephants have been forced for generations to assist in this destruction: the destruction of their own home. Sabah, Malaysia

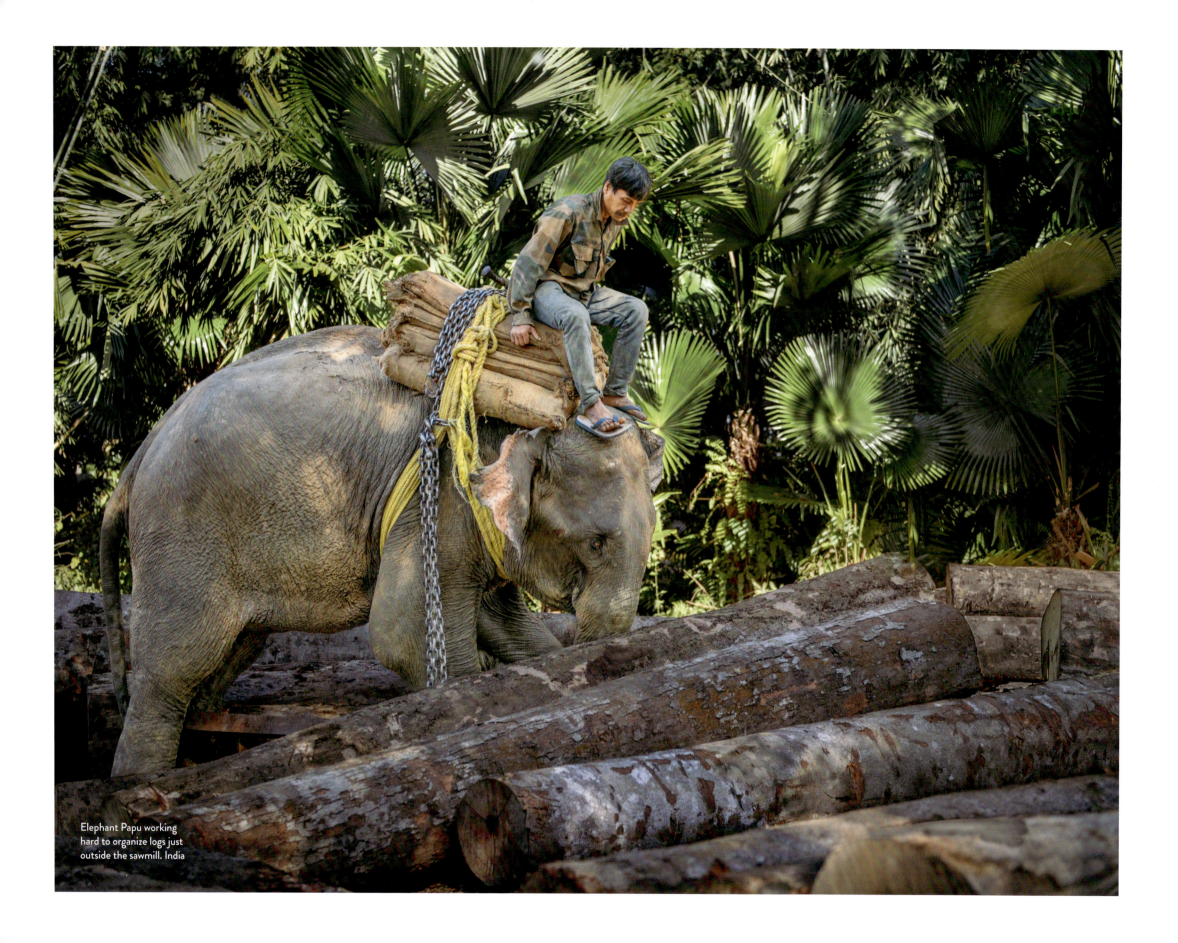
Elephant Papu working hard to organize logs just outside the sawmill. India

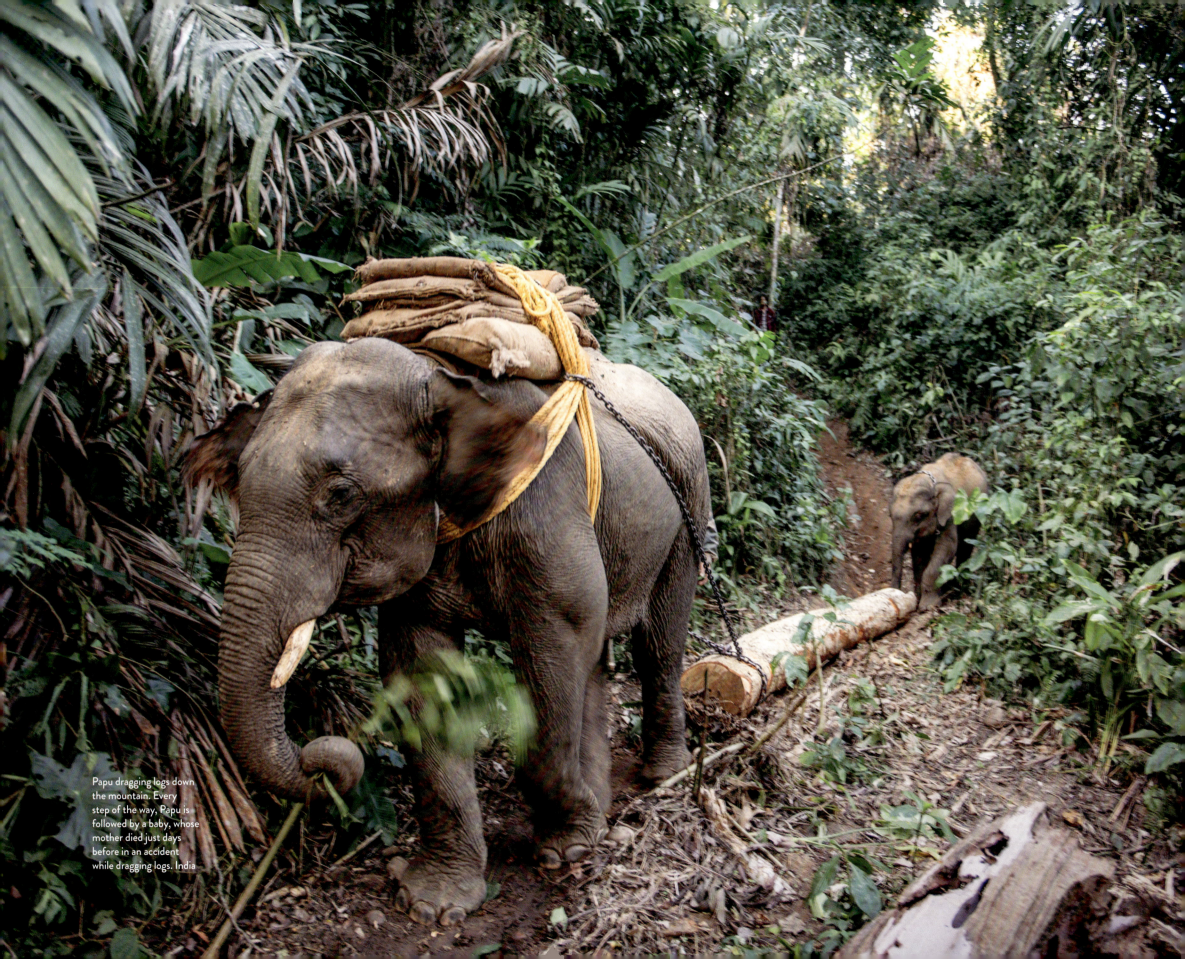

Papu dragging logs down the mountain. Every step of the way, Papu is followed by a baby, whose mother died just days before in an accident while dragging logs. India

BANDOOLA
TIMBER ELEPHANT

Maung Yit was a freedom fighter in Burma. As his country battled the imperial British in the early 19th century, his exploits on the field of battle turned him into a national hero. In a public ceremony, the king of the land promoted Maung Yit to the rank of senior commander and bestowed on him the title Maha Bandula. While defiantly defending a small town against superior British forces, the great Maha Bandula was killed in action and became a national legend. The year was 1825.

In 1897, elephant boy Po Toke was 15 years old, his life consumed by a fascination for elephants. The knowledge he had acquired from growing up with elephants in his camp was extensive. The experience he had gained under the employ of his future father-in-law, an elephant contractor, had won him the supervision of a female elephant named Ma Shwe.

Soon, Po Toke was looking after not only Ma Shwe but also her newborn baby. On the baby's second night of life, a tiger attacked. Both Ma Shwe and her attending auntie sustained terrible wounds in the defence of the little baby. Upon hearing the struggle, Po Toke and other mahouts came running, shouting and ready for a fight. The tiger ran off. Overcome with emotion that the baby he so adored had survived, Po Toke's mind turned to the admiration he held for his nation's hero, his hero, Maha Bandula, who had similarly survived life-threatening attacks. In an instant, he exclaimed Bandula's name, and so came to pass the naming of the little baby elephant, Bandoola.

In a short time, Po Toke and his young fiancée had secured a promise from her father that Po Toke could take control of the young Bandoola and train him in any way he saw fit. While the traditional method of taming a young elephant was traumatic and cruel, Po Toke, through his deep love of elephants, had conceived of a new approach that was based on love and care. The result was a relationship between human and elephant built on trust, not fear.

Shortly after young Bandoola had settled into his new life as a tamed elephant, a representative of a British teak-logging firm appeared at the camp, anxious to acquire new elephants. Overnight, Po Toke, Bandoola and the contractor's nine other elephants became the property of Britain's Bombay Burmah Trading Corporation, the largest teak wood harvester in the country.

As young elephants were not considered capable of working with logs until age 21, Bandoola was assigned to the company's team of travelling pack elephants,

This narrative was constructed from various writings of J. H. 'Elephant Bill' Williams, most notably the book Bandoola.

initially with Po Toke's brother-in-law as mahout. For 11 years, Bandoola worked as a pack animal, covering thousands of miles, carrying supplies to and from the company's remote logging camps in Upper Burma.

By his mid-teens, Bandoola proudly carried a well-developed set of tusks, and his body was as strong and muscular as those of working elephants, years older than he. What's more, he demonstrated an unusual spirit in his work, clearly attributable to Po Toke's attitude of respect. As a result, the company was keen on getting Bandoola into logging work as soon as possible.

For the next two years, Bandoola was initiated into handling logs by working alongside old, injured and crippled elephants. Stationed primarily along the banks of a river, he learned to use his head, tusks and trunk to keep teak logs out in the main channel, where they would drift downstream to the mill. As the logs were constantly drifting off course, Bandoola's strength and knowledge of logs grew quickly.

By this time, Po Toke had been joined in his affection for Bandoola by one of the company's forest assistants, James Howard Williams. Williams worked for the Bombay Burmah Trading Corporation for 22 years and then returned to his native England to write the stories of his life. These stories are the most detailed accounts ever recorded of elephants in Asia's controversial timber industry.

Despite Po Toke's and Williams's admiration and hopes for Bandoola, he was assigned to a rugged logging camp and given the exhausting work of dragging logs. Year after year, the struggles and the monotony of hard labour followed. Along the way, Bandoola experienced his first urge to breed, his first battle with a wild bull elephant and his first interactions with a captive female. At age 38, in his physical prime, Bandoola was one of only a few elephants in Burma capable of moving the largest logs ever extracted. During one logging season, he was recorded to have moved 300 tons of teak over a distance of two miles.

The routine wore on year after year, until January of 1942. The Second World War had turned the world upside down. Into every corner of Burma, the ruthless Japanese invaders flowed. The timber industry disintegrated overnight. The Japanese ordered all mahouts to report with their elephants to assist in the building of roads and the transport of weapons and supplies. Failure to comply was punishable by death. Many mahouts did comply, while others set their elephants free and disappeared into the forest. Po Toke chose to hide Bandoola up a rugged canyon outside his village, reporting to the Japanese that the elephant had run off.

Meanwhile, Williams had been commissioned by the British Army to create an 'Elephant Company' to support the effort of retaking control of Burma. Elephant No. 1, in his Company No. 1 of war elephants, was Bandoola. As the war progressed, Williams went to extraordinary measures to gather up all the former working elephants he could. Despite the deaths of dozens and the escape into the wild of others, at one point Williams held a force of 1,652 elephants.

His elephants were primarily used to construct roads and bridges that enabled British and Indian forces to move into position to confront the Japanese. But in the spring of 1944, the battle for Burma was nearing a climax and British command ordered Williams to get as many elephants as he could out of Burma, out of harm's way. Hundreds of thousands of refugees had streamed out of Burma to the west in the preceding months, but these escape routes were now blocked by the enemy. In the face of great danger, Williams managed to put together a caravan that included Bandoola, 52 other elephants, 40 Burmese soldiers, 90 mahouts, 64 refugee women and children, and four British officers.

> "Two men were sawing a log, and one of them wanted to go off and have a sleep, so he gave his end of the saw over to the elephant and told him to carry on. After a bit, his partner got sleepy too, and left the elephant sawing alone, which he continued to do so all by himself until the job was finished."
>
> – **SUSAN WILLIAMS**, Widow of forester James Howard Williams, a factual account from her autobiography *In the Footsteps of Elephant Bill*

The caravan faced challenges at every turn. They faced the ever-present threat of Japanese patrols. They endured cold temperatures, freezing rain, malaria, exhaustion and starvation. Through it all, the elephants laboured on, carrying supplies and the belongings of the refugees. And when refugees could no longer walk, the elephants carried them too.

From dawn until late afternoon, day after day, they pushed ahead toward India and safety. When the road ended, they followed game trails. When the trails ended, they hacked their way through heavy vegetation. And then all at once, they could go no further. The way forward was blocked by a high cliff, hundreds of feet high, and extended in either direction as far as the eye could see. The cliff was so sheer that neither man nor elephant could hold any hope of climbing it, save for one gallant possibility.

Williams set the men to carving steps into a narrow portion of the rock face. The work lasted two full days. The steps had to be adequate for elephants to negotiate, but in some places, the elephants would have to stand on their hind legs to reach the next step, all the while carrying their heavy loads. The effort was clouded by uncertainty. Would the elephants be willing to attempt such a perilous climb? Would they freeze in place? Or, worse yet, would they panic and run off?

The time came for all to gather for the attempt. The elephants would go first. Under Po Toke's leadership, Bandoola would lead the way, with the hope of inspiring the others to follow. The command was given and up the rock face climbed the brave Bandoola, his mahout wrapped around his neck, his load squarely on his back, and Po Toke following close behind. Each of the other 52 elephants, inspired by Bandoola's determination, followed in order, one by one. Up they went, step by step. It took each elephant more than three hours to scale the steep cliff. In time, the soldiers and refugees made their way up as well. It was Williams's finest hour, and Bandoola's as well.

It took three weeks for the caravan to reach safety in India. As the sick and exhausted group of elephants and humanity entered their safe haven, Bandoola was in the lead, a collection of eight sick refugee children in a basket on his back.

The reprieve for Bandoola was short-lived. Five months later, he was marched back into Burma on the heels of a great British counter-offensive about to rid Burma of the Japanese. Po Toke was put in charge of an elephant camp that supplied two sawmills with teak for British boat-building and repair, Bandoola under his watchful eye.

There are events that take place on this earth for which humans can never be forgiven. There are events that take place on this earth that can crush even the strongest heart. In a small grassy clearing, much like the ones where a baby elephant is born, a quarter of a mile outside Po Toke's elephant camp, someone aimed a gun at the faithful Bandoola's head and took his life away.

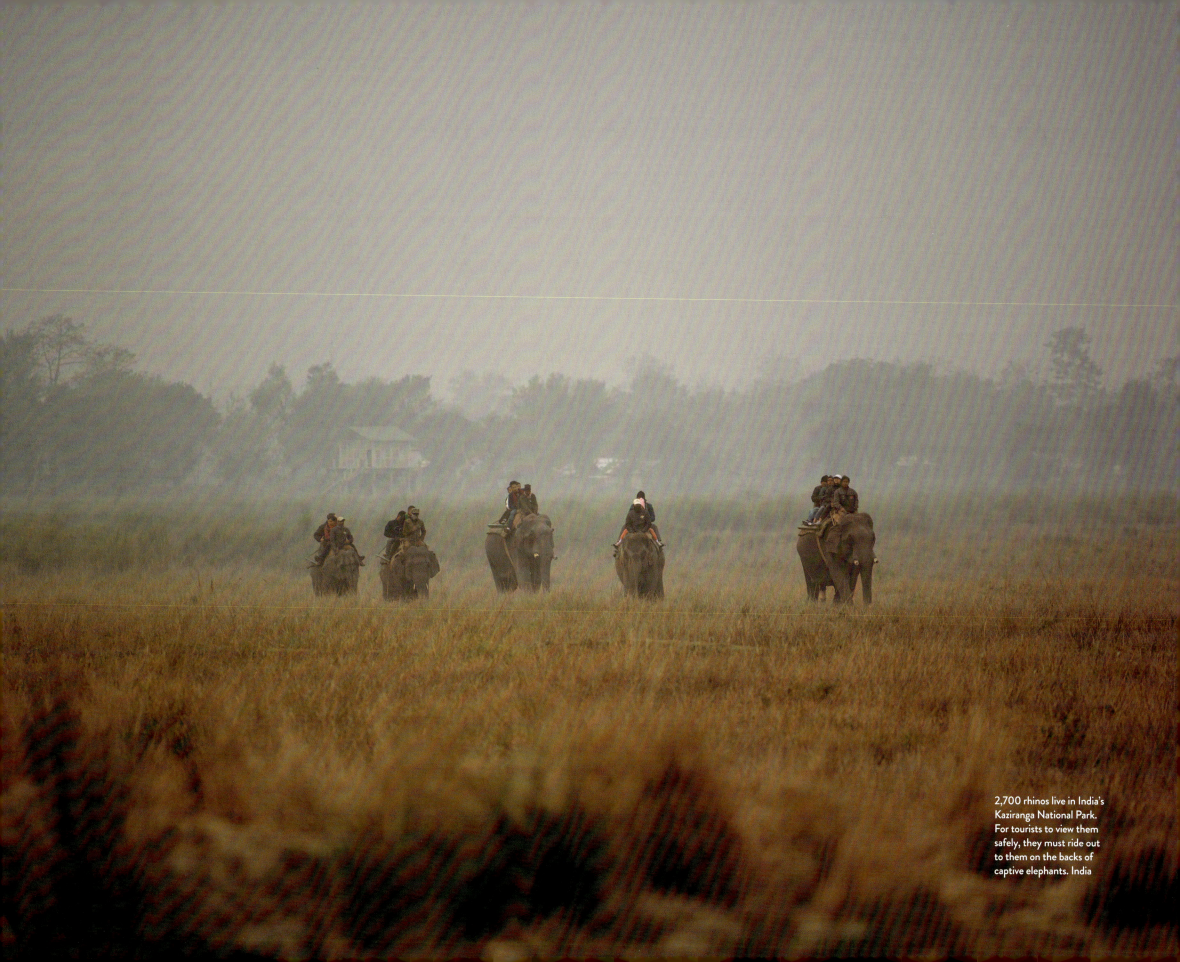

2,700 rhinos live in India's Kaziranga National Park. For tourists to view them safely, they must ride out to them on the backs of captive elephants. India

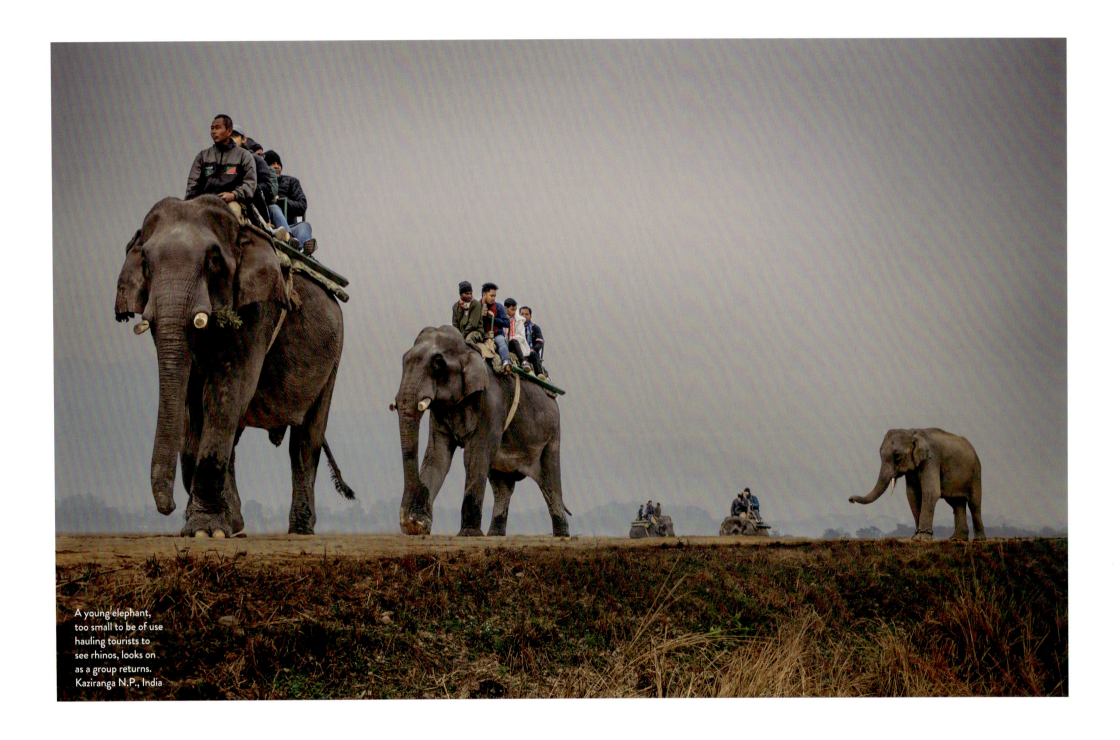

A young elephant, too small to be of use hauling tourists to see rhinos, looks on as a group returns. Kaziranga N.P., India

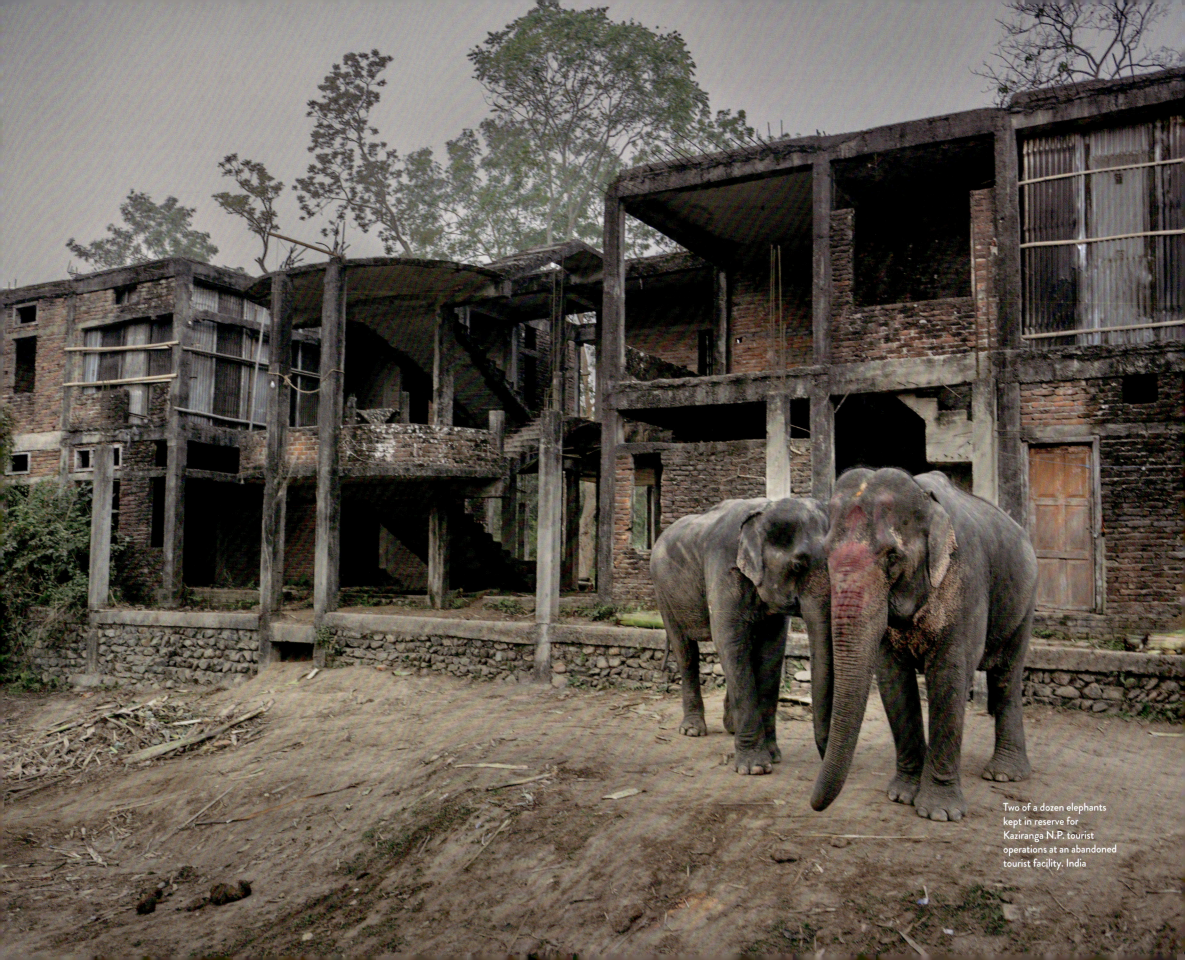

Two of a dozen elephants kept in reserve for Kaziranga N.P. tourist operations at an abandoned tourist facility. India

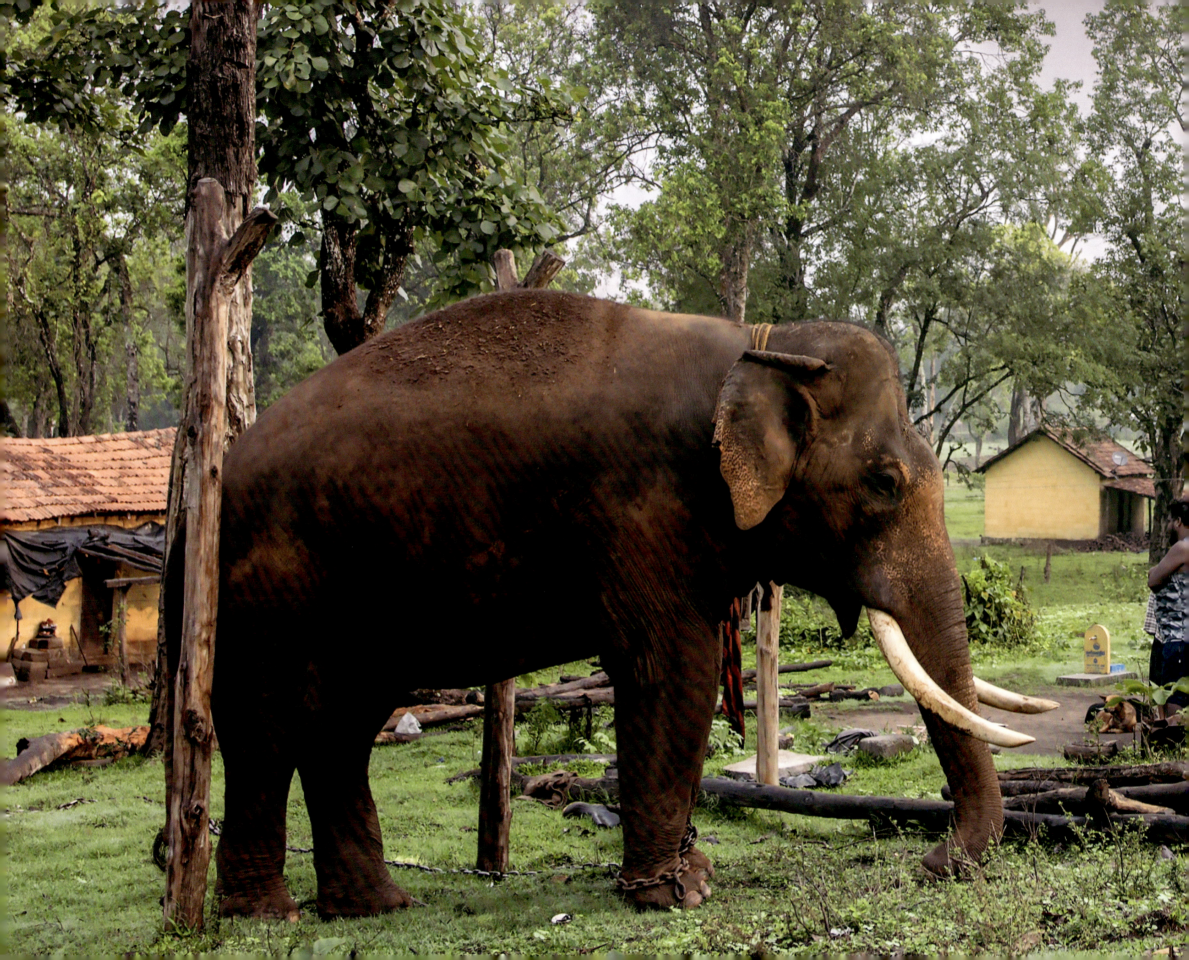

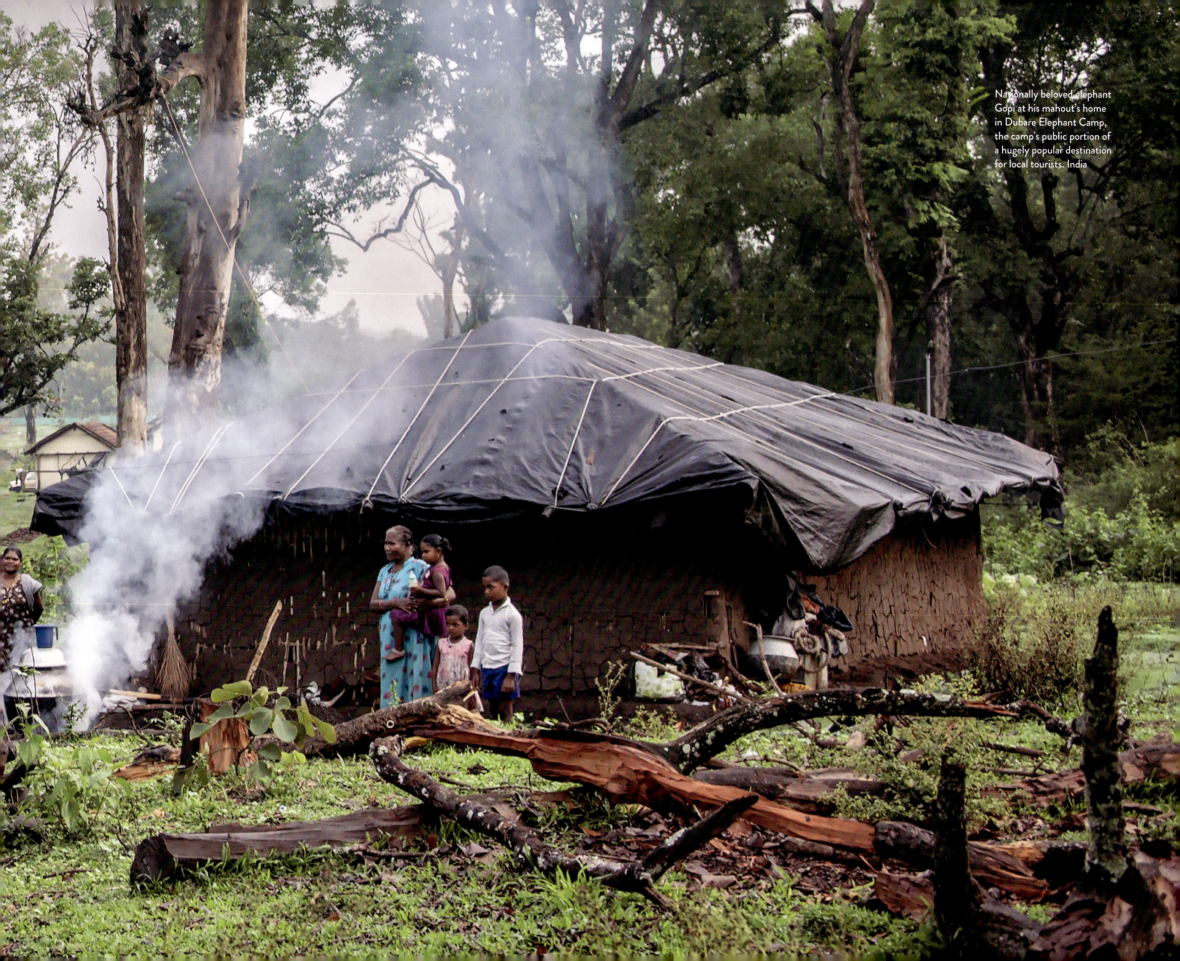

Nationally beloved elephant Gopi at his mahout's home in Dubare Elephant Camp, the camp's public portion of a hugely popular destination for local tourists. India

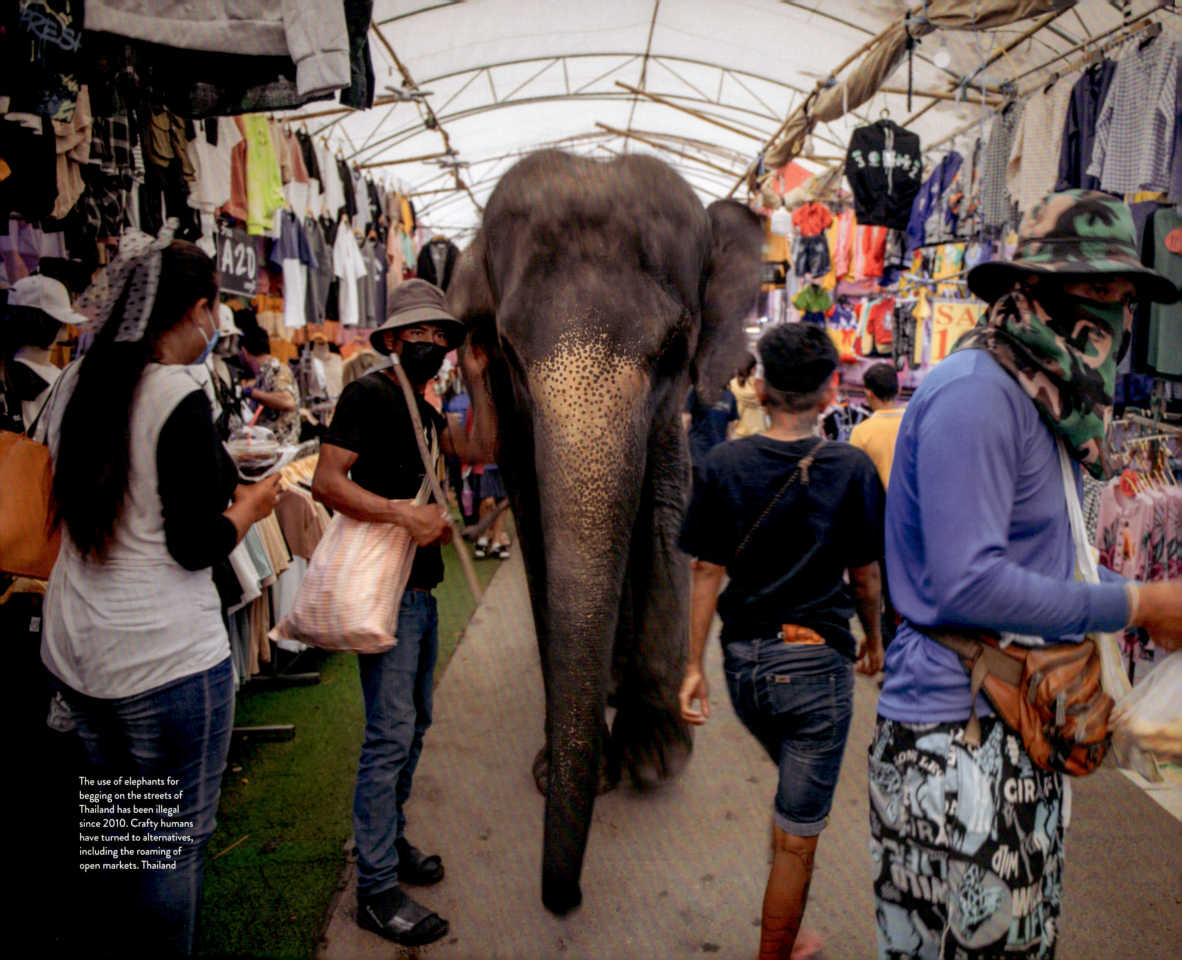

The use of elephants for begging on the streets of Thailand has been illegal since 2010. Crafty humans have turned to alternatives, including the roaming of open markets. Thailand

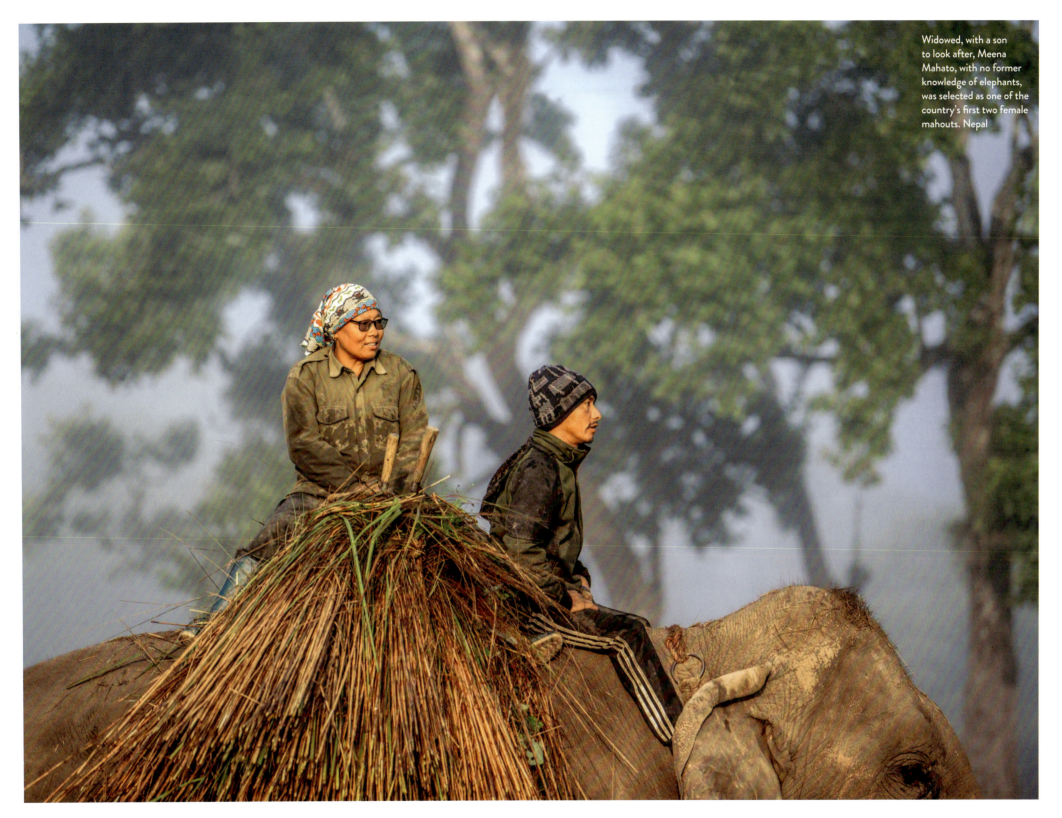

Widowed, with a son to look after, Meena Mahato, with no former knowledge of elephants, was selected as one of the country's first two female mahouts. Nepal

MAHOO NEE AND THE GUIDE MAN
TIMBER ELEPHANTS

As a hardwood, teak has many qualities useful to humans. We have used it to make everything from outdoor furniture to indoor flooring, and most significantly, for more than 2,000 years, to make boats.

The British Navy came to power on the high seas during the mid-17th century. In short order, the fleet was operating hundreds of ships, with each ship requiring over a thousand trees to make. With oak forests exhausted, the British turned to teak wood and began sourcing it from the rich forests of Burma in the early 1800s. In 1852, Britain took control of Burma's most productive teak-growing region. In 1886, Britain took control of the entire country.

Under British control, Burma soon produced 75% of the world's teak wood. Noting widespread deforestation in India and an inherently wasteful harvest in Burma, the British created the Forestry Department in 1856 to introduce scientific order. A system was put in place that included dragging the fallen logs out of the forest by elephant – just as Bandoola did in the previous narrative – so the logs could then be floated down waterways to mills and finally exported.

During this period, five big European-based logging companies moved in. The largest was the Bombay Burmah Trading Corporation. The forests were divided up, each company then dividing its territory into districts of ten logging camps, and each camp acting as a base for 10 to 30 men and up to several dozen elephants. A roving forest assistant kept each district running smoothly. The most notable of all the forest assistants was the very same James Howard Williams – 'Elephant Bill' – who would go on to escape Burma with Bandoola in 1944 and then write memoirs of his time with elephants, as related in the previous narrative.

Among the many memorable elephants that Williams was responsible for and wrote about was a female named Mahoo Nee. As with all working timber elephants, Mahoo Nee would either have been born to a working mother or captured in the wild at the age of about 15–20 years. She would then have been tamed and trained by a weeks-long process of intimidation and torture, before being placed in a logging camp.

Williams, though aware of the constant need for additional labour, despised the way elephants were trained. Just at the right time, he met a local elephant man named Po Toke, who, as related in the previous narrative, had conceived a kinder method of taming and training, and had successfully applied it on his

This narrative was constructed from various sources, most notably the book *Elephant Company*, by Vicki Constantine Croke and the recollections of James Howard Williams.

own young elephant, Bandoola. Williams immediately constructed a school and Po Toke began training all new timber elephants.

To maximize efficiency, working mothers would hastily be put back to work after giving birth, with their offspring tagging along nearby until the age of five. Then, in much the same way as a young human is dropped off at preschool or kindergarten, the mothers would be led to the taming school to witness their young ones join the ranks of others under training. Immediately, they would develop new relationships and be enjoined to an aspiring mahout. Together, each young elephant and each young mahout would learn the ways of each other and of the forest.

A new class of five-year-olds was about to begin learning. Mahoo Nee, now in her mid-thirties, was on her way from the work camp to drop her son off at the school, several miles away. Along the route, the accompanying mahout routinely swiped at overhanging vegetation with a knife. But in one instance, he accidentally swiped at and cut a poisonous vine that brushed Mahoo Nee's face and eyes as she passed by. Upon arrival at the school, Williams discovered that the faithful elephant Mahoo Nee was completely blind. Nothing could be done for her. In the moment, Williams felt he had no good options. It seemed that Mahoo Nee would have to be hand-fed and -watered for the rest of her life. If he left the calf with her, it would just be a matter of time before the young male would grow frustrated with the situation and wander off with a passing wild family.

But as the mother and calf were led away, Williams witnessed something remarkable happen. He later wrote, "I saw the calf back his hindquarters toward his mother's head. When she felt him, she raised her trunk and rested it on the calf's back, and in this way they moved about the clearing. It was like a little boy holding his blind mother's hand and steering her down the street."

This was particularly astonishing because young elephants, especially males, are prone to indulging streaks of independence and impulsively wandering away from their mother any chance they get. But in this moment of uncertainty, a deep sense of responsibility and devotion surfaced in Mahoo Nee's son.

Straight away, Williams imagined a future for the two elephants. He sent Mahoo Nee and her son to a camp for broken-down elephants in the gentle valley of the Mu River. Here they joined a group of old and crippled elephants. Regular shifts of light work still took place daily, such as pushing stranded logs off sandbanks back into the channel. In no time, the men of the camp became taken with Mahoo Nee and her son. In time, they named the young elephant Bo Lan Pya, The Guide Man.

Mother and son came up with a day-to-day routine. The Guide Man was free to wander around while Mahoo Nee worked a full shift, directed by a mahout. Then, The Guide Man would meet her and together they would enjoy their daily bath. Refreshed, as Williams recalled, "They would spend an hour feeding in tall elephant grass. Then, trunk on back, she would follow her son to the bamboos for a couple of hours more, then off again for a few hours in creeper and cane break jungle, another hour or so, browsing and resting under a shady tree and then down to the water to drink."

Mahoo Nee and The Guide Man were always together by choice. Despite the calf being on his own for all those hours each day while his mother worked, he was never tempted to join up with any wild elephants. The thoughts and movements of mother and son were united as they enjoyed a magical level of communication.

In spite of having no vision whatsoever, Mahoo Nee thrived. The Guide Man,

"I have worked with elephants for many years. I have never seen any bond like the love between elephants in any other animal, even humans. The love among them is unconditional love. They are totally opposite from humans. When they submit their love to somebody, they love forever. And the more they stay together, the more polite they are to each other. This is totally opposite from humans."

– **SAENGDUEAN LEK CHAILERT**, Founder of Save Elephant Foundation, Founder of Elephant Nature Park, with a history of having rescued over 200 elephants in need.

extremely fond of his mother, looked after her any way he could. She worked each day, ate all she needed at night and enjoyed her son's steadfast companionship. "For three years she was physically perfect," Williams wrote, "except that she was blind."

As one monsoon season got underway, Williams made a trip to Mahoo Nee's camp to look in on the blind elephant. On his arrival, it was raining and the adjacent river was rising quickly. On the near bank, he saw that Mahoo Nee was with several other elephants pushing logs into the river. On the far bank, he saw The Guide Man, roaming around but keeping relatively close.

Williams, believing something wasn't right with Mahoo Nee, called to her mahout to bring her ashore near him. As the mahout did this, Mahoo Nee called out for The Guide Man. "I looked across the river," Williams recalled, "and in a moment or two I saw the grand little head of the calf appear out of the tall elephant grass about four hundred yards away. His ears were cocked forward. His little tusks stood out like toothpicks. He bellowed back as much to say, 'Wait a mo', mum, I'm coming!' But the river bank at the point where he had emerged had a sheer drop of twelve feet."

As The Guide Man hurried to find a gentle slope on the bank on which to descend for his crossing, he came to a spot that had turned into an unstable ledge, the bank below it hollowed out by the racing water. All at once, the entire ledge collapsed under his weight. As he hit the water, more heavy mud came sliding down, trapping him. In a tragic instant, the little calf had drowned.

As the rain poured down, Mahoo Nee stood silently at first. Then the mahout directed her to the area where her son had perished. She began to call out for him, bellowing over and over. As she stood over the buried body of her son, Williams felt her shock and grief. The situation hopeless, the mahout commanded her to turn away and push her way through the current. She did so reluctantly while still crying out. Up onto the bank and all the way back to camp she cried. By nightfall she went silent. Heartbroken.

Three weeks later, Mahoo Nee passed away.

At its peak, the timber industry in Burma harvested astronomical numbers of teak trees each year. At this same time, over 10,000 elephants were at work in the country's forests, making this harvest possible.

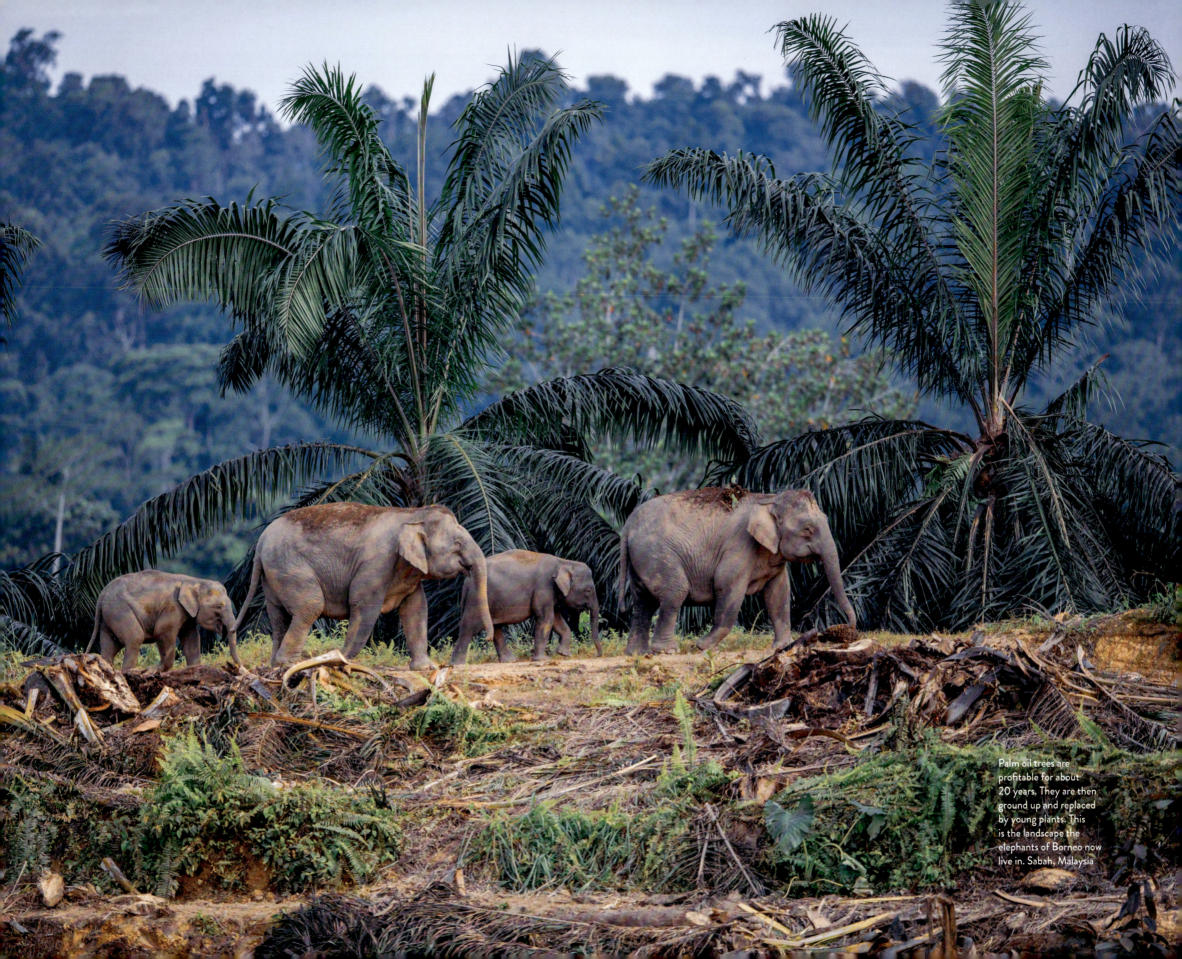

Palm oil trees are profitable for about 20 years. They are then ground up and replaced by young plants. This is the landscape the elephants of Borneo now live in. Sabah, Malaysia

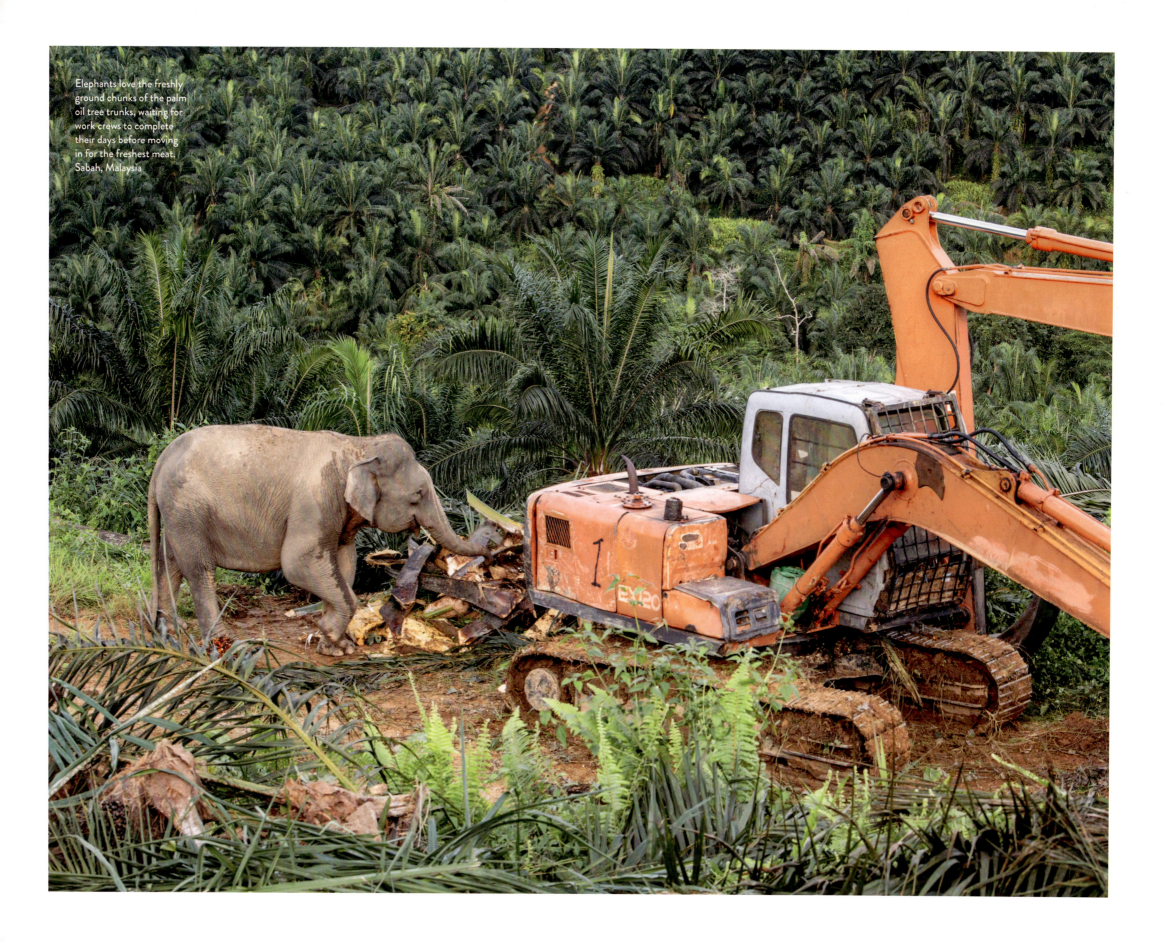

Elephants love the freshly ground chunks of the palm oil tree trunks, waiting for work crews to complete their days before moving in for the freshest meat. Sabah, Malaysia

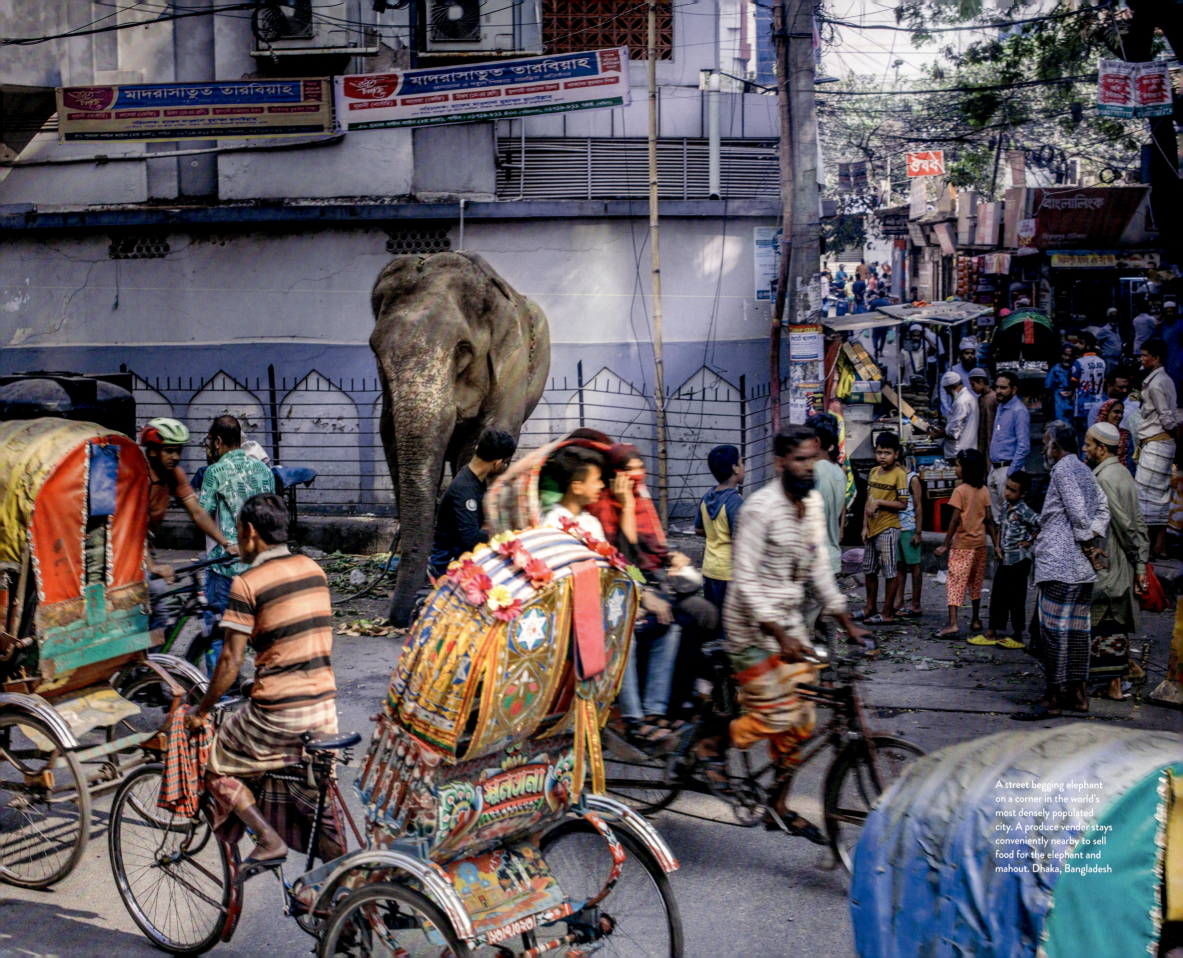

A street begging elephant on a corner in the world's most densely populated city. A produce vender stays conveniently nearby to sell food for the elephant and mahout. Dhaka, Bangladesh

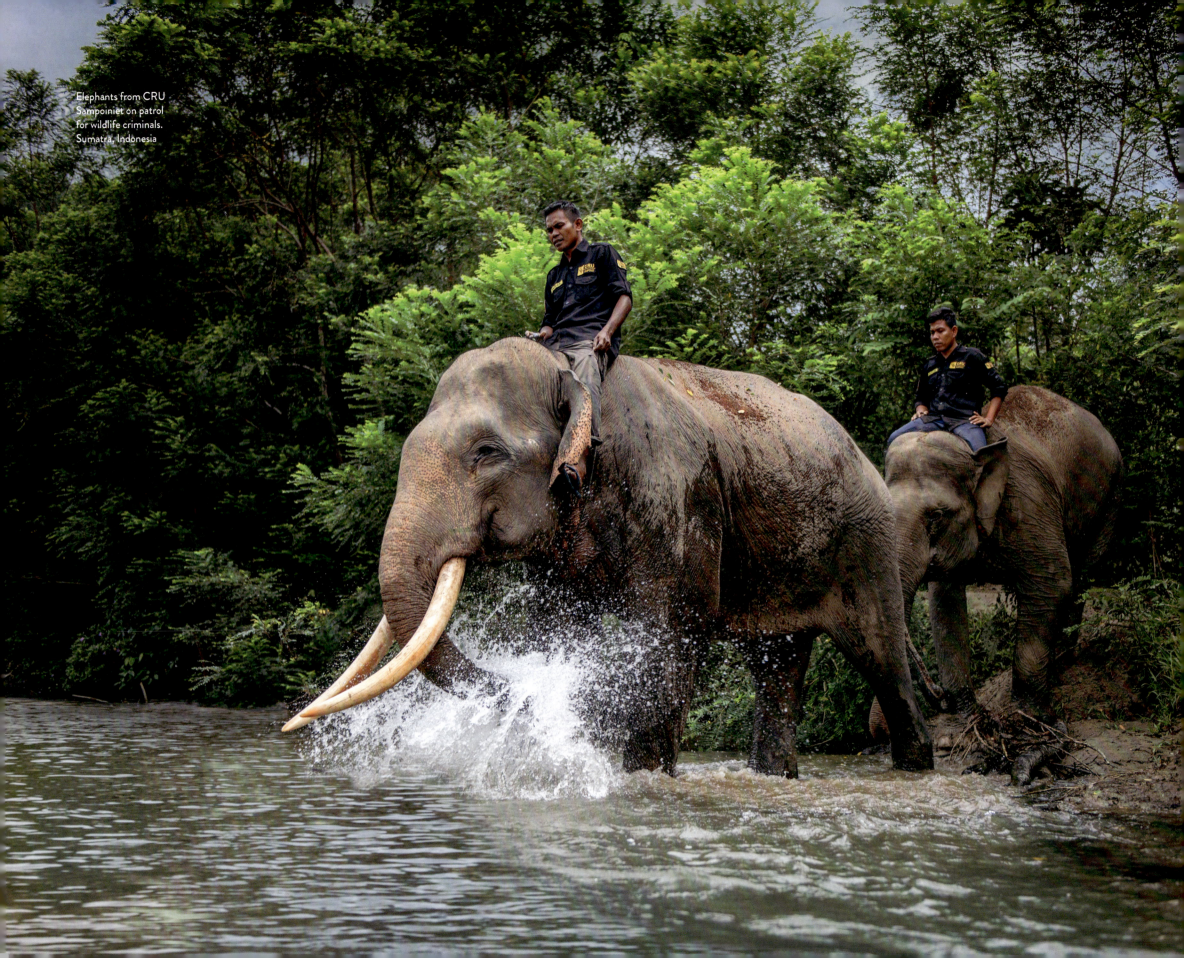

Elephants from CRU Sampoiniet on patrol for wildlife criminals. Sumatra, Indonesia

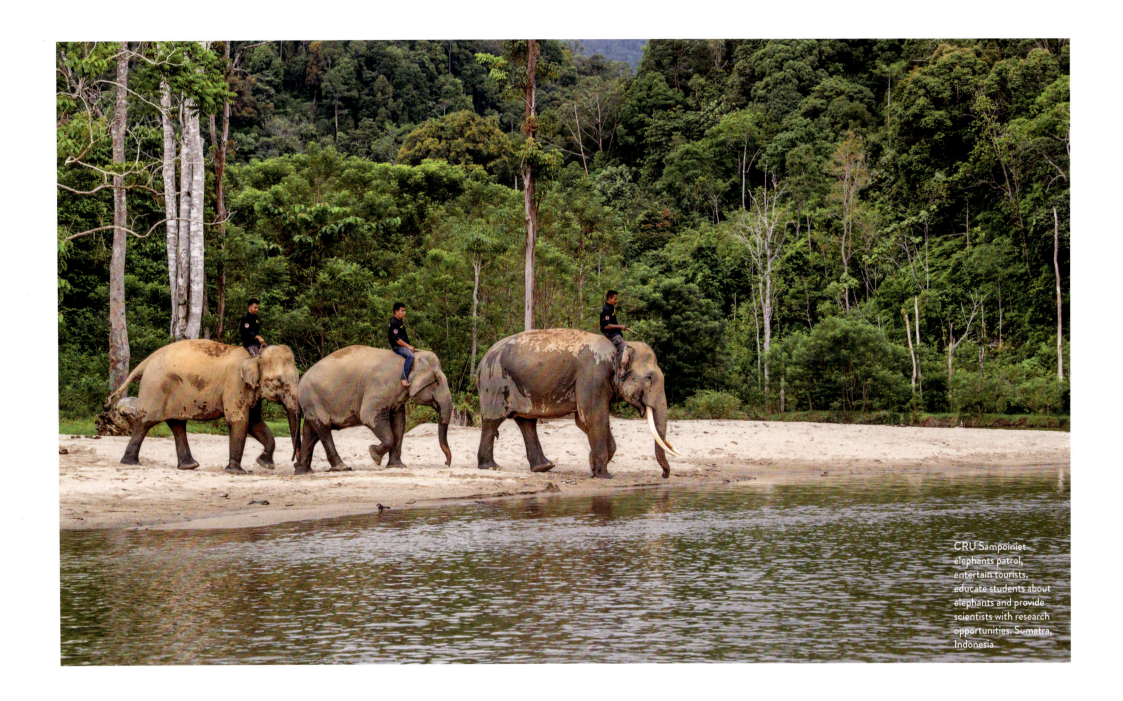

CRU Sampoiniet elephants patrol, entertain tourists, educate students about elephants and provide scientists with research opportunities. Sumatra, Indonesia

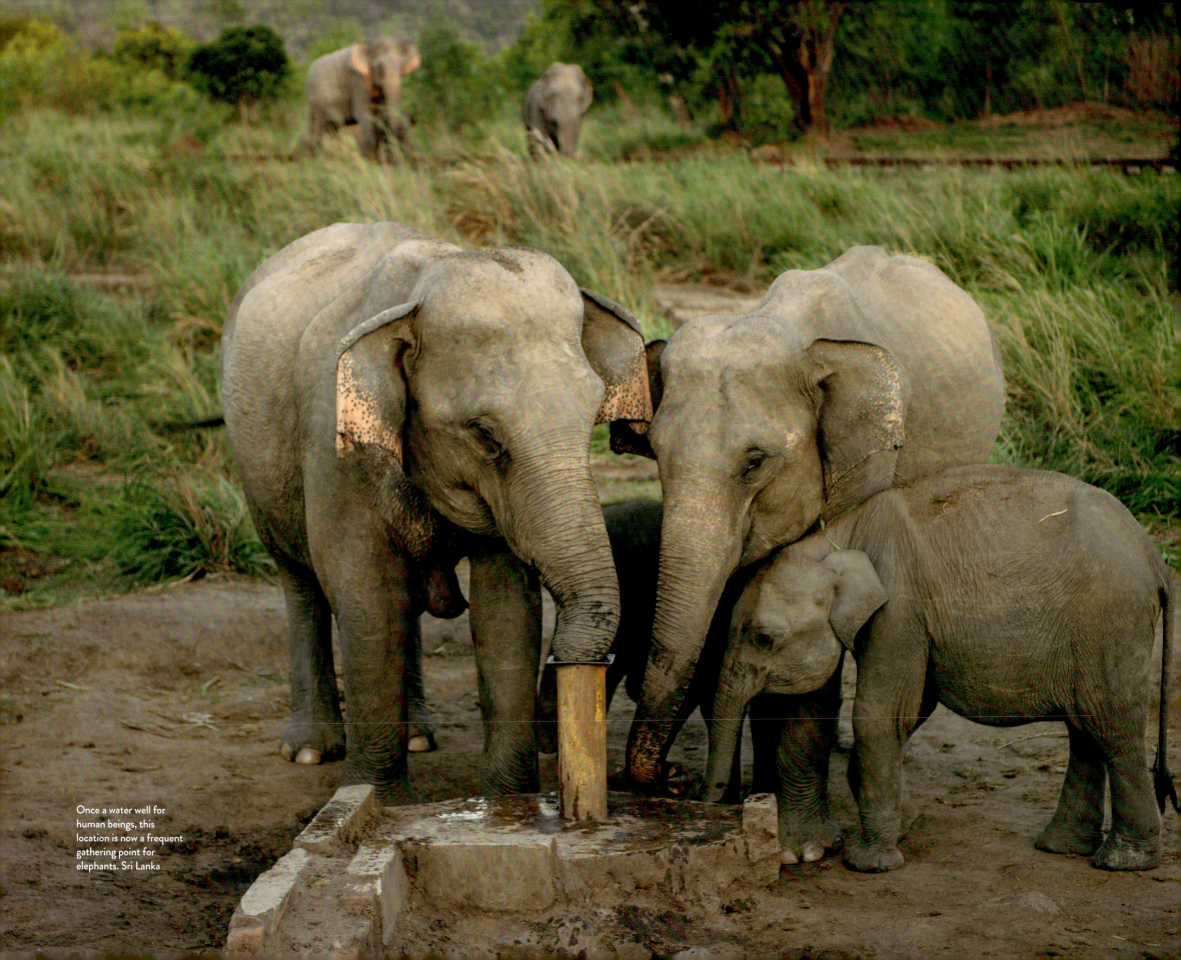

Once a water well for human beings, this location is now a frequent gathering point for elephants. Sri Lanka

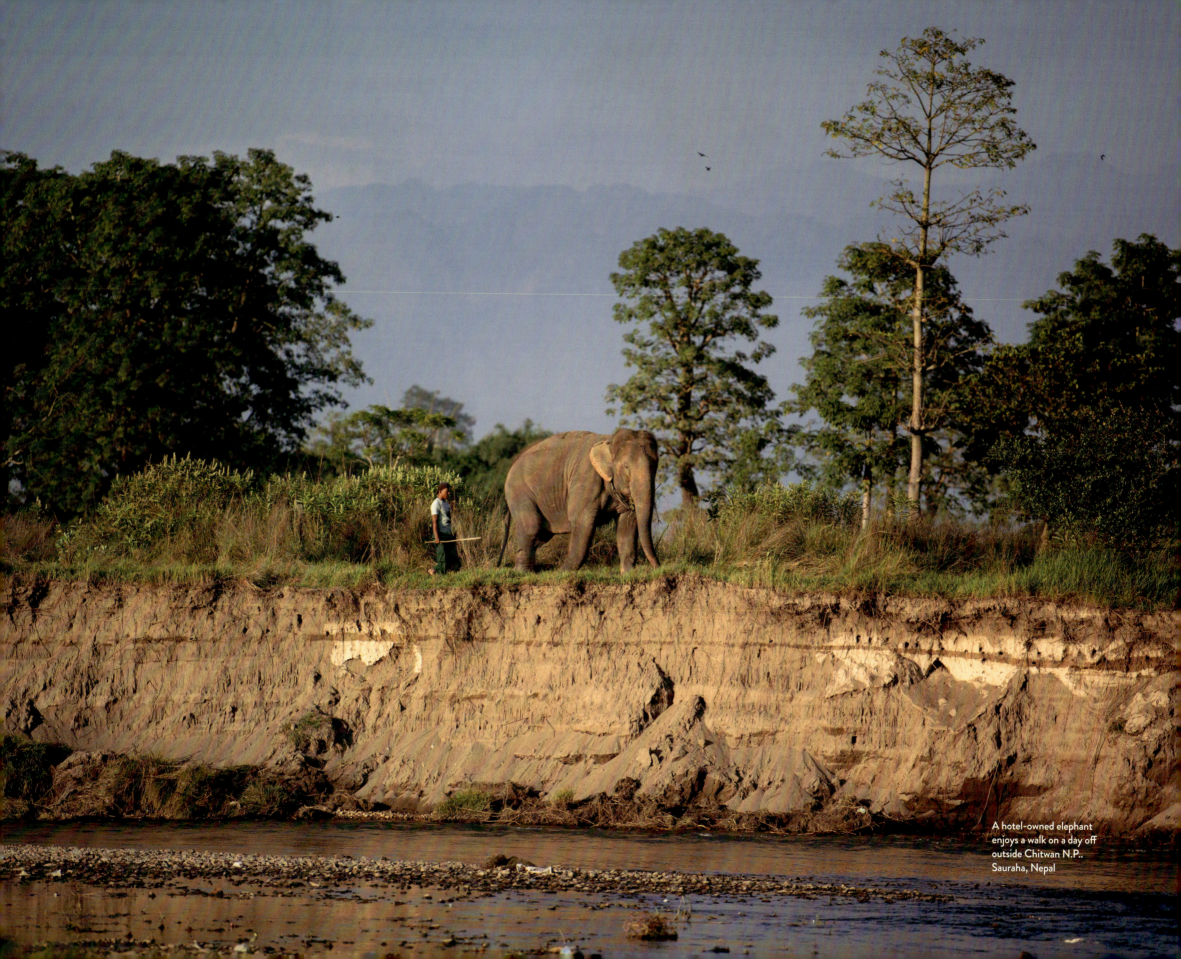

A hotel-owned elephant enjoys a walk on a day off outside Chitwan N.P., Sauraha, Nepal

This gentleman's family has kept elephants for generations. At the age of 12, he began caring for the family's elephants. At 18, he became an assistant on elephant catching trips. At 24, he started his career as a professional catcher. With his passing, the family tradition will end, as each of his five children want nothing to do with elephants. India

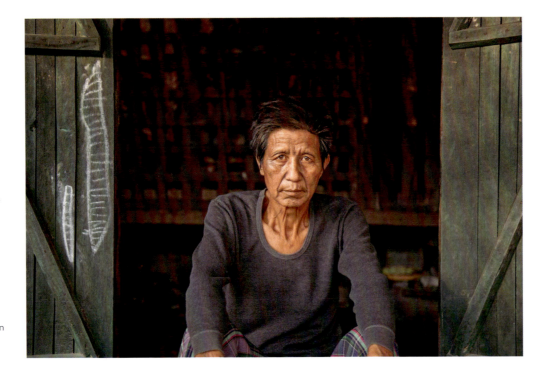

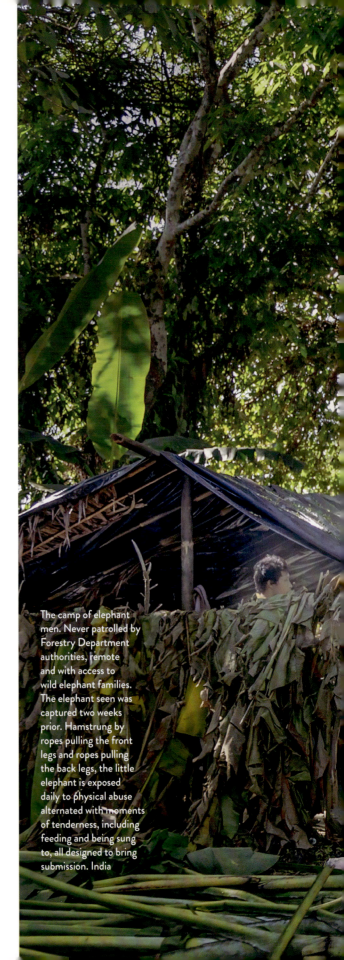

The camp of elephant men. Never patrolled by Forestry Department authorities, remote and with access to wild elephant families. The elephant seen was captured two weeks prior. Hamstrung by ropes pulling the front legs and ropes pulling the back legs, the little elephant is exposed daily to physical abuse alternated with moments of tenderness, including feeding and being sung to, all designed to bring submission. India

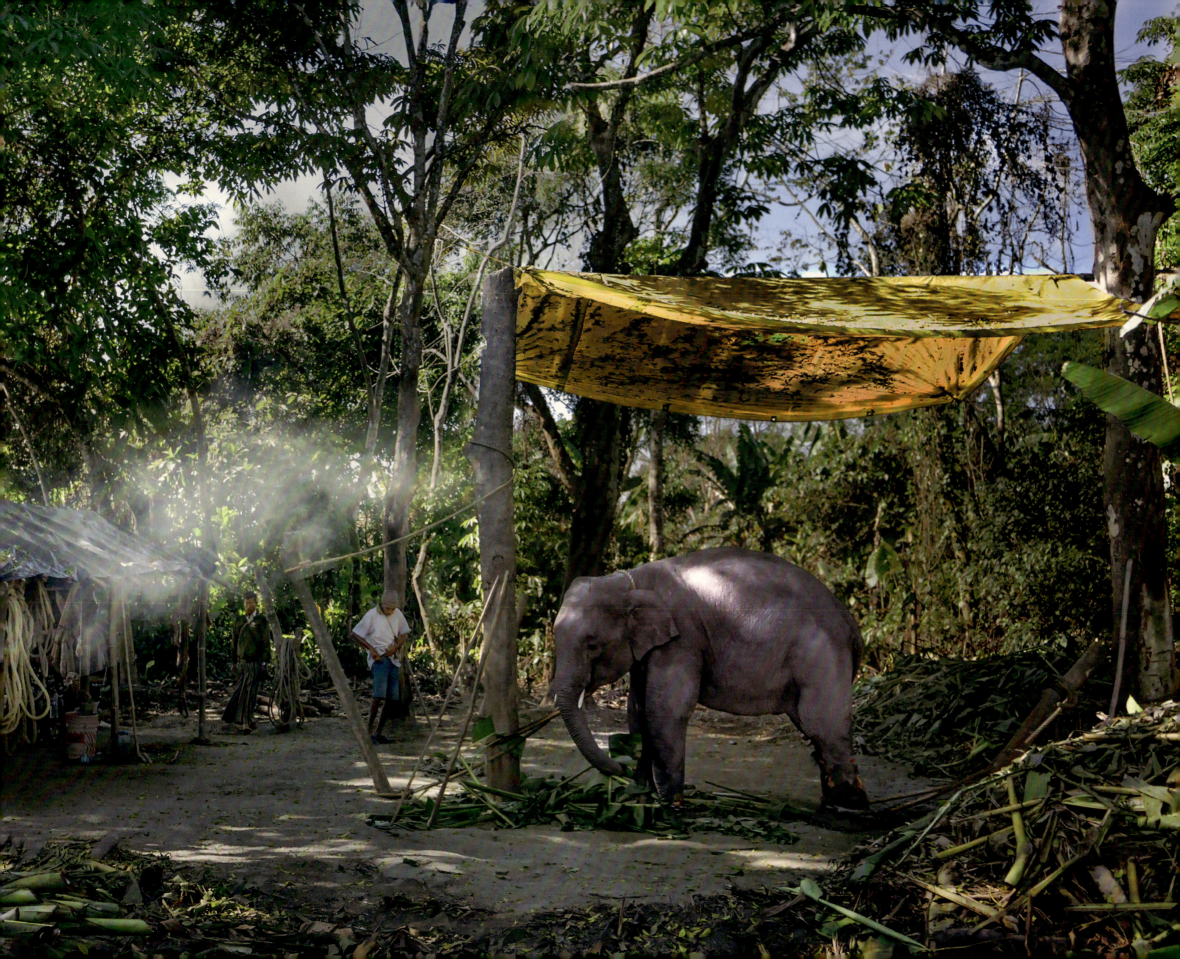

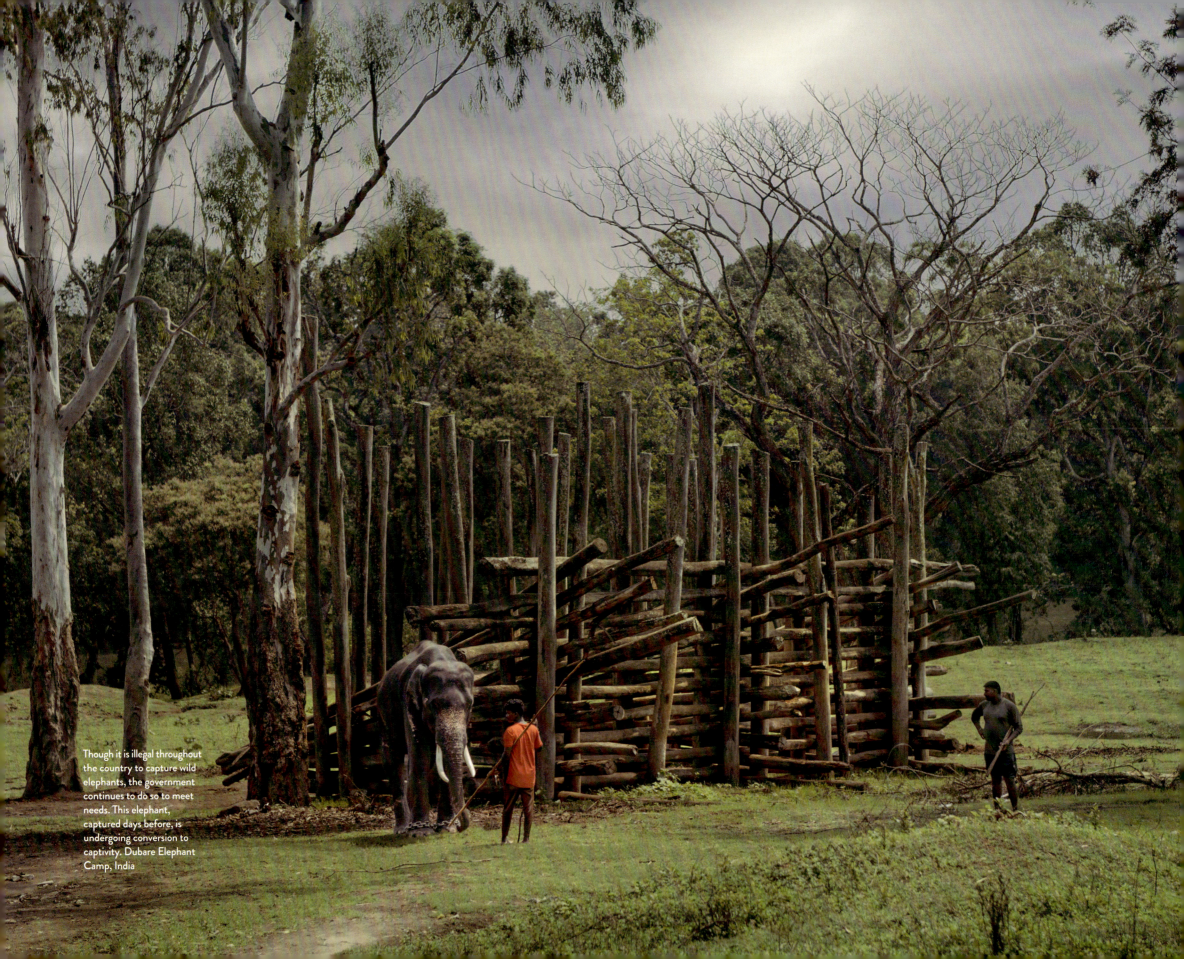

Though it is illegal throughout the country to capture wild elephants, the government continues to do so to meet needs. This elephant, captured days before, is undergoing conversion to captivity. Dubare Elephant Camp, India

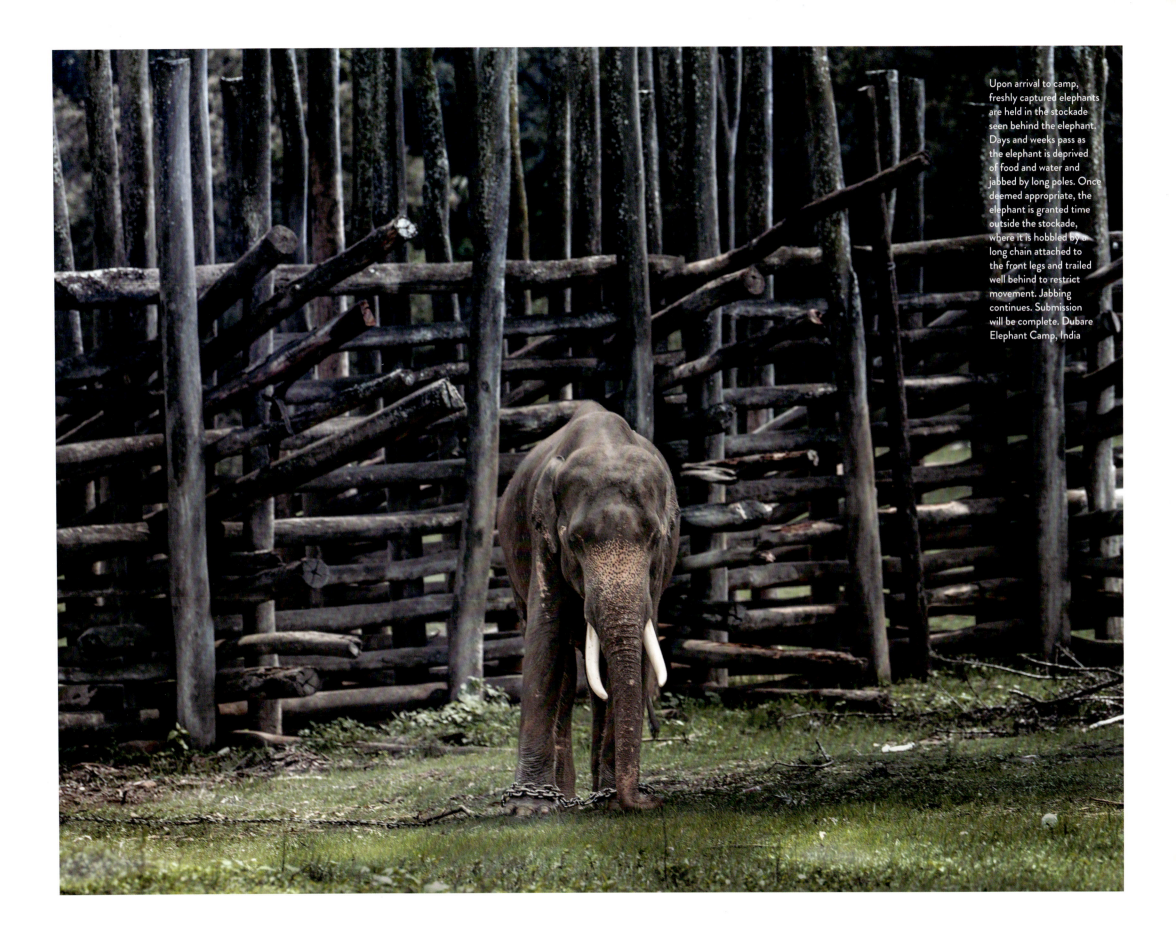

Upon arrival to camp, freshly captured elephants are held in the stockade seen behind the elephant. Days and weeks pass as the elephant is deprived of food and water and jabbed by long poles. Once deemed appropriate, the elephant is granted time outside the stockade, where it is hobbled by a long chain attached to the front legs and trailed well behind to restrict movement. Jabbing continues. Submission will be complete. Dubare Elephant Camp, India

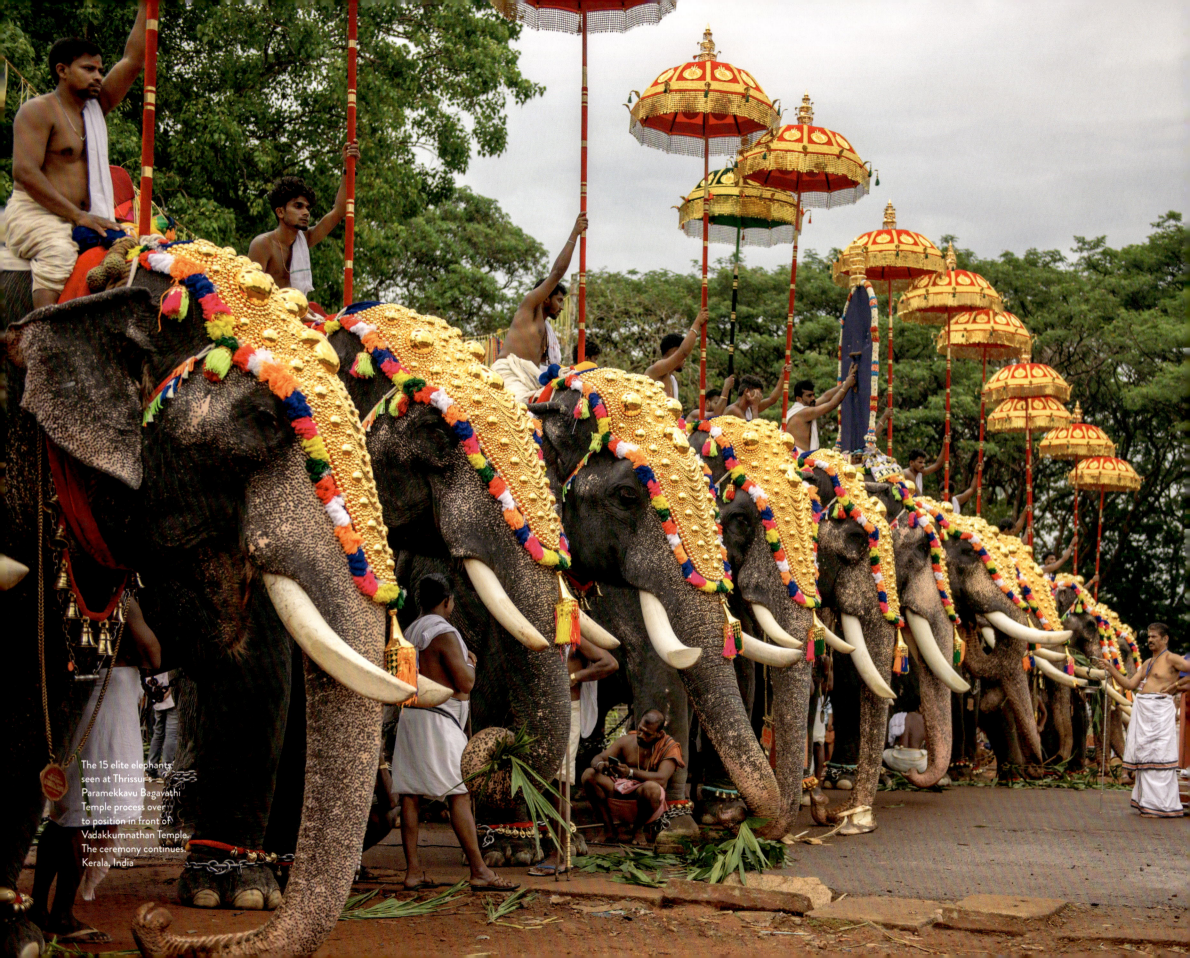

The 15 elite elephants seen at Thrissur's Paramekkavu Bagavathi Temple process over to position in front of Vadakkumnathan Temple. The ceremony continues. Kerala, India

TEMPLE ELEPHANT

This narrative was constructed by referencing *The Story of Asia's Elephants*, by Raman Sukumar, and by information obtained through various conversations between the photographer and author and Rajkumar Namboothiri, Temple Priest, Irinjadappilly Sree Krishna Temple, Kerala, India

Throughout the history of humans in Asia, the largest living thing has always been the elephant. Their impressive size, physical strength, confidence and courage have always been held in awe. As a result, elephants have appeared in Asia's mythology, folklore and religions since ancient times.

Evidence suggests that people worshipped an elephant-like god in early agricultural societies to protect them from elephant attacks on their crops, their shelters and their lives. In India, the fusion of a multitude of these beliefs and deities into Hinduism spread like wildfire. In the 4th century, India's rulers leveraged this phenomenon to unify the people, and it was during this period that the most popular of all deities appeared, Lord Ganesha.

In moments of spiritual curiosity, we humans entertain the idea of life without form, including the belief in an everlasting spirit. But deep down, we wonder, we sometimes doubt. We simply need something physical to relate to in our spirituality. The early Hindu wise men understood this. In Lord Ganesha, there emerged a masterpiece of symbolism. Lord Ganesha went on to represent a variety of fundamental human concerns. Among these are prosperity, wisdom, courage, purification of the soul and a peaceful life. So popular was he from the outset that as early Indian merchants spread across the Buddhist lands of Southeast Asia, devotees of Buddhism adopted him into their practices as well. Even the Muslims of Indonesia adopted him.

Seen through the eyes of roughly a billion followers of Hinduism, elephants are the living incarnation of Lord Ganesha. Seen through the eyes of over 520 million followers of Buddhism, elephants play a pivotal role in the life story of Lord Buddha. The first use of live elephants in either religious setting is uncertain. But in Hindu-dominated India and Buddhist-dominated Sri Lanka, once temples became the centres of worship in the 5th century, live, captive elephants began appearing on display.

Temple leaders had learned from watching royals when it came to employing elephants. They realized that the presence of elephants implies power and prestige, and that elephants attract people. When viewed in business terms, there are those temples that can't afford any elephants at all for their functions, and there are those that can afford dozens and dozens. While the wealthiest of temples own and maintain a stable of elephants

> "We admire elephants in part because they demonstrate what we consider the finest human traits: empathy, self-awareness, and social intelligence. But the way we treat them puts on display the very worst of human behaviour."
>
> – **GRAYDON CARTER**, Acclaimed Canadian Journalist, Writer for *Time* Magazine, *Life* Magazine, Editor of *Vanity Fair*.

outright, smaller temples, as able, will rent elephants from private owners in the number they can afford.

During temple festivals and other ceremonial events, processions are a highlight of the gathering. Elephants patiently march in measured fashion with participants immediately in front of and behind them while carrying the idols of deities. Depending on the size of a given festival or ceremony, it is common for the procession to include the deafening sounds of cymbals, trumpets and drums. In addition to tolerating this, elephants must also endure being surrounded by crowds of hundreds or thousands of oftentimes fanatic devotees.

When not marching in a procession, elephants are generally stationed about a temple's grounds, required to stand in one place for hours, commonly shackled and chained, tasked with bringing good luck, symbolizing power, soliciting donations, appearing in selfies, and occasionally granting blessings with the tap of a trunk.

For those elephants hired from private owners for various occasions, their appearance commonly involves shipment in a truck from their stable to the temple and back, trips that can last for hours, requiring the elephant to stand confined. During festival season, owners will book out their elephants to as many temples as possible to maximize their profits. This means that the rented elephants are essentially living on the road, travelling from festival to festival, commonly under a blazing sun in stifling heat, often living on a scant supply of food and water.

The cultural heritage of a nation is the glue that holds its humanity together. It does this by shaping the way people think and interact with one another. It provides a link to our ancestors and in doing so gives us a sense of belonging and stability. With so much invested in our heritage, we get attached to it, and even blinded by it. Such is the case with the ongoing exploitation of elephants for religious functions throughout Asia.

Dyed-in-the-wool devotees, festival organizers and temple leaders alike cannot imagine temple events without elephants. The Kerala Elephant Owners Federation of India states, "Those who assert that the use of elephants should be discontinued are intent on destroying the essence of temples, festivals, and rituals." But despite the hardened stance of traditionalists, a wave of enlightenment on behalf of the welfare of elephants is slowly but surely growing.

In the state of Kerala, India, at Irinjadappilly Sree Krishna Temple, the first robotic elephant was inaugurated in 2023. On that day, the temple brought an end to its tradition of employing live elephants in rituals. Other temples are also embracing this revolution. And inside the little factory where the robotic elephants are manufactured by hand, the energetic crew chips away at the growing waiting list for the new generation of elephants, a type of elephant that will finally end unjustifiable abuse and cultivate the human spirit, which is what we claim to be about in the first place.

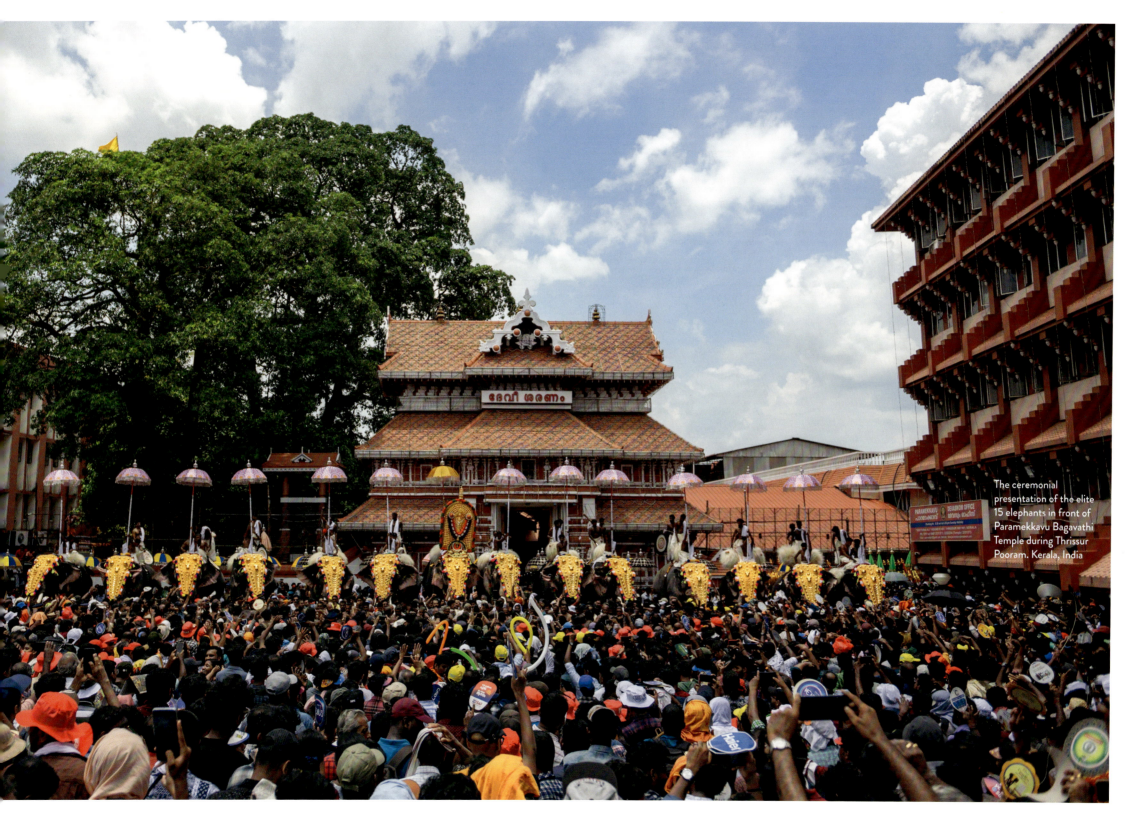

The ceremonial presentation of the elite 15 elephants in front of Paramekkavu Bagavathi Temple during Thrissur Pooram. Kerala, India

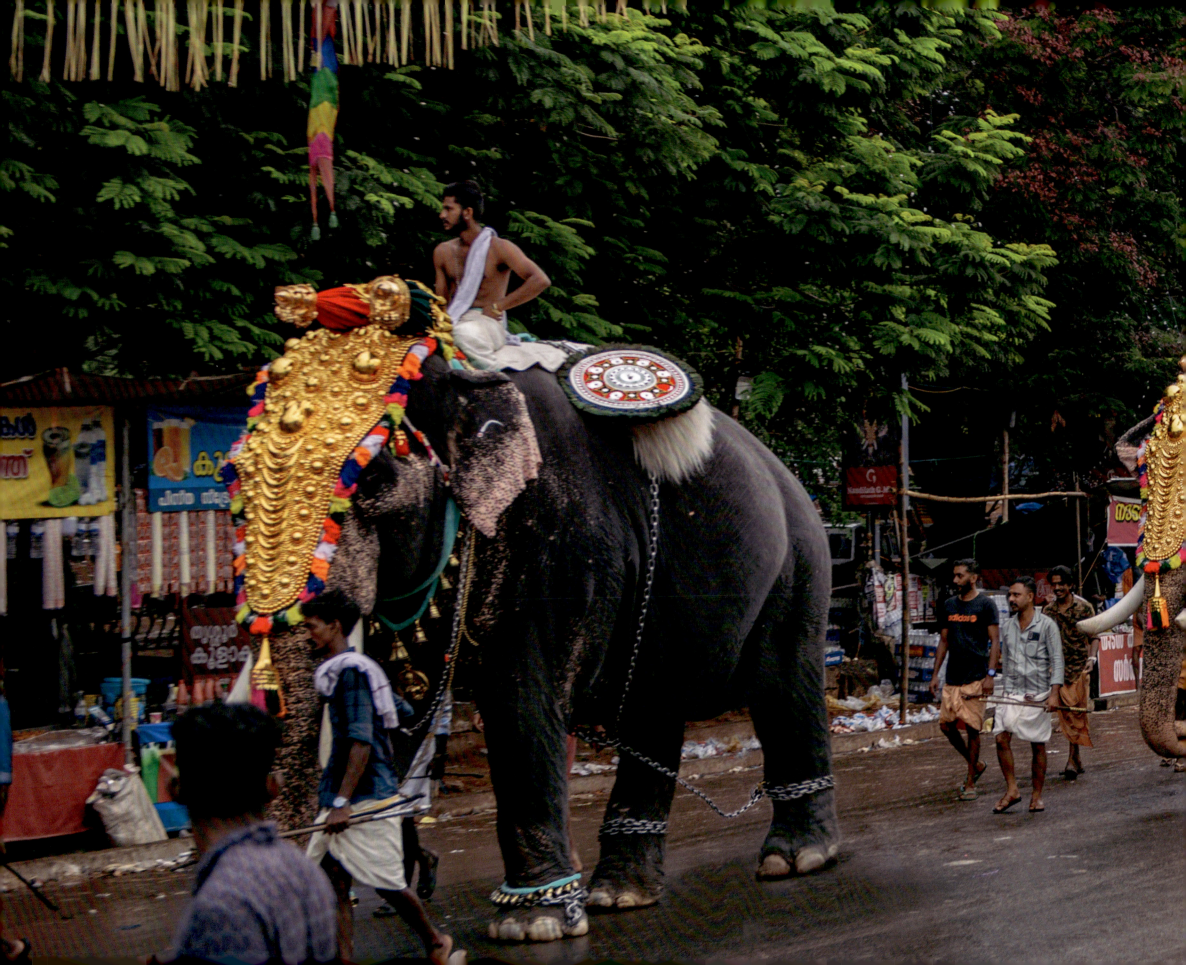

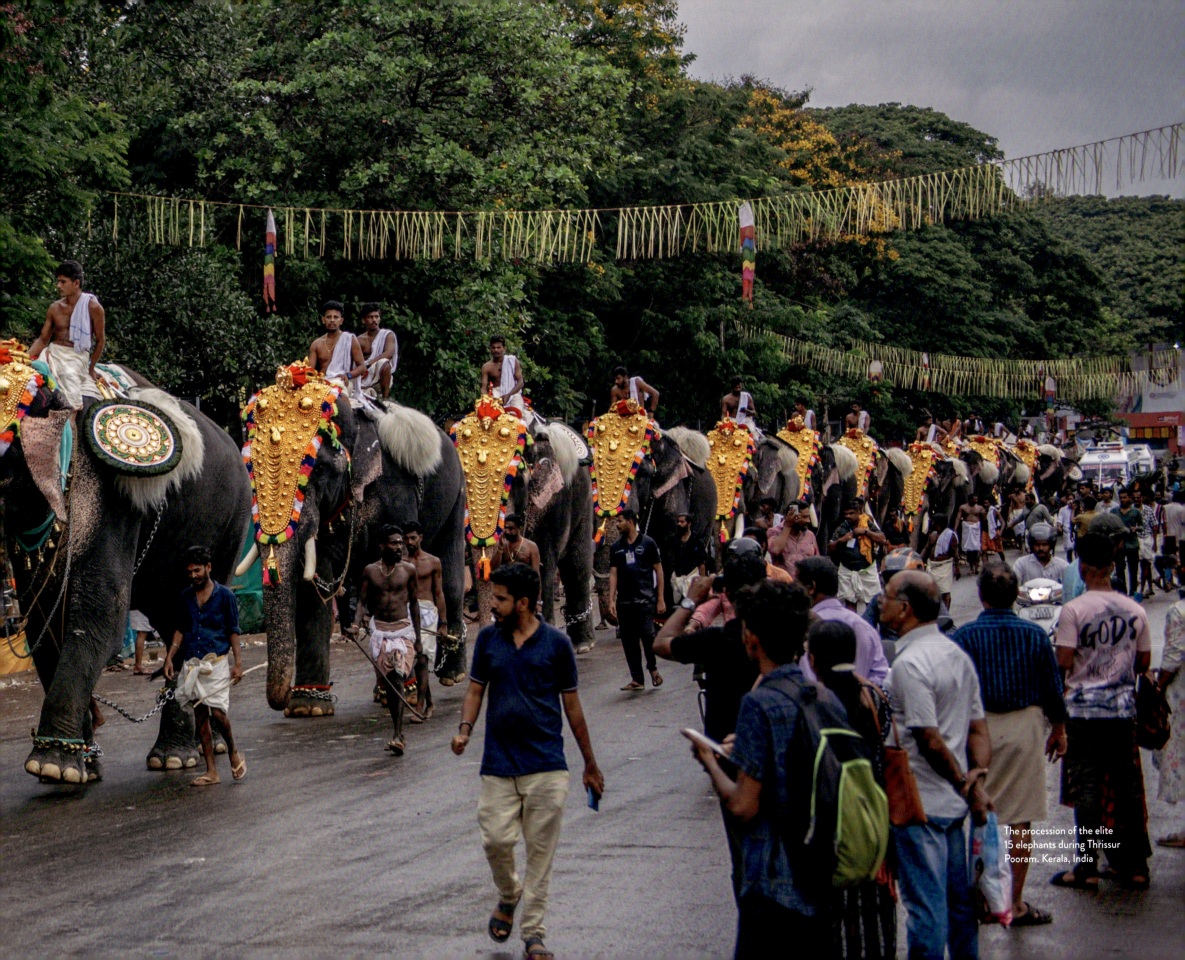
The procession of the elite 15 elephants during Thrissur Pooram. Kerala, India

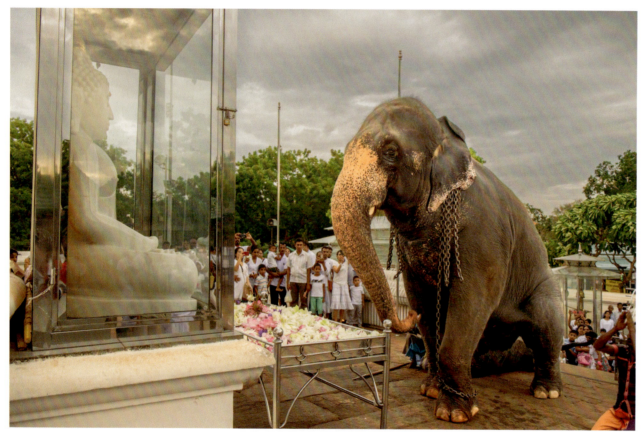

Following a 100-yard procession, this elephant places a lotus blossom before a likeness of the Lord Buddha at a regional temple. Sri Lanka

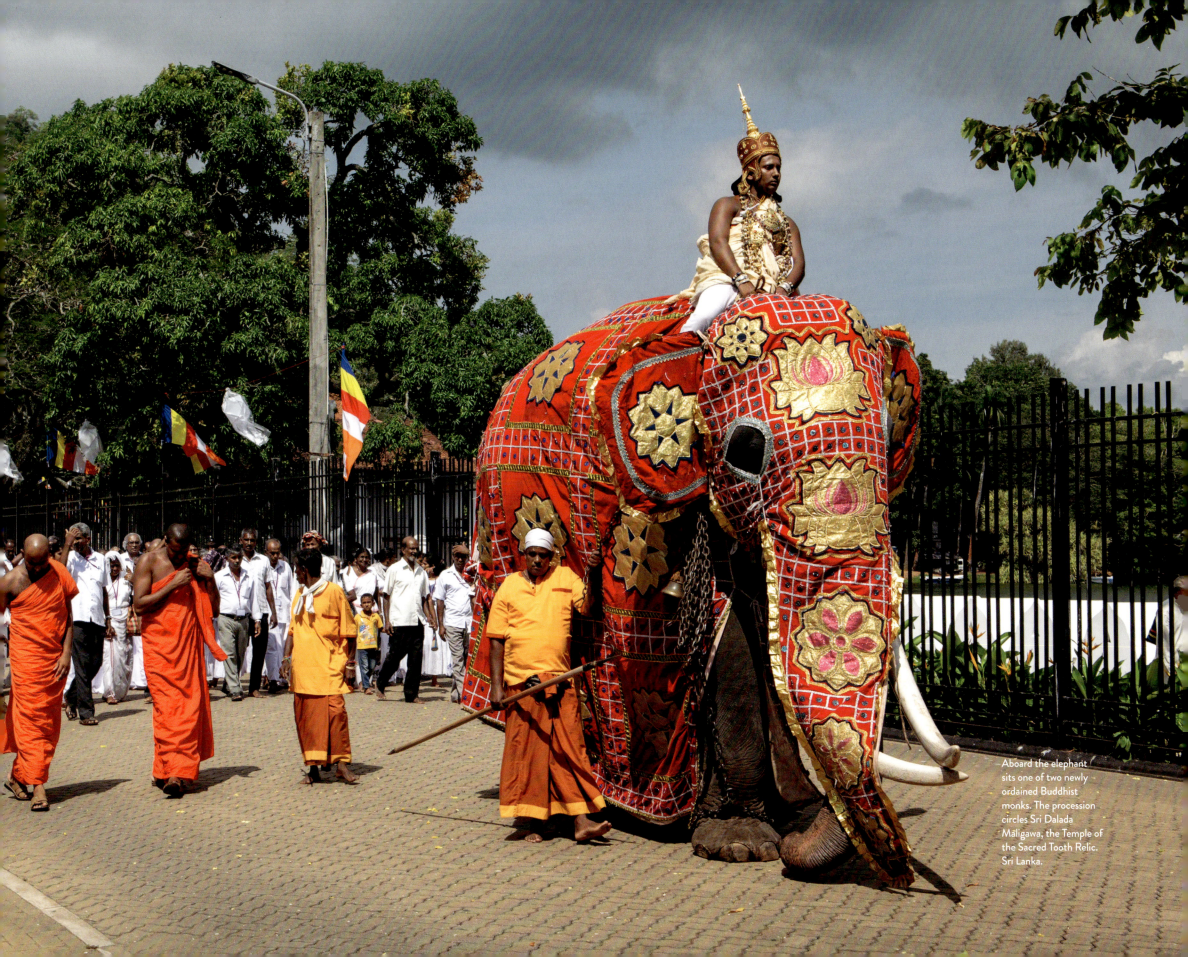

Aboard the elephant sits one of two newly ordained Buddhist monks. The procession circles Sri Dalada Māligawa, the Temple of the Sacred Tooth Relic. Sri Lanka.

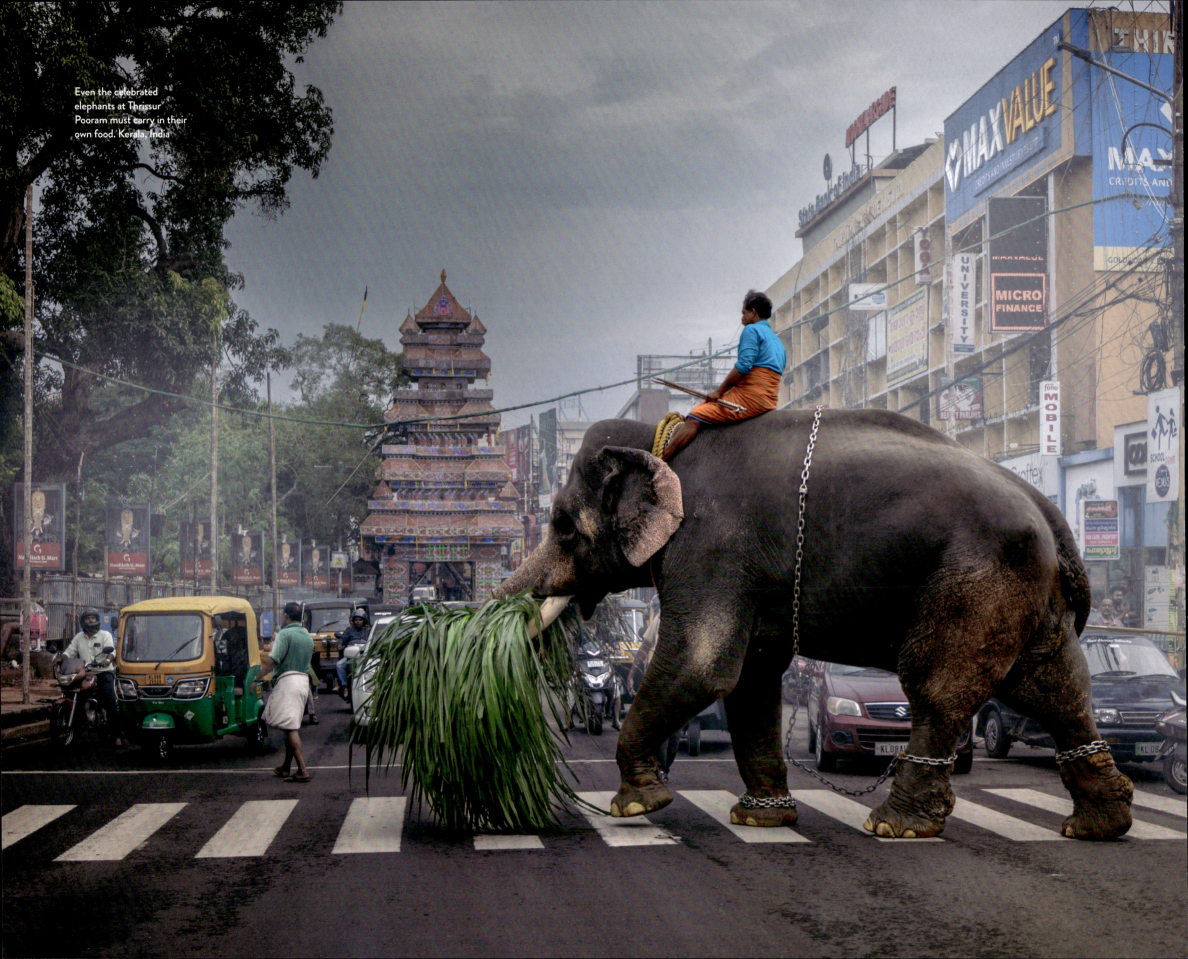

Even the celebrated elephants at Thrissur Pooram must carry in their own food. Kerala, India

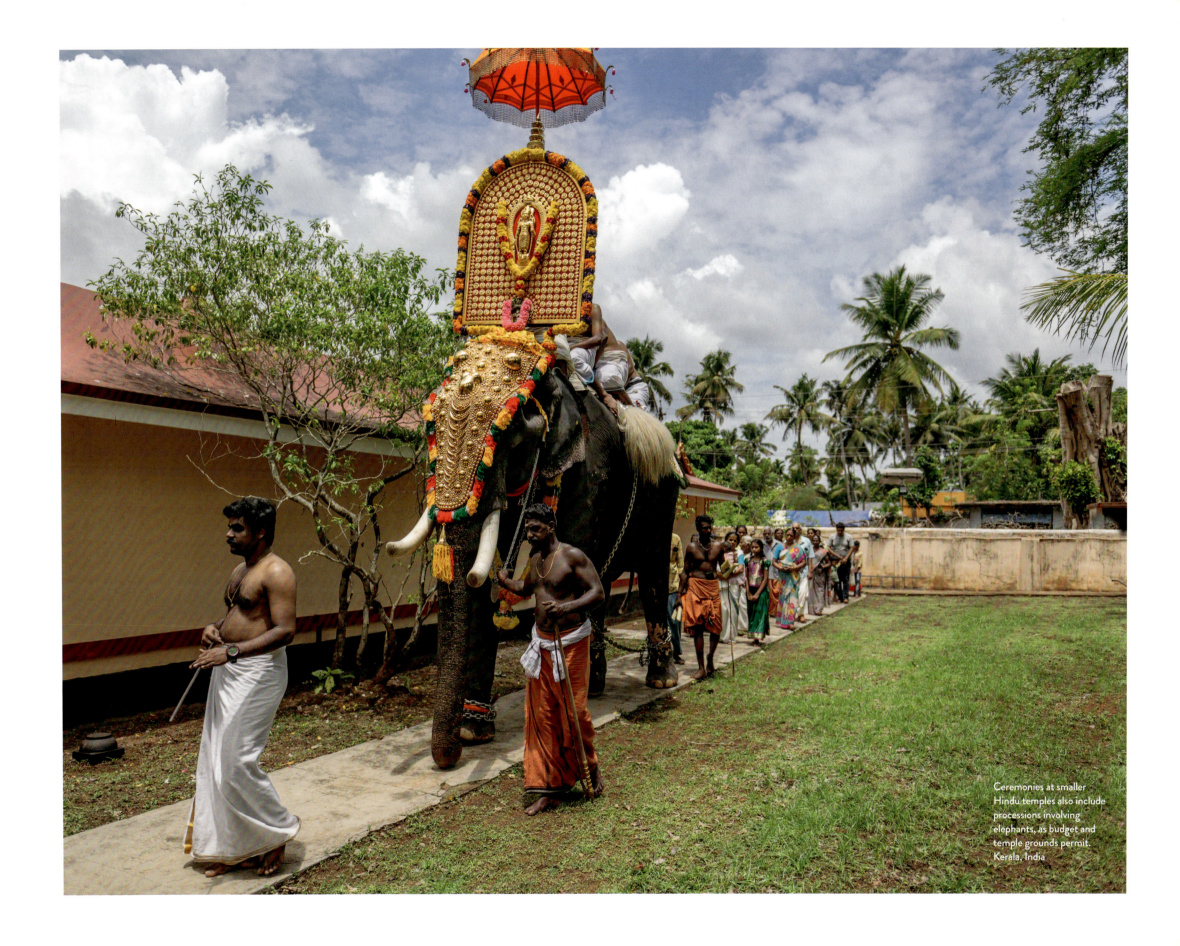

Ceremonies at smaller Hindu temples also include processions involving elephants, as budget and temple grounds permit. Kerala, India

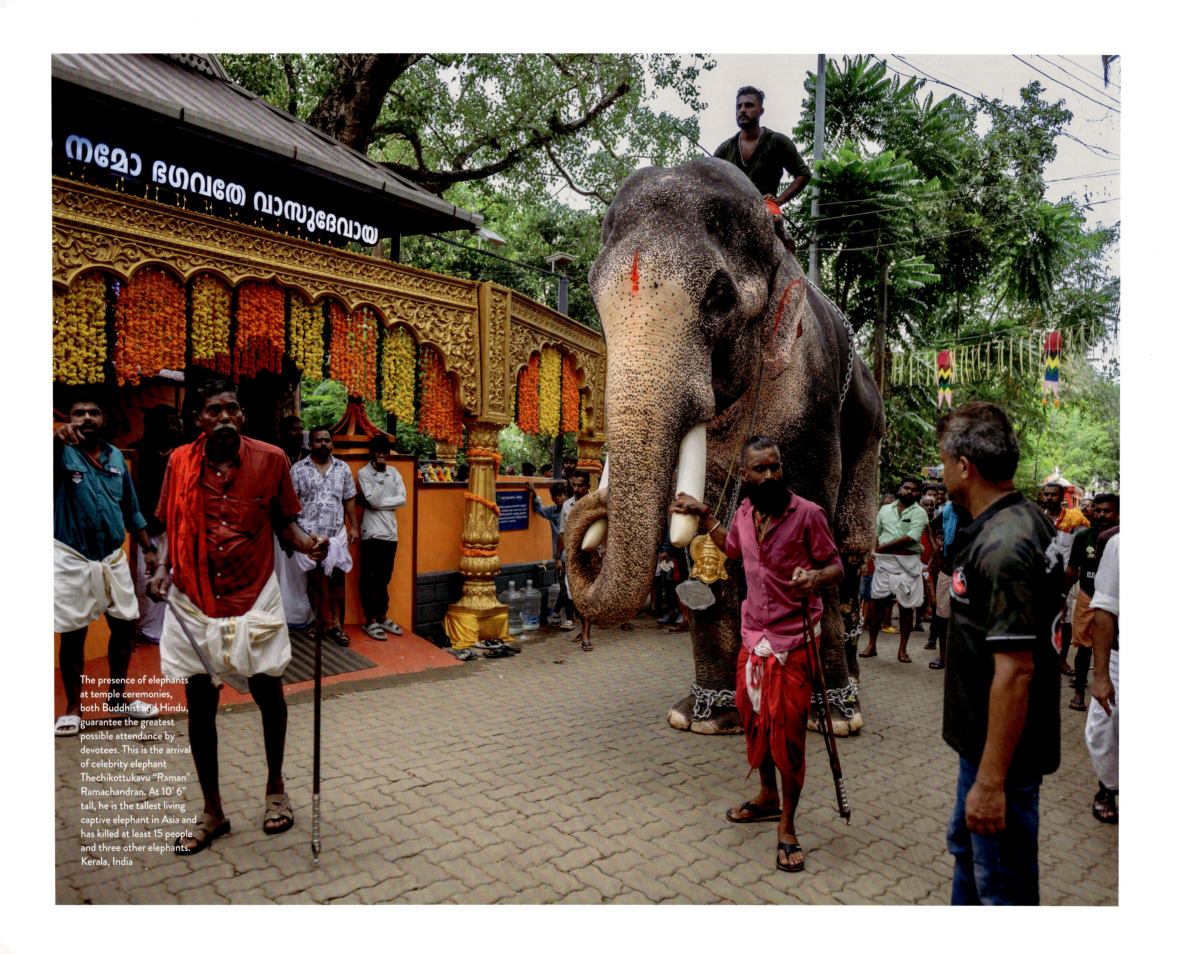

The presence of elephants at temple ceremonies, both Buddhist and Hindu, guarantee the greatest possible attendance by devotees. This is the arrival of celebrity elephant Thechikottukavu "Raman" Ramachandran. At 10' 6" tall, he is the tallest living captive elephant in Asia and has killed at least 15 people and three other elephants. Kerala, India

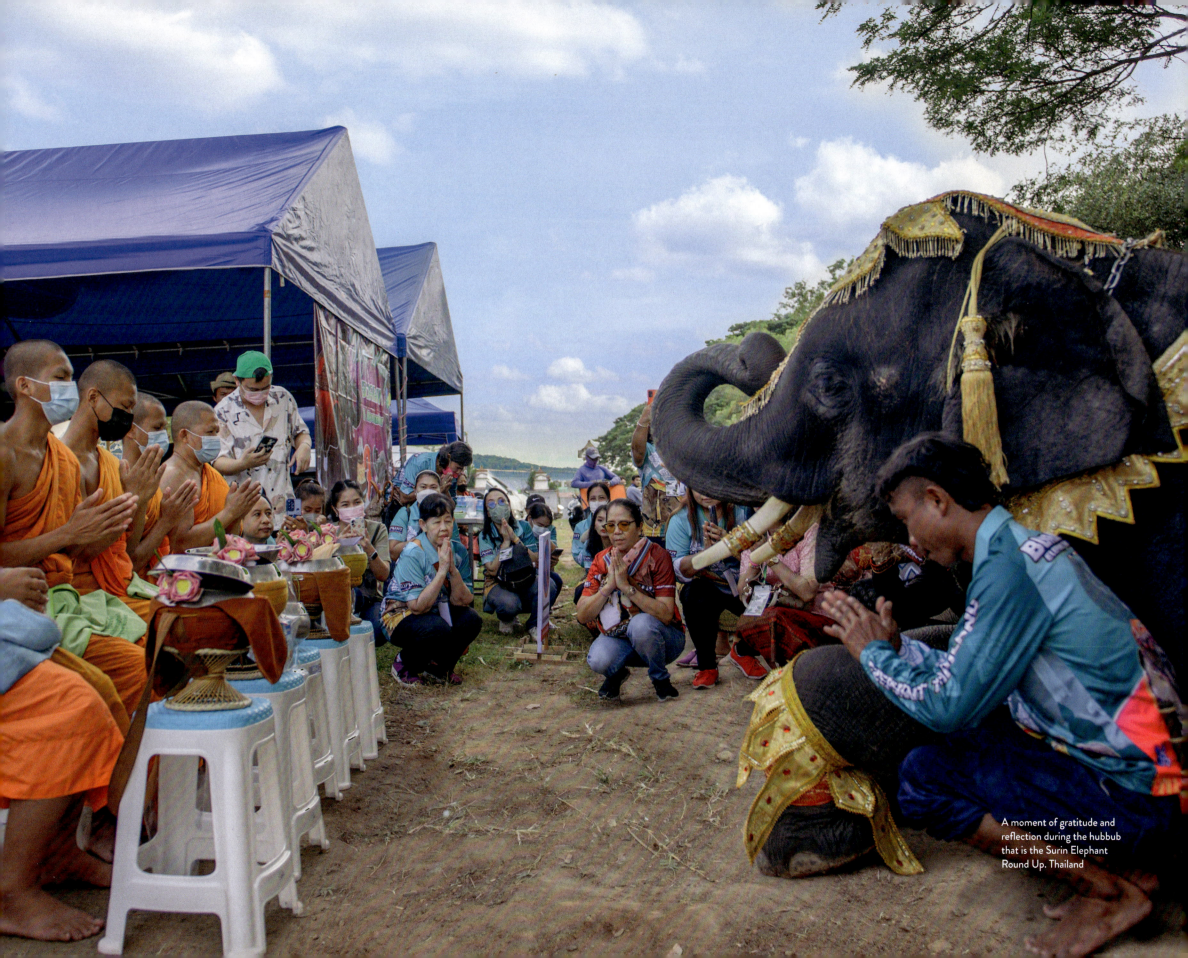

A moment of gratitude and reflection during the hubbub that is the Surin Elephant Round Up. Thailand

MALIGAWA RAJA
TEMPLE ELEPHANT

Ceremonies and festivals are a large part of the social fabric of Sri Lanka. The most significant of the gatherings last up to two weeks and are often tied to events like the full moon, the anniversary of the arrival of Buddhism, and the anniversary of a visit by Lord Buddha to a certain location. These celebrations, known as peraheras, always include elephants, as their presence is considered profound and associated with good fortune.

In Buddhism, relics, including the remains of the Buddha, are held in the highest regard. There is no relic in Sri Lanka valued more highly than the Sacred Tooth, which is kept at the temple Sri Dalada Maligawa in Kandy. Consequently, the annual perahera held there is the most celebrated of all.

From the early days, tenants on land belonging to the king of Kandy were required to take part in the perahera's nightly processions by drumming, dancing or blowing horns. Those who owned elephants were expected to bring them, with as many as 150 joining the march. Among the many elephants who participate, the highest regard is given to the tusker who carries the relics. And among the select number of elephants who have carried the relics over the years, one is held in the highest respect.

That elephant was born in the jungle in the early 20th century. In 1925, a local governor, bent on reaching greater standing in Buddhism, had this young elephant and another captured with the intent of gifting them to Sri Dalada Maligawa. Little Maligawa Raja and Skanda would one day carry the sacred relics during the perahera.

Upon arrival at the governor's compound, the two youngsters bonded immediately with the governor's prized adult female elephant. For the next 12 years, they enjoyed love and care from the adult female as they received careful training in preparation for their future lives of service to Lord Buddha.

In 1937, Raja and Skanda were gifted to Sri Dalada Maligawa. A great crowd gathered for the event's customary procession of dancers and musicians, who accompanied the two elephants, cloaked in white silk, to the temple.

For their first few peraheras, the two elephants simply marched among the many other elephants in the processions. As they proved their skills and dedication, their standing grew until eventually both were promoted to flank Dhanthaloota, the main tusker carrying the relics.

In 1948, Dhanthaloota was retired. A replacement was needed immediately. The decision boiled down to Raja or Skanda. Owing to Raja's supreme

This narrative was constructed from various sources, including "Selection of Tuskers to Carry the Relic Casket" by Asha Senevirathne, Sunday Observer, 10 August 2008.

physical characteristics and obedient nature, he was chosen as the new chief elephant, with Skanda continuing in the flank position and occasionally carrying the casket of relics in lesser peraheras.

For each night's procession, Raja wore a red velvet dress with a fringe of gold that shimmered with lights and sequins. The golden casket containing the relics of the Buddha sat squarely on his back. His tusks were decorated in gold and his feet decorated with silver anklets. In no time, crowds of thousands were coming to adore him.

Each procession began with Raja standing on the temple steps, assuming a bowed position while the crowd chanted. As he made his way forward on the route, a white cloth was laid on the ground in front of him. At times when the cloth was delayed in reaching its position, Raja would pause with dignity, sometimes even assisting the laying with his trunk. Through it all, he moved with amazing grace and composure, especially considering the distractions of crowds, drumming and whip-cracking. And as each procession concluded back at the temple, Raja approached the structure, and crouched down as a sign of respect. This he is reported to have done without any prompting whatsoever.

Despite all the uncertainties, all the chaotic human distractions, Raja demonstrated the utmost composure, night after night, year after year, for decades. For one evening's perahera in 1986, he had been dressed and loaded with the golden casket when his mahout became seriously ill and was transported to the hospital. The other mahouts refused to fill in. A solution was needed immediately as the anxious crowd waited with great anticipation. Raja's supervisor, who had been with him for 12 years, made a decision. In spite of all the risks, Raja carried the golden relic casket that night alone, without a mahout to control and assure him. His conduct was unprecedented. For three and a half hours and of his own determination, Raja marched and paused, marched and paused, amid all the distractions. His legend hit new heights.

In 1988, just a few months before the perahera, Raja became seriously ill. Teams of doctors and assistants stayed with him 24 hours a day. Thousands of concerned Sri Lankans from all over the country gathered at the temple, bringing gifts of fruit and flowers. Then, he collapsed, falling to the ground. It appeared the end was near.

In a desperate, last-ditch effort, a massive crane was brought in, and he was lifted to his feet. With hearts swelling, it was proclaimed with great fanfare that Raja had recovered. In all his glory, through still further exhibition of his indomitable spirit, Raja took part in two more peraheras. But Raja was not well.

He was finally relocated to his supervisor's gardens, where a special pool was built for therapeutic baths. As the next perahera celebrating the Sacred Tooth relic was fast approaching, a replacement for Raja was selected and brought to the supervisor's residence so the two elephants could meet. The very next morning, following a healthy breakfast, the legendary Maligawa Raja passed away. It was clear that the great elephant felt assurance that his important responsibilities would be taken care of and the time had come to let this world go.

Thousands of people swarmed the supervisor's home to show their admiration. Following tradition, Raja lay there, on a bed of leaves, decorated appropriately, until a simple ceremony paid him his last respects. The Sri Lankan government proclaimed a national day of mourning. The great elephant Raja had passed away on 16 July 1988 at age 75 from heart failure. He was mourned across the world by millions.

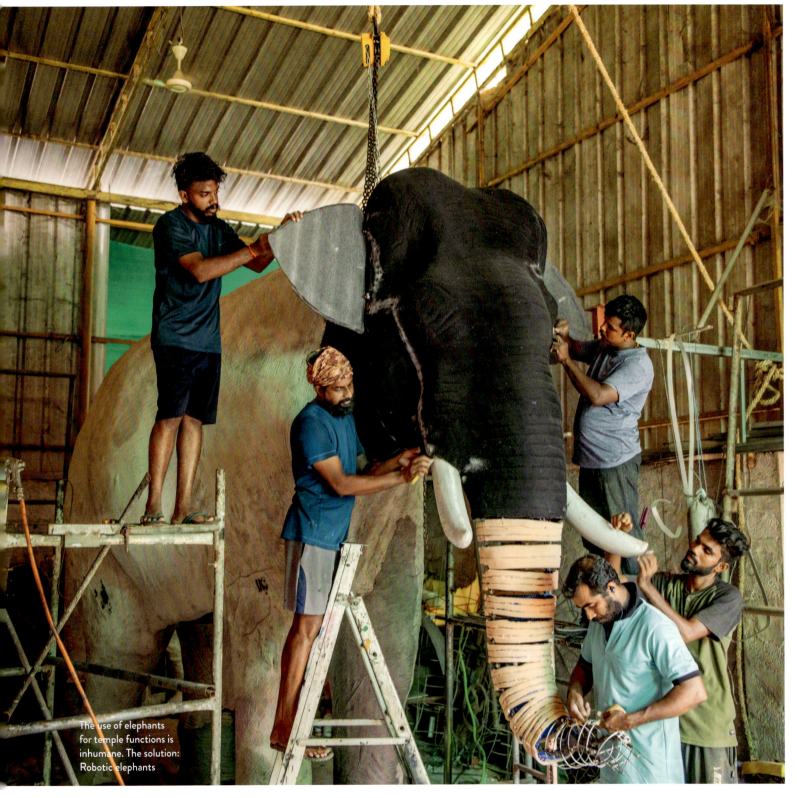

The use of elephants for temple functions is inhumane. The solution: Robotic elephants

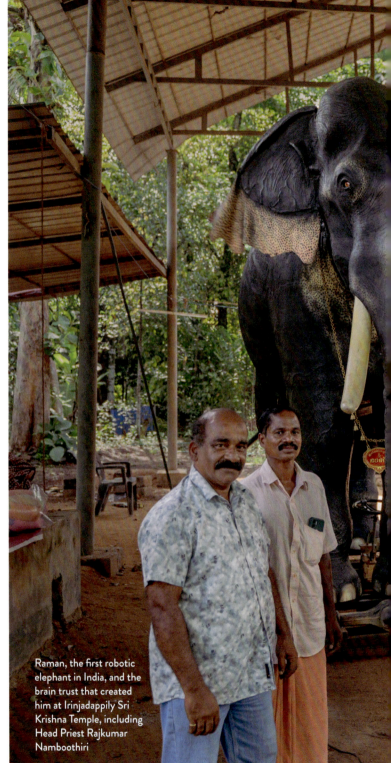

Raman, the first robotic elephant in India, and the brain trust that created him at Irinjadappily Sri Krishna Temple, including Head Priest Rajkumar Namboothiri

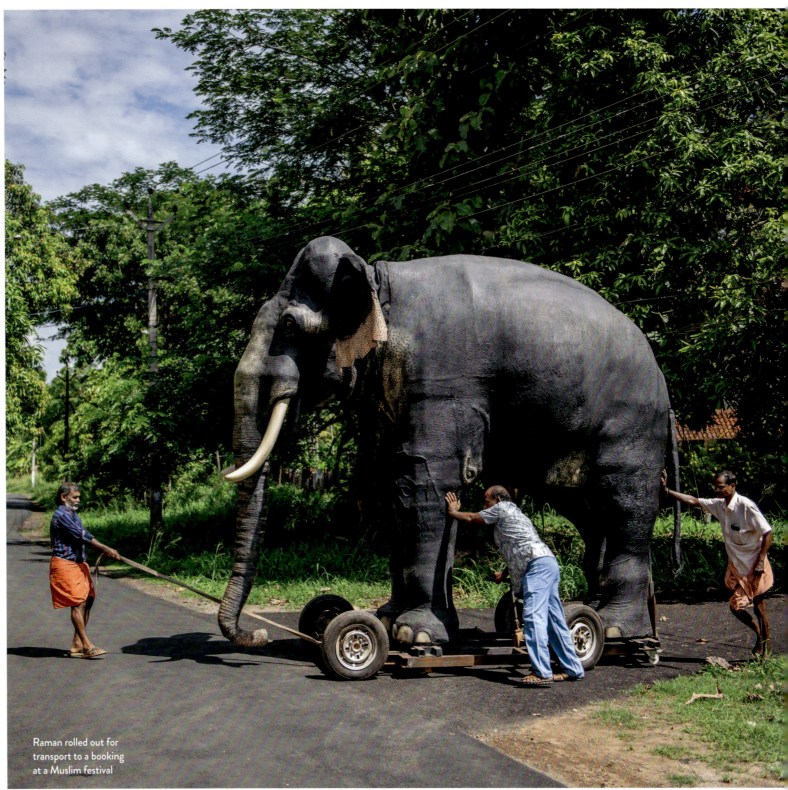

Raman rolled out for transport to a booking at a Muslim festival

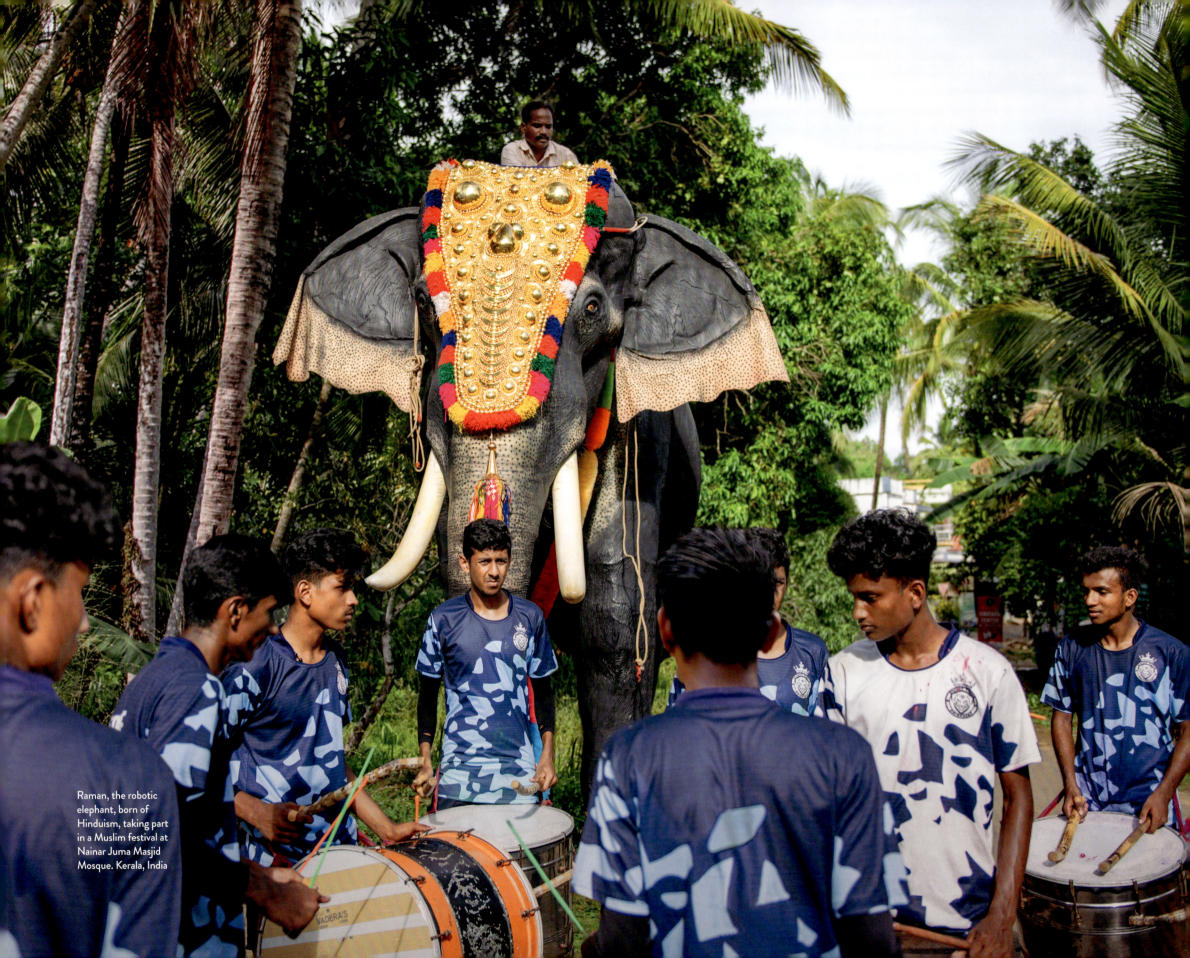
Raman, the robotic elephant, born of Hinduism, taking part in a Muslim festival at Nainar Juma Masjid Mosque. Kerala, India

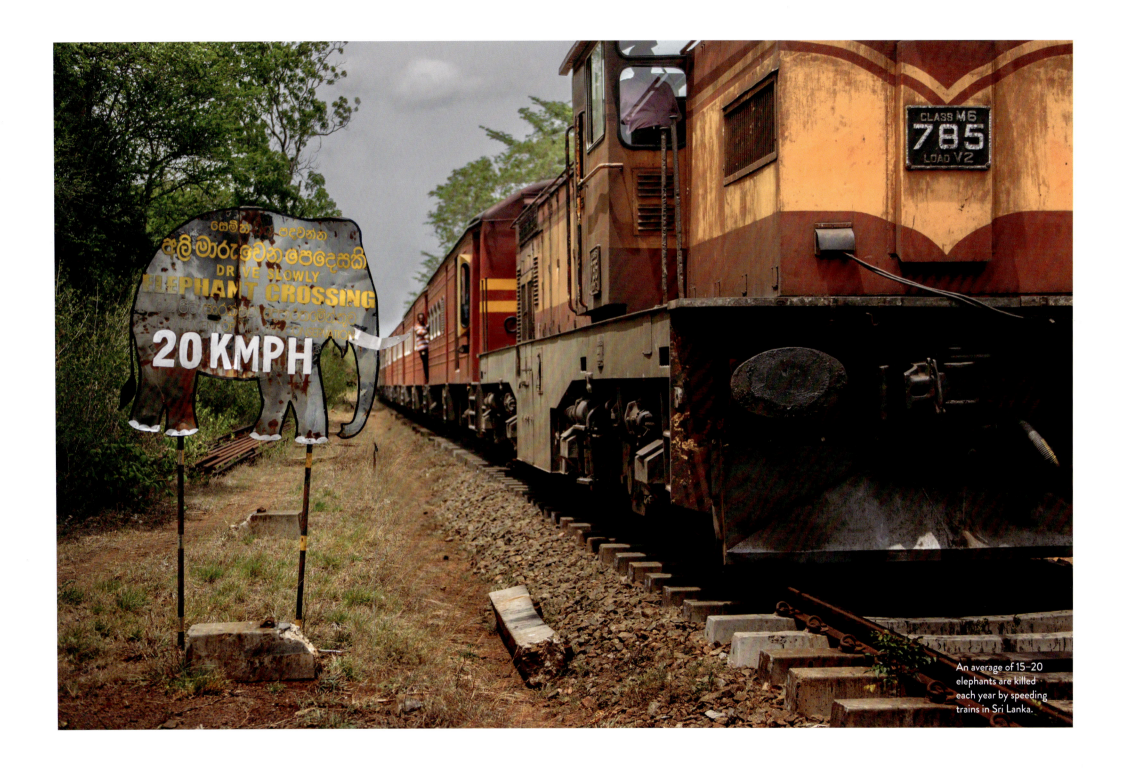

An average of 15–20 elephants are killed each year by speeding trains in Sri Lanka.

It is reported that 200 captive elephants live at Ban Ta Klang Elephant Village, a government-planned community intended to preserve the region's rich elephant heritage. Thailand

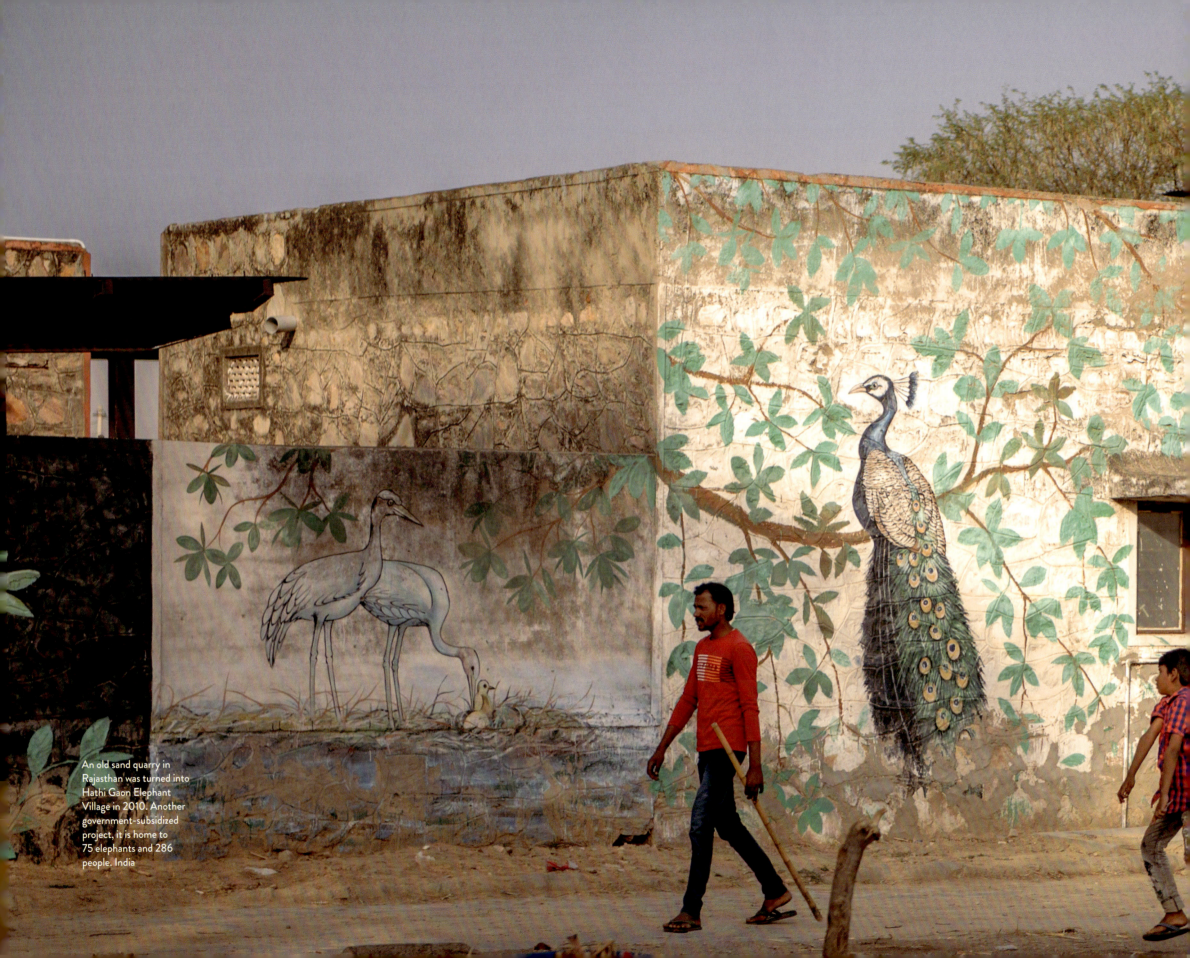

An old sand quarry in Rajasthan was turned into Hathi Gaon Elephant Village in 2010. Another government-subsidized project, it is home to 75 elephants and 286 people. India

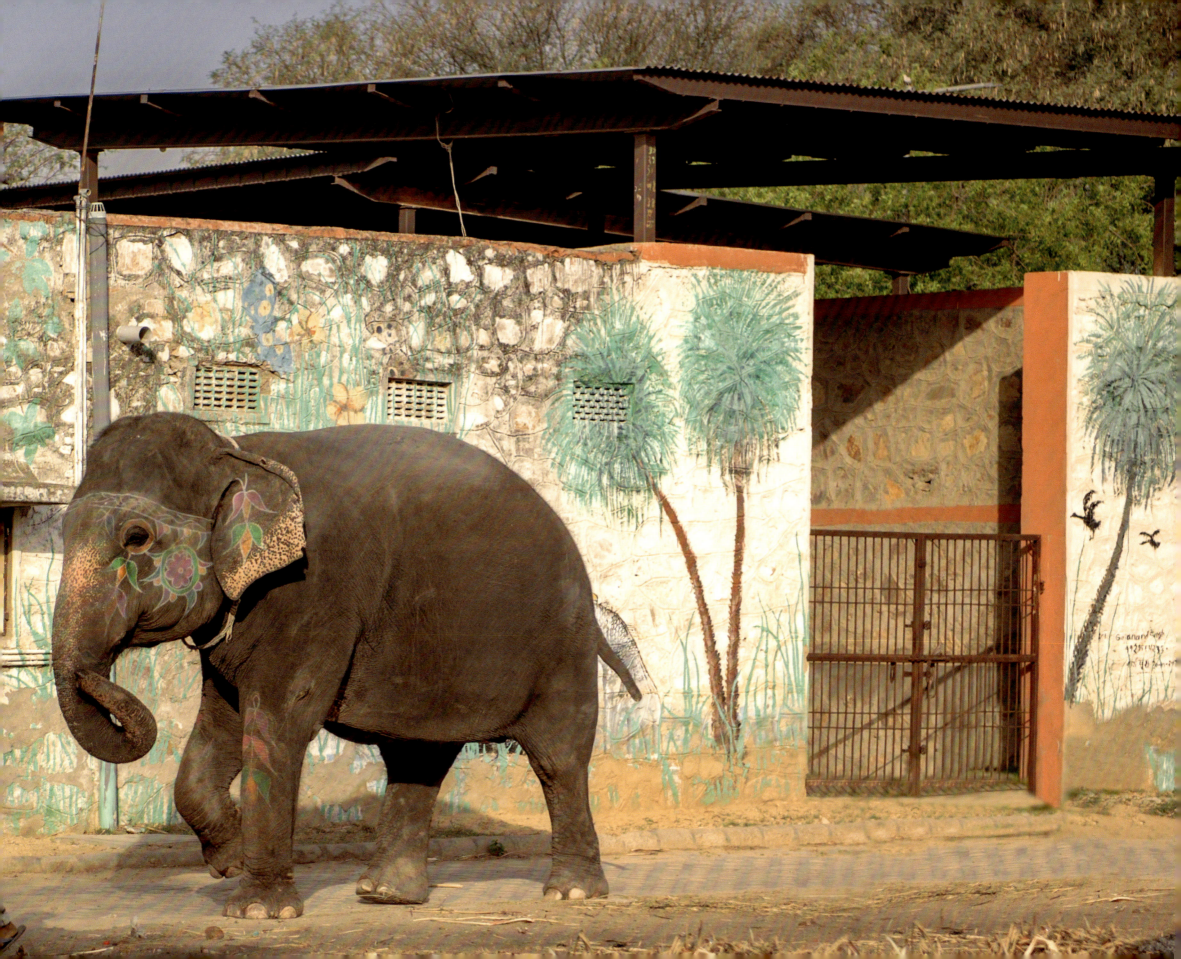

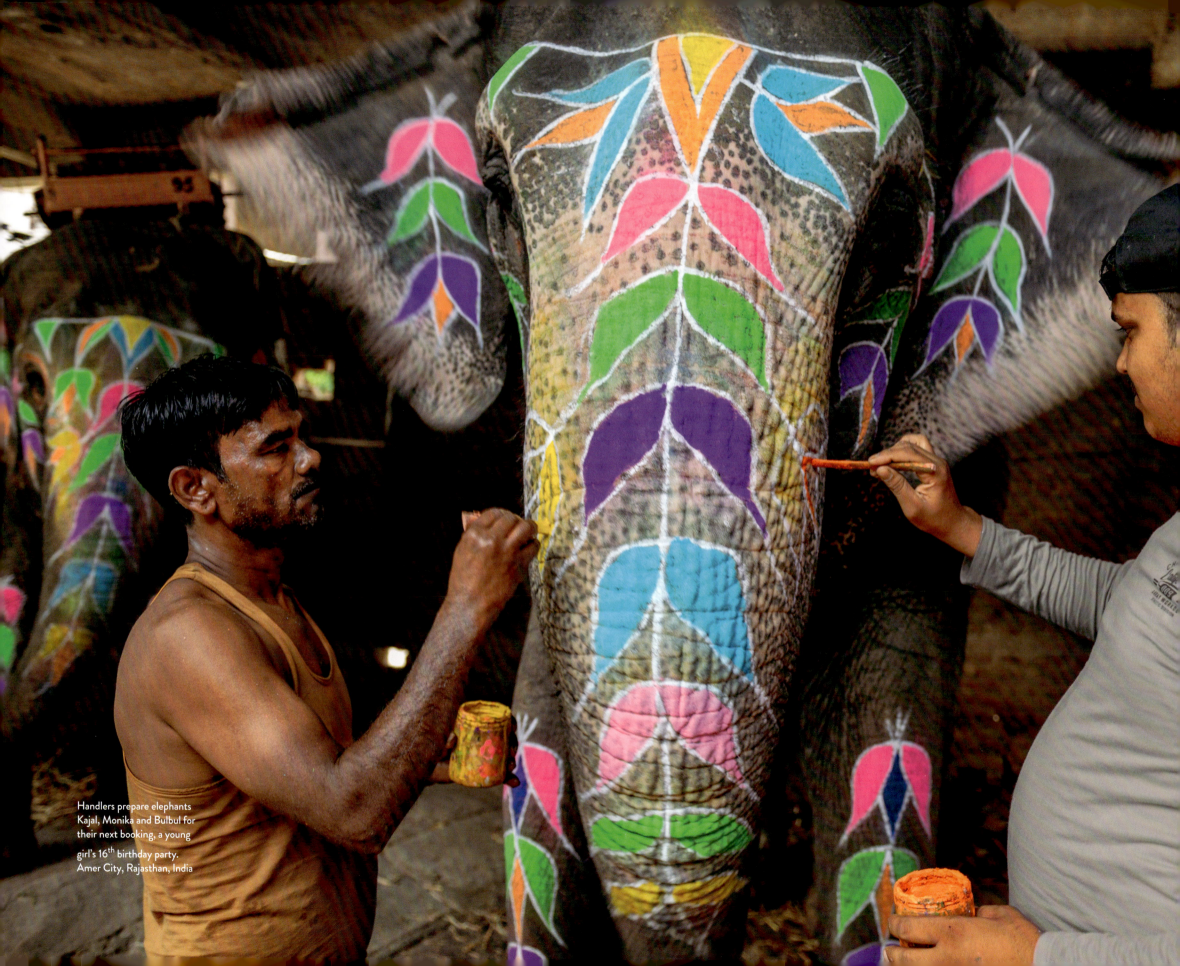

Handlers prepare elephants Kajal, Monika and Bulbul for their next booking, a young girl's 16th birthday party. Amer City, Rajasthan, India

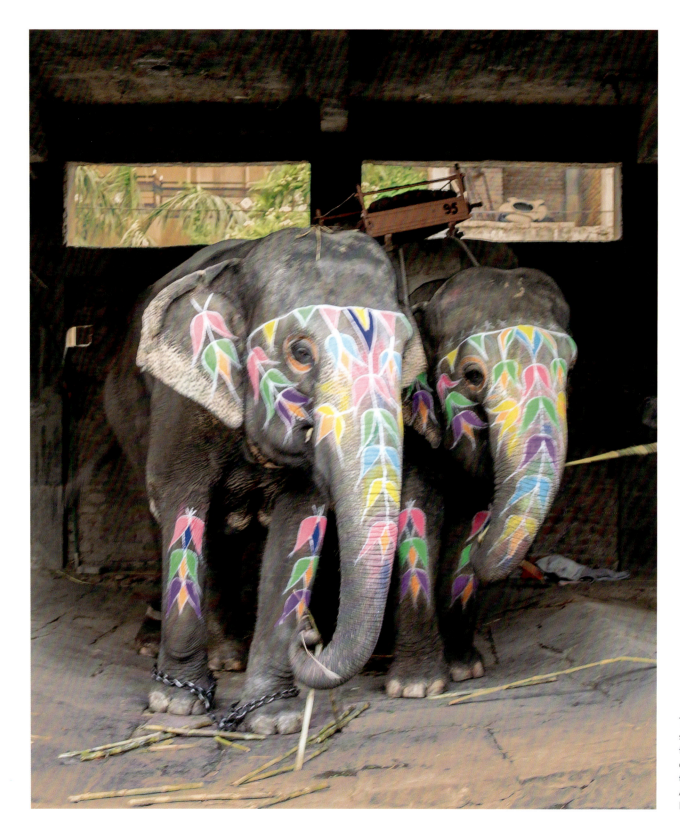

These elephants work all sorts of engagements from parties to the daily grind, hauling tourists up to the nearby Amber Fort. Amer City, Rajasthan, India

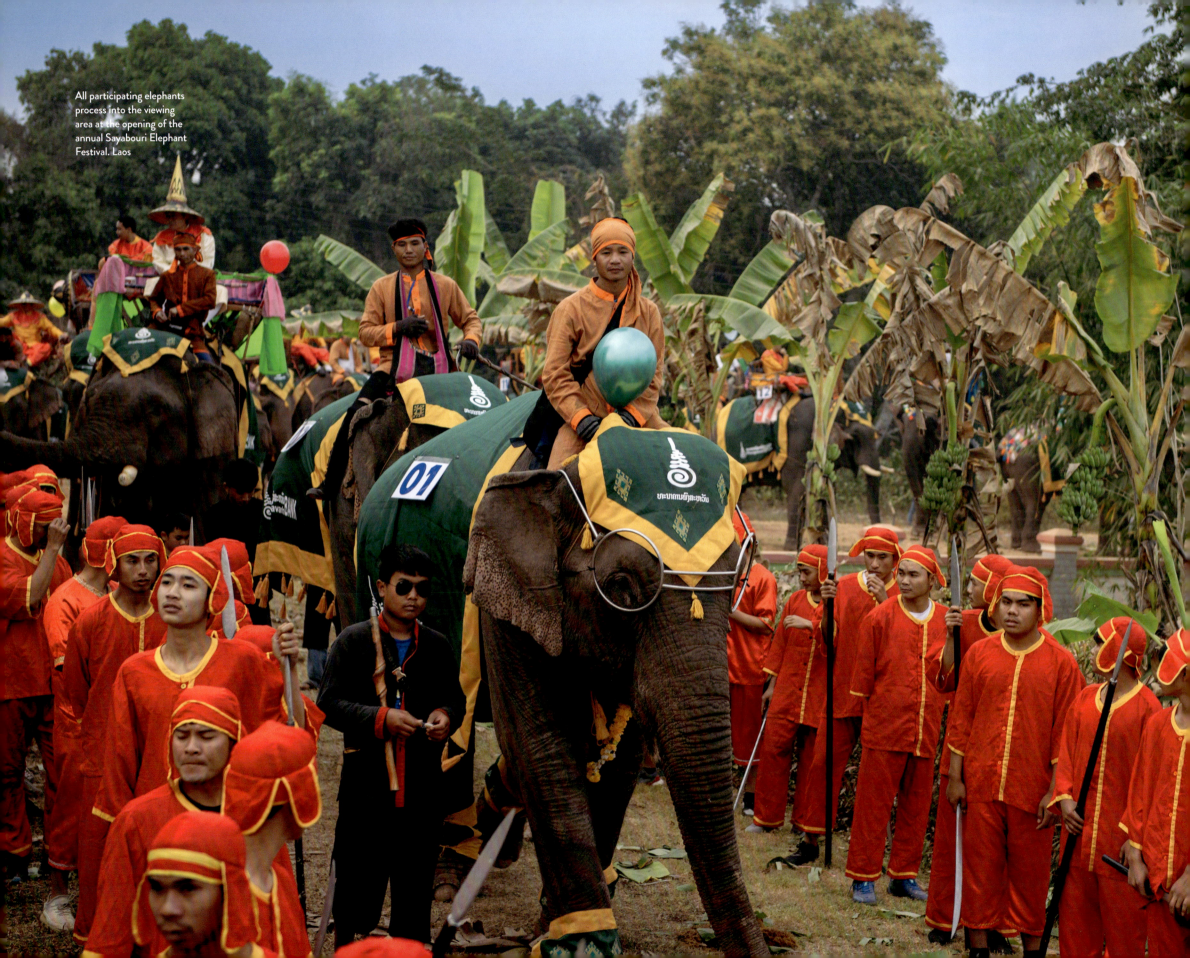

All participating elephants process into the viewing area at the opening of the annual Sayabouri Elephant Festival. Laos

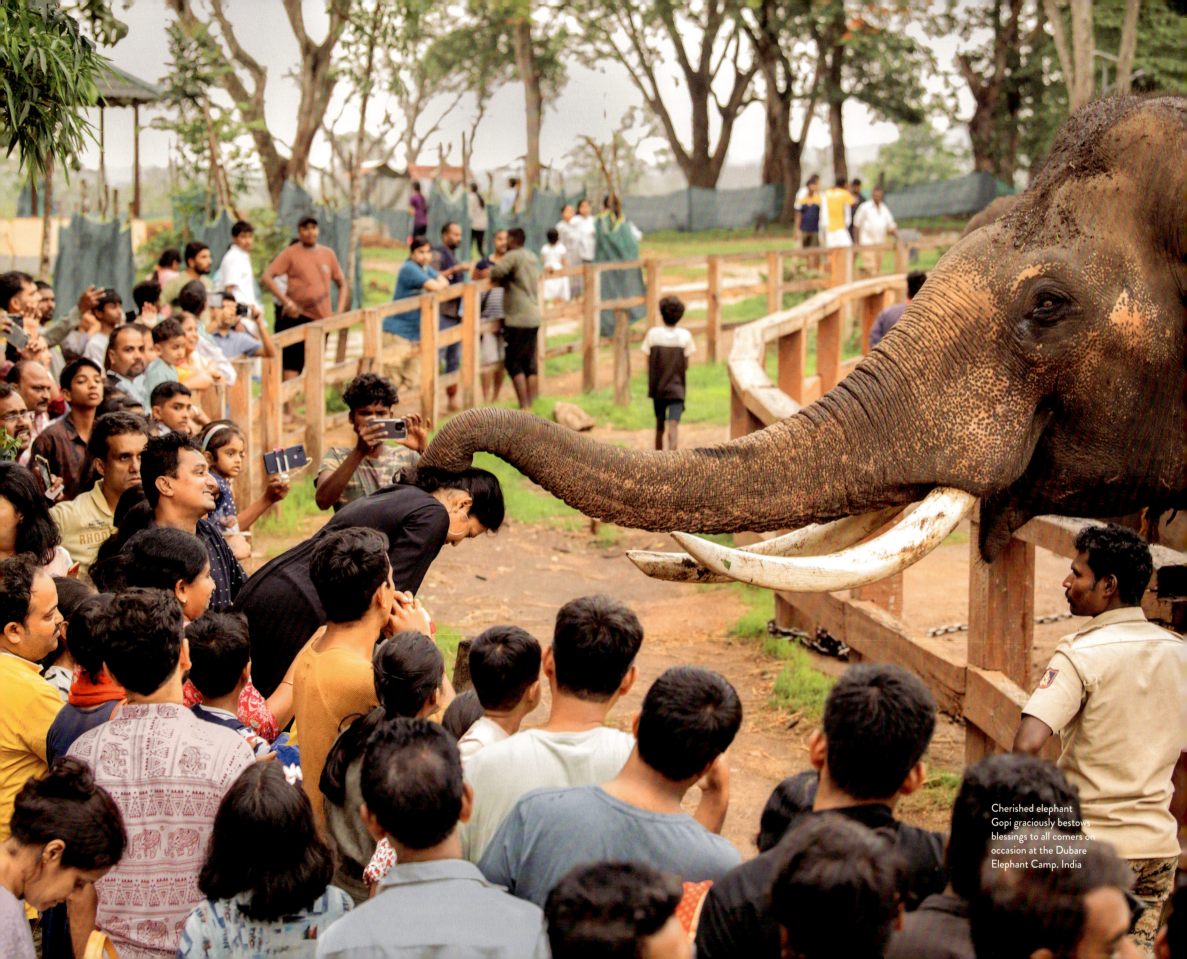

Cherished elephant Gopi graciously bestows blessings to all comers on occasion at the Dubare Elephant Camp, India

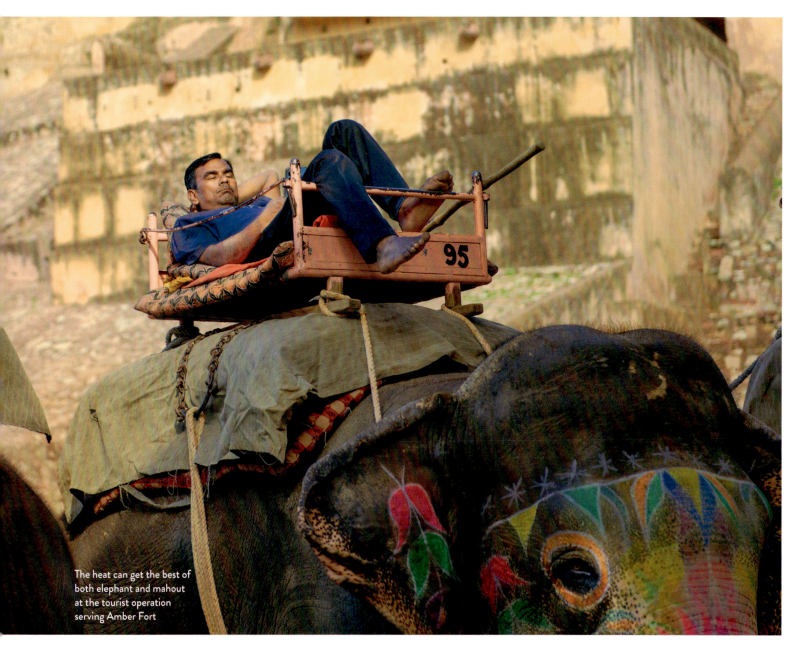

The heat can get the best of both elephant and mahout at the tourist operation serving Amber Fort

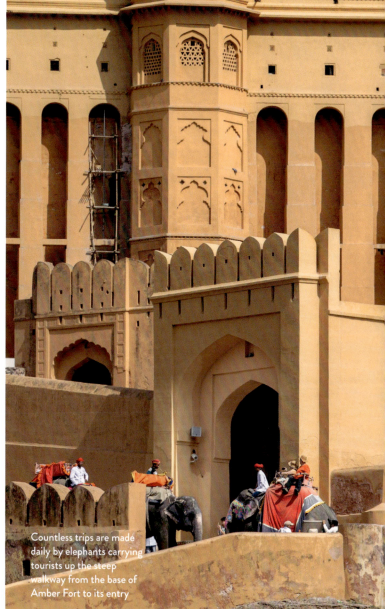

Countless trips are made daily by elephants carrying tourists up the steep walkway from the base of Amber Fort to its entry

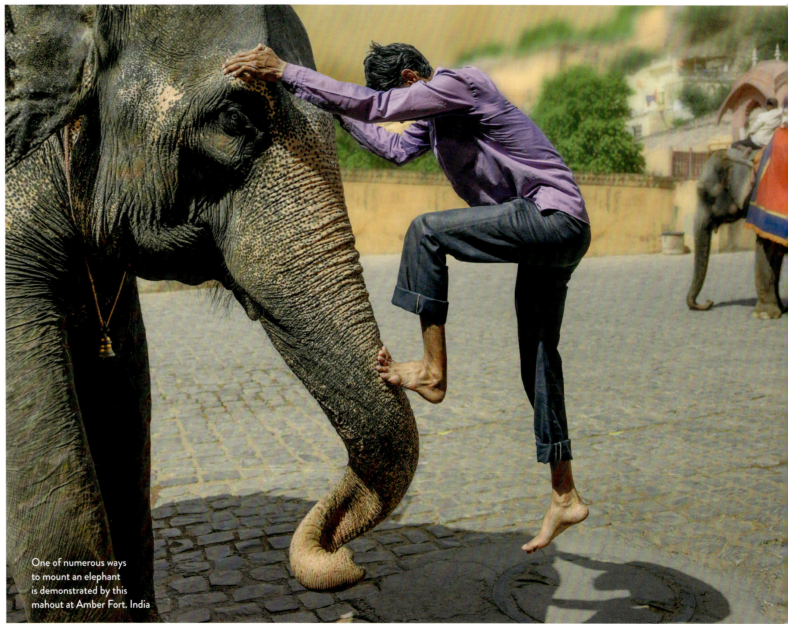

One of numerous ways to mount an elephant is demonstrated by this mahout at Amber Fort, India

ENTER THE VICIOUS

Asian elephants have survived a long list of challenges for 250,000 years. They have survived drastic changes in earth's climate. They have survived the loss of most of their habitat to humans. They have survived being hunted to extinction from the Mediterranean Sea to Pakistan. And for the past 4,500 years, they have endured the constant threat of human capture. But nothing could have prepared the vastly intelligent, adaptable elephant for the coming of the Europeans 500 years ago.

Puffed up by advances in science, shipbuilding and navigation, seafaring folk like the Portuguese, Spanish, Dutch, British and French set out on the high seas to vacuum up everything they saw. Trading posts were established in Asia. And as the scope of trade grew, competition spurred each nation on. Eventually, European domination of Asia became so thorough that every nation except Thailand had become a colony of one European country or another.

The events that took place on the island of Ceylon, today's nation of Sri Lanka, reveal just how vicious the exploitation was. The island in ancient times had become a haven for elephants, a land where they happily flourished. In time, the early human residents captured and tamed them, developing an active trade with India as their elephants became prized above all others in Asia for their abilities in work and warfare.

The first Europeans to invade were the Portuguese, in the year 1498. With no interest in making friends with the ruling inland kingdom in the centre of the island, they took control of whatever they wanted, including the elephant trade. Eventually becoming fed up, in 1658 the inland kingdom formed an alliance with the Dutch to force the Portuguese out. The Dutch in turn also seized the elephant trade and other markets, extracting even greater profits. Next, the inland kingdom turned to the British, and in 1796 they moved in. But the British didn't stop with the acquisition of the elephant trade. In 1815, they conquered the inland kingdom as well and took control of the entire island.

The British used captured elephants for the ambitious project of clearing huge tracts of jungle for development. In all corners of the island, sprawling coffee and tea plantations were installed.

Suffering huge losses to the land they had lived on for centuries, wild elephants brought heavy damage to the new agriculture in their search for food. While mass captures continued to support the trade, greater numbers were captured as

This narrative was constructed from various sources including the article "Death Tolls Mount as Elephants and People Compete for Land in Sri Lanka," by Thaslima Begum in the Guardian, 19 March 2024, and the book The Elephant in Sri Lanka, by Jayantha Jayewardene

> *"The time I spent in the jungles held unalloyed happiness for me, and that happiness I would now gladly share. My happiness, I believe, resulted from the fact that all wildlife is happy in its natural surroundings. In nature, there is no sorrow, and no repining. A bird from a flock, or an animal from a herd, is taken by hawk or carnivorous beast and those that are left rejoice that their time had not come today..."*
>
> – **EDWARD JAMES "JIM" CORBETT**, Anglo-Indian big-game hunter turned conservationist, instrumental in creating India's first wildlife reserve, later renamed in his honour

a means of protecting the plantations. Casualties during these captures were heavier than ever, with only one out of every three elephants surviving the brutality. Even more horrendously, those captured elephants who were deemed unsuitable for training or work were simply shot dead.

Most damnable of all was the British practice of hunting elephants for sport on the island. The results were tragic. Around the year 1807, the British upper class and military men alike became fascinated with the notion of taking down earth's largest animal as a test of manhood, a display of domination over a foreign land. Accomplished 19th-century explorer and big-game hunter Sir Samuel W. Baker summed the venture up, calling it "the most dangerous of all sports." Baker and his companions shot hundreds of elephants during their expeditions into the jungles of Ceylon. But their trophies stood as child's play next to those of other big-game hunters of the day. Among these were Major Thomas Rogers, killer of 1,500 elephants, and Captain Philip Gallwey and Major Thomas Skinner, who each killed 1,200 elephants.

Spurring on the killing were periodic rewards offered by the colonial government, which was intent on protecting the plantations. In the middle of the 19th century alone, over 8,000 elephants were slaughtered on Ceylon. To quote Baker once more, "by Englishmen alone is the glorious feeling shared of true, fair, and manly sport. The character of the nation [England] is beautifully displayed in all our rules for hunting, shooting, fishing, fighting, etc.; a feeling of fair play pervades every amusement."

European elephant trophies also took the form of live animal exports. The Portuguese began the practice during their early 16th-century expeditions by taking four live elephants back to Europe. Further expeditions by several European powers during the 17th and 18th centuries saw more elephants taken away for display. But during the 19th century, when the circus was all the rage in England and spreading throughout the world, the British gave the green light. In both Ceylon and India, the wholesale export of captive elephants became as common as the export of bananas. In one of countless deals made over the latter half of the 19th century, a German circus owner imported 300 elephants, with 65 coming from Ceylon and the rest from India. The elephant had won the heart of circus-goers worldwide and no respectable circus could operate without at least one. During an 1887 performance in New York, an American circus company put 160 elephants on the floor of Madison Square Garden at one time.

Today, the pitiful history of elephants in Sri Lanka is adding a new chapter. With 7,000 elephants in total on the island and 22 million people, Sri Lanka is currently the worst country in the world for human–elephant conflict. In 2023, 470 elephants were killed, while 176 people died in elephant encounters. The cause, as is true throughout Asia, comes from the actions of people. Legally and illegally, humans are continuing their destruction of the remaining jungle to replace it with agriculture and other development. With their sources of food taken away, elephants are forced to find fuel wherever they can. And this search, just to survive, is proving deadly.

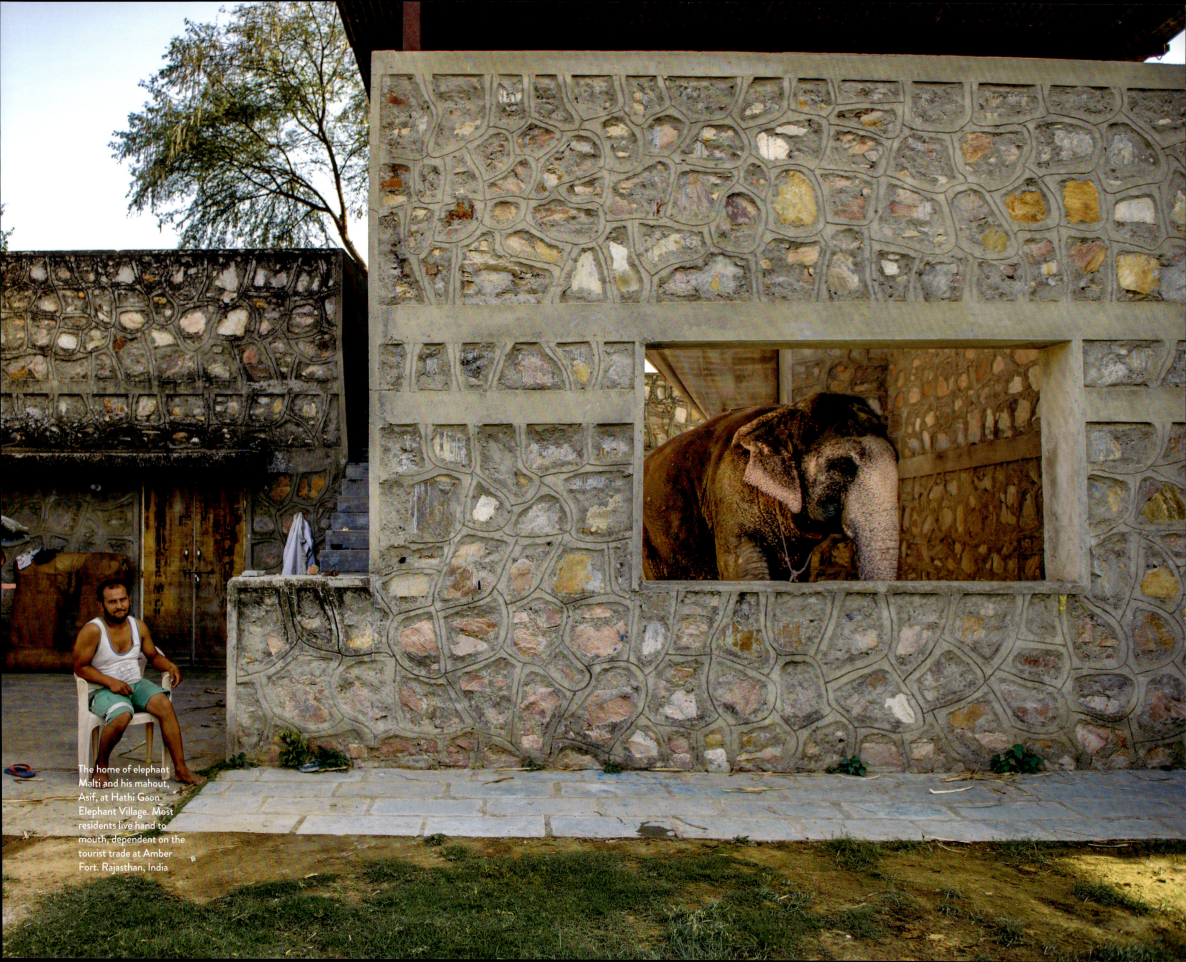

The home of elephant Malti and his mahout, Asif, at Hathi Gaon Elephant Village. Most residents live hand to mouth, dependent on the tourist trade at Amber Fort. Rajasthan, India

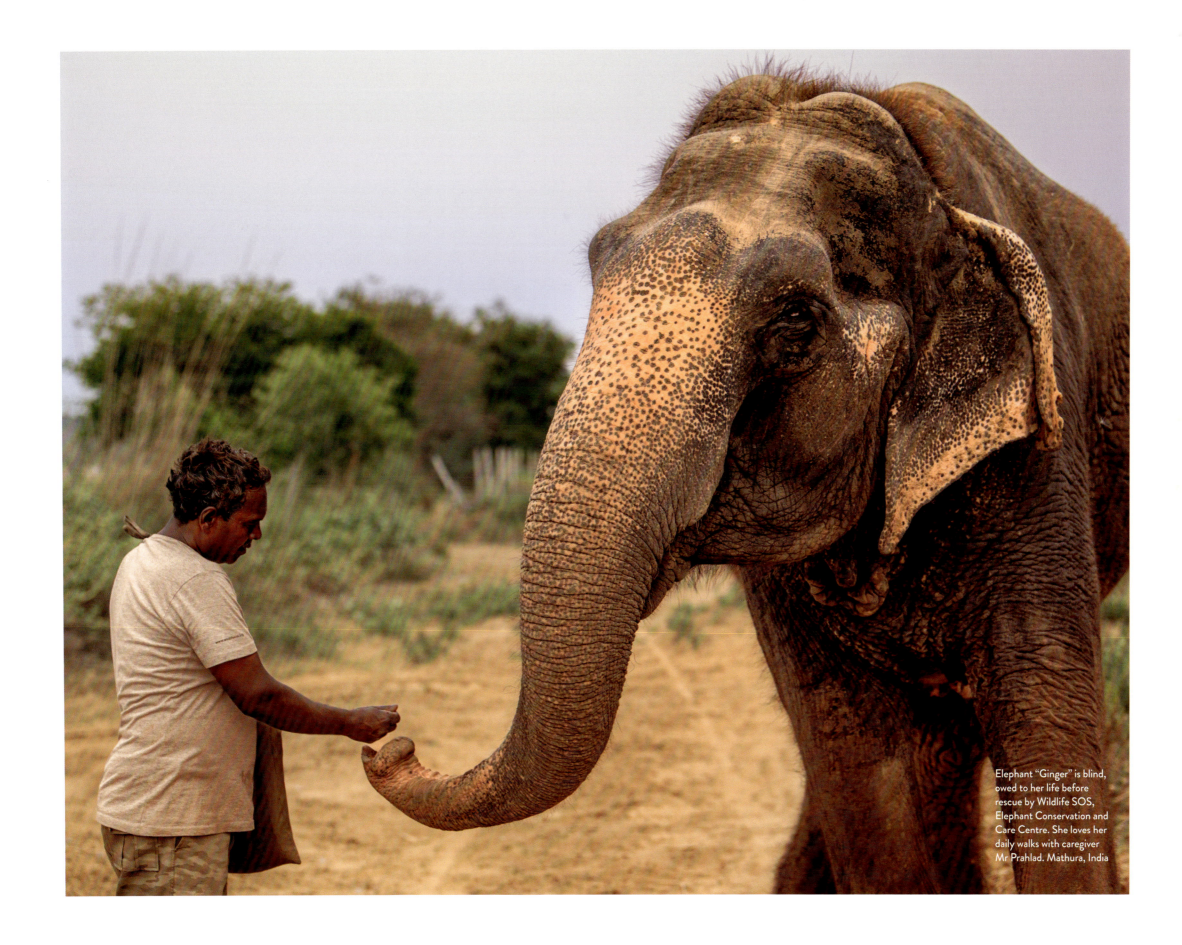

Elephant "Ginger" is blind, owed to her life before rescue by Wildlife SOS, Elephant Conservation and Care Centre. She loves her daily walks with caregiver Mr Prahlad. Mathura, India

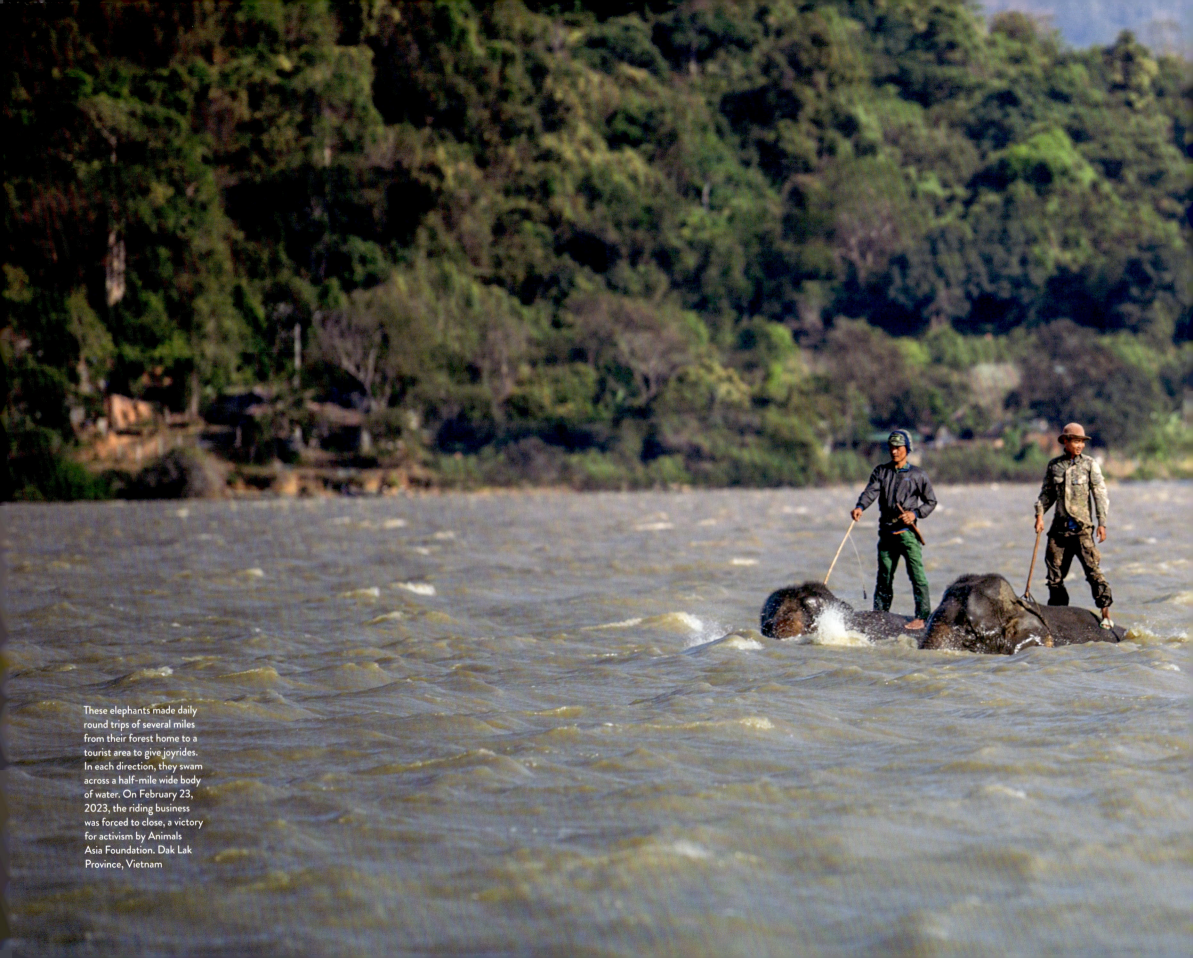

These elephants made daily round trips of several miles from their forest home to a tourist area to give joyrides. In each direction, they swam across a half-mile wide body of water. On February 23, 2023, the riding business was forced to close, a victory for activism by Animals Asia Foundation. Dak Lak Province, Vietnam

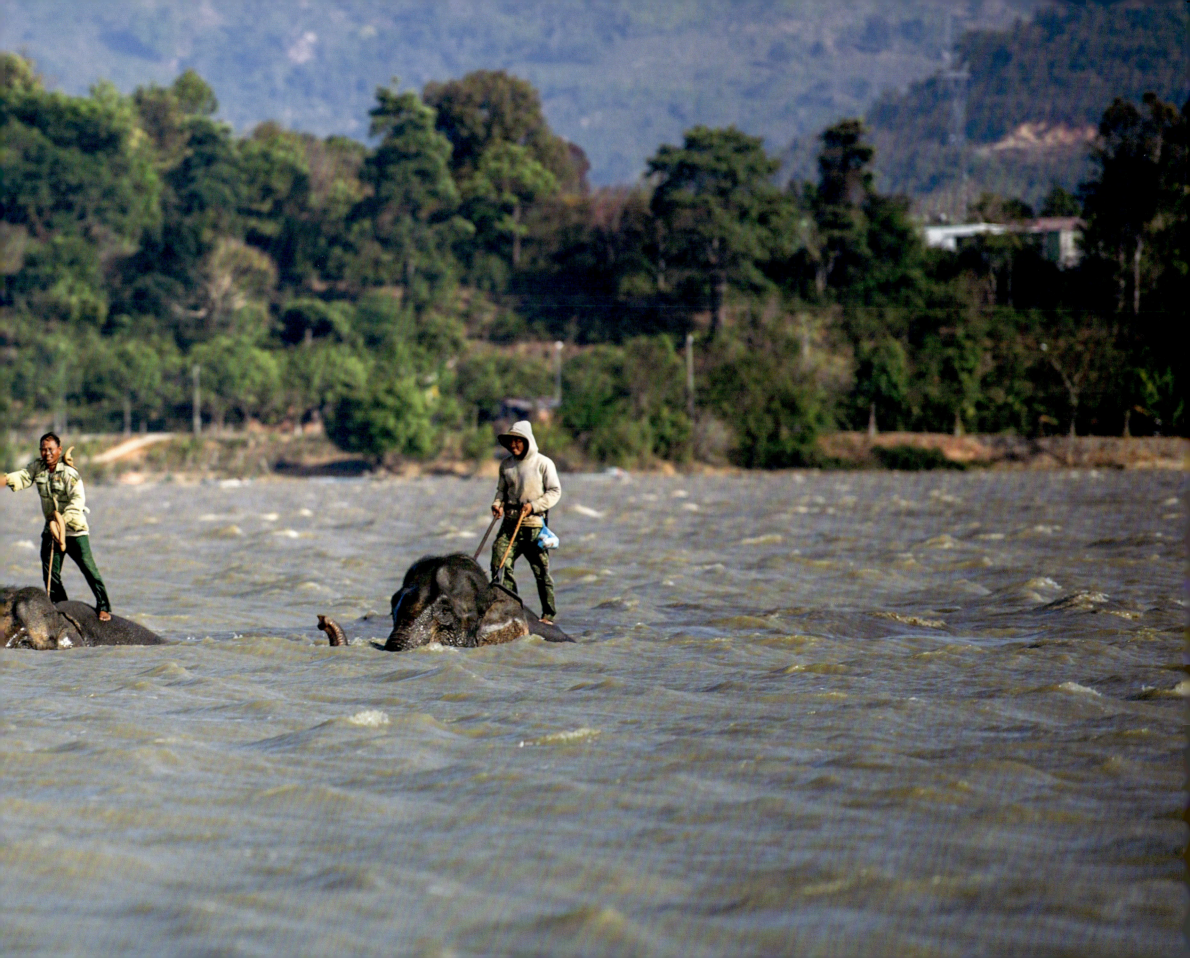

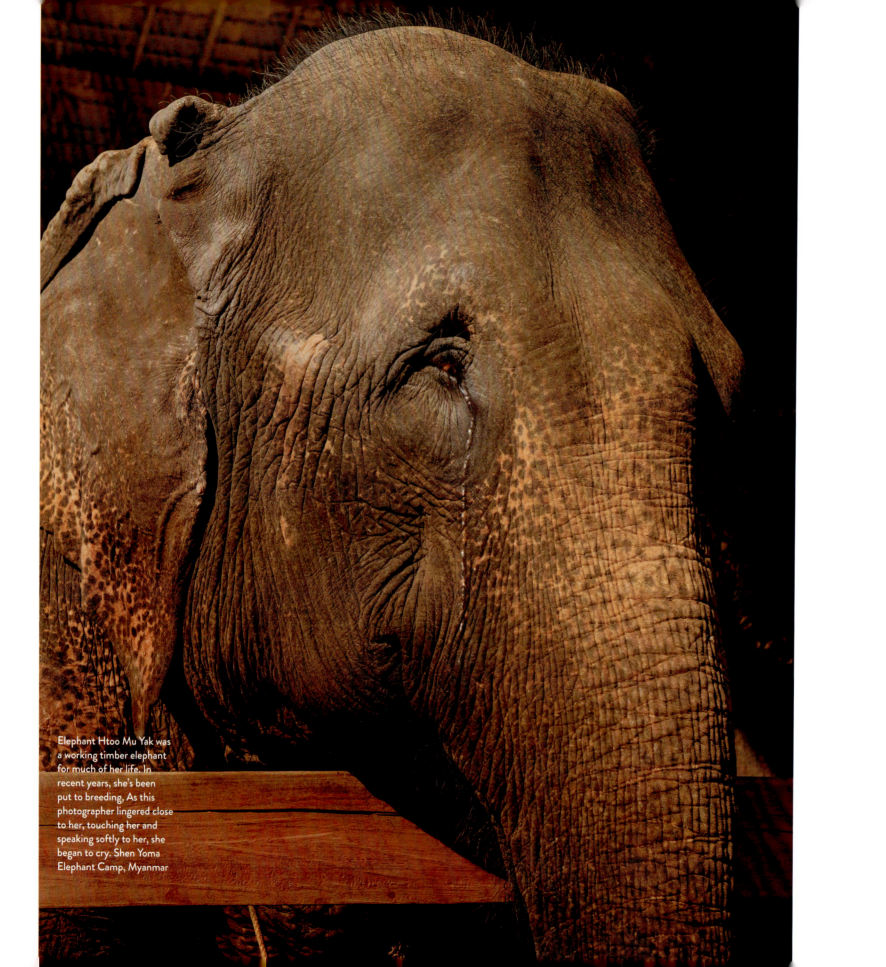

Elephant Htoo Mu Yak was a working timber elephant for much of her life. In recent years, she's been put to breeding. As this photographer lingered close to her, touching her and speaking softly to her, she began to cry. Shen Yoma Elephant Camp, Myanmar

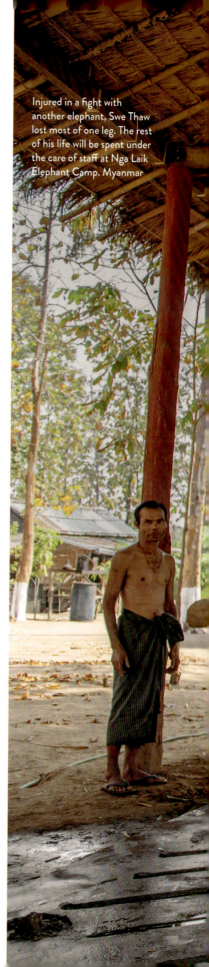

Injured in a fight with another elephant, Swe Thaw lost most of one leg. The rest of his life will be spent under the care of staff at Nga Laik Elephant Camp, Myanmar

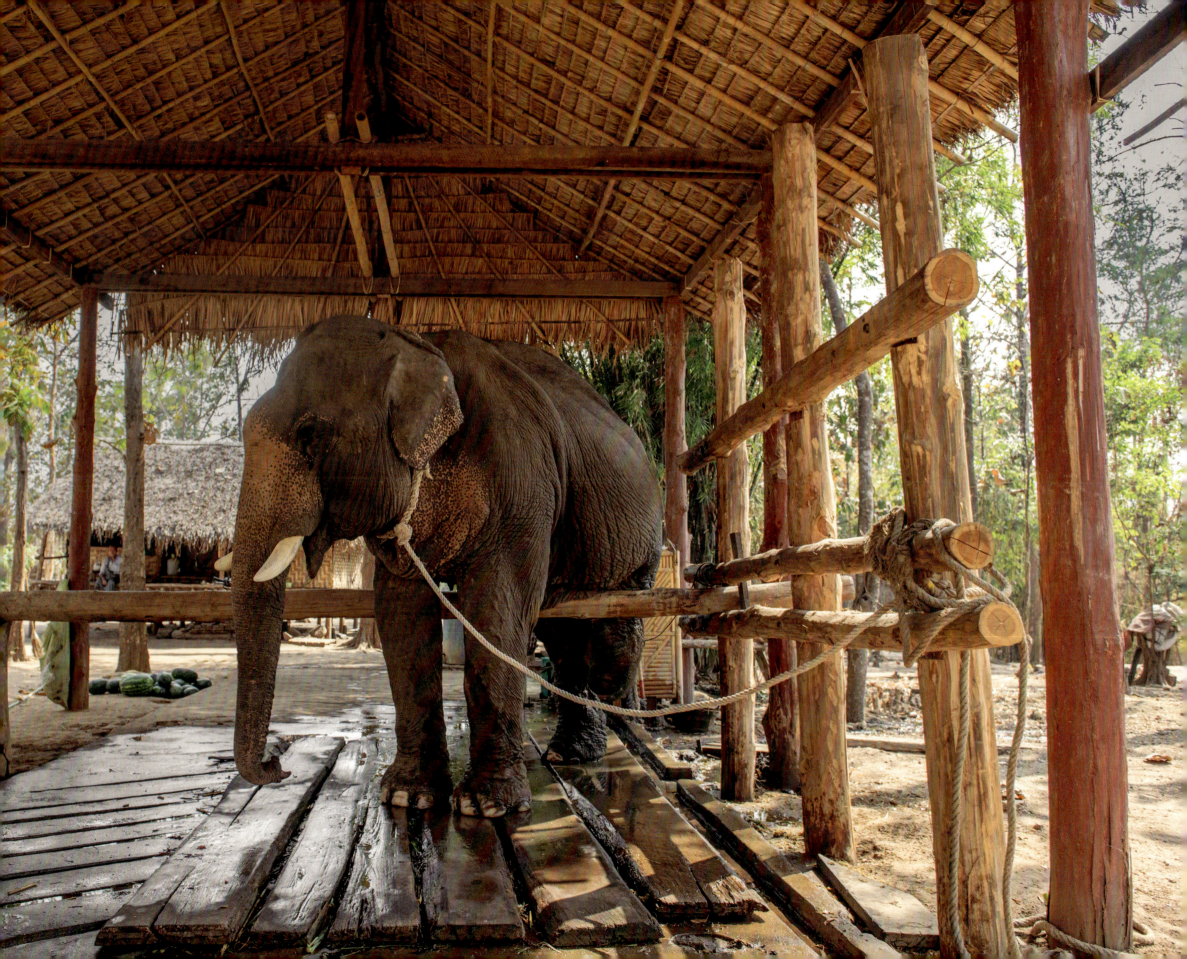

VANISHING POINT VIETNAM

Just over 58,000 Americans died in the Vietnam War. Around 225,000 South Vietnamese fighters never made it home. On the other side, 1.1 million North Vietnamese and Viet Cong soldiers were killed. On both sides, over 2 million civilians lost their lives. There is no final tally for the number of innocent elephants who were killed during the Vietnam War, but there were many.

Like the killing of civilians, the killing of elephants wasn't the kind of thing discussed after the fact. One account during the 1960s, though, did somehow make its way to American news outlets. A group of American fighter pilots had come upon a column of 11 pack elephants. Considered in the service of the enemy, they were fired upon. Five died immediately. Another five fell to the ground gravely wounded. Only one walked away. Meanwhile, from local accounts, we know of a town in Gia Lai province that had more than 28 of its captive elephants killed. The number of elephants who died while hauling food and military supplies for North Vietnam along the Ho Chi Minh Trail will never be known. The same lack of accounting holds for those lost in the South, where they were put to work in patrols, searching for the enemy.

At one time, thousands of elephants lived in what is now Vietnam. As the human population grew and began filling fertile lowland areas, the elephants were pushed into the uplands, along the borders to the west with Laos and Cambodia. In time, the beautiful Central Highlands region, north of Saigon, became the quiet home to both elephants and tribes of Indigenous peoples alike.

For a thousand years, the tribal people took note of their neighbours, the elephants, weaving them into their culture. No bond between human and elephant has been stronger than the one developed by the people known as the M'Nong and their neighbouring tribe, the Ede.

For the M'Nong, the elephants around them were taken into their community as family. The adults would call them 'son' or 'daughter,' while the children would call them 'brother' or 'sister.' They were included in traditions and festival rituals. Stories of elephants are featured prominently in the community's history. And generations of children have sung of elephants from a young age. In all, the elephant became a cultural symbol for the people of the Central Highlands and the entire country.

But one haunting reality has been conveniently overlooked all along. Somebody has always had to go out into the forest to capture these sons and daughters, brothers and sisters.

This narrative was constructed by sourcing several articles including "Conflict Threatens Vietnam's Last Elephants," by Govi Snell and Anton L. Delgado in Dialog Earth, the article "Vietnam's Elephants Face Threats from Near and Far," By Marianne Brown, in Voice of America News, 05 December 2012 and the article "The Mnong and the Elephants in Vietnam – The Ritual," by French photographer Réhahn.

For generations, chosen baby elephants were taken away from their mothers, their families and their lives of freedom. In a way, the disconnection is similar to how children in the Western world figure out about Santa Claus but play along with the tradition, so the gifts keep on coming. But M'Nong children haven't been quite as passive in their beliefs. In fact, a good percentage of M'Nong children in the past grew up dreaming of becoming great elephant catchers themselves.

It was a quaint, even story-book way of coexisting, as long as the traumatic capture and training process took place out in the forest, away from the villages. Upon completion of months of training, the young elephants were ceremoniously marched into the village for introduction, where they were confirmed as members of the community. And, like all members of the community, they were expected to work, especially in the most arduous duties of agriculture and logging the forest.

In time, traders who lived in neighbouring countries brought great demand for the beloved elephants of the region. The M'Nong generously provided. By the 20th century, the Central Highlands were known as the largest elephant market in all of Southeast Asia, selling scores of elephants to buyers in Asia, and to zoos and circuses around the world.

As the tribal relationship with elephants expanded to embrace commerce, the love of elephants became a vice. Arrogance and greed appeared commonplace in the forest as elephant hunters took more and more babies. One celebrated elephant hunter took just under 500 elephants in his career. A descendent of his took nearly 300, and on some hunting trips brought back as many as ten new captives for training. At the height of the trade, as many as 400 M'Nong and Ede tribesmen were working as elephant catchers.

It goes without saying that the assault on the region's wild elephants far surpassed their abilities to reproduce. Populations dwindled. By the end of the Vietnam War, in 1975, there were just several hundred elephants left in the provincial heart of the M'Nong region. In 1996, there were 40, and in 2000 there were only 15 to 20. Other provinces where elephants lived reported even greater losses. And though capture was eventually banned, it continued.

The catastrophic decline in elephants nationwide has several human origins. For a long, long time, elephants have been killed outright as revenge for eating crops or damaging property. During periods of high ivory demand, they were killed simply for the harvest of their tusks. During the mid-1990s, a ring of four Vietnamese men went on a three-year killing spree, massacring dozens of elephants, including some living in captivity, just to take their ivory. And, most threateningly of all, the lands that elephants have lived on for centuries have been seized by the growing human population, cleared and developed primarily for agriculture.

The accounting for the loss of habitat doesn't stop there. Whole forests were destroyed during the Vietnam War by the systematic spraying of 19 million gallons of poison, primarily Agent Orange. Elephants died outright and the generations that followed suffered with effects on their health, not to mention the challenges of living in a post-apocalyptic habitat.

Y Vinh is a member of the M'Nong tribe today and still shares his home with an elephant. "I'm worried that my children will not see elephants in the future," he says. "[If this happens], I don't know what they can be proud of ... because to our ethnic group, to Highland people, the elephant is the symbol of our culture. If one day the elephants are all gone, we will also lose the culture of the M'Nong tribe."

Today, in all of Vietnam, only 75 to 100 wild elephants remain. They live separated into 22 groups, with some 'groups' consisting of just one lone elephant. As for those living in captivity, less than 90 in all, they too are on the decline. Unless some sort of international effort is brought to bear soon, Vietnam's recent success stories for humans will not be including the conservation of elephants, as they edge closer and closer, day by day, to their vanishing point.

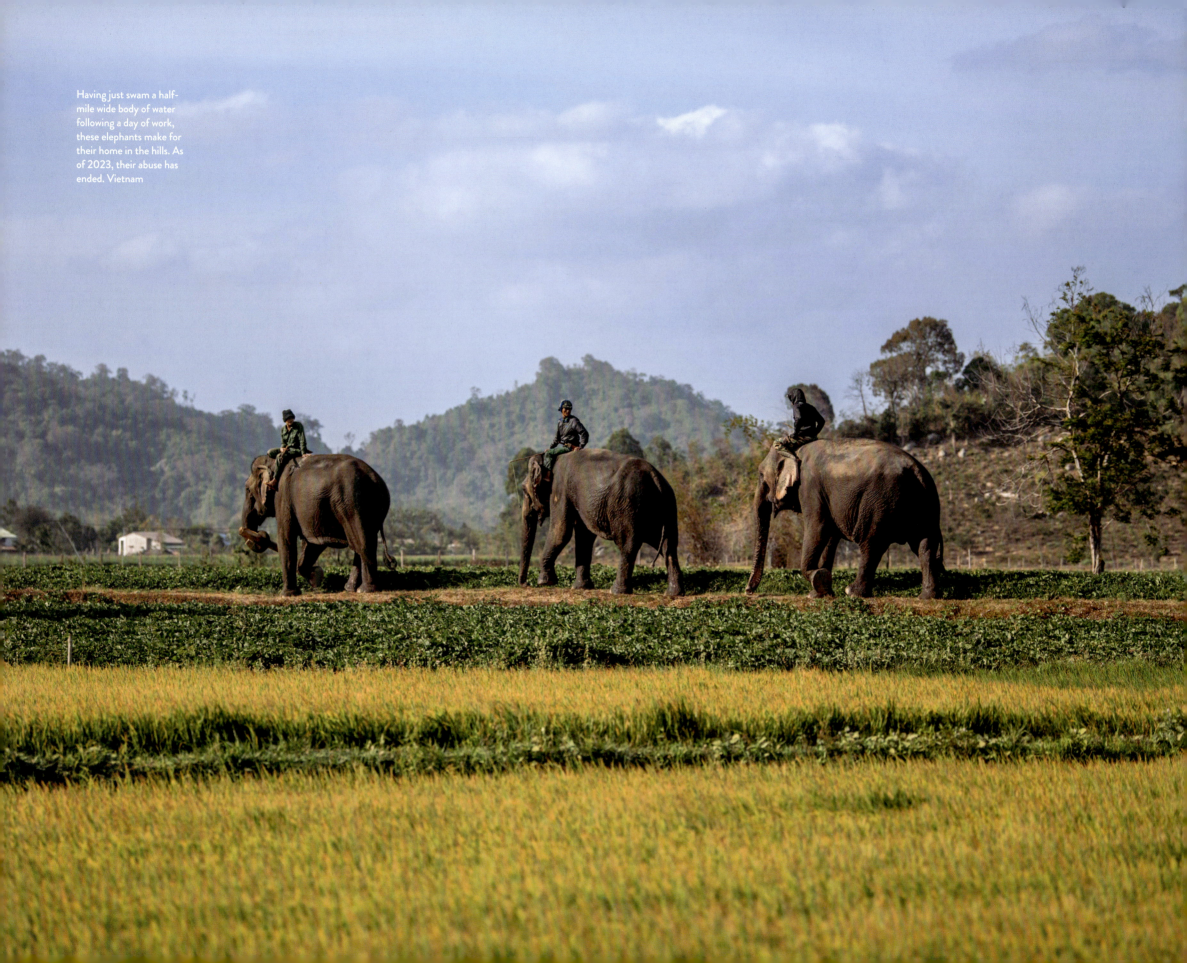
Having just swam a half-mile wide body of water following a day of work, these elephants make for their home in the hills. As of 2023, their abuse has ended. Vietnam

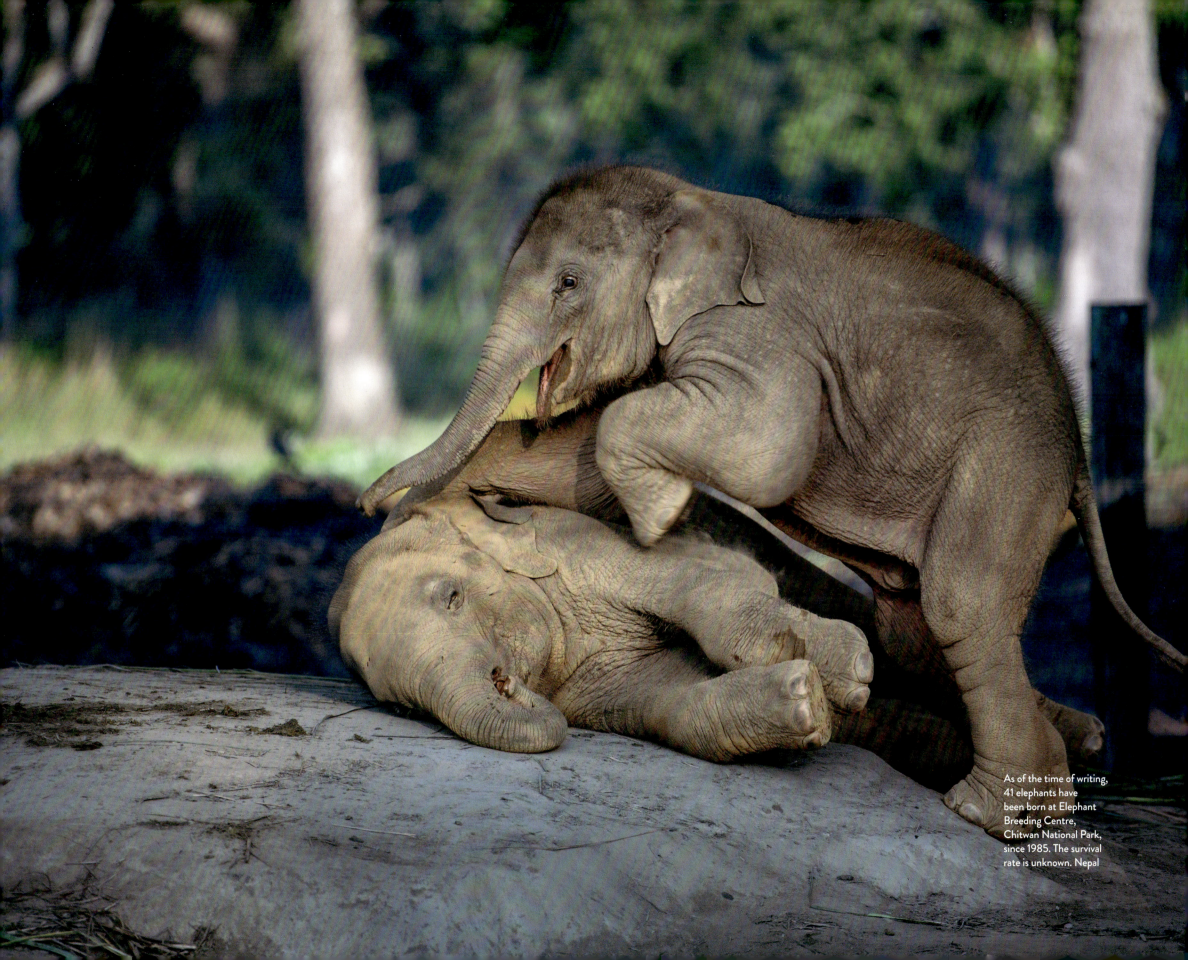

As of the time of writing, 41 elephants have been born at Elephant Breeding Centre, Chitwan National Park, since 1985. The survival rate is unknown. Nepal

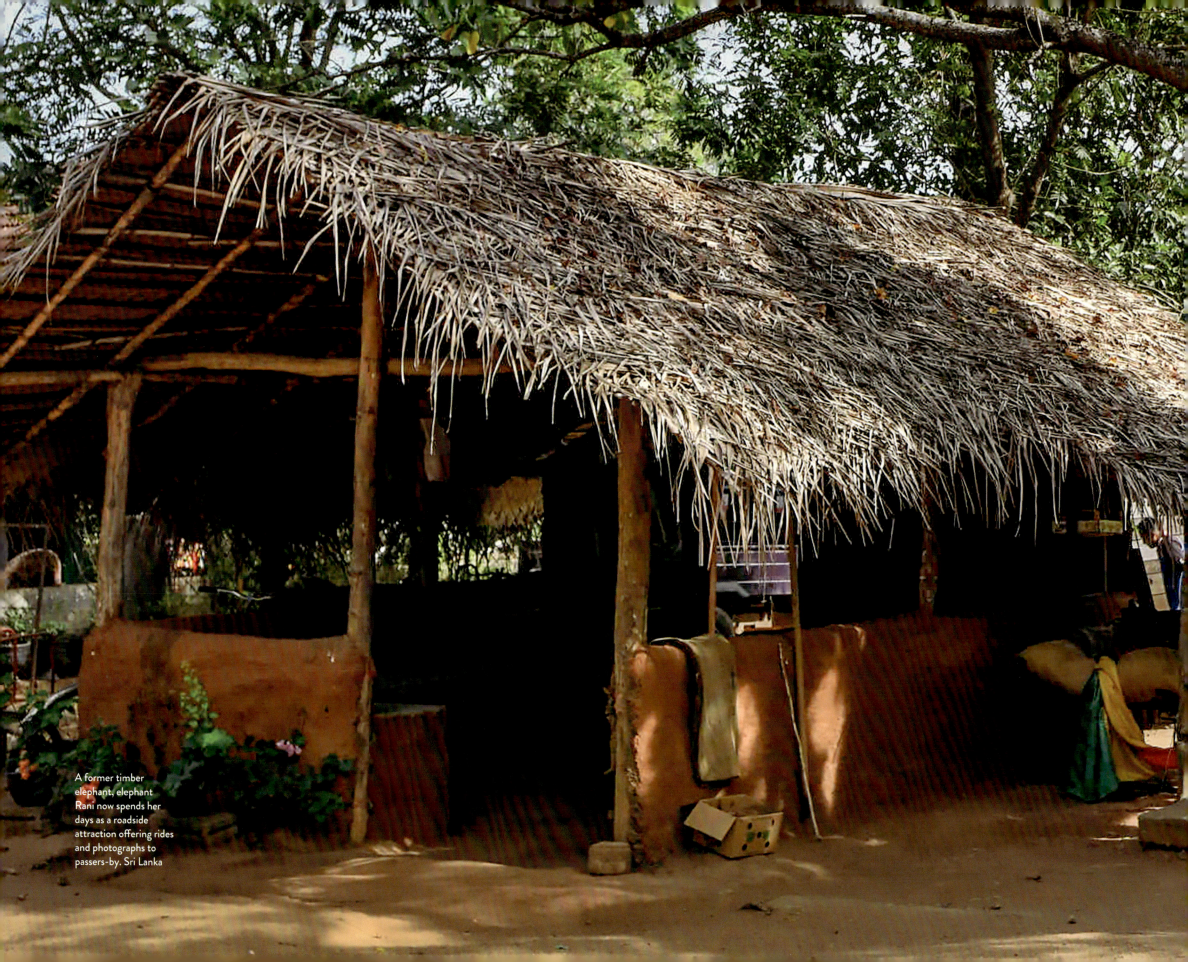

A former timber elephant, elephant Rani now spends her days as a roadside attraction offering rides and photographs to passers-by. Sri Lanka

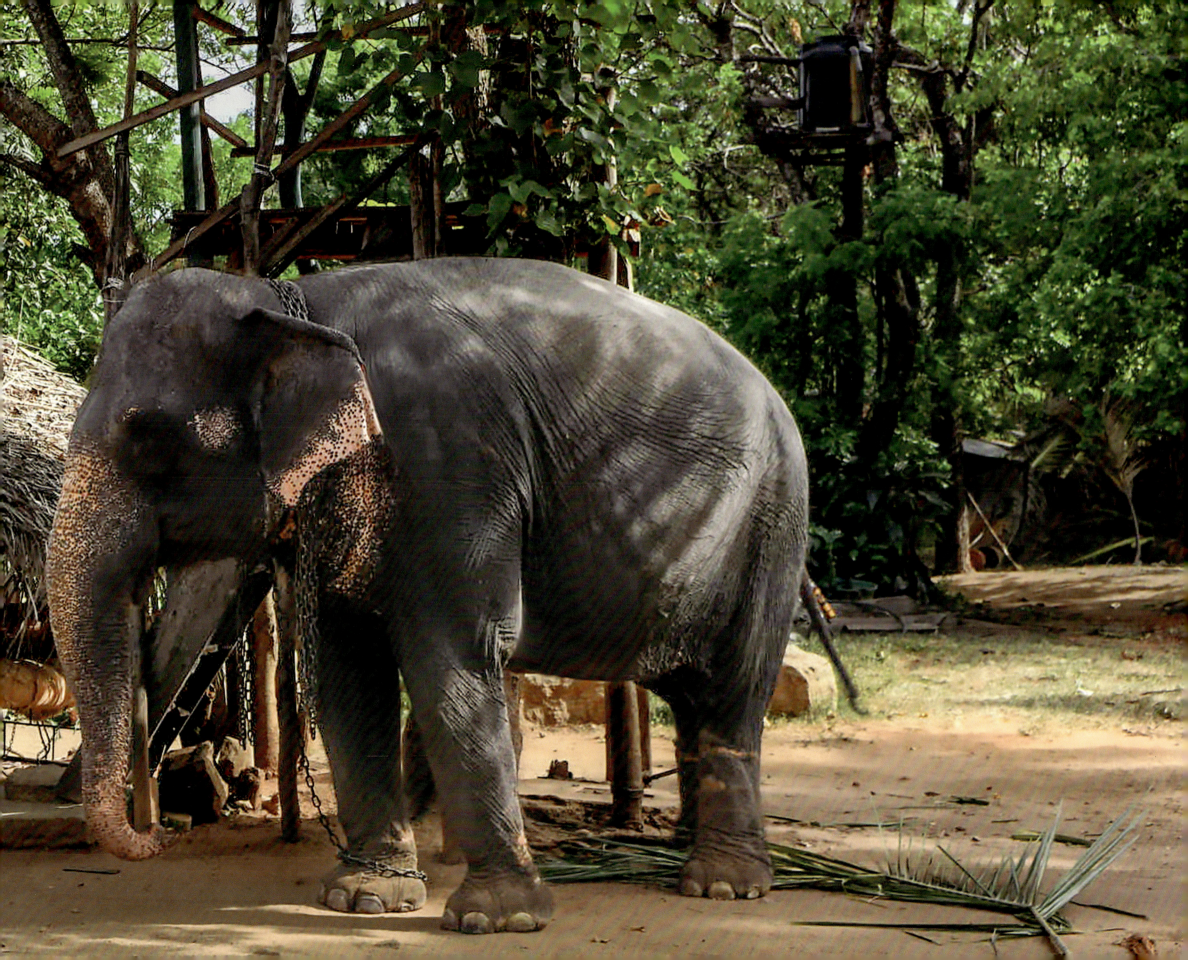

LAKSHMI THE FUGITIVE
BEGGING ELEPHANT, ELEPHANT FOR HIRE

Within the enormous mega-city of Delhi, India, there is a place where humans have lived since the 6th century BC. Near that area stood the centre of political and financial power of Delhi for centuries. Over time, the palaces of noblemen and members of the royal court sprang up to dominate the landscape. As symbols of their power, these elites commonly kept elephants in elaborate stables and could often be seen moving about the city with ornately decorated elephant rigs.

As time passed, the captive elephant population of the city grew and grew. Elephants were gifted back and forth, all players bearing in mind that the more powerful you were, the more elephants you owned. Citizens of lower classes also came to own elephants as they were rewarded by grateful elites for assistance in various endeavours. It is impossible to know just how many hundreds if not thousands of captive elephants were held in Delhi at any one time. But it is known that as recently as 50 years ago, there were more than 200 living within the city limits.

Elephants had become immensely popular among the rich and the poor alike. They were expected to appear at all sorts of public gatherings, including religious functions, parades and weddings and, of course, in recent years could be seen giving joyrides to foreign and domestic tourists alike. Over the course of countless generations, the elephant became fundamental to the cultural fabric and visual landscape of the city of Delhi.

As the last century came to a close, though, signs were emerging to indicate that Delhi and other crowded cities of India were no place for elephants. Pollution dominated the air, land and water. On the roadways, an increasing number of elephants were being killed or maimed at the hands of reckless drivers. In 2010, in a town adjacent to greater Delhi, two elephants went on a rampage at the lavish wedding of two members of parliament. Passers-by were attacked and 20 cars crushed.

In more recent years, the cries of activists have finally been heard by government. Existing animal welfare laws are increasingly enforced, and stronger regulations have been passed to protect elephants. Activists in another mega-city of India, Mumbai, fought hard to prompt the first ban of elephants in an Indian city in 2007. Across the country, other activists have spoken out, bringing about a wave of growing awareness. But in Delhi, the elephant owners, mahouts and traditionalists were loath to see the centuries-old presence of

This narrative was constructed from numerous online sources, most notably "The 'Undisputed Last Elephant' of Delhi," by Nikhil M. Babu, which appeared in The Hindu.

"Like humans, elephants periodically get a jolt from hormones. Once each year, the mature male elephant gets a kick that can last up to three months. In the worst cases, elephants go out of their minds, attacking other males, attacking people, destroying property. A few years ago, a resident elephant of Kerala named Kabali fell victim. Daily, he parked himself in a busy highway's lane of traffic. If he didn't like your vehicle, he'd attack. Buses were his favourite adversaries. On one occasion, he charged a bus, lifted one end into the air, and continued to have his way for two hours. In another bus incident, he charged but the driver backed up to avoid contact. For five miles Kabali charged and for five miles the driver continued backing up."

– **STORY BY VIPIN VIJAYAN**, condensed from his article
"Kabali Road Show Continues: Lifts KSRTC Bus With His Tusks," in *Asianet Newsable*

elephants come to an end. The resulting ideological conflict evolved into a battle.

While authorities finally began prompting the relocation of Delhi's remaining captive elephants, a dozen or so elephants and their mahouts held out, refusing to leave. Some elephants were found dead from neglect. Others just disappeared in the night. Eventually, the outcome of the battle was placed in the hands of the courts.

In 2017, only seven elephants remained in all of Delhi. Of these, one was rescued and given a good home by a successful businessman, the courts permitting her to live out her life within the city limits. The owners of the remaining six elephants, though, were presented with an ultimatum: surrender your elephants or have them seized. There were to be no more elephants at all within the city limits, save for the female held by the businessman.

One by one, six of the remaining elephants were removed from their owners and placed in new homes away from the city until there was just one left. The final elephant, known as Lakshmi, had been ill and deliberately left for last. As the authorities arrived at the home of Lakshmi's owner to finally take possession of her, a peculiar drama unfolded.

Lakshmi's owner, who had been out with one of his sons, returned home to find Forestry Department officials and several police officers in a heated confrontation with his wife. Lakshmi's mahout and other family members had stepped in to resist the elephant's seizure and roughed up the authorities. During the altercation, the owner and other family members gathered Lakshmi and made a run for it. Following a three-hour chase, the owner, two of his sons and Lakshmi waded across the Yamuna River and disappeared into the forest.

The daring escape hit the newspapers. A warrant was issued for the arrest of the owner. Government officials notified neighbouring states to be on the lookout for any elephant matching Lakshmi's description. A special team of authorities was marshalled to comb the forest. But the elephant and her accomplices had completely disappeared.

Following two months of hiding, the owner made contact with a newspaper. He had been moving from the home of one relative to another, never using the same mobile phone twice and keeping Lakshmi in a secluded barn. To the newspaper, he claimed to be tired of the whole thing and hoped for a favourable ruling by the courts.

Meanwhile, authorities had traced Lakshmi to a small community on the fringes of Delhi. Reports that she had resumed appearing at religious festivals and weddings had given her away. Uncertain of just what the reception would be from the family, the authorities patiently embarked on a rescue operation that lasted more than 16 hours.

Once in custody, Lakshmi was initially led to a nearby property from which she would be transported by truck to her new home at a facility run by animal-rescue organization Wildlife SOS and the state forestry department. That night, she was moved for safekeeping to the nearby police station.

By morning light, a crowd had gathered and the show was on. The authorities had decided to load Lakshmi into the waiting truck a short distance from the police station. As the Wildlife SOS team and the forestry department personnel attempted the loading, a mob made up of the mahout's family and the owner's family intervened with aggressive protest, prompting Lakshmi to freeze in her tracks. Police reinforcements were called in and the elephant was returned to the police station.

Later, when tempers had cooled, Lakshmi, under the command of the mahout's assistant, was marched to a nearby open space on foot, accompanied by a remarkable procession of six teams of police, the wildlife authorities, and a convoy of government vehicles and motorcycle police officers.

At the open space, Lakshmi was immediately fed sugarcane and a dozen bananas before undergoing a medical examination to ensure her fitness for the long ride ahead. The effort to coax Lakshmi into the truck took nearly four hours but was eventually successful.

Standing in a layer of mud to aid her stability during the ride, she was joined in the truck bed by a plentiful stack of sugarcane, bananas, cucumbers, watermelon and green fodder. Accompanying her were three forestry department specialists along with four trained mahouts and a veterinarian from Wildlife SOS, all to ensure the safest and most comfortable transfer possible.

Lakshmi's mahout, despite his arrest for many charges including obstructing a public servant, immediately brought a suit against the authorities for seizing his treasured elephant with the hope that he would be able to take her back. In due time, the suit was dismissed but some sort of visitation arrangement seemed likely. The owner and his sons have not been heard of since.

At Wildlife SOS's Ch. Surinder Singh Elephant Rehabilitation Centre in Haryana, Lakshmi began a long period of recovery from a life of starvation and abuse.

The long history of captive elephants in Delhi, for all intents and purposes, has finally come to an end. How much longer will it take for change to come for India's temple elephants? The world is watching.

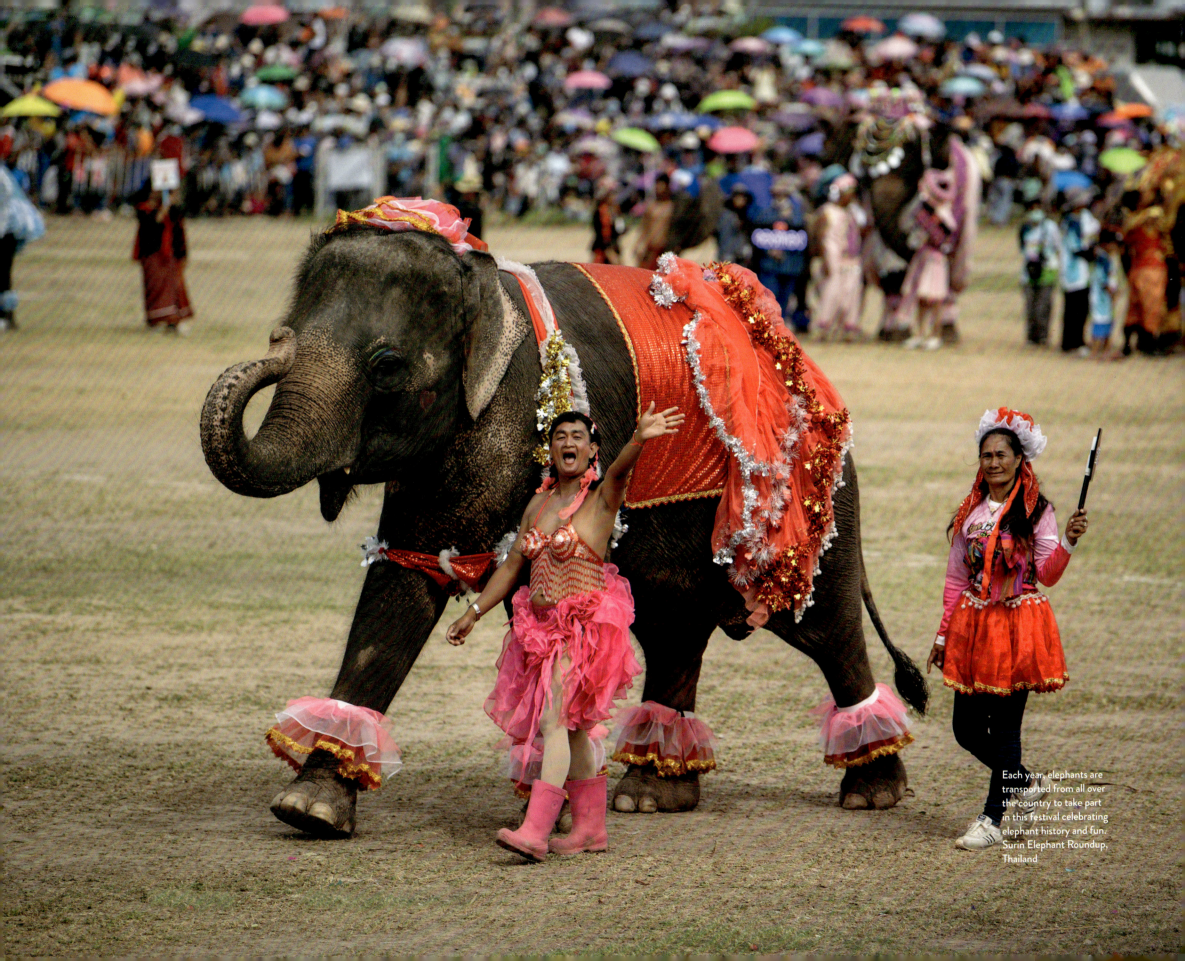

Each year, elephants are transported from all over the country to take part in this festival celebrating elephant history and fun. Surin Elephant Roundup, Thailand

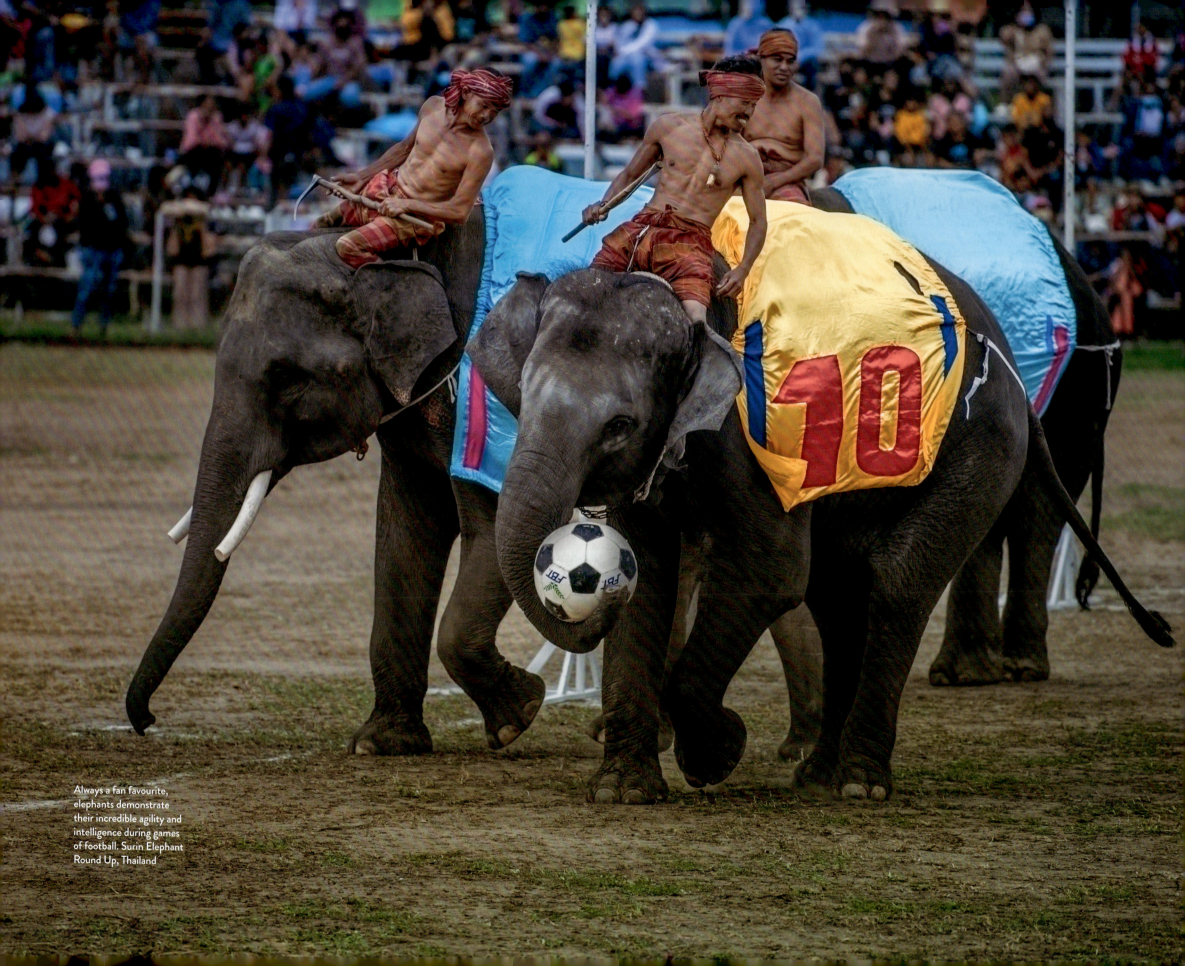

Always a fan favourite, elephants demonstrate their incredible agility and intelligence during games of football. Surin Elephant Round Up, Thailand

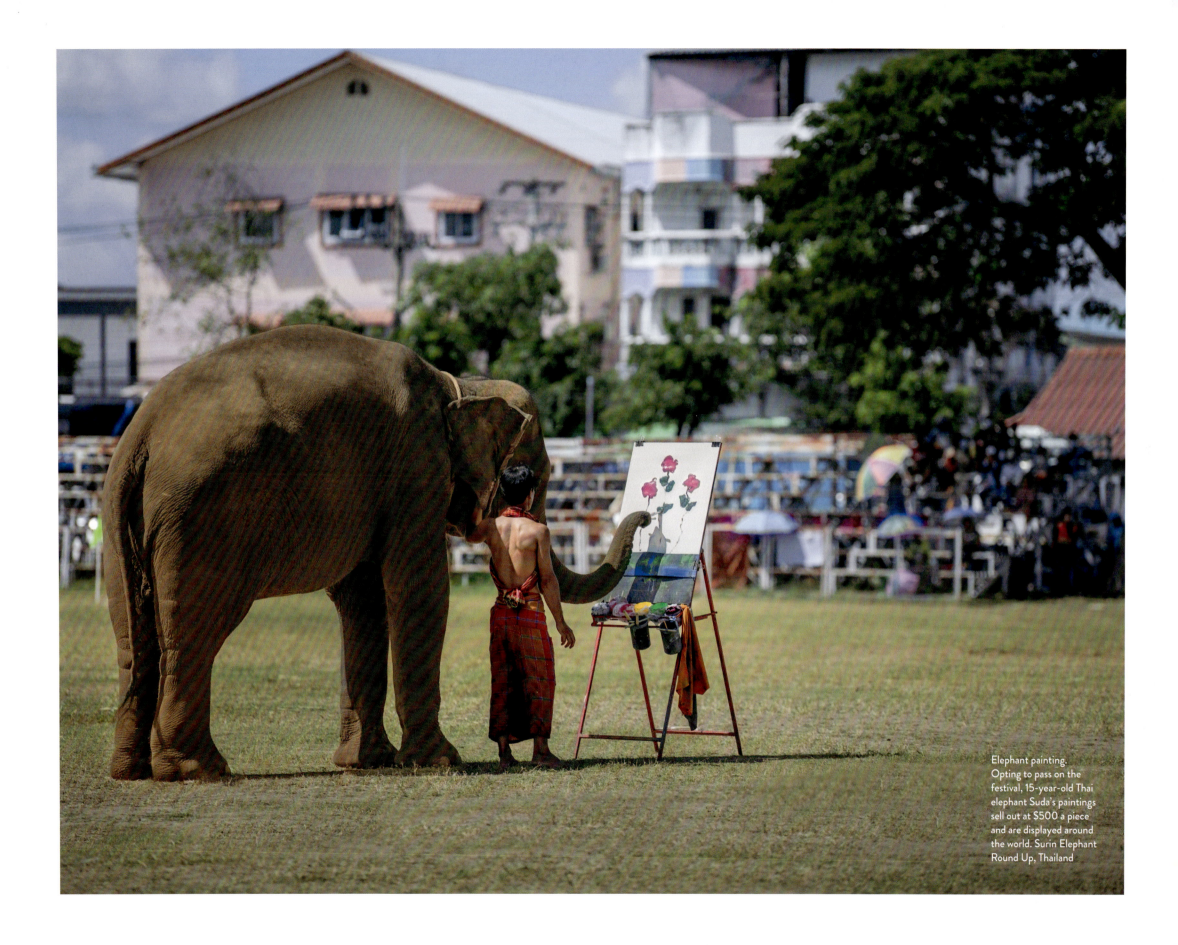

Elephant painting. Opting to pass on the festival, 15-year-old Thai elephant Suda's paintings sell out at $500 a piece and are displayed around the world. Surin Elephant Round Up, Thailand

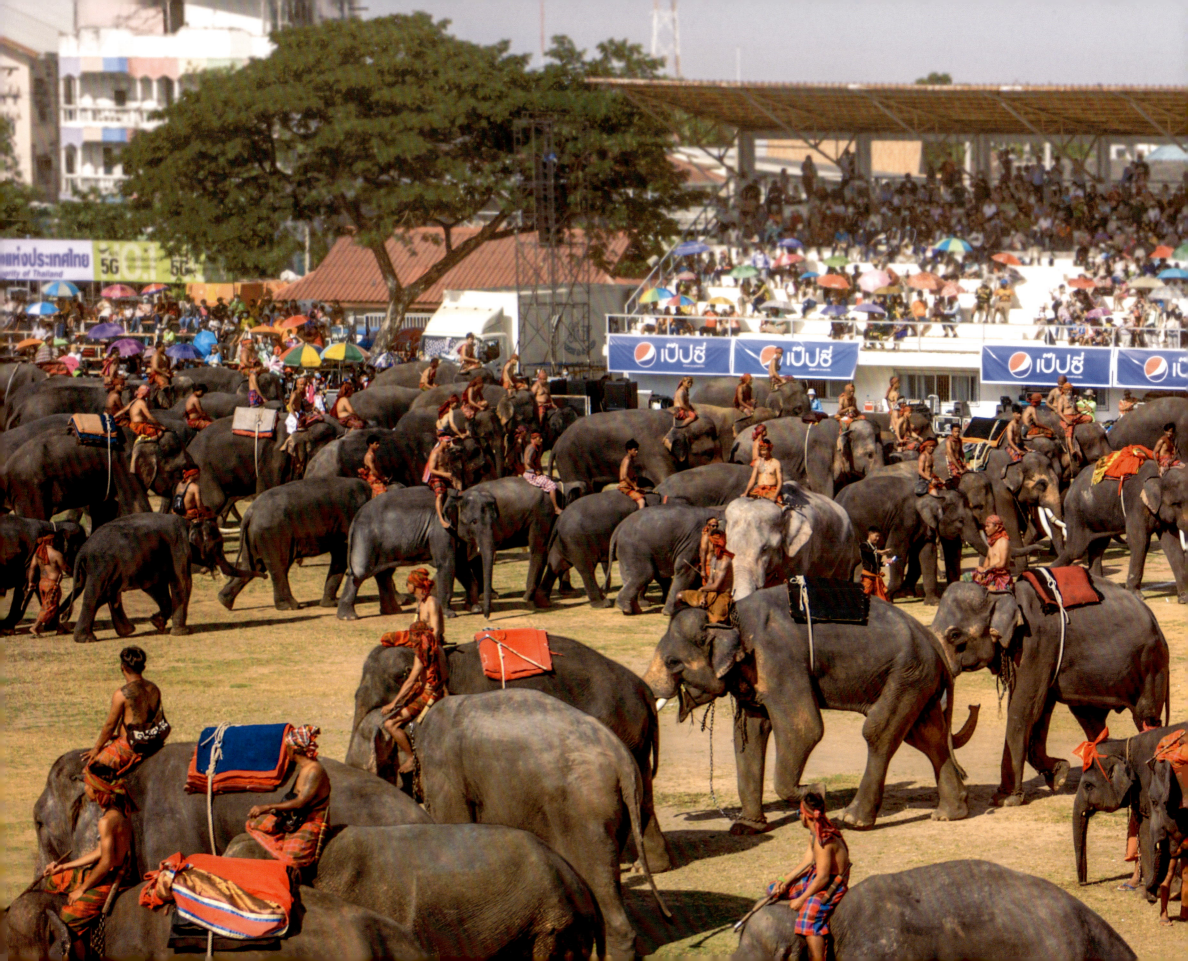

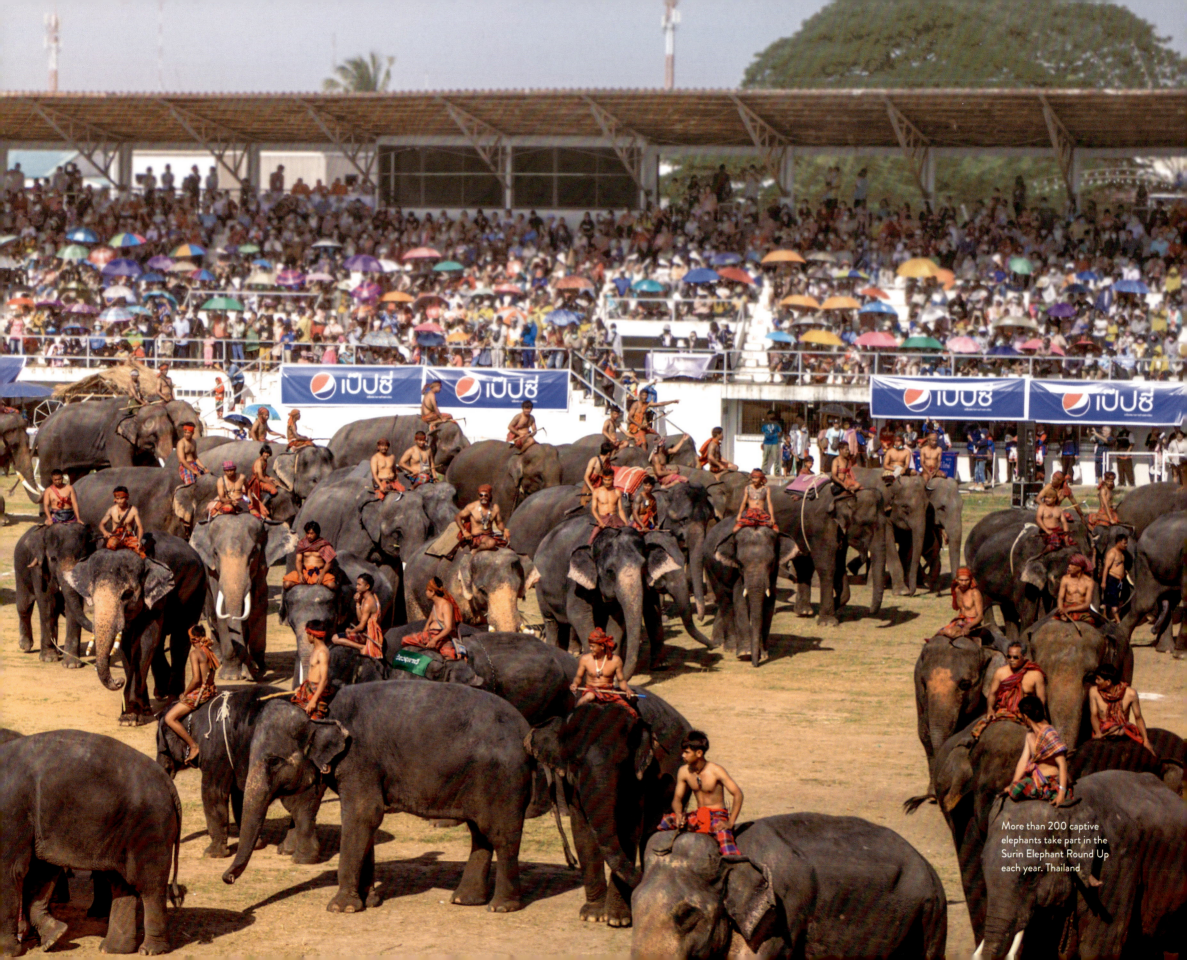

More than 200 captive elephants take part in the Surin Elephant Round Up each year. Thailand

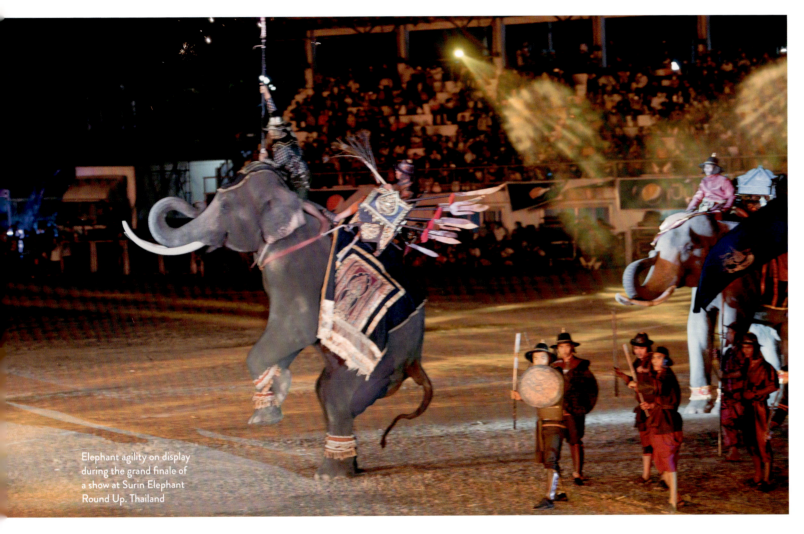

Elephant agility on display during the grand finale of a show at Surin Elephant Round Up, Thailand

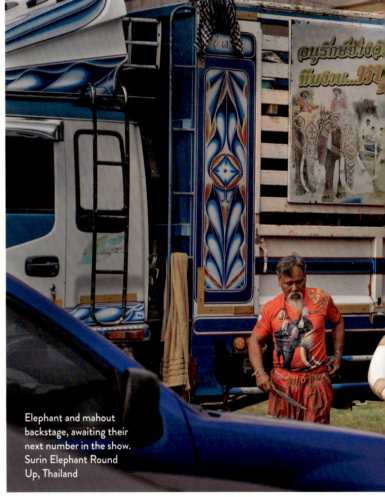

Elephant and mahout backstage, awaiting their next number in the show. Surin Elephant Round Up, Thailand

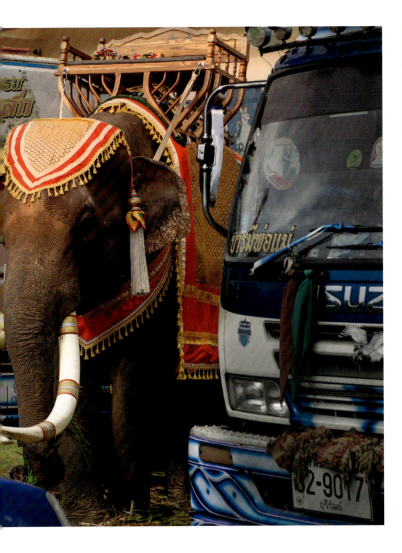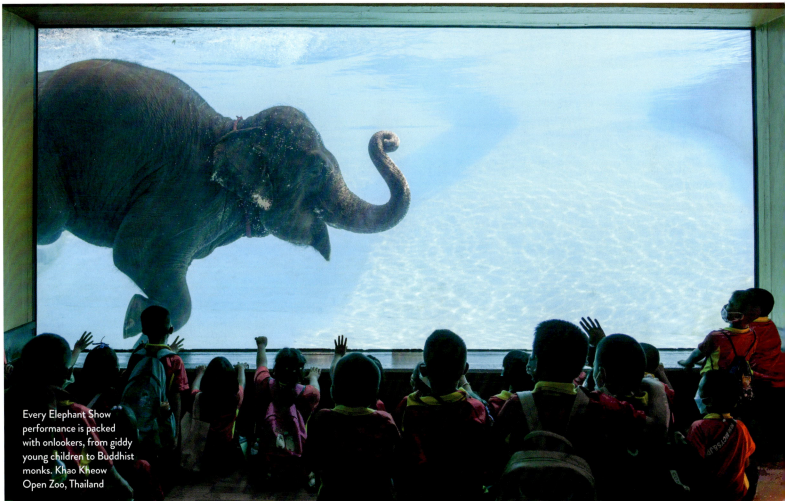

Every Elephant Show performance is packed with onlookers, from giddy young children to Buddhist monks. Khao Kheow Open Zoo, Thailand

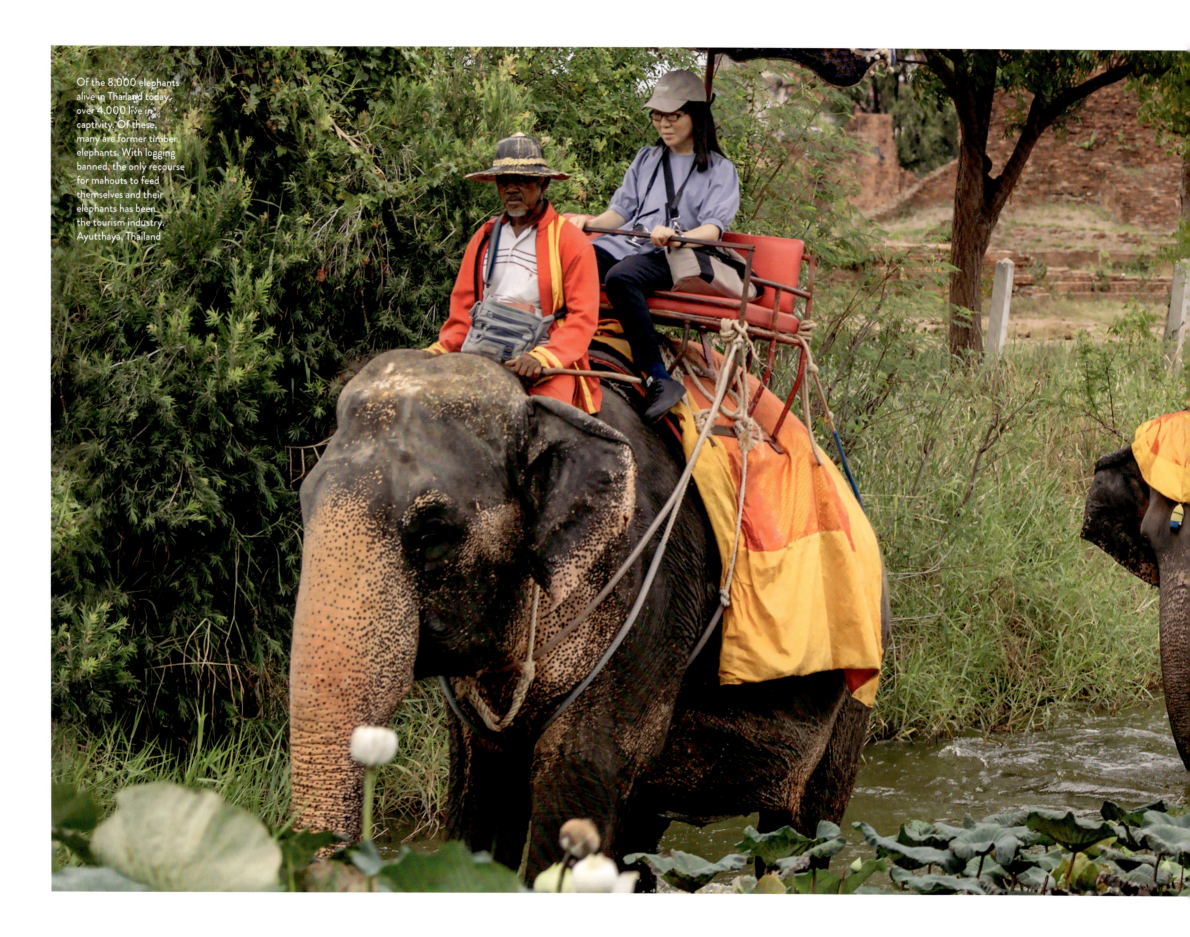

Of the 8,000 elephants alive in Thailand today, over 4,000 live in captivity. Of these, many are former timber elephants. With logging banned, the only recourse for mahouts to feed themselves and their elephants has been the tourism industry. Ayutthaya, Thailand

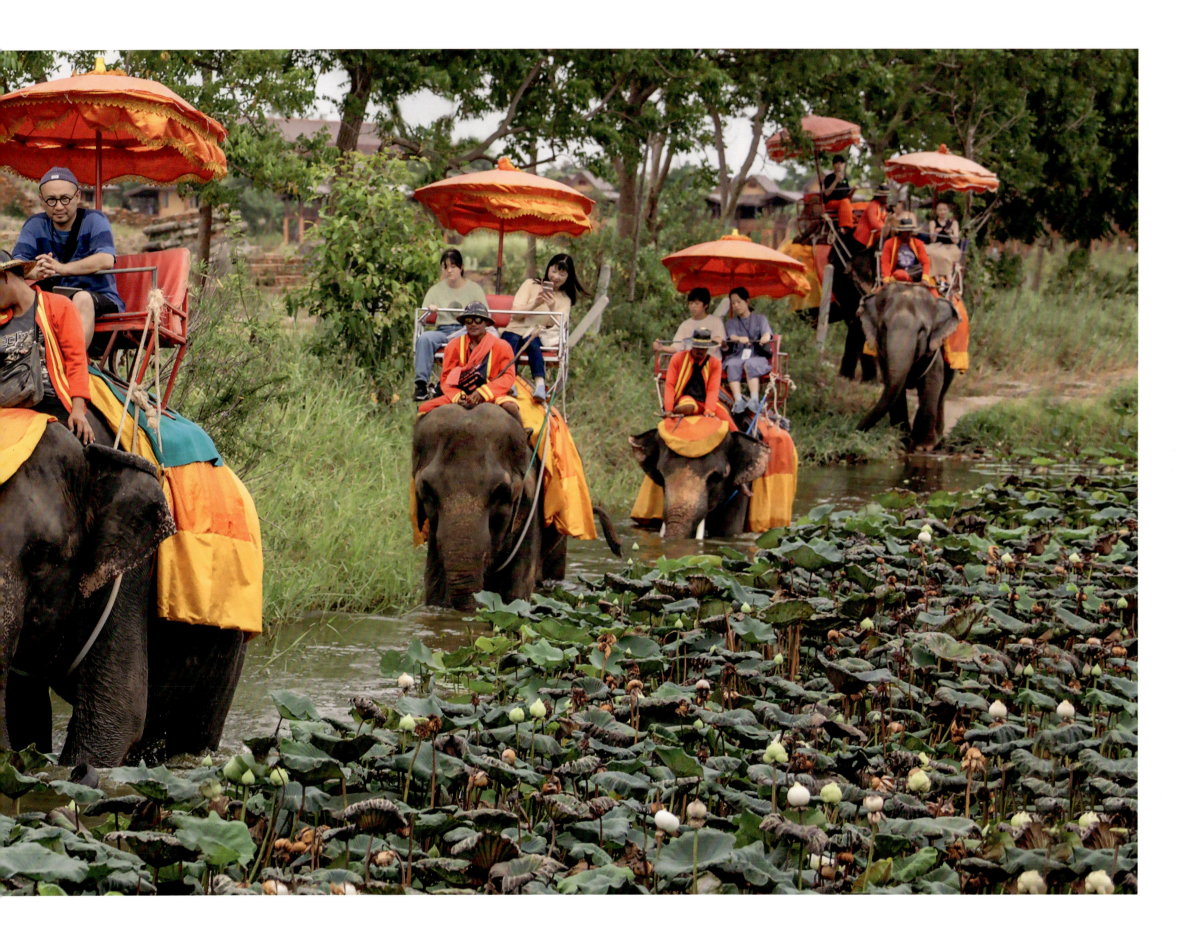

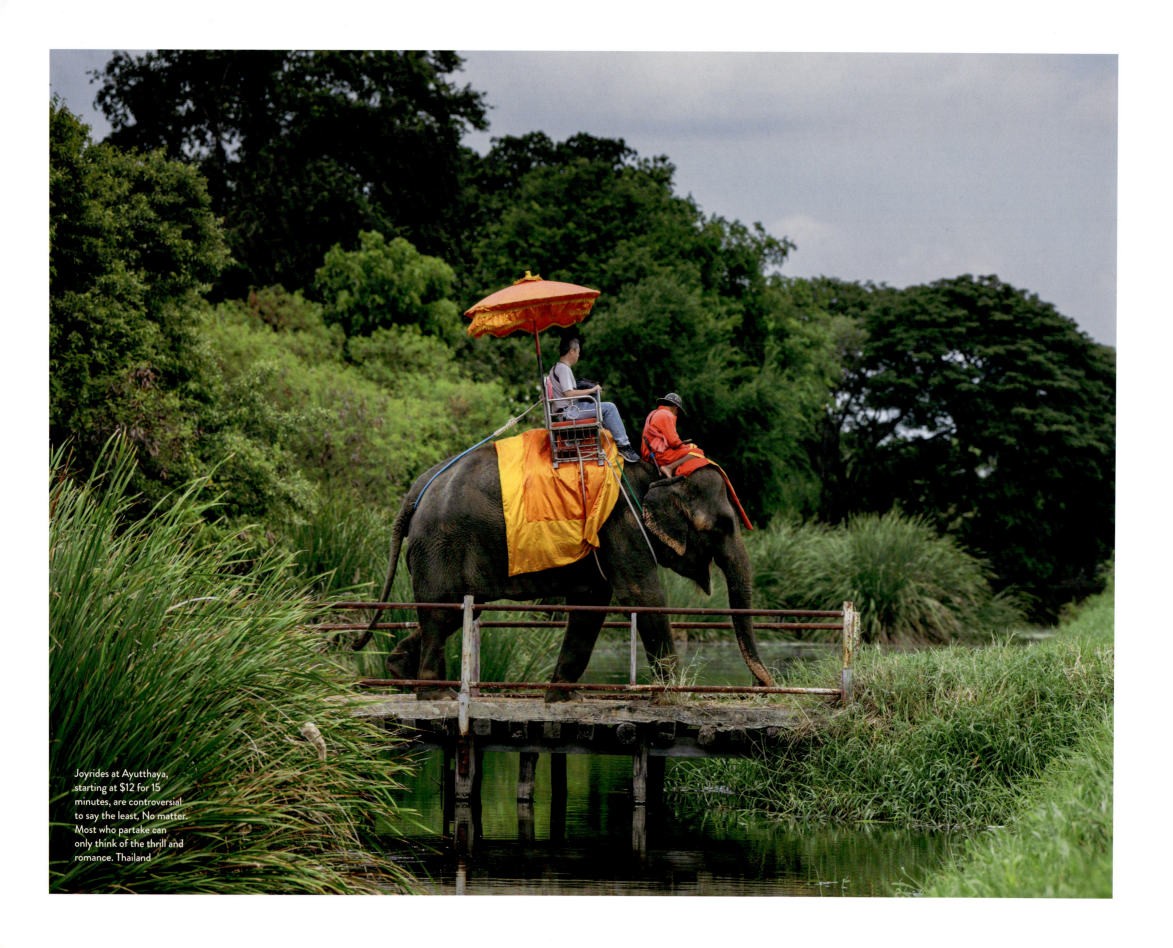

Joyrides at Ayutthaya, starting at $12 for 15 minutes, are controversial to say the least. No matter. Most who partake can only think of the thrill and romance. Thailand

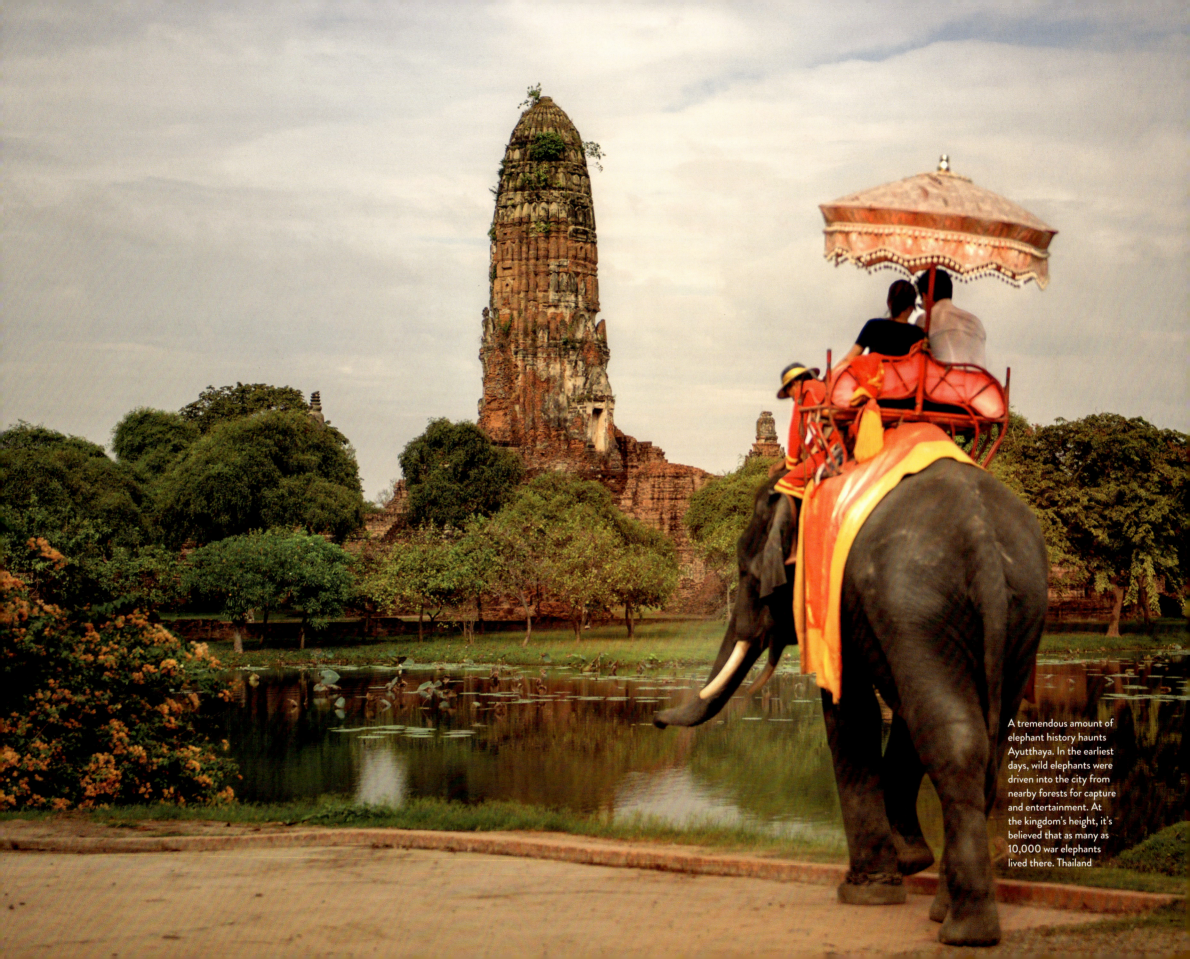

A tremendous amount of elephant history haunts Ayutthaya. In the earliest days, wild elephants were driven into the city from nearby forests for capture and entertainment. At the kingdom's height, it's believed that as many as 10,000 war elephants lived there. Thailand

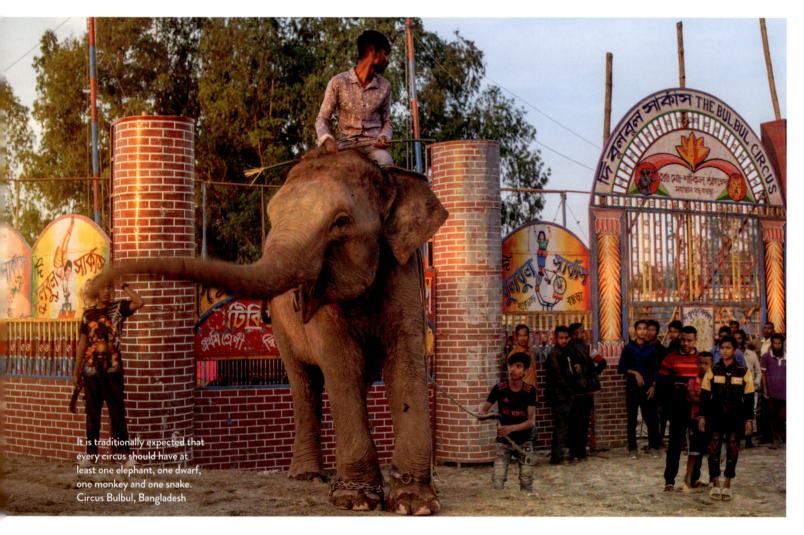

It is traditionally expected that every circus should have at least one elephant, one dwarf, one monkey and one snake.
Circus Bulbul, Bangladesh

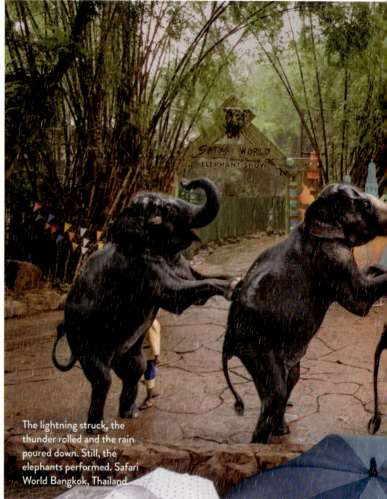

The lightning struck, the thunder rolled and the rain poured down. Still, the elephants performed. Safari World Bangkok, Thailand

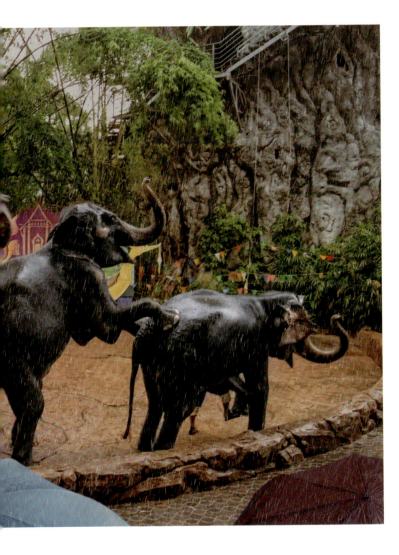
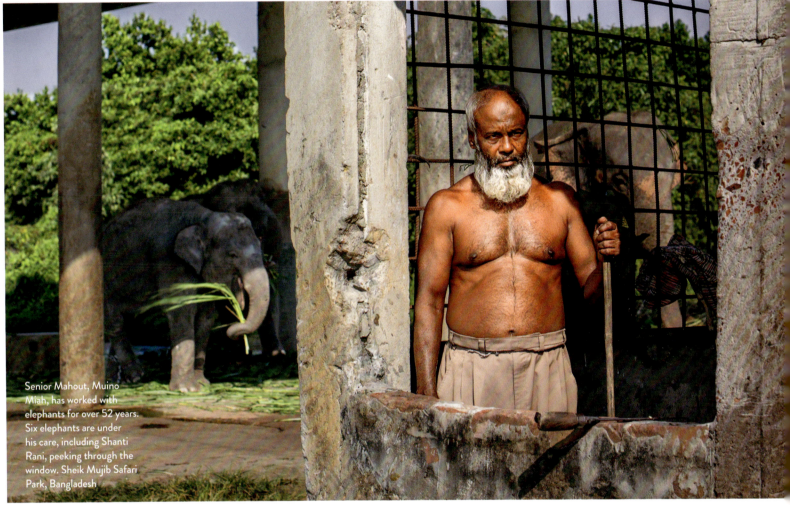

Senior Mahout, Muino Miah, has worked with elephants for over 52 years. Six elephants are under his care, including Shanti Rani, peeking through the window. Sheik Mujib Safari Park, Bangladesh

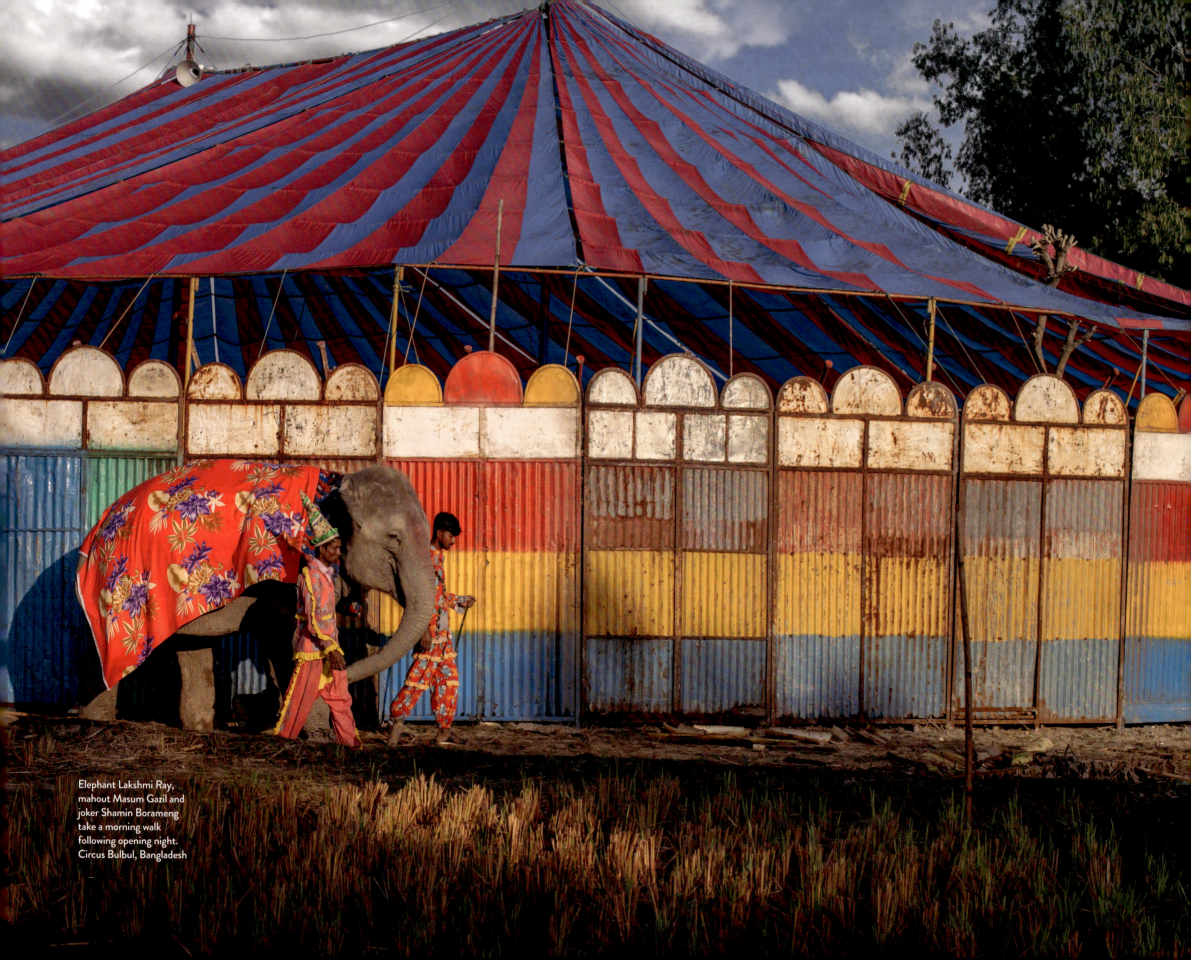

Elephant Lakshmi Ray, mahout Masum Gazil and joker Shamin Borameng take a morning walk following opening night. Circus Bulbul, Bangladesh

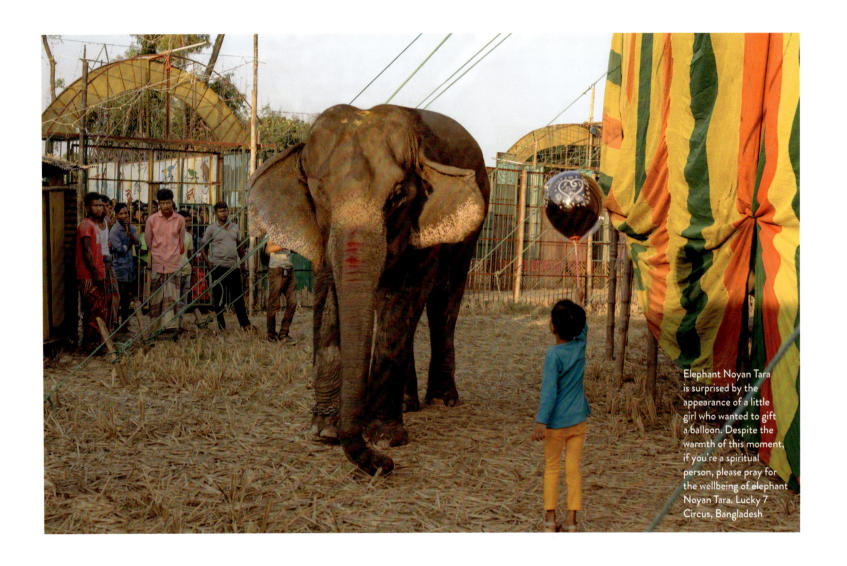

Elephant Noyan Tara is surprised by the appearance of a little girl who wanted to gift a balloon. Despite the warmth of this moment, if you're a spiritual person, please pray for the wellbeing of elephant Noyan Tara. Lucky 7 Circus, Bangladesh

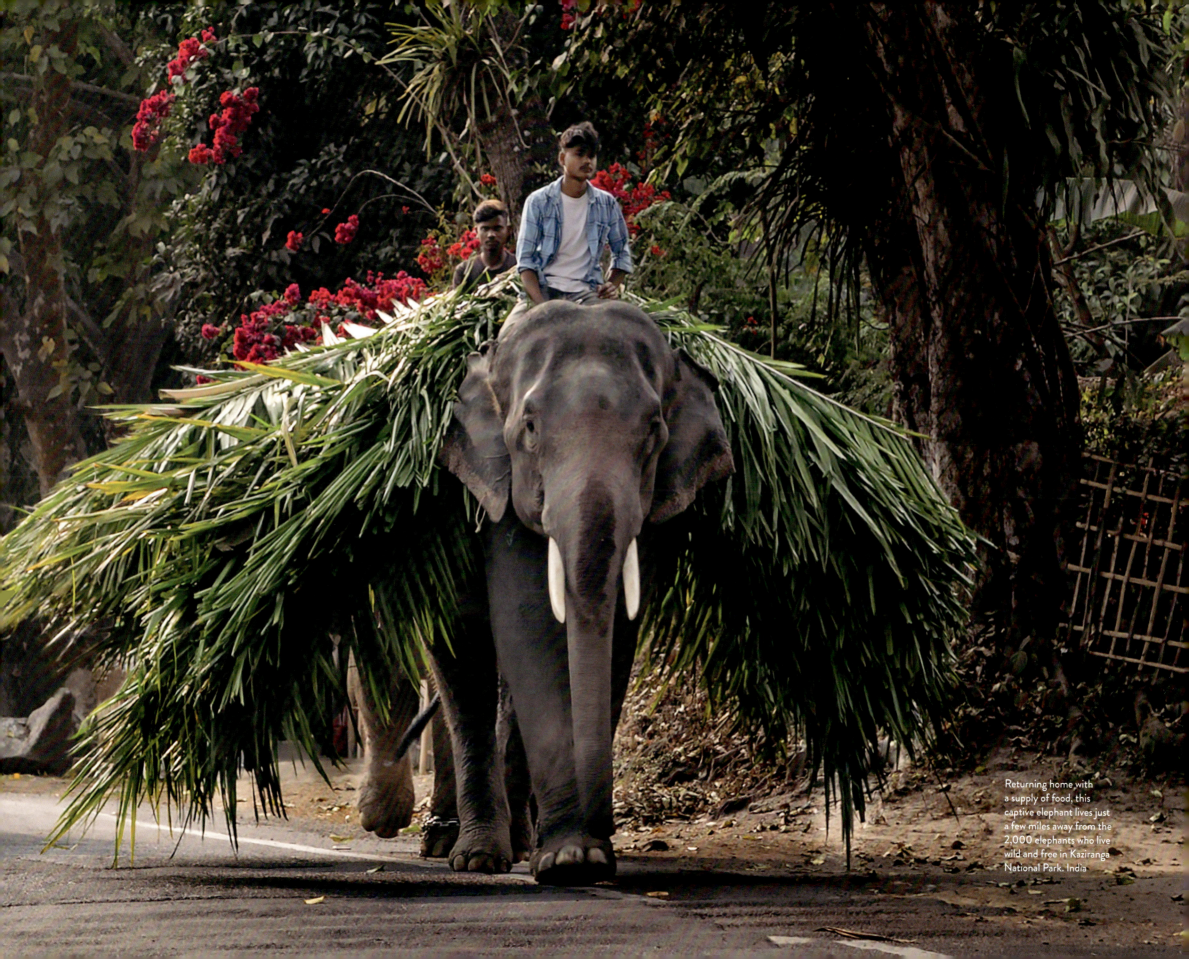

Returning home with a supply of food, this captive elephant lives just a few miles away from the 2,000 elephants who live wild and free in Kaziranga National Park, India

UNCLE BOO LOY
ELEPHANT SANCTUARY WORKER

The story of Boo Loy, a humble villager living in remote Thailand, begins with the story of another human being with humble beginnings, a person who grew up in a very different corner of the world, named Katherine Connor.

During a visit to Thailand from her native England, Connor volunteered at a hospital for elephants. It was here that she met a tiny elephant baby named Boon Lott. The baby had been born prematurely, his mother traumatized during an accident while working in the timber industry. Despite complications, the baby's lust for life was so infectious to Connor that she took it upon herself, exhausting all possible means, to try to save Boon Lott's life. But the baby's health was beyond recovery, and at age two years eight months, in Connor's arms, little Boon Lott passed away.

As Connor ran her hands over Boon Lott's body, her tears falling on his lifeless face, she uttered a promise: "I promised him I would go on to do everything in my power to help his kind. I promised him I would tell his story and that the world would know his name." And this promise has been fulfilled over and over again as Connor has gone on to create one of the world's most respected sanctuaries for elephants, and its name is recognized around the world: Boon Lott's Elephant Sanctuary (BLES).

Early on in the history of BLES, Connor married her late husband, a Thai man who was a mahout named Anon. Anon had an uncle named Boo Loy, a troubled man, notorious throughout the nearby village as being mentally ill, perceived as out of his mind. As life goes for such people throughout the world, the uncle was completely ignored, save by those who saw fit to bully him. His family saw no remedy other than to push him away. Day after day, alcohol and smoking fuelled his madness as he sat alone or roamed the streets engaged in endless conversations with himself. Confusion and anger had overcome the once humble man known as Boo Loy.

Remarkably, as construction of BLES unfolded, Boo Loy began showing up to help. He took part in planting trees and in construction projects. Though he claimed to have never held down a job in his life, he seemed to be taken by the idea of a sanctuary for elephants. However, he made one thing perfectly clear over and over: "I cannot be a mahout, because I'm too stupid." The smoking and drinking continued.

By and by, one of the first elephants to be taken in by BLES was an 80-year-old

This narrative was constructed from several interviews by the author and photographer of Katherine Connor, founder and director of Boon Lott's Elephant Sanctuary, Ban Tuek, Thailand

victim of the timber industry, Mare Boon Mee. Her rehabilitation was a lot to take on. She had severe problems with her teeth that had gone ignored by her owner, and these problems had nearly led to her death. To make matters worse, she had lived and worked in isolation for most of her life, not having even seen another elephant for the past 25 years. On the BLES property, she was most comfortable by herself, avoiding the company of any other living beings, commonly preferring to spend a lot of time alone in her stable.

In those early days, Connor developed a routine of using the downtime of lunch hour to check up on Mare Boon Mee. On one especially hot day that Connor will always remember, "Mare Boon Mee had ventured deep into the nearby bushes. I could hear her ears flapping, and then I heard something else, a voice, a man's voice. Nervously, I moved forward and then I found them, Mare Boon Mee, happily grazing, and Boo Loy, peacefully sitting by her feet, peeling bananas for her, talking and smiling."

As construction continued, the touching lunchtime rendezvous between man and elephant became a regular occurrence. Connor's appreciation of what she was witnessing grew into an idea. Both Connor and Anon proceeded to spend hours trying to convince Boo Loy to take the job of Mare Boon Mee's mahout. Anon assured Boo Loy that he would teach him all he needed to know. But over and over, Boo Loy refused, always referring to how stupid he was, how he'd never held a job or how he wasn't good enough.

Then Connor said some magic words: "I said that he really didn't have a choice because Mare Boon Mee had chosen him." Boo Loy went quiet, and after a moment agreed to take care of Mare Boon Mee for a few weeks, just until a real mahout could be hired. In the end, Boo Loy took care of Mare Boon Mee for the final four years of her life. And in exchange, she taught him how to be a mahout, how to have purpose in his life. He stopped drinking. He stopped smoking. And he became a truly happy man, a man who took pride in his life with Mare Boon Mee. The transformation of both man and elephant eventually led to Mare Boon Mee learning to enjoy the company of other elephants, and she finally found her place in the BLES family.

Though Mare Boon Mee's passing brought sadness, that same month, two additional rescued elephants arrived at BLES. Connor and Anon had discovered the first of the two elephants quite accidently, while they were out looking into the plight of another elephant. As they first laid eyes on her, they saw that she was limping, with half of one of her feet blown away by a landmine. To make matters worse, blood was dripping down over her face from puncture wounds inflicted by her vicious mahout. Despite her hardships as a logging and trekking elephant, the elephant known as Wassana carried with her a strong spirit and physical strength.

Just days following the passing of Mare Boon Mee and the arrival of Wassana, Boo Loy sought Connor out. With a huge smile on his face and determination in his voice, he announced that he would be Wassana's mahout. When Connor offered up the idea that the other elephant might be a better fit, Boo Loy stood firm. When Connor questioned Boo Loy as to how he could be so certain that the relationship between he and Wassana would work out, without flinching, he stated, "She has chosen me."

As of the publication of this book, Boo Loy and Wassana have been together for 15 years. Among all who know BLES, they are known as 'The Honeymoon Couple.' They love each other. And each is protective of the other, with Wassana constantly keeping an eye on Boo Loy. If for some reason Wassana loses sight of her partner, she immediately stops whatever she is doing to seek him out.

As Connor has stated, "It's not always the humans saving the animals here. It's a never-ending circle of healing energy. The elephants heal the humans, just as much as we help heal them."

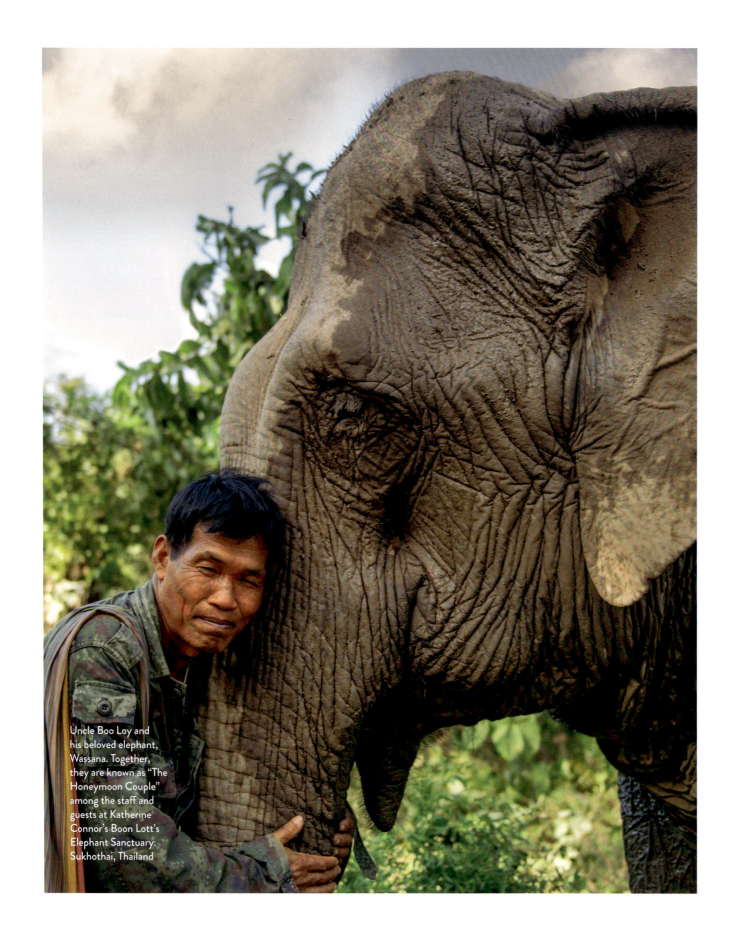

Uncle Boo Loy and his beloved elephant, Wassana. Together, they are known as "The Honeymoon Couple" among the staff and guests at Katherine Connor's Boon Lott's Elephant Sanctuary. Sukhothai, Thailand

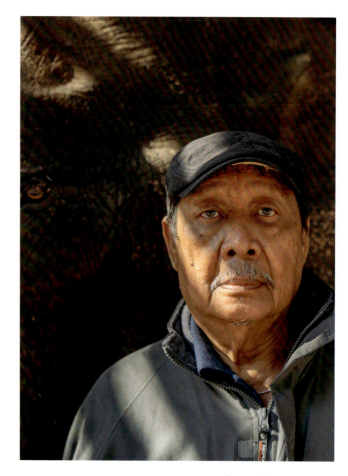

Preecha Phongkum graduated university at the age of 18 and went on to live a legendary life of caring for elephants. In the field, he worked at the Young Elephant Training Centre. In treatment, he has been the longstanding lead veterinarian at the Thai Elephant Conservation Centre. Thailand

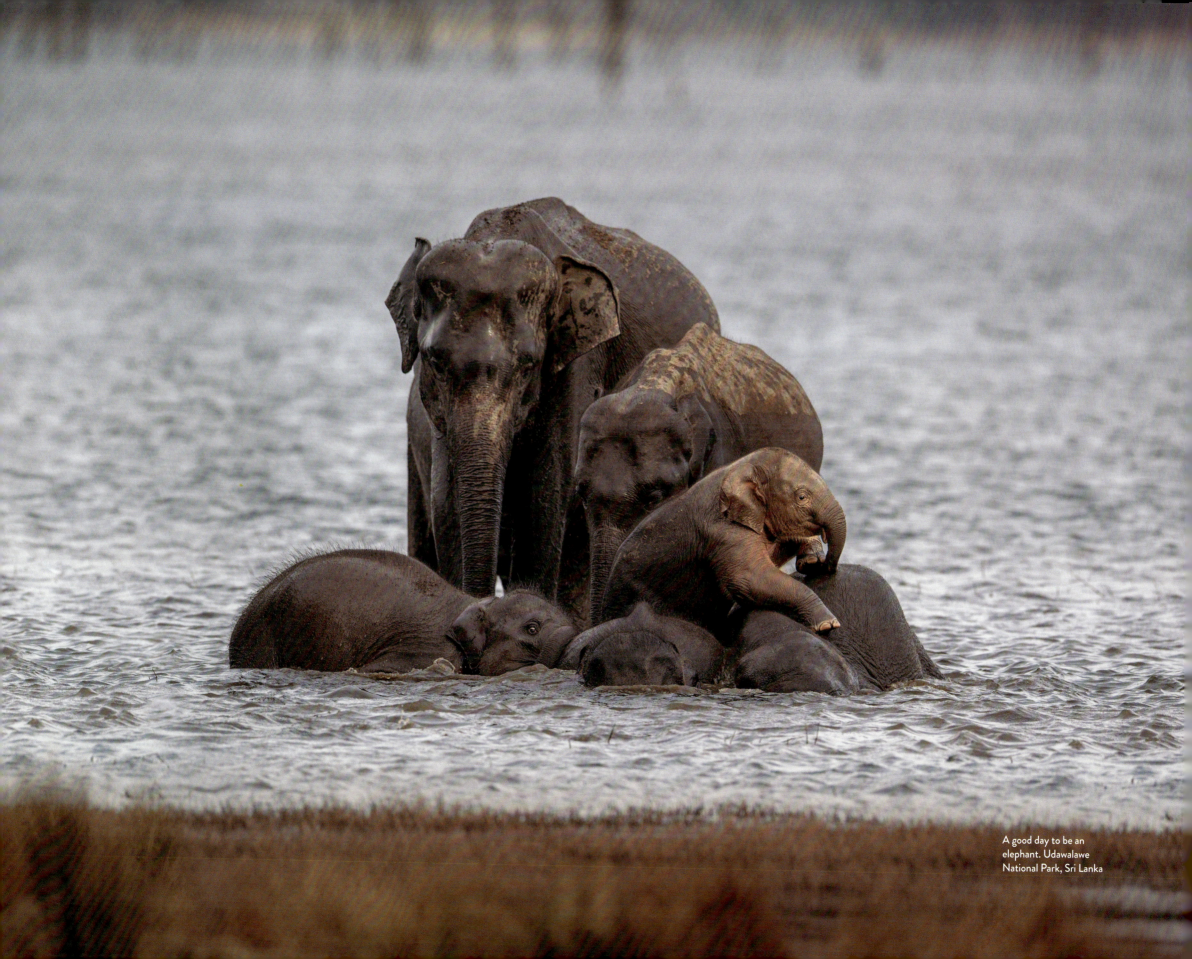

A good day to be an elephant. Udawalawe National Park, Sri Lanka

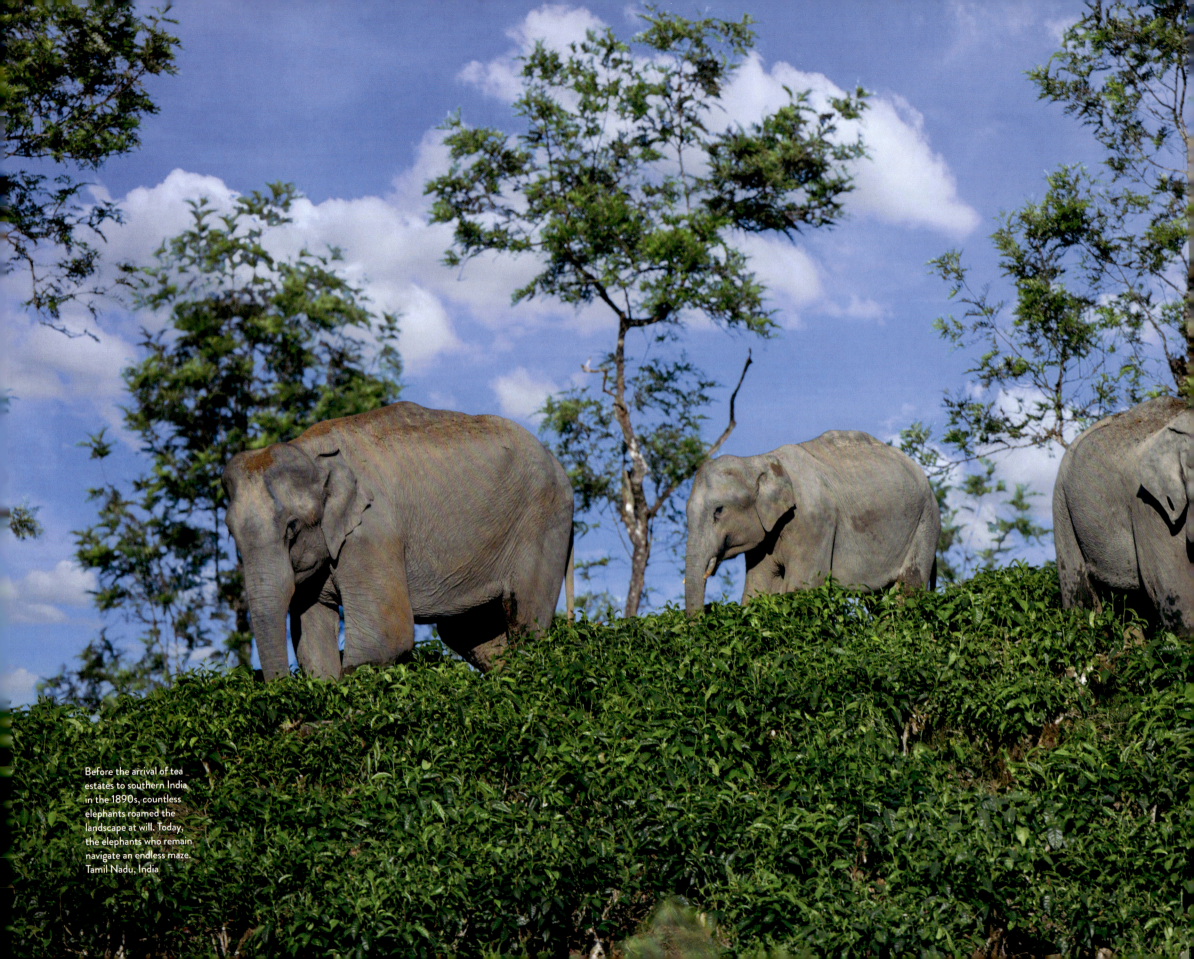

Before the arrival of tea estates to southern India in the 1890s, countless elephants roamed the landscape at will. Today, the elephants who remain navigate an endless maze. Tamil Nadu, India

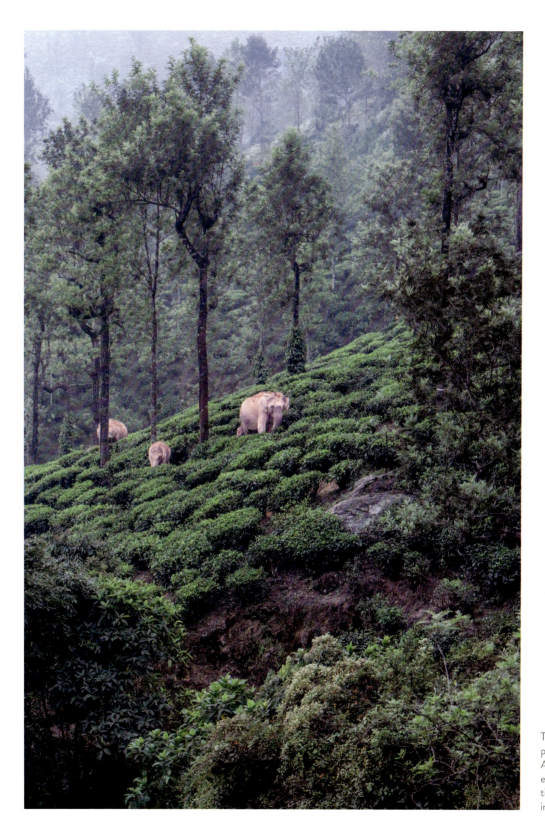

Tea estates cultivate every possible inch of their land. And the footsteps of elephants can be seen at one time or another on every inch. Tamil Nadu, India

(Top)
Among favourite activities for elephant, tourist and volunteer alike is elephant bathing. Sri Lanka

(Bottom)
Though water is present, bathing is not available at this tourist attraction, where stunts for the camera dominate the elephant's time. Phuket, Thailand

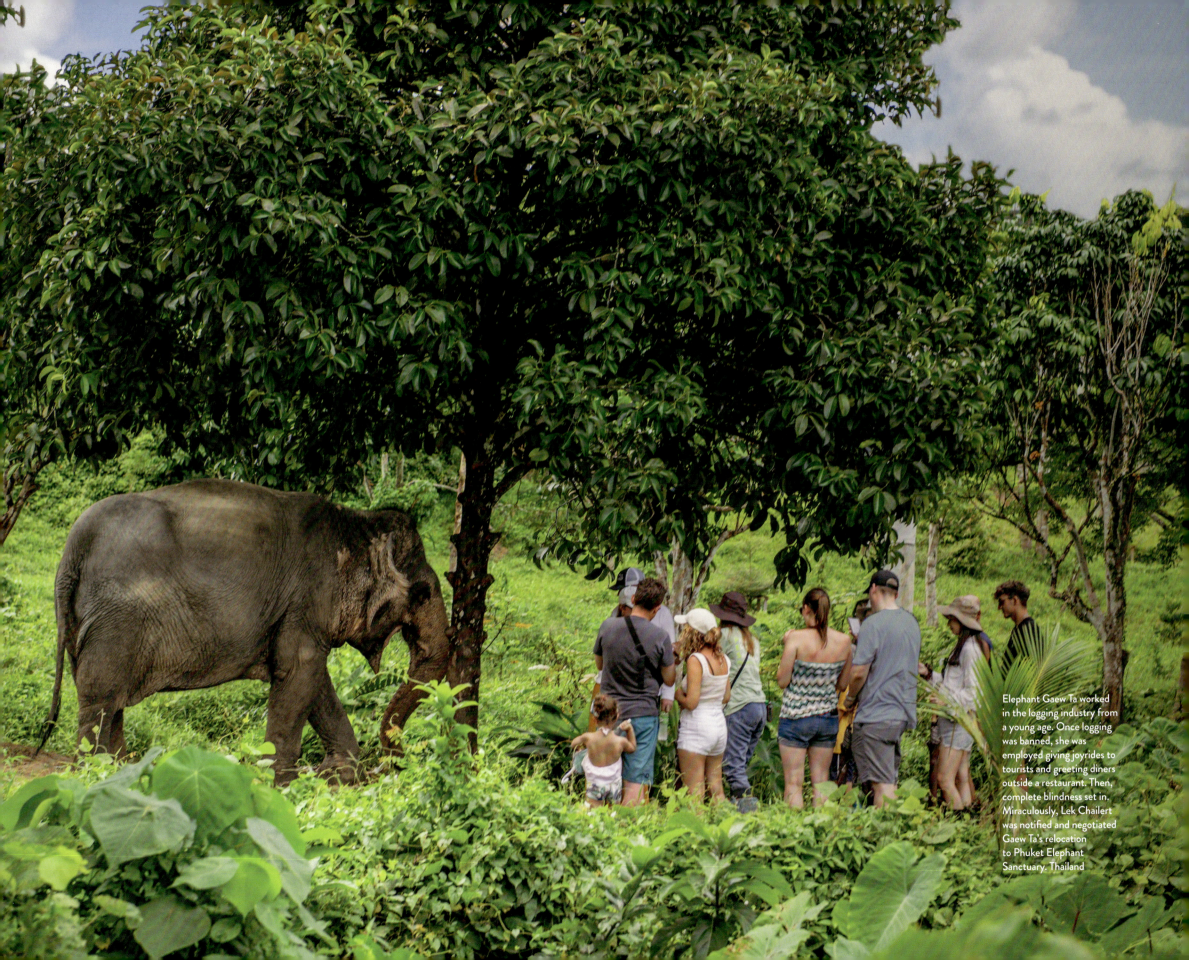

Elephant Gaew Ta worked in the logging industry from a young age. Once logging was banned, she was employed giving joyrides to tourists and greeting diners outside a restaurant. Then, complete blindness set in. Miraculously, Lek Chailert was notified and negotiated Gaew Ta's relocation to Phuket Elephant Sanctuary, Thailand

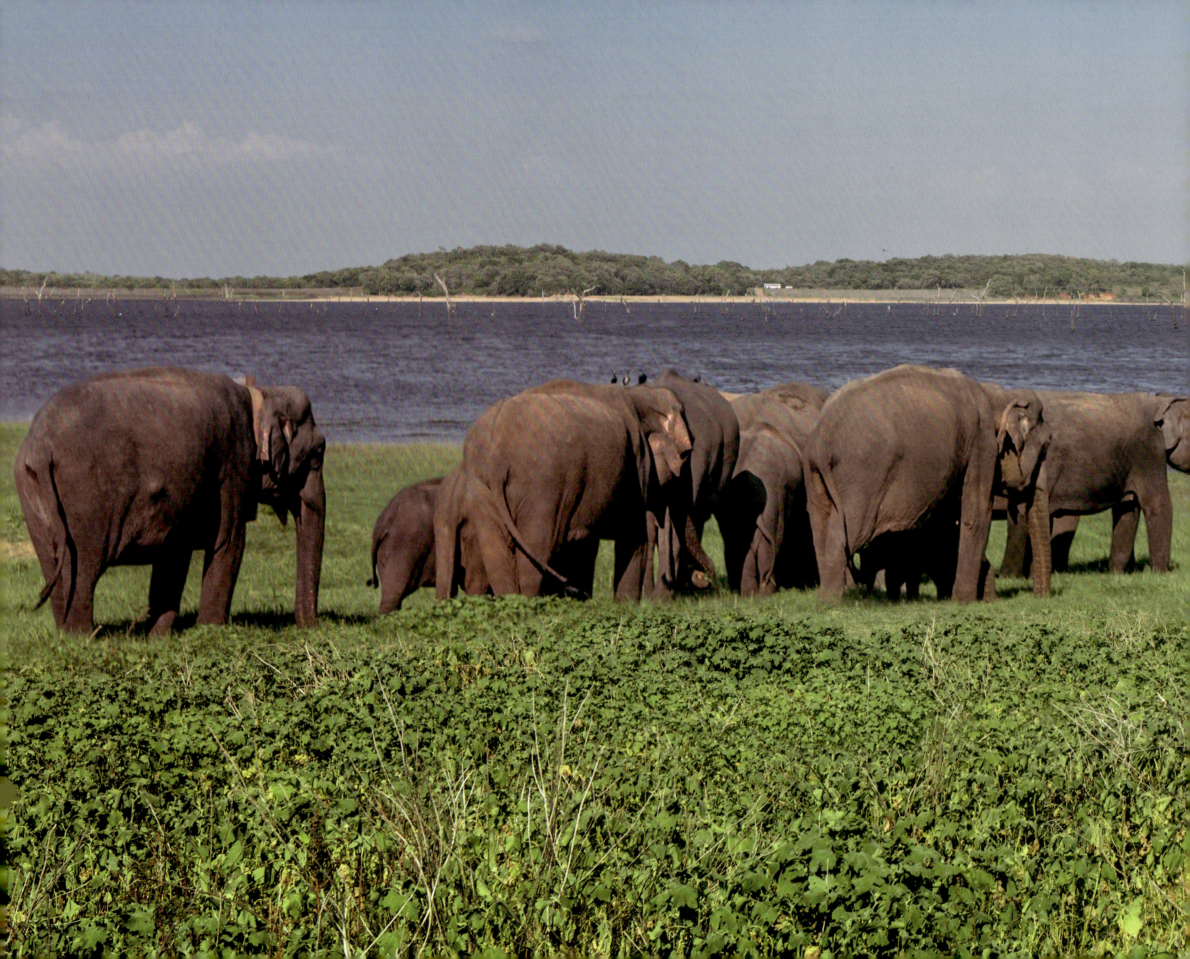

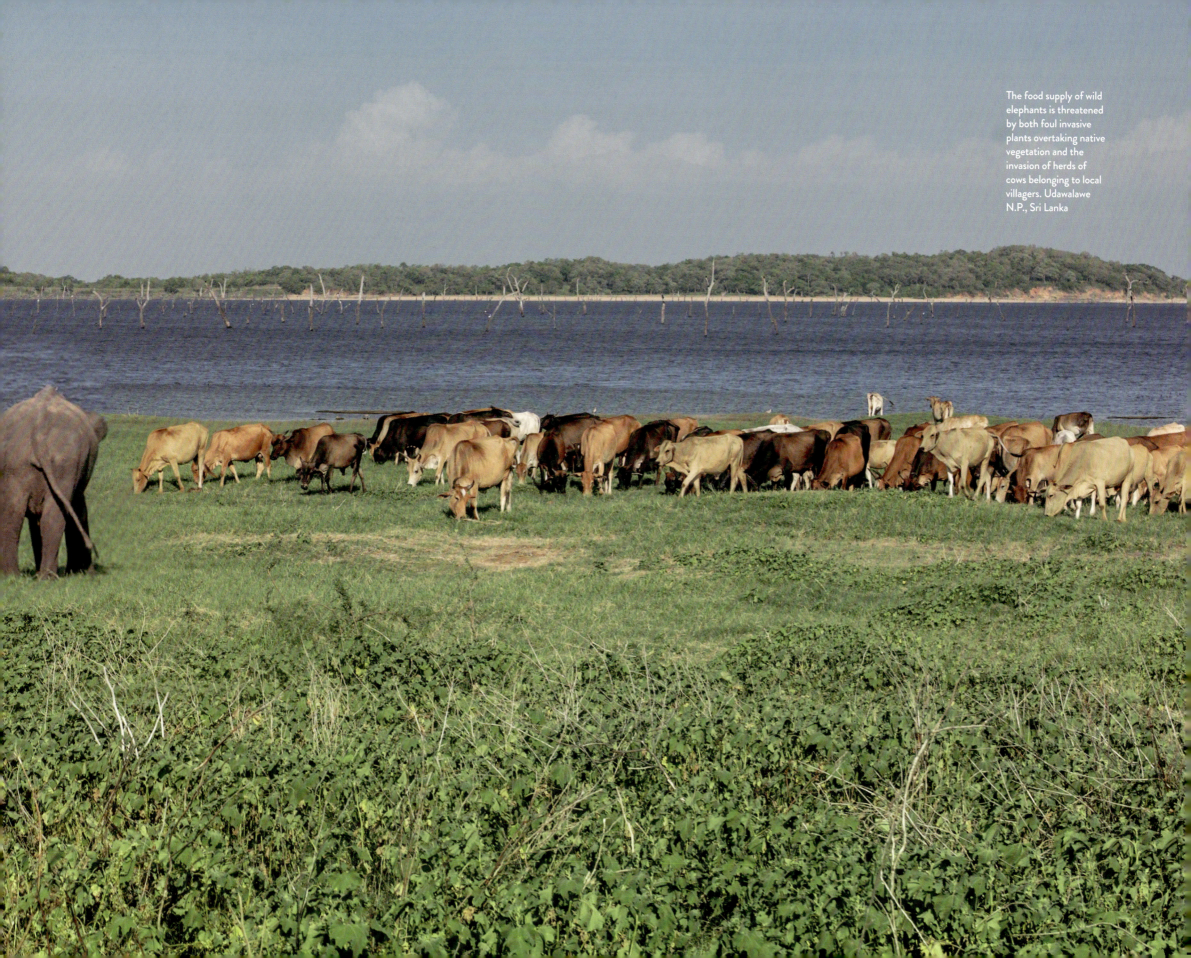

The food supply of wild elephants is threatened by both foul invasive plants overtaking native vegetation and the invasion of herds of cows belonging to local villagers. Udawalawe N.P., Sri Lanka

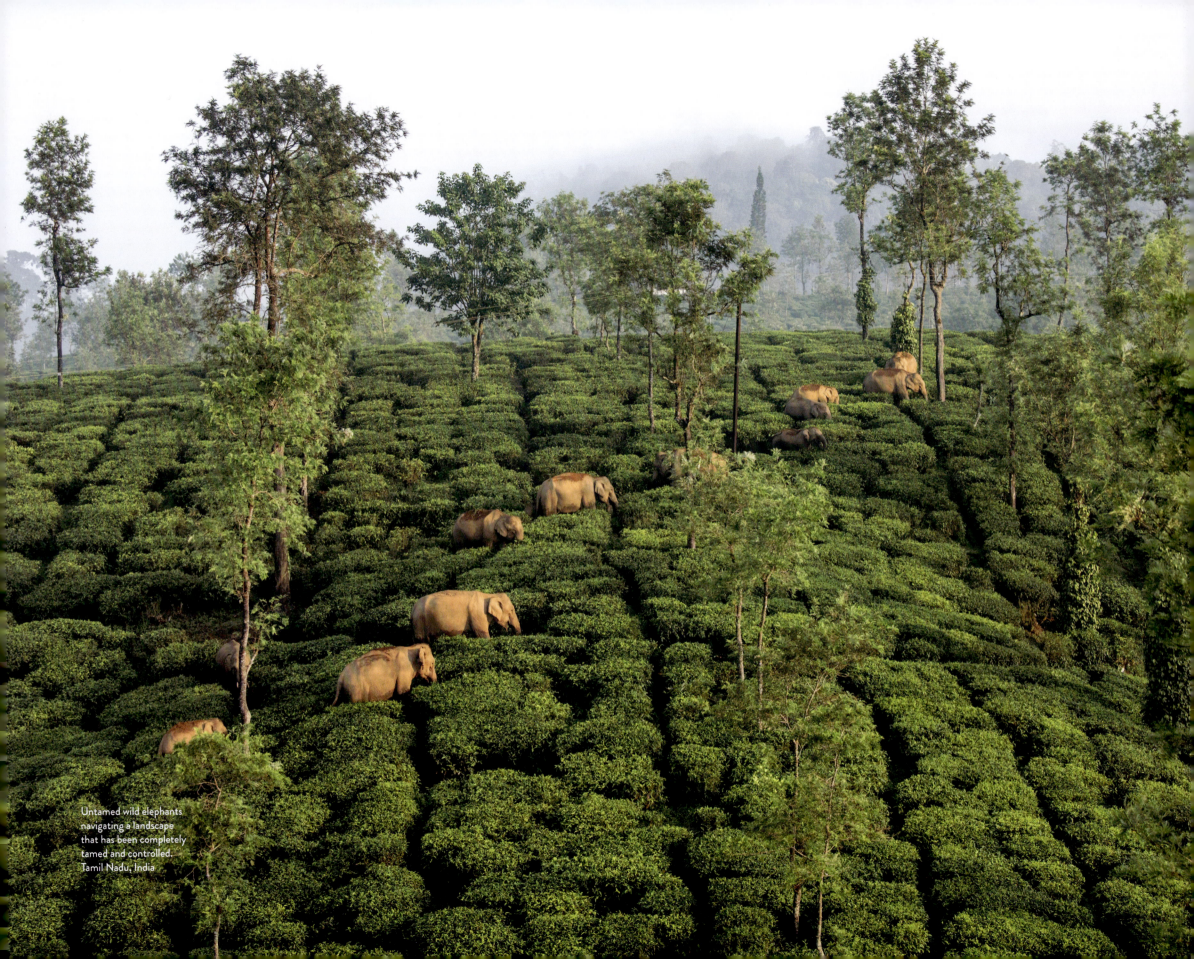

Untamed wild elephants navigating a landscape that has been completely tamed and controlled.
Tamil Nadu, India

AFTERWORD

Elephants today cling to life in 13 of their original 19 Asian range countries. With the exception of India, these nations are home to elephant populations numbering only in the few thousand or few hundred, and in some cases just a few dozen. In each of the 13 nations, their fight to survive as a species is perilous.

Wild Asian elephants in today's world are not living free in the true sense of the word. Human beings assault them daily by taking still more of their remaining habitat and threatening them directly with violence.

Meanwhile, the populations of captive elephants throughout the nations of Asia also face uncertain futures. Almost one out of every three Asian elephants today lives in captivity. While human beings around the world continue to wrestle with how to treat each other, it comes as no surprise that we are still learning how to relate to captive elephants. Thousands of elephants across Asia still live in chains. To the Western mind, the sight of this conjures up thoughts of the demon slavery. And why not? Slavery knows no bounds in its 11,000-year history, as a multitude of races, colours and creeds have suffered. It is clear that the human being has imposed the same wicked justifications on the captive elephant as we have done on each other.

In order to ensure that Asia's elephants survive this century, we humans have to acknowledge a few things. Both elephants and humans appeared on this earth a long time ago, both having evolved from other species. In time, both of us had the drive to explore the earth and populated most of it. Ironically, elephants are among the animals of this earth that are most like us. Despite the great size differential, we both walk this earth with great intelligence, constantly thinking, adapting to our surroundings and using information passed from generation to generation. We both survive and thrive using complicated social networks, constantly communicating with each other in a variety of ways. And still other similarities include the value of the family unit, the experience of emotions and daily use of our memories.

Elephants, however, are not like us at all in one important regard. They can recognize the greater good. They have always lived in relative harmony with other animals, rarely killing, and on countless occasions coming to the aid of other species in peril. As vegetarians living on a variety of plant life, elephants have always been critical in maintaining the balance of nature in every landscape they live in. In their family units, they are always aware of each other's well-being and acting accordingly. Their daily demonstrations of love and care for each other make good reminders for each of us in the human family of how we can be better.

While it has been my intent here to present a comprehensive account of Asia's elephants in the 21st century, there are individuals and organizations positioned around the planet, positioned in roles of strength and influence, to ensure that the elephants of Asia survive the 21st century. They are biologists, veterinarians, researchers, government officials and most notably everyday human beings. Almost all have left successful careers in other areas, taken time away from their families and completely restructured their lives to stand up for the beleaguered elephants of Asia.

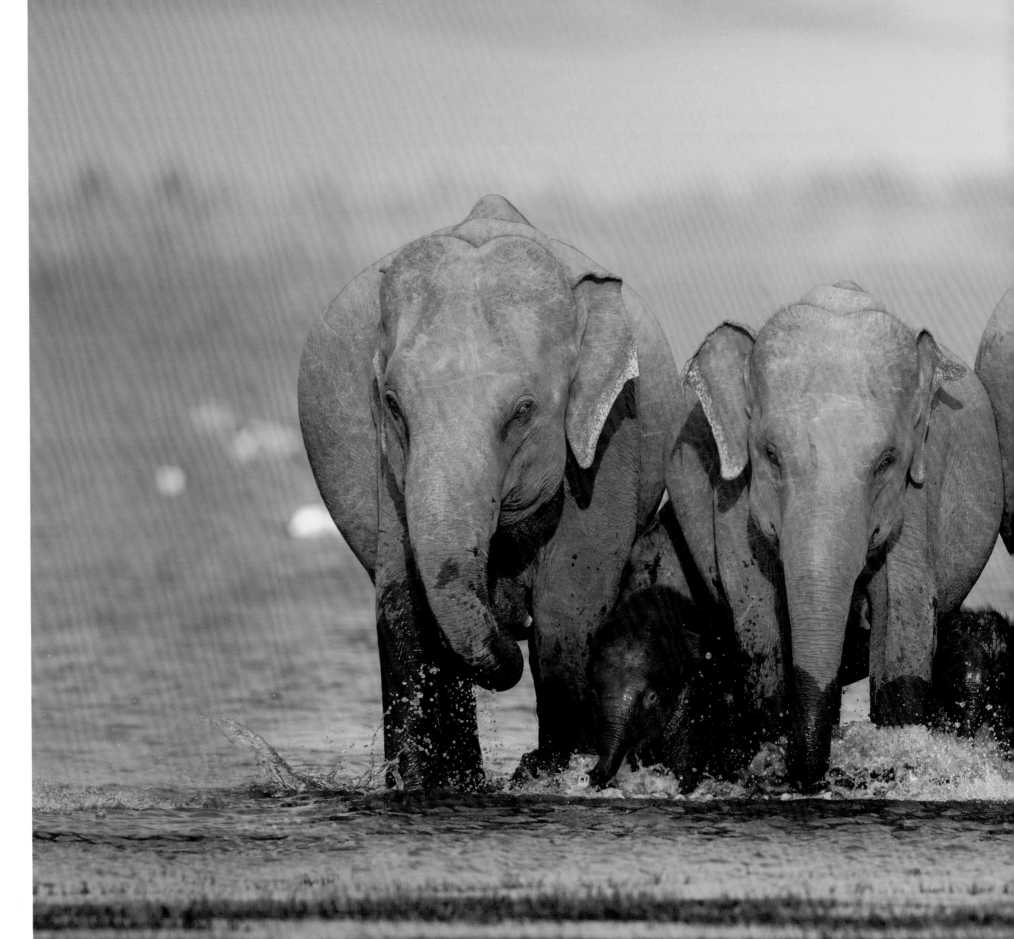

Playtime complete, a family of elephants charges ashore to get a bite to eat. Udawalawe N.P., Sri Lanka

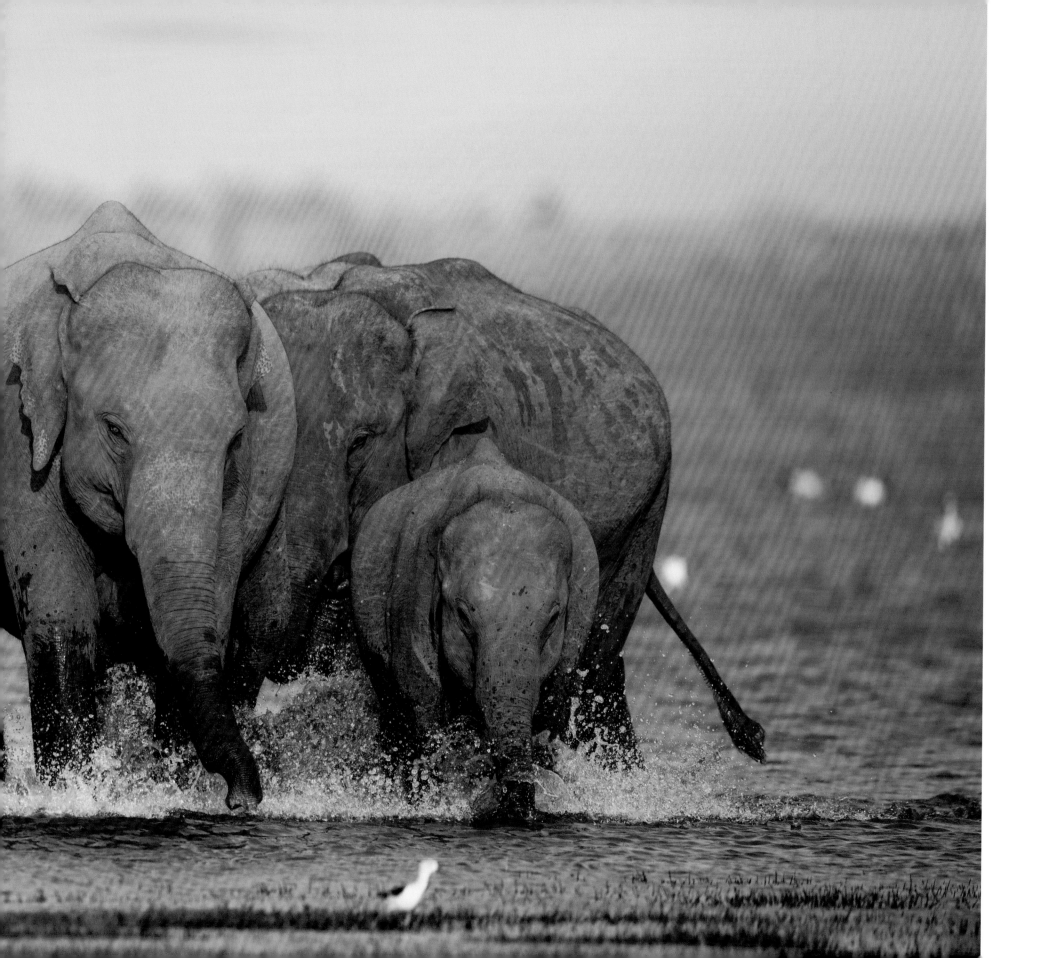

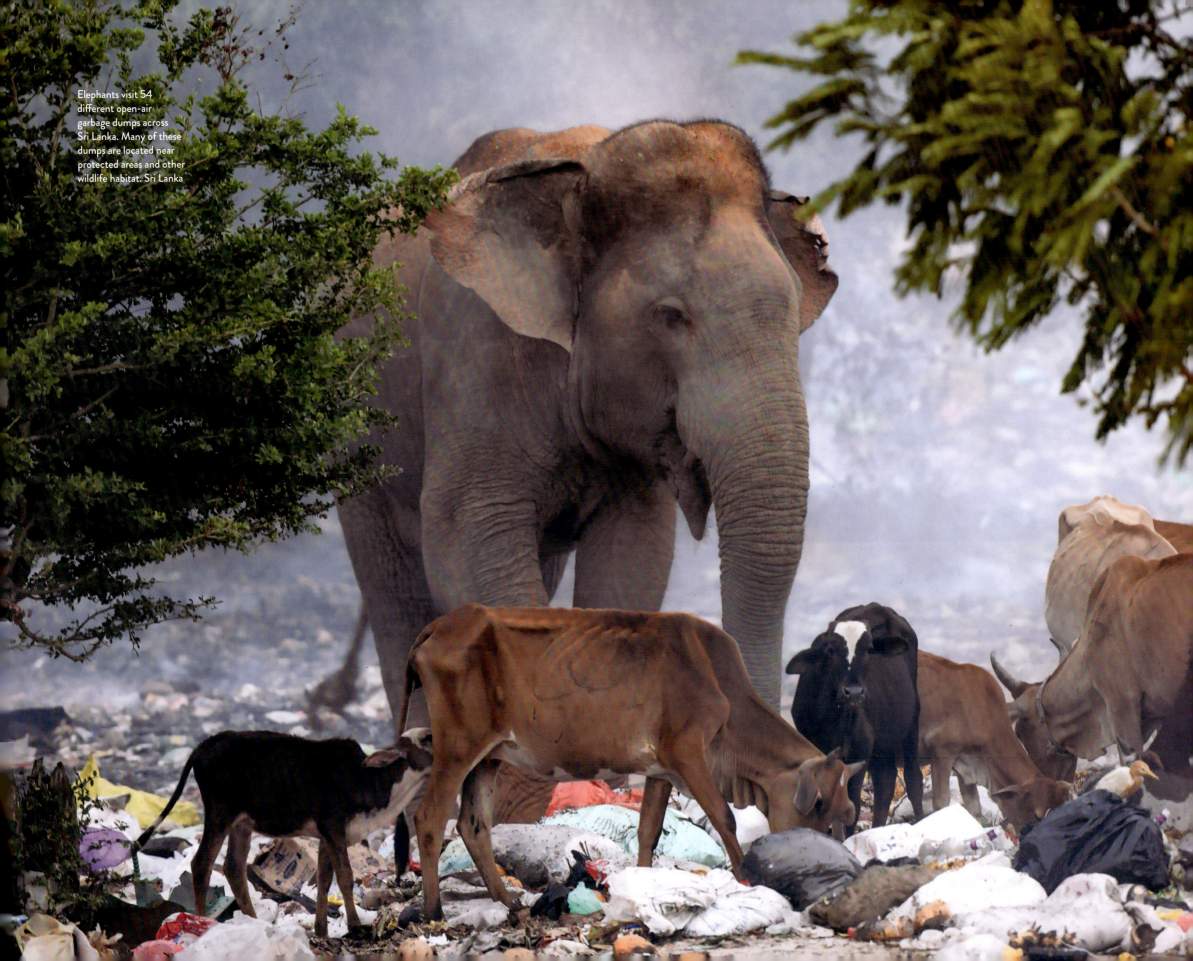

Elephants visit 54 different open-air garbage dumps across Sri Lanka. Many of these dumps are located near protected areas and other wildlife habitat. Sri Lanka

YOU CAN HELP

With the hope that you too might join me in supporting these caring human beings and organizations, an abbreviated list follows.

Action for Elephants UK
Animals Asia Foundation
Asian Elephant Specialist Group
Asian Elephant Support
Asia Wild
Boon Lott's Elephant Sanctuary
Born Free Foundation
Centre for Conservation and Research, Sri Lanka
EleAid
ElefantAsia
Elephant Family

Future for Elephants e.V.
MandaLao Elephant Conservation
The Nature Conservancy – Asia Pacific
Save Elephant Foundation
Save the Asian Elephants
Stand Up 4 Elephants
Sumatran Elephant Conservation Initiative
Voices for Asian Elephants
Wildlife and Nature Protection Society, Sri Lanka
Wildlife SOS

Your donations and your sharing the names of these organizations with others makes a difference. And if you're feeling adventurous, I invite you to volunteer for a few days, a few weeks, at one of the elephant sanctuaries. I've seen with my own eyes, over and over again, the difference your caring can make.

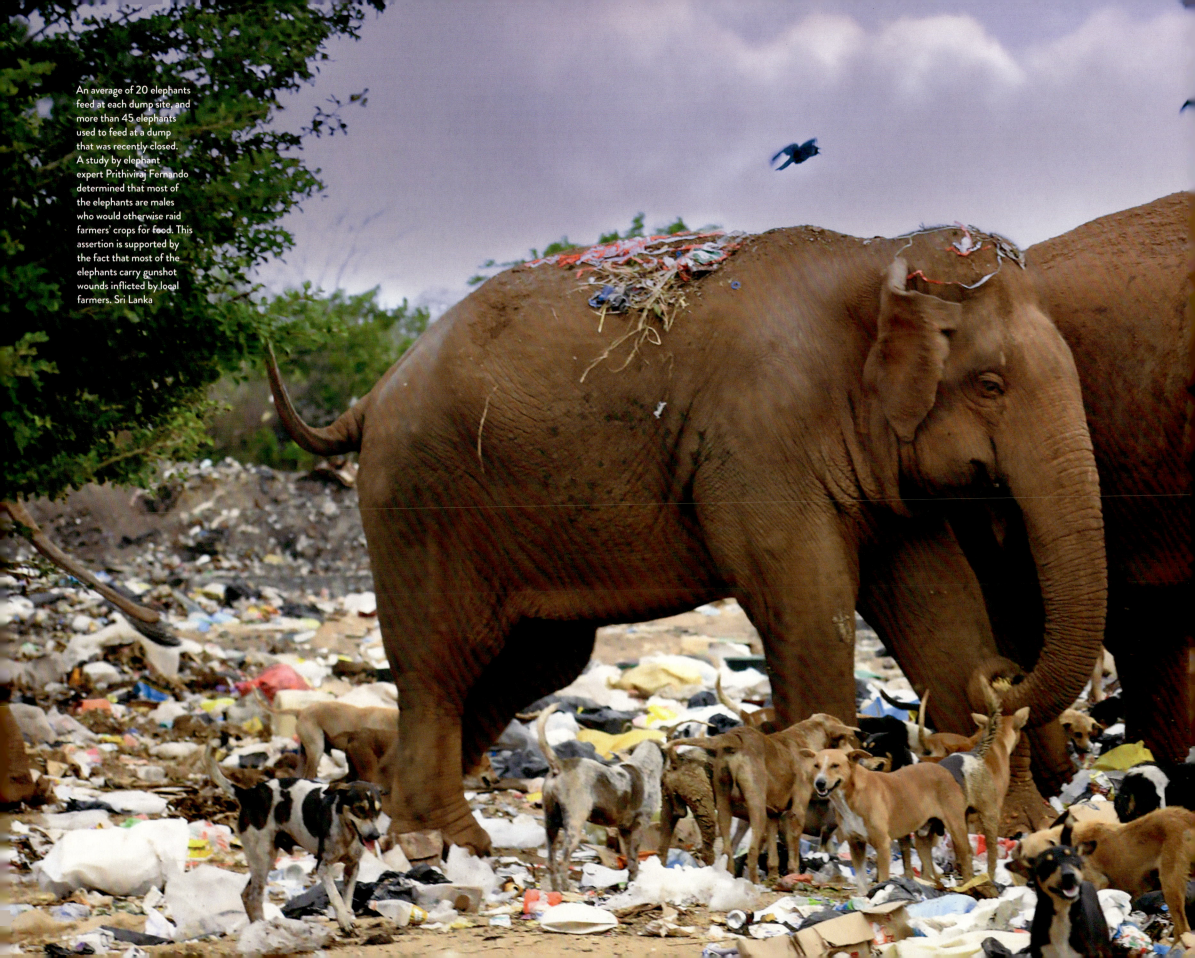

An average of 20 elephants feed at each dump site, and more than 45 elephants used to feed at a dump that was recently closed. A study by elephant expert Prithiviraj Fernando determined that most of the elephants are males who would otherwise raid farmers' crops for food. This assertion is supported by the fact that most of the elephants carry gunshot wounds inflicted by local farmers. Sri Lanka

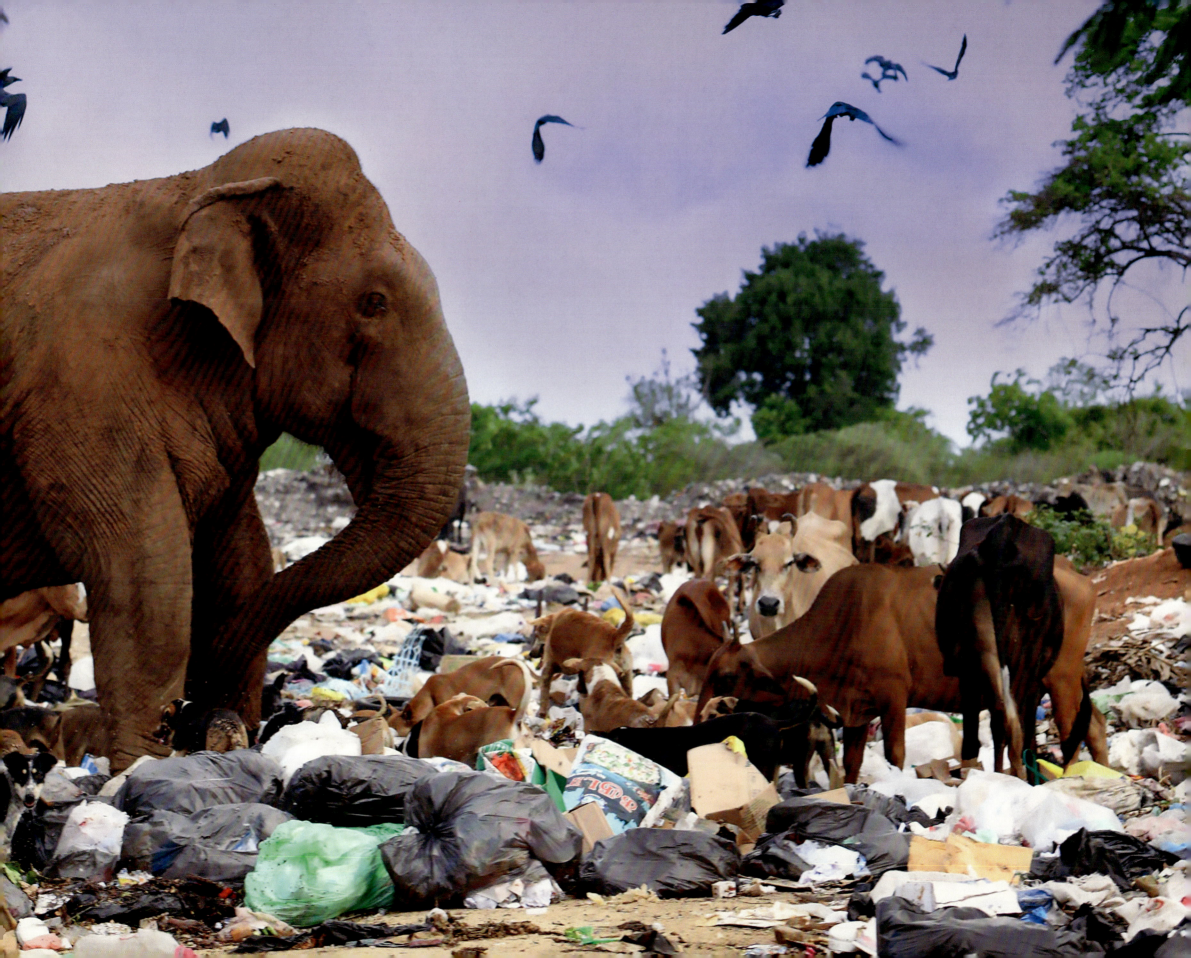

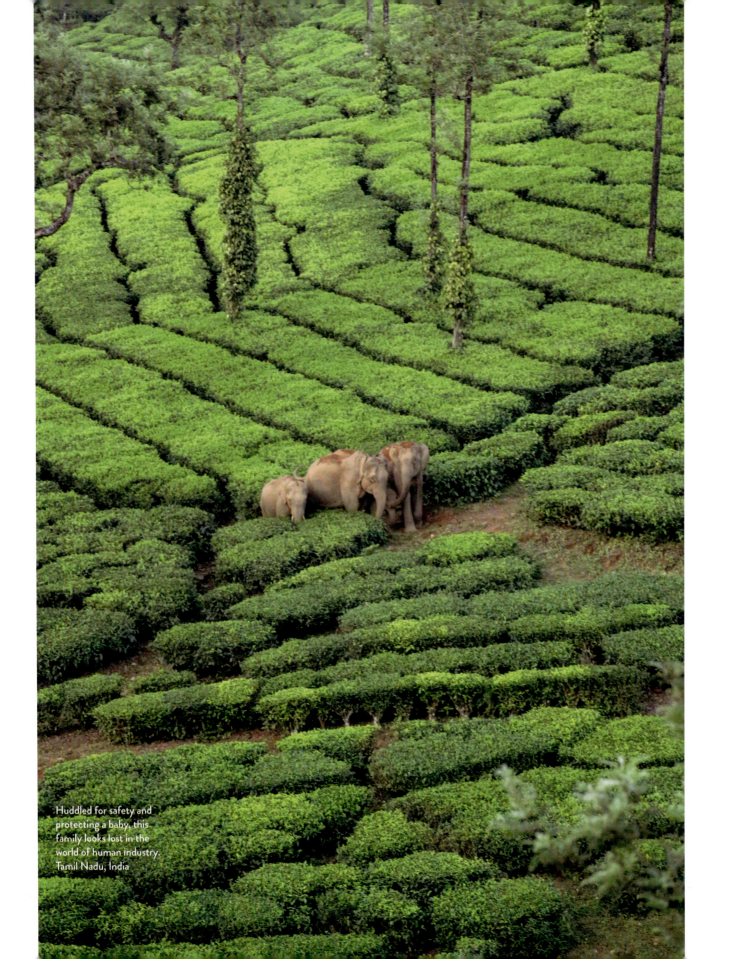

Huddled for safety and protecting a baby, this family looks lost in the world of human industry. Tamil Nadu, India

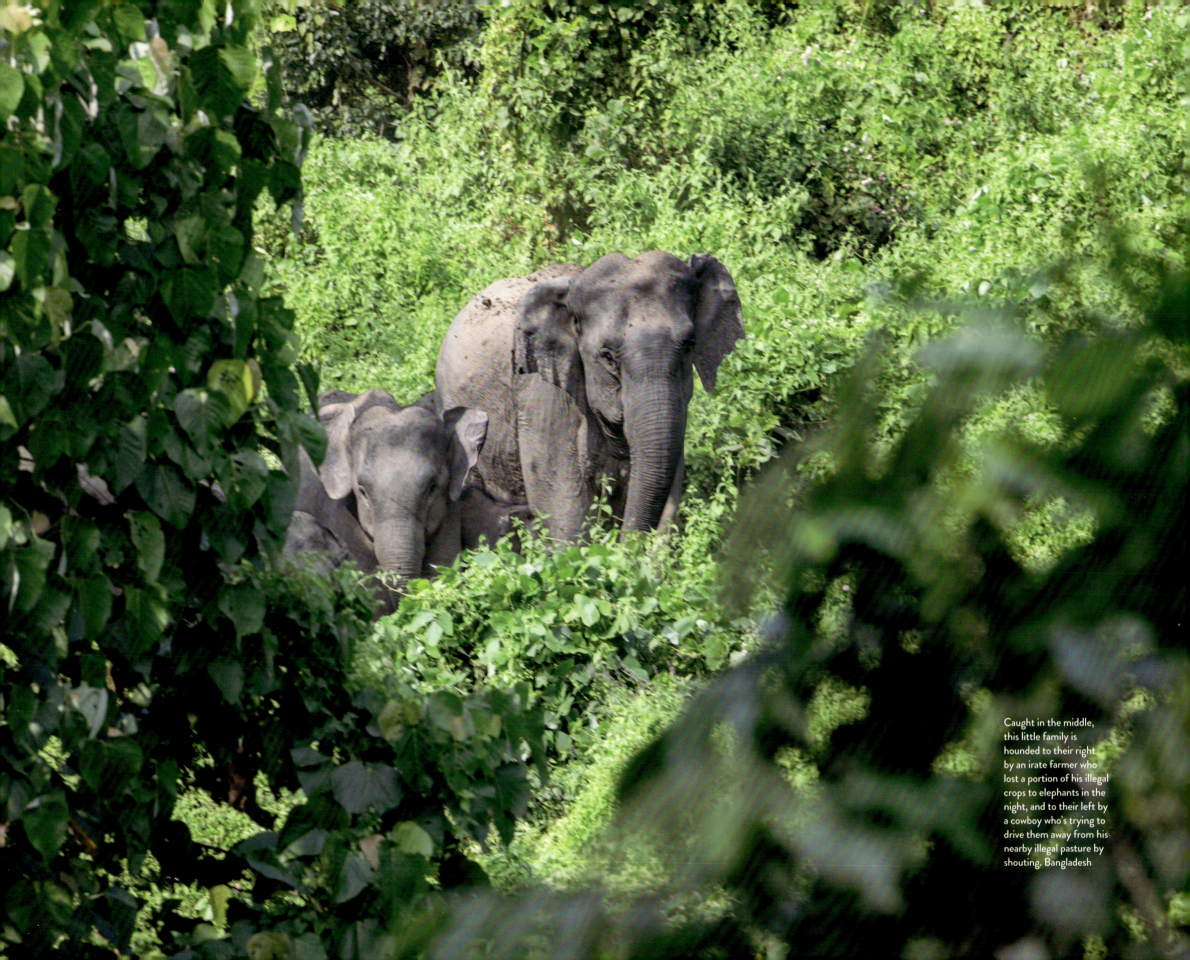

Caught in the middle, this little family is hounded to their right by an irate farmer who lost a portion of his illegal crops to elephants in the night, and to their left by a cowboy who's trying to drive them away from his nearby illegal pasture by shouting. Bangladesh

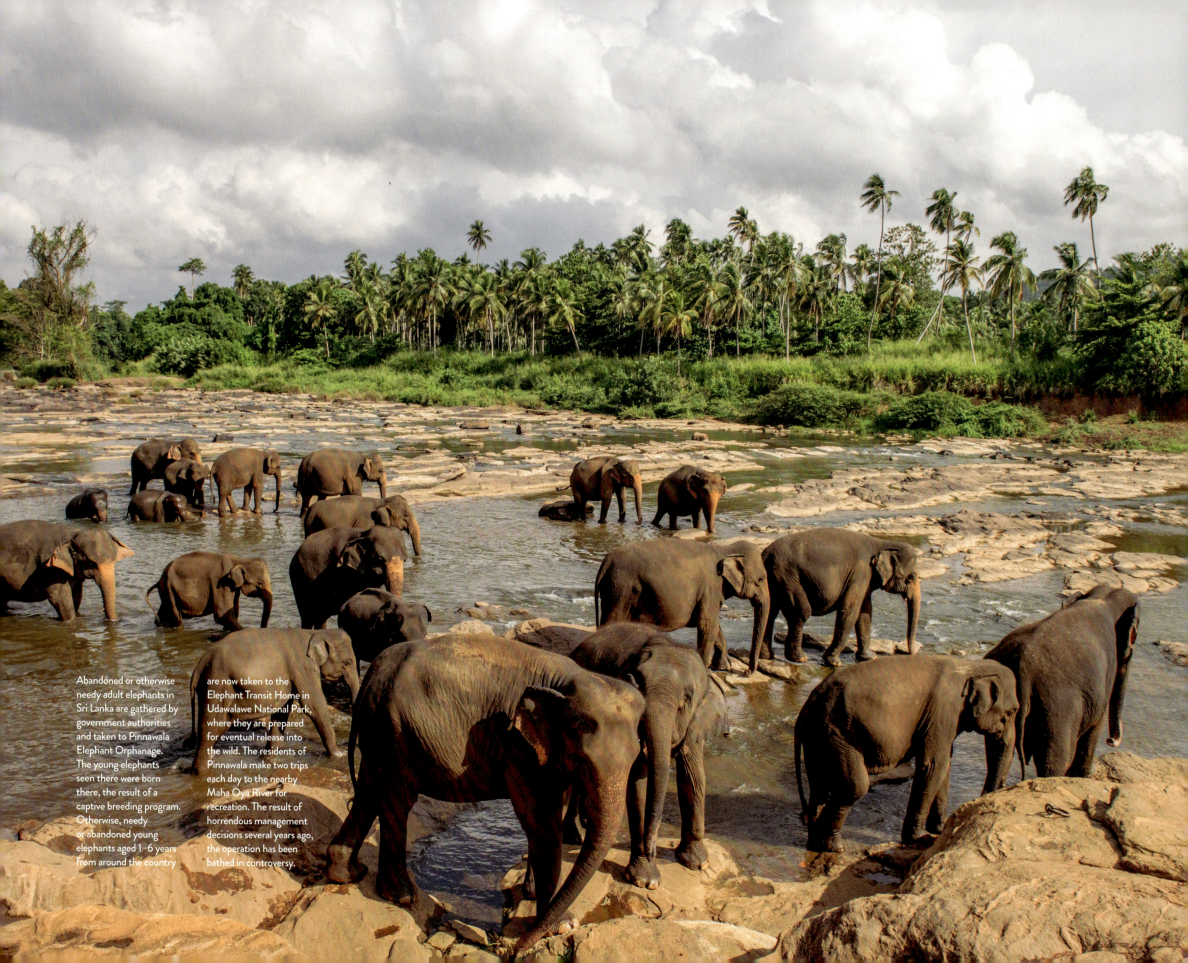

Abandoned or otherwise needy adult elephants in Sri Lanka are gathered by government authorities and taken to Pinnawala Elephant Orphanage. The young elephants seen there were born there, the result of a captive breeding program. Otherwise, needy or abandoned young elephants aged 1–6 years from around the country are now taken to the Elephant Transit Home in Udawalawe National Park, where they are prepared for eventual release into the wild. The residents of Pinnawala make two trips each day to the nearby Maha Oya River for recreation. The result of horrendous management decisions several years ago, the operation has been bathed in controversy.

ACKNOWLEDGEMENTS

With each new stage of this project, a new collection of people appeared to facilitate my explorations. While most spoke English, some did not. While some were familiar with elephants, some were not. But at every turn, the people who appeared in my life did so with great determination to assist me, inspired by my unique appreciation of elephants. I find particular joy in recognizing that by the conclusion of our times together, almost every single person commented that they were grateful for the time together, for the fact that they too now held a significant appreciation for elephants.

SRI LANKA

Angelo Dias, andBeyond Lanka	Planning and Logistics
Toby Sinclair, Guide	Planning
Ramani Jayewardene, Kulu Safaris, Naturalist	Guidance and Logistics
Namal Daluwattha, Driver	Transportation and Support
M. R. Mohamed, Park Warden, Maduru Oya National Park	Permissions and Guidance
Sanath Hewage, Manager, Elephant Transit Home	Guidance
Sumith Pilapitiya, Scientist	Guidance and Consultation

BORNEO, MALAYSIA

Charles Ryan, Director, Sticky Rice Travel	Planning and Permissions
Akhmal Aron, Guide, Sticky Rice Travel	Guidance
Kamsah 'Janu' Bin Amad, Boatman, Borneo Nature Lodge	Guidance
Chun Xing Wong, Conservation Officer, 1StopBorneo Wildlife	Guidance
Shavez Cheema, Conservationist, Founder, 1StopBorneo Wildlife	Guidance
Bazrin Bin Usran, Conservation Department, Sabah Softwoods Berhad	Guidance
Jamal Jamaluddin, Conservation Department, Sabah Softwoods Berhad	Guidance

SUMATRA, INDONESIA

Paul Hilton, Photographer and Conservationist	Guidance and Logistics
Fendra Tryshanie, Conservationist	Guidance
Samsul Rizal, Ranger, Sampoinient Elephant Camp	Guidance
Bruce Levick, Photographer, Sumatra	Planning

NEPAL

Sumith Pilapitiya, Scientist	Planning and Logistics
Rabin Kadariya, Chief, National Trust for Nature Conservation (NTNC), Bardia	Guidance
Umesh Paudel, Conservation Assistant, NTNC, Bardia	Guidance
Krishna Kumar, Driver, NTNC, Bardia	Guidance and Transportation
Laxmi Deula, Guide, Racy Shade Resort, Bardia	Guidance
Rabilal Tharu, Mahout, Bardia Breeding Centre	Guidance
Manny Lal Chaudhary, Assistant Manager, Chitwan Breeding Centre	Guidance
Mina Mahato, Mahout, Chitwan Breeding Centre	Guidance
Ram Kumar Aryal, former NTNC Executive; Owner, Rhino Lodge, Sauraha	Guidance
Nishant Adhikari, Guide, Rhino Lodge, Sauraha	Guidance
Michael Bailey and Floriane Blot, Stand Up 4 Elephants, Founders, Sauraha	Guidance
Raj Kumar Gaga, Mahout, Sauraha	Guidance
Anil Darai, Mahout, Sauraha	Guidance
Dr Patricia London, Veterinarian and former Elephant Owner, Sauraha	Guidance

THAILAND

Laurence Pirlet, Kensington Tours	Planning and Logistics
Nisuth 'Pok' Patittabutr, Guide	Guidance
Surat 'Rat' Sukkay, Driver	Transportation
Preecha Phongkum, Father of Elephant Conservation Centre	History and Guidance
Dr Khajohnpat Boonprasert, DVM, Elephant Conservation Centre	Guidance
Somchat 'Danger' Changkarn, Director of Mahout Training School, Elephant Conservation Centre	Guidance
Saengduean Lek Chailert, Principal, Elephant Nature Park	Guidance
Darrick Thomson, Co-Principal, Elephant Nature Park	Guidance
Arongkon 'T' Jansongsang, Elephant Nature Park	Guidance
Katherine Connor, Principal, Boon Lott's Elephant Sanctuary	Guidance
Kru Sing, Boon Lott's Elephant Sanctuary	Guidance

NORTHEAST INDIA

Jacob Shell, Associate Professor of Geography and Urban Studies, Author	Guidance
Bengia 'Bulldog' Mrinal, Guide	Guidance and Logistics
Saji Natung	Transportation and Support
Disi Thuing, Elephant Man	Guidance
Chow Sokamein, Elephant Man	Guidance
Teynam Mein, Elephant Man	Guidance
Enseng Mantaw	Guidance
Kongham Manpang, Elephant Man	Guidance
Lamirip Singpha, Elephant Man	Guidance
Tung Baula Hopak, Elephant Man	Guidance

LAOS

Ellen Sparling, Kensington Tours	Planning and Logistics
Mr Ken Sanaphan, Elephant Conservation Centre	Guidance
Khamla Champou	Guidance
Sommai 'Chit' Chith, Driver	Transportation
Mr Deng, Manager, Manifa Elephant Camp	Guidance
Mr Salermm, Elephant Owner, Xayaboury Elephant Festival	Logistics
Mr Senglaloun Latsawong, Elephant Owner, Xayaboury Elephant Festival	Logistics
Noy Dedlakhone, ManadaLao Elephant Conservation	Guidance
Boun Than, ManadaLao Elephant Conservation	Guidance

CAMBODIA

Toeun Khoeura, Elephant Valley Project	Guidance
Ret 'King' Sarai, Driver	Transportation

VIETNAM

Nguyen Quoc Hung	Guidance
Tran Van Huy	Transportation

SOUTHERN INDIA

Anit Singh, Kensington Tours	Planning and Logistics
Bala Chanbran	Transportation, Kerala
Sreeni T. S., Neelambari Heritage Cultural Arts Centre, Kerala	Guidance and Logistics
Hadlee Renjith	Guidance, Munnar
Ashwin H. P., Guide Service	Guidance and Logistics
Shivam Rai, Wildlife SOS	Guidance
Mr Adul Pathak, Wildlife SOS	Guidance
Anil, Driver	Transportation, Delhi and Jaipur

SOUTHERN THAILAND

Maria Alvarez, Kensington Tours	Planning and Logistics
Nisuth 'Pok' Patittabutr	Guidance
Thanabadee Promsook, Owner of Plai Ekachai	Permissions and Guidance
Woraman Sangpon, Manager, Chang Thong Khum Elephant Conservation Centre	Guidance
Weerasak 'Sun' Sombosnphan	Guidance, Phuket
Nan, Bathing with Elephants, Phuket	Guidance
Yayah, Phuket Elephant Sanctuary	Guidance
'Mr OK' Panupong, Manager, Elephant Care Camp at Siray Phuket	Guidance

BANGLADESH

Klaus Lueckert, Exito Travel USA	Air Transportation
Shahriar Caesar Rahman, Scientist	Advanced Planning
Sultan Ahmed, Scientist	Guidance and Logistics
Sona Miah, Scientist	Guidance, Cox's Bazar
Nurul 'Manik' Huda	Guidance, Cox's Bazar
Ali Hossain	Guidance, Cox's Bazar
Shovon Jamman, Beat Officer, Forest Department	Permissions, Cox's Bazar
Khurshed Alom	Guidance, Moulvi Bazar
Md. Sobuj Mia, Forest Department	Guidance, Sherpur
Motalab Akhando, Forest Department	Guidance, Sherpur
Muna B Ali, Forest Department	Guidance, Sherpur
Maqrul Papel, Ranger, Forest Department	Consultant, Sherpur
Masum Hossain, Management, Circus Bul Bul	Logistics, Kalimela
Masum Islam, Management, Circus Bul Bul	Logistics, Kalimela
Ripon Ray, Scientist	Logistics, Saidpur and Dhaka
Ramjan Ali, Driver	Transportation, Sherpur

SOUTHERN INDIA, SECOND SURVEY

Klaus Lueckert, Exito Travel USA	Air Transportation
Parthipan Sonapathy, Driver	Transportation
Lingesh Kalingarayar, Sheikalmudi Bungalow, Tahr Trails	Lodging and Logistics
Prakash Ramakrishnan, Photographer	Guidance
Ganesh Raghunathan, Photographer, Nature Conservation Foundation	Guidance
Balaji and Pandi, Staff, Sheikalmudi Bungalow, Tahr Trails	Support
Mohamed Ismail, Staff, Sheikalmudi Bungalow, Tahr Trails	Support
Abishek Vaidyanathan, Operations Manager, Briar Tea Bungalows	Guidance
Mohan Babu, Briar Tea Bungalows, Puthuthotlam Estate	Permissions and Guidance

MYANMAR (BURMA)

Klaus Lueckert, Exito Travel USA	Air Transportation
Min Soe Wai, Tours by Locals	Planning, Logistics and Guidance
Yin Lin, Driver	Transportation
Hnin Yu Mon Aye, Senior Forest Ranger, Win Gau Baw Elephant Camp	Guidance
Aung Win Tun, Manager, Maw Yaw Gyi Elephant Camp	Guidance
Ko Chan, Administrative Assistant, Phokyar Elephant Camp	Guidance
Nyi Nyi Aung, Manager, Nga Laik Elephant Camp	Guidance
Soe Min Oo, Assistant Manager, Shen Yo Ma Elephant Camp	Guidance
Tue Aung, Assistant Manager, Wa Net Elephant Camp	Guidance
Thador Shin Thant, Senior Forest Ranger, Wa Net Elephant Camp	Guidance
Myo Min Aungr, Veterinarian, Palin River View Elephant Camp	Guidance

UNITED KINGDOM

Martin Liu, LID Business Media	Chief Operations Officer and Publisher
Aiyana Curtis, LID Business Media	Editorial Manager
Caroline Li, LID Business Media	Art Director
Hazel Bird, LID Business Media	Copy Editor

UNITED STATES

Elfie Larkin, Teacher, Oakland Public Schools, Oakland Zoo Docent	Guidance and Inspiration
Peter Beren, Author, Publisher and Literary Agent	Guidance and Support
Steve McCurry, Photographer	Inspiration
Dexter Jung, Biostatistician	Technology Support
Annette Laverty, Public Health Professional and Animal Rescue Technician	Transportation and Support
Ron Pereira, Ron Pereira Graphic Design	Project Stuntman and Magician

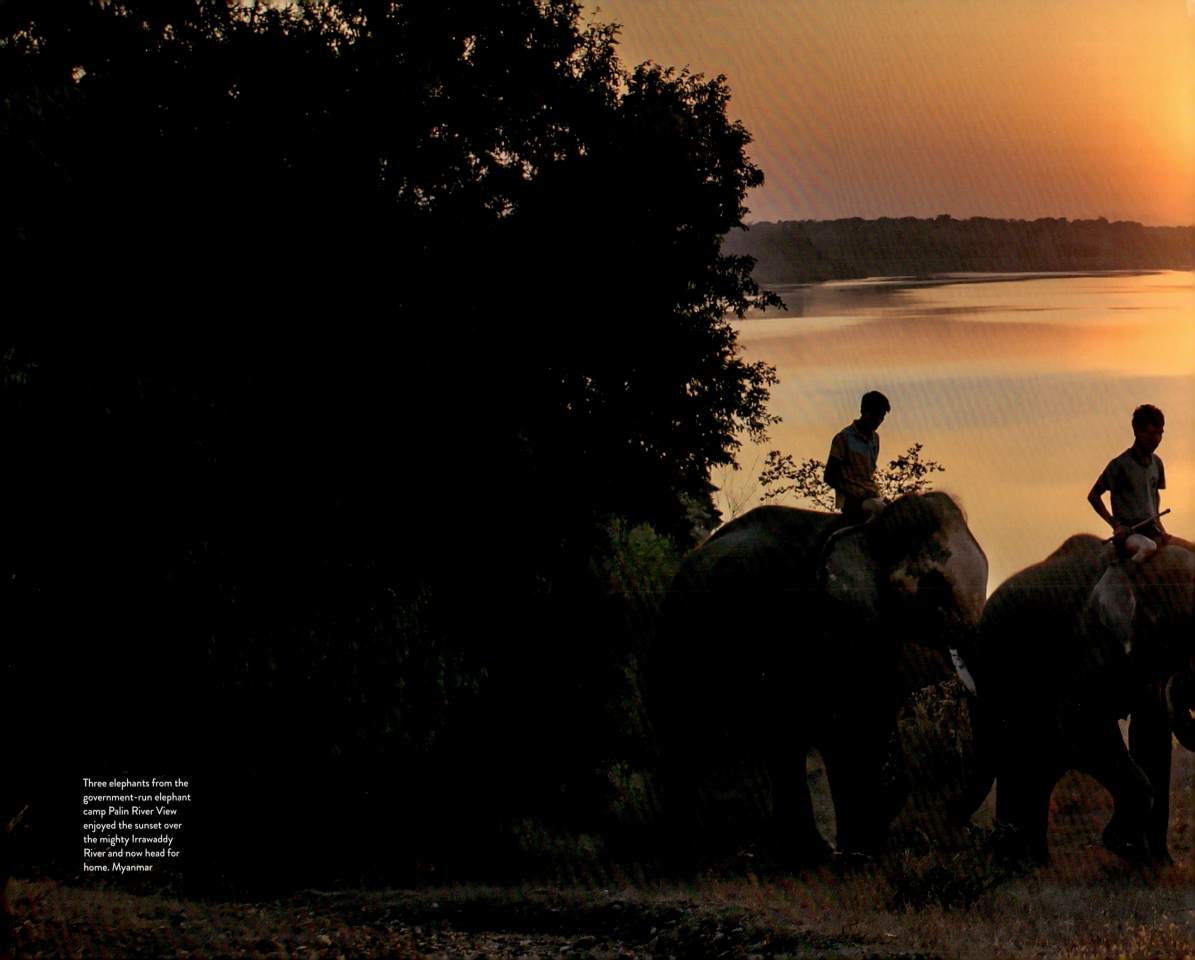

Three elephants from the government-run elephant camp Palin River View enjoyed the sunset over the mighty Irrawaddy River and now head for home. Myanmar

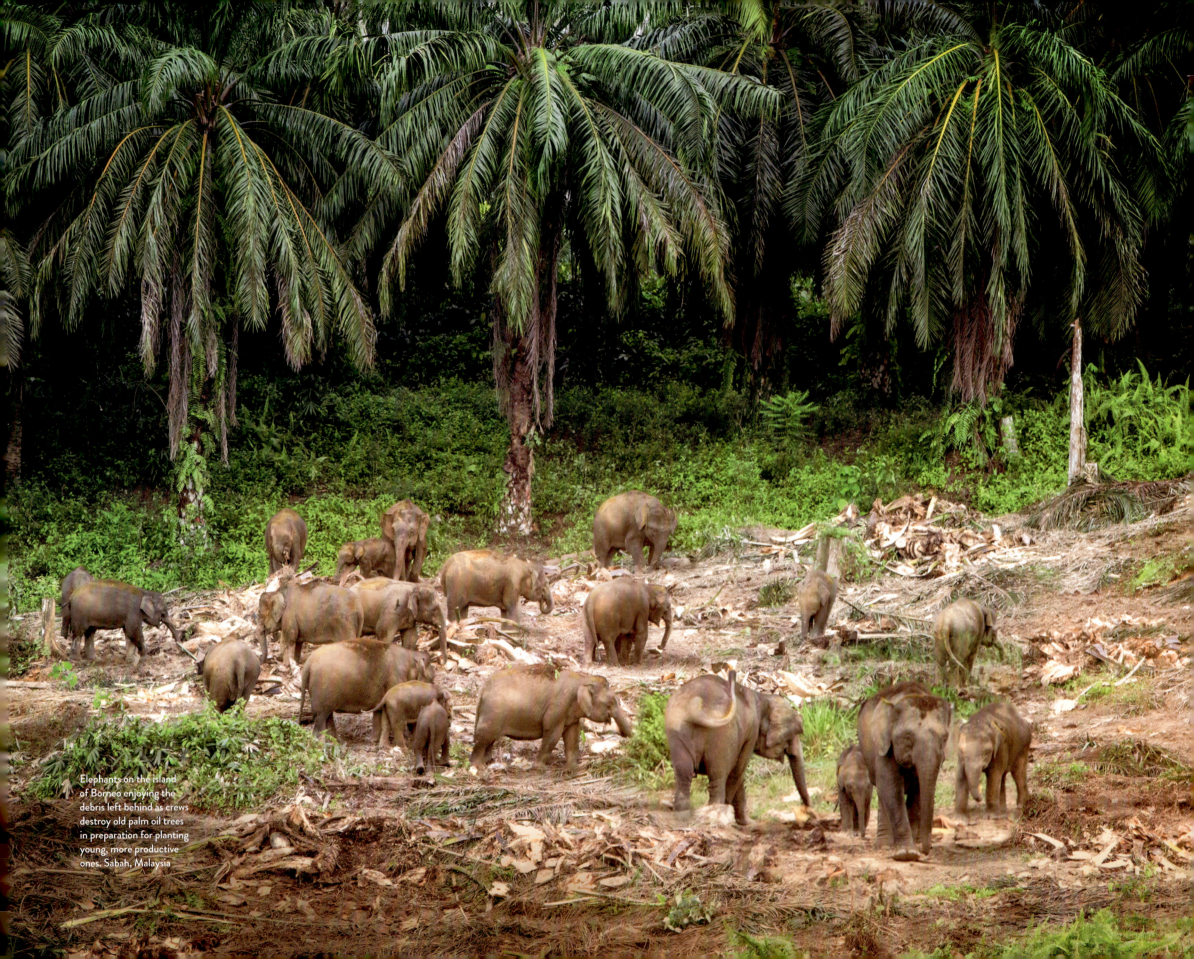

Elephants on the island of Borneo enjoying the debris left behind as crews destroy old palm oil trees in preparation for planting young, more productive ones. Sabah, Malaysia

BIBLIOGRAPHY

Alter, Stephen. *Elephas Maximus: A Portrait of the Indian Elephant.* Orlando: Harcourt, 2004.

Babu, Nikhil M. "The 'Undisputed Last Elephant' of Delhi." *The Hindu*. Last modified 29 September 2019, https://www.thehindu.com/news/cities/Delhi/the-undisputed-last-elephant-of-delhi/article29545151.ece.

Baker, Samuel W. *The Rifle and Hound in Ceylon*. Chicago: S. A. Maxwell & Co., c. 1880.

Begum, Thaslima. "Death Tolls Mount as Elephants and People Compete for Land in Sri Lanka." *The Guardian*. 19 March 2024, https://www.theguardian.com/environment/2024/mar/19/sri-lanka-elephants-people-deaths-natural-resources-climate-crisis-coexistence-aoe.

Campbell, Reginald. *Teak Wallah: The Adventures of a Young Englishman in Thailand in the 1920s.* Singapore: Oxford University Press, 1986.

Cannon, Teresa and Peter Davis. *Aliya: Stories of the Elephants of Sri Lanka*. Victoria, Australia: Airvata Press, 1975.

Croke, Vicki Constantine. *Elephant Company: The Inspiring Story of an Unlikely Hero and the Animals Who Helped Him Save Lives in World War II*. New York: Random House, 2014.

Daniel, J. C. *The Asian Elephant: A Natural History*. New Delhi: Natraj Publishers, 1998.

Doherty, Faith and Alec Dawson. "Myanmar's Tainted Timber and the Military Coup." *Environmental Investigation Agency*. Last modified 28 June 2021, https://eia-international.org/forests/myanmars-tainted-timber-and-the-military-coup/.

Gale, U Toke. *Burmese Timber Elephant*. Yangon: Trade Corporation, 1974.

Jayewardene, Jayantha. *The Elephant in Sri Lanka*. Colombo, Sri Lanka: WHT Publications, 1997.

Kistler, John M. *War Elephants*. Westport, CT: Greenwood Publishing Group, 2005.

Motaleb, Mohammad Abdul and Mohammad Sultan Ahmed. 2016. *Status of Asian Elephants in Bangladesh*. Dhaka: International Union for Conservation of Nature, https://portals.iucn.org/library/sites/library/files/documents/2016-085.pdf.

Réhahn. *Réhahn Photography*. "The Mnong and the Elephants in Vietnam – The Ritual." https://www.rehahnphotographer.com/mnong-elephant-rituals-vietnam/.

Senevirathne, Asha. "Selection of Tuskers to Carry the Relic Casket." *Sunday Observer*. Last modified 10 August 2008, https://archives.sundayobserver.lk/2008/08/10/jun08.asp.

Shell, Jacob. *Giants of the Monsoon Forest: Living and Working with Elephants*. New York: W. W. Norton and Company, 2019.

Skinner, Thomas. *Fifty Years in Ceylon*. London: W. H. Allen & Co., 1891.

Snell, Govi and Anton L. Delgado. "Conflict Threatens Vietnam's Last Elephants." *Dialog Earth*, 12 July 2023, https://www.dialog.earth/en/nature/conflict-threatens-vietnams-last-elephants/.

Sukumar, Raman. 2011. *The Story of Asia's Elephants*. Mumbai: Marg Publications.

Sutradhar, Bibek and Sabrina Ferdous. *Elephant Conservation in Bangladesh: The Facts and the Fictions.* Mauritius: Lap Lambert Academic Publishing, 2017.

Vardar, Serdar and Pelin Ünker. "Blood Teak for the Super Rich Props Up a Cruel Regime." *Deutsche Welle*, 03 February 2023, https://www.dw.com/en/blood-teak-for-the-super-rich-props-up-a-cruel-regime/a-64854613.

Williams, J. H. *Elephant Bill*. New York: Doubleday & Company, 1950.

Williams, J. H. *Bandoola*. London: Rupert Hart-Davis, 1953.

Williams, Susan. *The Footprints of Elephant Bill*. London: William Kimber and Co., 1962.

Wylie, Kenneth C. "Elephants Used as War Machines." *Elephants, Majestic Creatures of the Wild*, edited by Dr. Jeheskel Shoshani, Rodale Press, 1992.

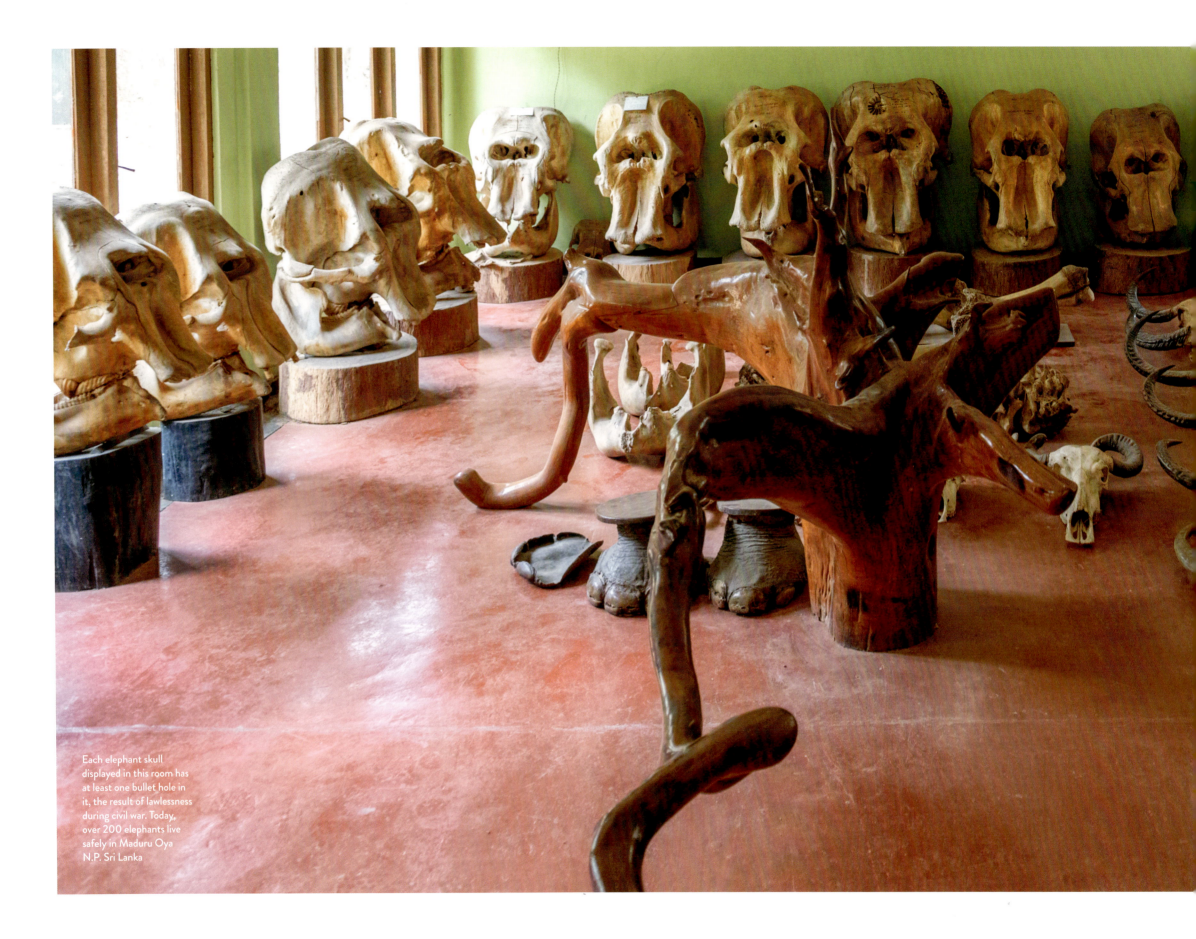

Each elephant skull displayed in this room has at least one bullet hole in it, the result of lawlessness during civil war. Today, over 200 elephants live safely in Maduru Oya N.P. Sri Lanka

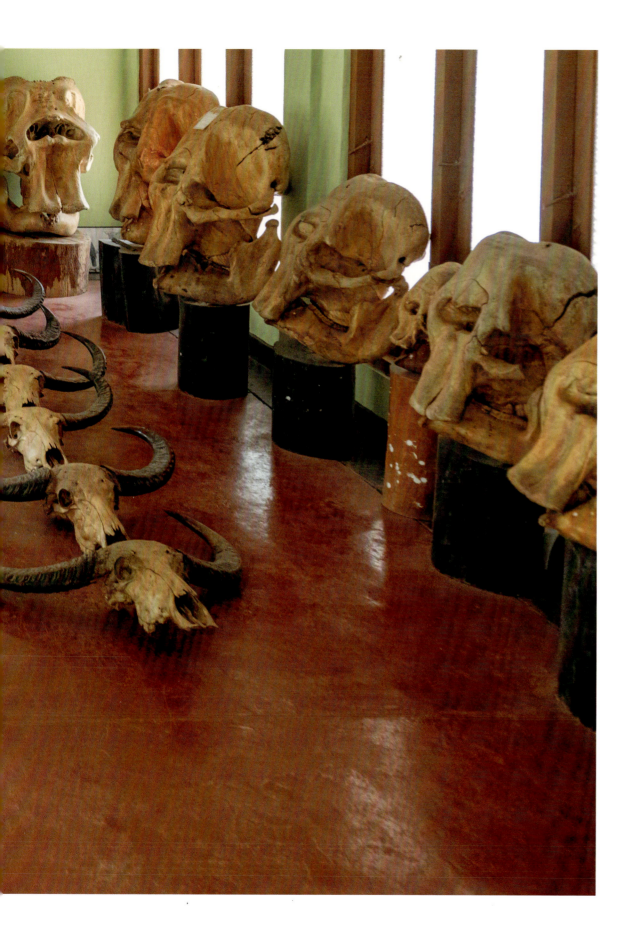

Asian elephants supplied the continent's iconic ivory-carving industry for thousands of years. At some point, demand for ivory art outpaced the supply of raw ivory. By the 14th century, carvers had begun carving on ivory sourced from African elephants. This piece, carved between 1900 and 1920 in Peking, was sold to an American collector in 1984

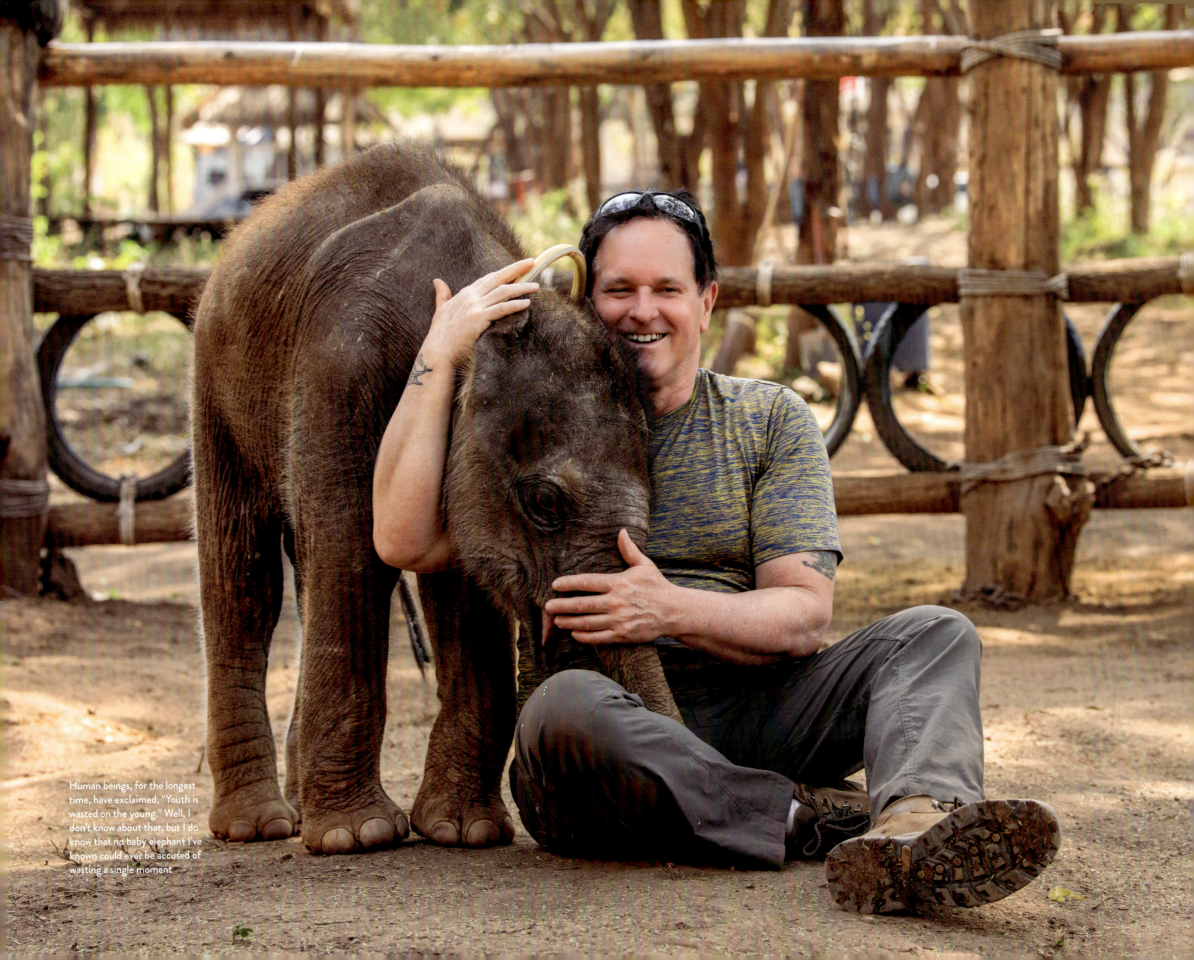

Human beings, for the longest time, have exclaimed, "Youth is wasted on the young." Well, I don't know about that, but I do know that no baby elephant I've known could ever be accused of wasting a single moment

IN DREAMS

The story of the Asian elephant is a tragedy. The more I learn of their lives and the more I see, the more my heart grows heavy. The lives of those held in captivity are particularly pitiful. Over the course of my surveys of Asia, I met hundreds of these poor souls. I spent time, a good deal of time, with many of them. Then as now, in those awkward moments, I like to think that they saw me, just as much as I saw them: deeply. I like to think we shared something, because I certainly shared something with them. I shared my love for each one and for their kind, and I made it known to them over and over.

I like to think that we'll all see each other again soon, out in some great open field under a blue sky, the babies darting here and there, our gathering held far away from the trappings of humanity. And did I mention that we'd be joined by piles of sugar cane stalks and bananas? I like to think of all of this. In my dreams.

MY PRAYER FOR YOU

Look at the world through elephant eyes. Be confident in who you are and your place in this world. Embrace compassion for other beings from a place of loving curiosity. And give back with all you've got to the elephant, who has, deep in the collective heart and mind of humanity, made this world a far better place to live.

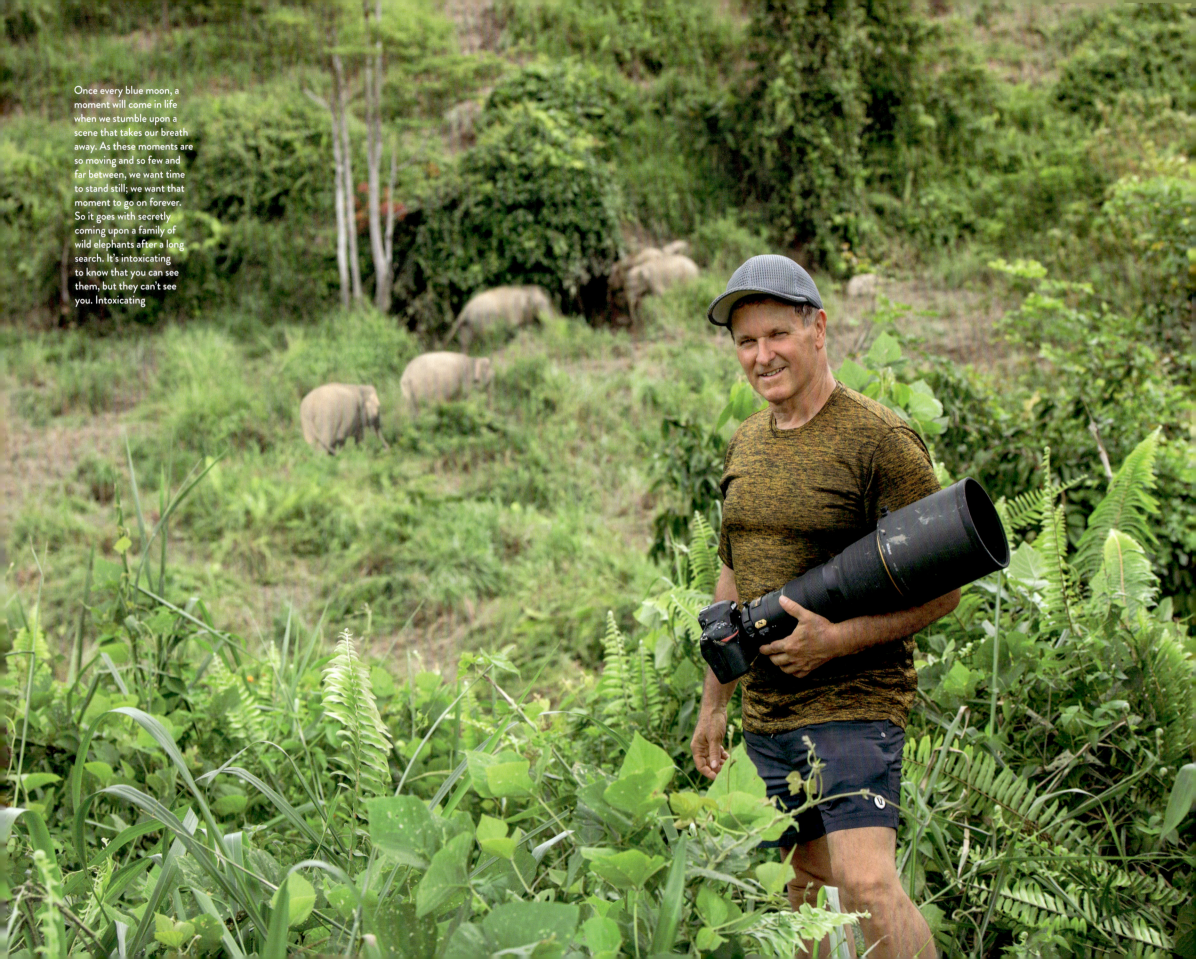

Once every blue moon, a moment will come in life when we stumble upon a scene that takes our breath away. As these moments are so moving and so few and far between, we want time to stand still; we want that moment to go on forever. So it goes with secretly coming upon a family of wild elephants after a long search. It's intoxicating to know that you can see them, but they can't see you. Intoxicating

ABOUT THE AUTHOR AND PHOTOGRAPHER

Following a 30-year career as a Hollywood actor, Larry Laverty became one of the most popular nature photographers in the world. His aggressive style and comprehensive coverage of wildlife have been captivating viewers for more than a decade. As a champion for conserving wildlife habitats and the lives of animals in captivity, Larry has also been a voice for animals through writing. Following his first book, *Power and Majesty* (2019), highlighting Africa's elephants, Larry has written, directed or produced several wildlife films, including *Where Buffalo Roam* (2021). For this book, *Magnetic*, he travelled through 11 Asian countries over the course of five years. Larry holds a BS degree in finance and a BA degree in political science, and has pursued graduate studies at several institutions including Johns Hopkins University. He is a member of The Explorers Club, The Wildlife Society, the American Alpine Club, the Screen Actors Guild, the Actors' Equity Association, the National Eagle Scout Association, and Advisory Board member of Voices for Asian Elephants. Larry makes his home in Oakland, California, at the very place where passing butterflies in his childhood ignited his appreciation for the natural world.

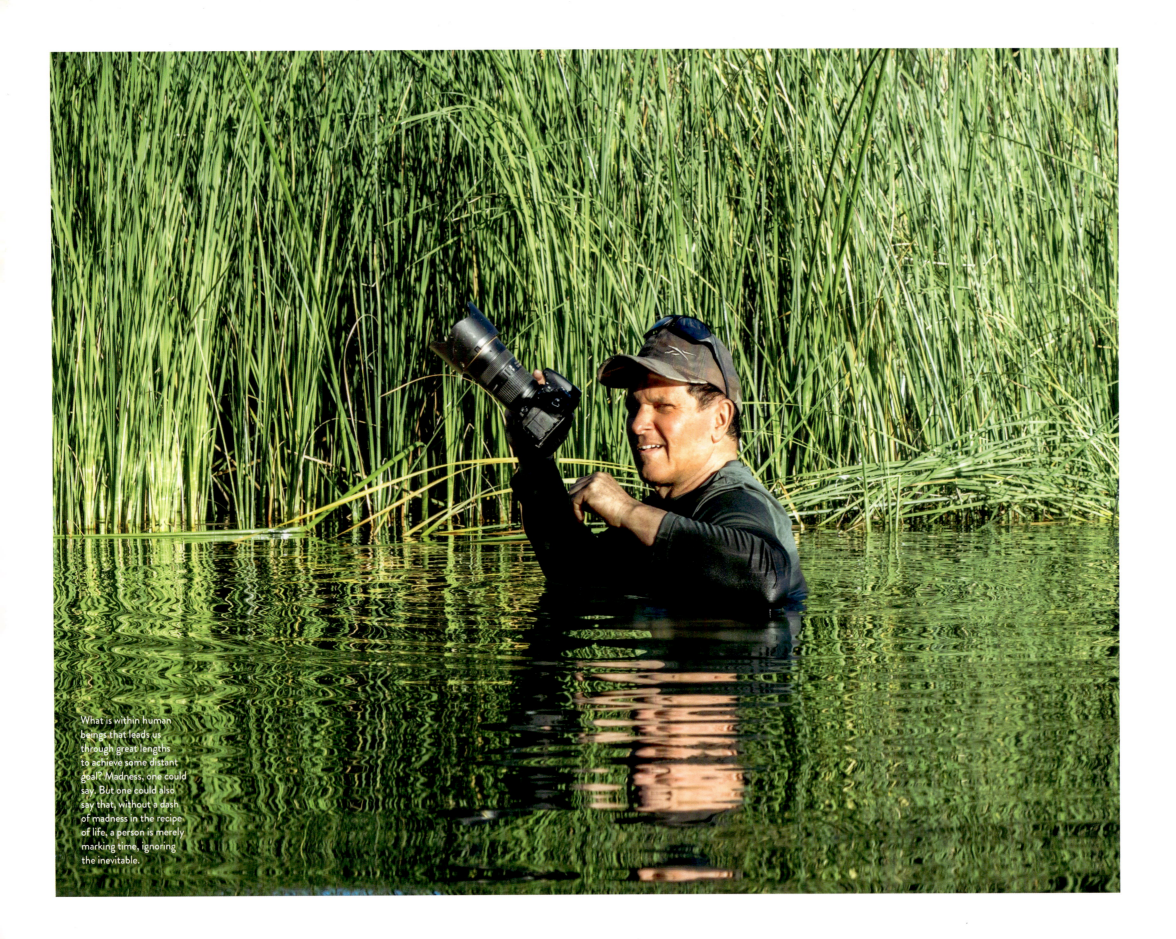

What is within human beings that leads us through great lengths to achieve some distant goal? Madness, one could say. But one could also say that, without a dash of madness in the recipe of life, a person is merely marking time, ignoring the inevitable.

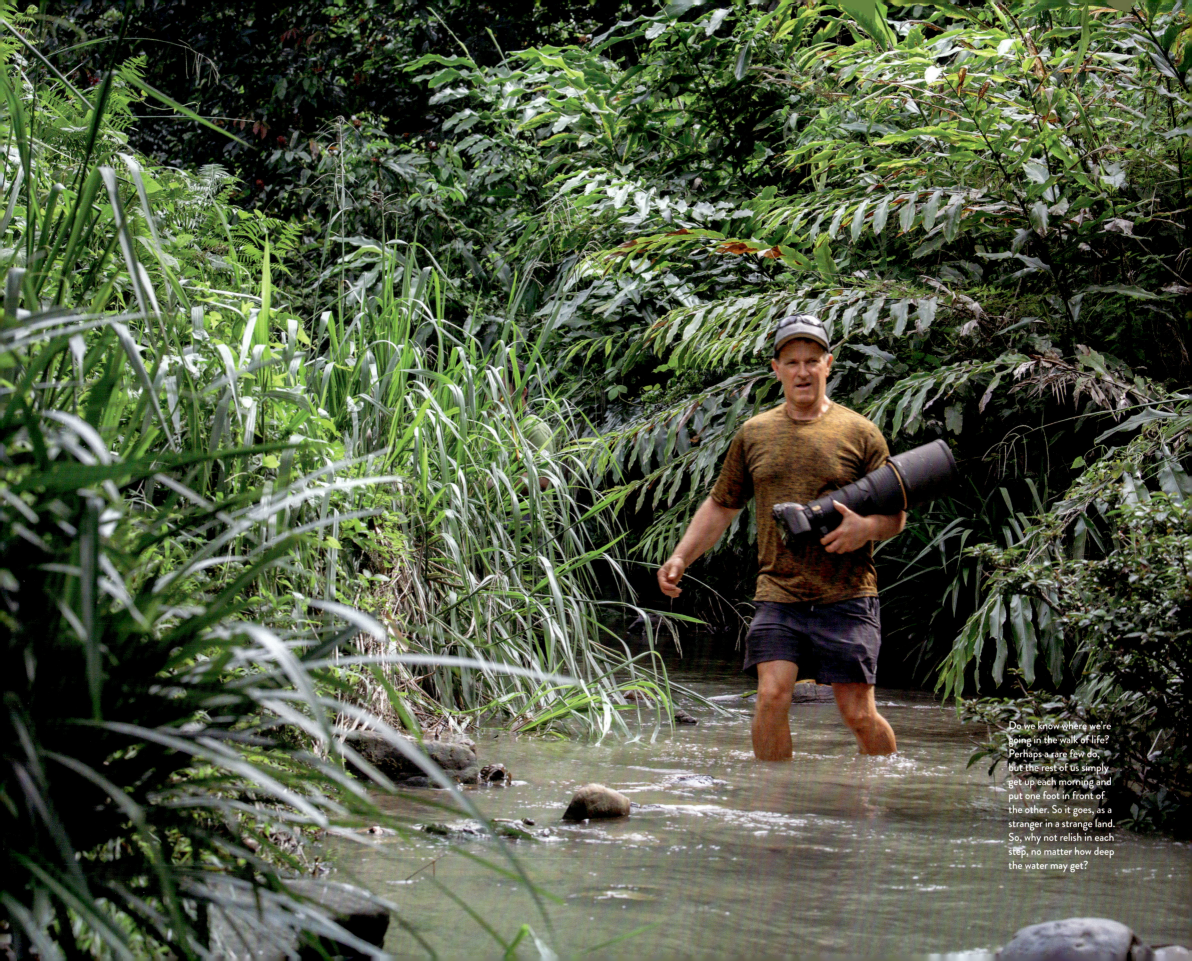

Do we know where we're going in the walk of life? Perhaps a rare few do, but the rest of us simply get up each morning and put one foot in front of the other. So it goes, as a stranger in a strange land. So, why not relish in each step, no matter how deep the water may get?

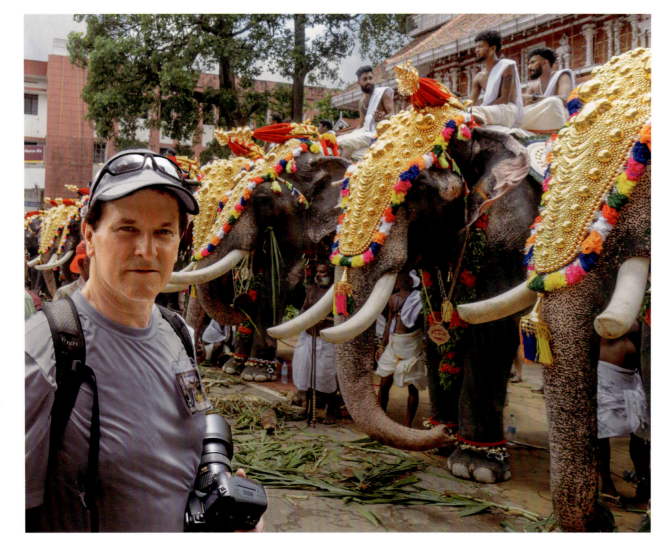

Funny thing. I have never felt so alone as I have while in the company of a crowd of people. Meanwhile, on the other side of the token, I have rarely felt so among kindred spirits as I have while lingering among a family of elephants.

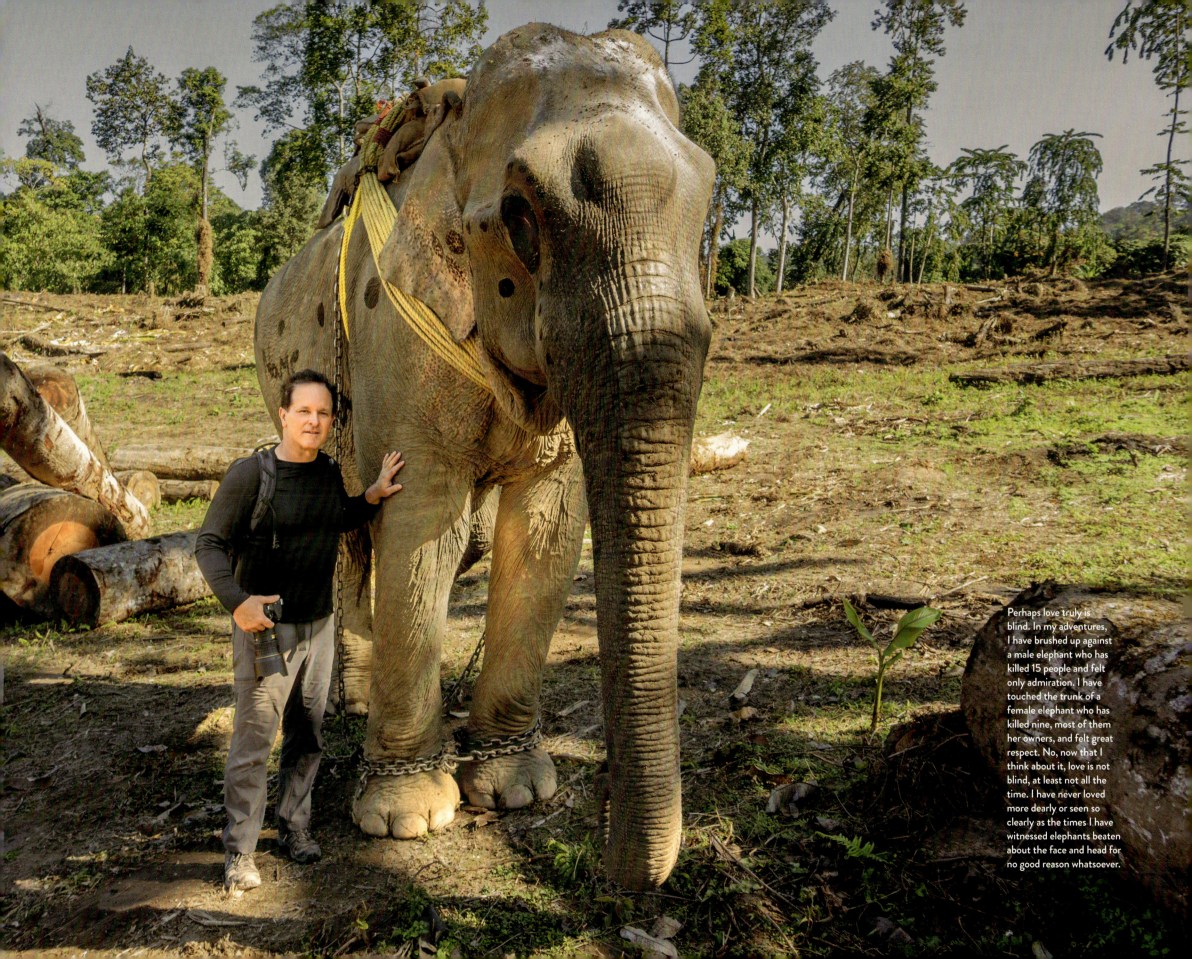

Perhaps love truly is blind. In my adventures, I have brushed up against a male elephant who has killed 15 people and felt only admiration. I have touched the trunk of a female elephant who has killed nine, most of them her owners, and felt great respect. No, now that I think about it, love is not blind, at least not all the time. I have never loved more dearly or seen so clearly as the times I have witnessed elephants beaten about the face and head for no good reason whatsoever.

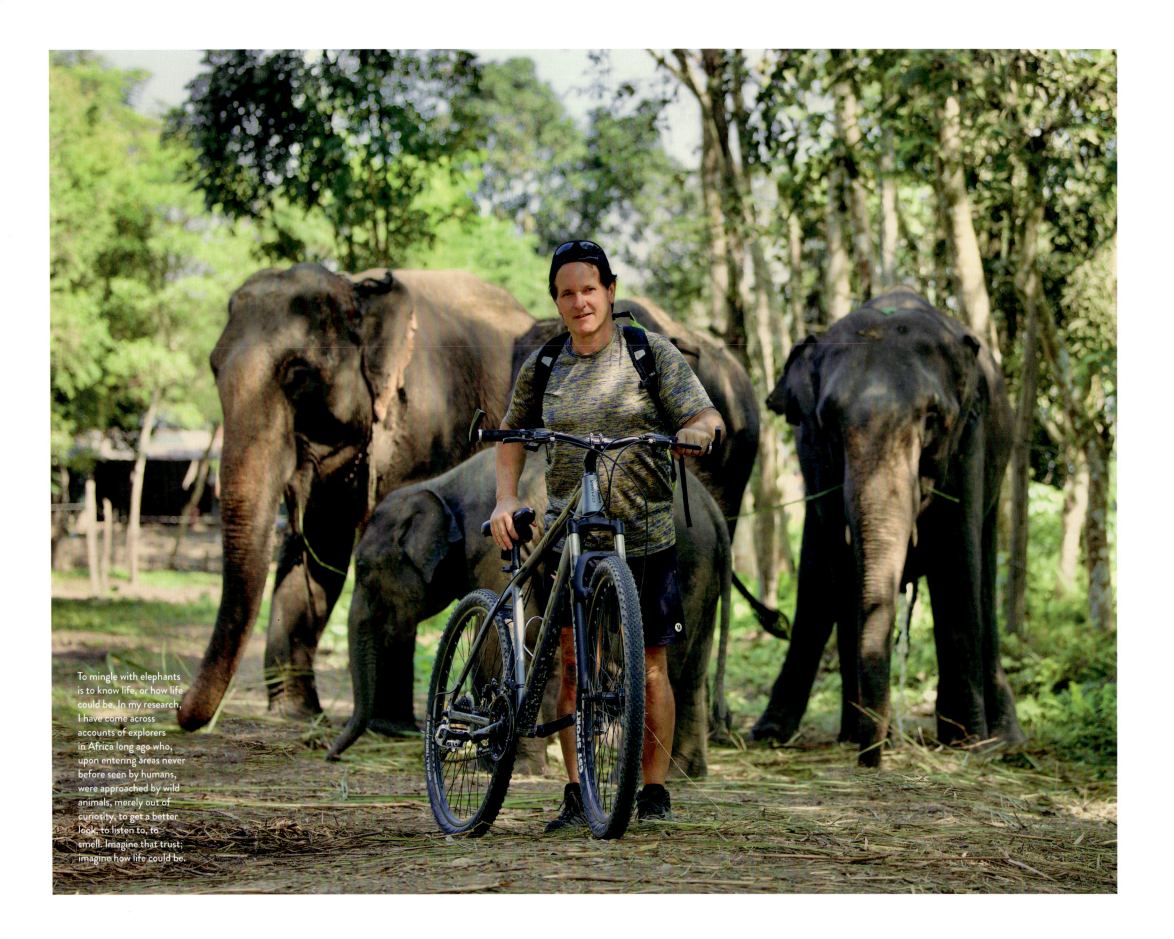

To mingle with elephants is to know life, or how life could be. In my research, I have come across accounts of explorers in Africa long ago who, upon entering areas never before seen by humans, were approached by wild animals, merely out of curiosity, to get a better look, to listen to, to smell. Imagine that trust; imagine how life could be.